The Systemic Image

The Systemic Image

A New Theory of Interactive Real-Time Simulations

Inge Hinterwaldner
Translated by Elizabeth Tucker

The MIT Press
Cambridge, Massachusetts
London, England

The translation of this work was funded by Geisteswissenschaften International—Translation Funding for Humanities and Social Sciences from Germany—a joint initiative of the Fritz Thyssen Foundation, the German Federal Foreign Office, the collecting society VG WORT and the Börsenverein des Deutschen Buchhandels (German Publishers and Booksellers Association).

Every effort has been made to contact the copyright holders of the images in this book. Please address any queries to the author, care of The MIT Press.

This book was set in Stone Sans and Stone Serif by Toppan Best-set Premedia Limited.

Library of Congress Cataloging-in-Publication Data

Names: Hinterwaldner, Inge, author. | Translation of: Hinterwaldner, Inge.
 Systemische Bild.
Title: The systemic image : a new theory of interactive real-time simulations
 / Inge Hinterwaldner.
Other titles: Systemische Bild. English
Description: Cambridge, MA : The MIT Press, 2017. | Includes bibliographical
 references and index.
Identifiers: LCCN 2016016809 | ISBN 9780262035040 (hardcover : alk. paper)
ISBN 9780262549646 (paperback)
Subjects: LCSH: Art--Computer simulation. | Science--Computer simulation. |
 Visualization. | Interactive multimedia. | Simulation methods. | Art and
 technology.
Classification: LCC N72.T4 H5613 2017 | DDC 700/.41--dc23 LC record available at https://lccn.loc.
gov/2016016809

Contents

Acknowledgments

The manuscript for this book was submitted as a doctoral dissertation to the University of Basel in 2008, was defended in 2009, and in 2010 received the Prize for the Humanities awarded by the Faculty of the Humanities, University of Basel (for the best PhD thesis of the academic year 2009/2010). The German version of the text was also published in 2010 by Wilhelm Fink Verlag, Paderborn.

For placing their faith in me and granting me their interest, for the equally inspiring and intensive mentoring of this work, I thank my dissertation advisors, Gottfried Boehm (University of Basel) and Michael Hagner (ETH Zurich). I profited from stimulating research environments from 2000 to 2006 at the Karlsruhe University of Arts and Design's graduate college "Image. Body. Medium. An Anthropological Perspective" (led by Hans Belting and Beat Wyss), as well as from 2005 to 2008 at the graduate college "Image and Knowledge" (under the direction of Gottfried Boehm and Ludger Schwarte) within the National Centre for Competence in Research program, "Iconic Criticism: The Power and Meaning of Images" at the University of Basel. Thanks go to all who made this possible for me—to the financing institutions (the German Research Foundation and the Swiss National Science Foundation), as well as, not least, to the colleagues with whom I worked and tested out ideas. I give particular thanks to Hans H. Diebner for countless discussions, tips, and his support. My brother Rudi F. Hinterwaldner was ready to help at any time with all of my possible, and impossible, technical requests. Many people took me further in my research with suggestions on matters of content. I can list only a few of them here: Claudia Blümle, Beate Fricke, Frank Furtwängler, Marion Gartenmeister, Annamira Jochim, Tanja Klemm, Tabea Lurk, Bernd Mahr, Stéphane Montavon, Samantha Schramm, Sandro Schönborn, Barbara van der Meulen, Hans-Christian von Herrmann, and Mirjam Wittmann. I do not want to forget all the researchers and artists whom I had the opportunity to visit and interview, as well as the museums and exhibition spaces that allowed me to conduct my studies on their materials and make documentation, even beyond general opening hours. The Swiss National Science Foundation, the German Research Foundation, and the Max Geldner Foundation enabled my research through their financial contributions.

Lev Manovich encouraged and supported me in preparing the English edition. The translation by Elizabeth Tucker, whom I thank for her brilliant accomplishment and an ideal collaboration, was made possible through the Geisteswissenschaften International Prize. This special recognition is part of Geisteswissenschaften International's award to support the translation of academic books, granted by the German Publishers & Booksellers Association, Fritz Thyssen Foundation, VG Wort, and the German Federal Foreign Office. Thanks to Wilhelm Fink Verlag, and especially to Alexandra Schmidt, for their accommodation with the English publication rights. The publication of the translation was generously supported by the Swiss National Science Foundation through the National Centre for Competency in Research program, "Iconic Criticism," specifically Ralph Ubl and Orlando Budelacci, as well as by the Freiwillige Akademische Gesellschaft Basel.

At MIT Press, I am deeply grateful to my editor Doug Sery for accepting the book manuscript for translation and to Gita Manaktala for her continuing support in moving the publication forward. I was also fortunate to work with Susan Buckley who prepared the manuscript for editing and cleared the picture rights. Thanks go as well to Marcy Ross who made sure the publication took shape by finalizing the text and to Yasuyo Iguchi who designed the cover and paid careful attention to the book's layout. They earn my wholehearted acknowledgment as they all contributed substantially to the success of the outcome.

Inge Hinterwaldner, June 2016

Introduction

While often postulating a reference to reality through their unique position between test environment and explicit design, computer simulations currently serve scientific knowledge, education, training, therapy, and recreation. It does not look as though they will lose significance in the near future. Their great merit lies in being able to represent objects and situations in their changes and progressions. For this purpose, the entity to be simulated is conceived or defined in some number of functional characteristics deemed to be essential. This group of ascribed features determines the radius of action, the sensitivity to external influences, and, via the temporal components, the outward manifestation. These framing conditions are expressed in a mathematical model that organizes the relationships between parts of a complex into a structure—a systemic architecture. The model in turn is integrated into a source code and, finally, executed with the help of a computer. The execution of the mathematical model is referred to as dynamic simulation.

The Object of Study

This book takes dynamic computer simulations as the object of study. Although the process by which simulations are produced is also taken into view and considered as central, the foreground is devoted not to mathematical and technical components as explored in computer science or computational visualistics, but rather to the sensory aspects of the realization, so it is sufficient here to understand the basic concepts that underlie the algorithms. These are extensively discussed and developed in more strongly technical and application-oriented disciplines. The focus of our interest here lies in the aspects of simulations that can be experienced by the senses: in the optic, acoustic, haptic/tactile, or, more broadly, sensory-motor (but rarely olfactory) impressions that simulations offer. Iconicity for the most part plays a dominant role.

In simulation, a presented situation is calculated in an ongoing, iterative manner on the basis of given constellations and actions. We are therefore concerned not with work whose interactive potential is exhausted in the selection of a previously laid-out pathway (as in some "virtual" worlds), but rather with dynamic, continuously recalculated configurations.

These allow influence and interlinkage at an elementary level. The results of calculation are entered again to influence the process further. Simulations involve reciprocal effects, coordination, and coupling; feedback mechanisms come into play that require a complex, transformable "(re-)acting" object beyond mere navigability. One could think of the user as the intervening aspect of these model scenarios.

By no means are real-time user interventions worthwhile in all fields. Substantial areas of computer-based productions in the natural sciences can be excluded, except where it could be argued that the interacting user embodies the role of an influencing factor external to the section of reality under investigation (which is kept as isolated as possible).

The restriction to interactive real-time simulations is grounded in the desire to examine characteristics of an iconicity that until now has been realizable in this form only through simulations. If the user is to intervene meaningfully in the ongoing process of computer simulation, the state of the results of calculation must be presented to him or her immediately. Furthermore, the results must, as a rule, be shown in a way that the user can grasp what is going on as quickly as possible—or at a speed that accords with the designers' intentions. Simulations exhibit various modes of presentation according to what exactly is intended with a particular application. There is a broad spectrum of design solutions and priorities, from simple scenarios intentionally kept abstract to those in which the objective is to depict certain aspects as naturalistically as possible, to the point of individualism.

Our subject is therefore computer simulations that allow interaction in real time on the part of the user and that unfold their possibilities only through a close connection with the interactor. What is real time? "From a real-time system, one generally expects promptness, simultaneity [parallel processing], and a timely reaction to spontaneous events."[1] According to the German industry norm (DIN 44300), a real-time system is defined as a time-critical computational system in which the results of processing must be available within a predetermined time span (i.e., one that can be defined at will). In any case, data processing does not have to be carried out in a few milliseconds; it must only be unconditionally fast enough for a particular application.[2] Since the simulations discussed here aim for user involvement in the action, in this context human sensory physiology sets the frequency. In a reprint of a text by the natural scientist Karl Ernst von Baer from 1864, an outline is sketched of concepts that characterize the "moment" as atomized psychological time; in other words, it is the smallest possible temporal element of experience, also termed the "subjective time quantum."[3] This species-specific moment is of interest here. In a real-time simulation, the (human) moment is undercut by the frequency of iteration in both image construction on the monitor and the calculation of the dynamic being shown in order to cheat the senses and convey the impression of continuity.[4] The combination of the frequencies of image construction and calculation adds up to real time as it is understood here. It is thus conceived not as the real time of what is being simulated but rather as an anthropomorphic measurement.

Thanks to uninterrupted calculation, which is also not interrupted by user interactions, there is no perceptible delay between intervention and the ensuing reaction in the presentation. The emergence of the scenario is carried out continuously with the recipient's assistance and evades tangibility as each moment that is present now: "It doesn't offer a static situation or something you can observe like a frozen image, but it is always there."[5] In discussing time in image generation, the artist Edmond Couchot speaks simply of a "quasi-instaneity."[6] A more precise formulation would therefore be that it is always there *fast enough*. Even if under these conditions no changes are perceivable, the sensory presentation with which we are concerned is not simply static, since the situation could hypothetically change twenty or thirty times a second. This is what these sensory scenes are designed for.

In order to understand the dynamic components and the specific nature of this interactivity, a direct engagement with simulations is indispensable. According to art historian Dieter Daniels, the essential aspects of these installations, unlike traditional, static artworks, cannot be conveyed through photographs; consequently, publications about them capture only fragments. "The most elaborate media inventions are precisely the ones which exceed the capacities of the mass media, and are therefore neglected by media coverage. Ironically, the anachronistic result is that the viewer wishing to experience the actual interactive quality must travel to festivals and media-art exhibitions, just as formerly people travelled for the sake of art."[7] Printed descriptions and screenshots seldom provide adequate information on the design solutions, which are ephemeral. We also encounter this problem in this study. The experiences of multimodal involvement—the physical fatigue, the often tense concentration in the attempt to reach a set goal or explore an environment for its boundaries—cannot be captured adequately in static images, sequences of stills, or video documentation. These are only provisional means that grant the static shots more weight than they really should have. These moments have been torn out of their context, and yet are intended to show the substance of an application whose characteristic feature is a sequence of action that plays out differently each time.

"Systemic Image" in Two Connotations

If the nature of iconicity in computer simulations is to be studied, it is evident that such a study cannot be limited to a discussion of what these stills are able to show. The term *systemic image* points to two areas where the iconicity under investigation goes beyond these bounds. On the one hand, there is the implied connection to the underlying model and its structure, and on the other hand, there is the relationship to the recipient. *Systemic* first of all means "related to the system." Those sciences that place the system at the center as a conceptual aid—including cybernetics as well as systems, information, decision, and game theory—can roughly agree on an understanding of the system as a group of components and relations in interaction. It is no accident that it is nearly impossible to find a technologically oriented definition of *simulation* that does not use the concept of the system: the underlying

functionalist and networking attitude represents a first step toward the type of modeling that leads to a formulation that meets the processing requirements of a digital computer. Computers, formal logic, and a cybernetic/systemic approach were developed in parallel in the mid-twentieth century. All of these areas are of central concern for simulations.

Let us return to the first point—the connection to the simulation model. We thus understand *systemic iconicity* as an iconicity that emerges *in the frame of* (systemically structured) computer simulations and that consequently is given a particular orientation. The simulation's dynamic plays an enormous role in shaping its sensory presentation.

There is a parallel to Lev Manovich's *The Language of New Media,* which takes the opportunity not only to witness the emergence of the new meta-medium but also to lay out some first conceptual characteristics to frame this innovative technology. He offers a systematic account of the narrative strategies, modes of address, audience reception patterns, and so forth that are the language of computer media. As Manovich uses *language* "as an umbrella term to refer to a number of various conventions,"[8] the word *image* in the title of this book is meant in this way too. In other words, the term's existing plurality of meanings is recognized and appreciated, while the range of phenomena we are dealing with is narrowed to interactive computer simulations to allow the articulation of significant shared conditions. Whereas Manovich uses the history and theory of cinema as a conceptual lens to reveal specific features of new media, our lens is the *cybernetic approach.* Although simulations and human/computer interfaces designed for interaction can be best described as systemically or cybernetically organized, I do not use systems theory as a method for analyzing simulation images.[9] This is also the position of journalist and artist Luca Barbeni, who identifies feedback loops as the critical feature in order to designate as "cybernetic images" the new filmesque formats that allow viewer participation. Unfortunately, Barbeni does not develop these thoughts any further.[10]

Along with connection to the model, the second connotation implied in *systemic image* relates directly to possibilities for interaction. It is closely tied to the cybernetic idea of control and piloting (and thus also communication). What is this about? The mathematician Louis Couffignal discusses the metaphor of the pilot as employed by a famous philosopher: "Plato distinguishes carefully between the roles of the captain, the pilot, and the helmsman. The captain chooses the harbor where the ship is to be brought. The helmsman operates the rudder, which steers the ship in the appropriate direction. And the pilot constantly instructs the helmsman how much to turn the rudder so that the ship will reach the harbor."[11]

The pilot, who constantly shifts between things as they ought to be and things as they are, is *kybernetes* in Greek. Simulations also involve control, influence, and readjustment, so that a process is achieved according to laws and objectives established previously (in the model of the captain). Thus, in simulations, one could imagine the emergence of a dynamic that exerts its influence on the iconic formation. The pilot could also be thought of as the perceivable simulation, which directs or at least subtly guides users in their interactions. The

viewers' actions are not uninfluenced by the design of what is being offered to them; this is what gives the scenario its unique quality.

Of course, in this second connotation, *control* is meant in a figurative sense. Beyond the simulation dynamic and with respect to the recipient, the image also performs this role. But it does so in its own way. It does not simply "say" in an objective, information-oriented manner; rather it suggests, deters, offends, whispers, entices. Iconicity knows a wide spectrum from direction to seduction.

Divisions

With regard to its view of the phenomena under examination, this work can be divided roughly into two parts. Chapters 1 through 4 tend to focus on computer simulation. Against this background, the discussion centers on aspects of sensorialization, or the rendering of calculation data accessible by the senses; it is necessary in order to make the simulation dynamic perceivable. In addition to the dynamic provided by the computer simulation, the sensorialization—which I also refer to as "iconization,"—integrates its own valences, which are characterized as semiautonomous: they exceed or lend additional expression to the underlying calculated processes. This rhetoric of the free-standing aspect of the sensorialization could incorrectly lead to the impression that the dynamic and the iconic level act from contrary positions. This is not my view. However, it is worthwhile to allow for this heuristic separation first in order to create space for testing the ways in which they do relate. The intention is also not to play simultaneity and succession against each other in iconic configurations. In the second part of this book—chapters 5 and 6—iconicity is at the forefront of our thoughts. Here, the components that are kept apart in the first part become more closely interwoven. In this way, qualities that appear prominent in the constellation with simulations can be taken into view. Under examination are the expressive possibilities that the simulation image achieves in connection with continuously calculated explicit changes. The aesthetic is fundamentally influenced by the fact that the often multisensory experiential presentation allows the immediate inclusion of user interactions. The situation thereby takes on a unique communicative component, which necessitates a behavior of reaction to user input on the part of the simulation and its sensorialization. A design of consequences is required.

A second, more detailed possibility for structuring this work is presented through the use of sociologist Niklas Luhmann's distinction between medium and form. Luhmann follows the mathematician George Spencer-Brown in his concept of form:[12] medium and form do not designate particular entities but stand in relation to each other as a difference. Hence, form marks a difference. The embedding of difference is constitutive for it. That entity that serves as the basis for the marking of difference is always also given and is designated as a medium. According to Luhmann, the differentiation of medium and form is performed by the perceiving organism. Through perception, the medial substrate, which features loose

couplings (in the sense of a majority of open or possible connections), is bound into forms through tight couplings (consolidations, selections), without the medium's being used up. Media can be recognized only by the contingency of the forms that they enable.[13] What is important to us is only that medium and form are not thought of in isolation and that their difference is registered again at every level of viewing. According to the philosopher Sybille Krämer, "What from a certain perspective is a medium can then from another perspective become a form. It is this change of position that makes clear that Luhmann's distinction between medium and form should indeed be contrasted with the traditional material/form distinction."[14] Thus, one can set the levels of viewing wherever one likes, as long as difference can be detected within them. The form is always different from the respective medium in whose context it can manifest through its higher degree of differentiation. It thus makes sense to draw the boundaries where significant differentiations appear. Since this study discusses nested, differentiated instances of imaging—or, more generally, forming—it may also be divided accordingly.

Four successive instances of forming are distinguished. The first, and the most abstract and universal, instance is the systems perspective as a technologically consolidated cultural medium, as a process and schema. As is shown in chapter 2, this first instance establishes the frame for how a dynamic simulated in a digital computer is fundamentally structured.

The second instance of forming, the mathematical model, can be located within this frame. This is the subject of chapter 3. Due to the rigidity of the computer with respect to the formulation of the model, the latter remains heavily indebted to the perspectivation. This is the case although the scope of the model's design is substantial, the stages of modeling are multiple, and their points of reference and sources of knowledge are diverse. Ultimately, however, it is all cast in a strict mathematical formulation. If I speak only of "the model" here, although there are many stages of modeling, this is because, while acknowledging the production procedure, I concentrate on the final model that is calculated—that is, executed—as the simulation. While the first instance of forming, the perspectivation, is established in advance and therefore is independent of any content, the model proves to be already related to what is being modeled. The model marks off the boundaries within which the contours of the temporal form can be actualized.

The third instance of forming is the iconization. This stage is given a long treatment in the second part of chapter 3 as well as in chapter 4 (in the discussion of the display). In the iconization's orientation to the viewer, as compared with the dynamic produced by the simulation, a sensorially perceptible figuration is always added. In order to meet the challenge productively of offering a sensory presentation based on a preexisting explicit process, an iconic vocabulary must be invented. The fact that a concretization occurs through the sensory aspect can be seen in the virtually infinite variety of representations that simulation results allow. But one would not want to design arbitrarily or make an arbitrary design. Moreover, not all options are equally possible if one considers the programs used in designing as an influential parameter.[15]

In chapters 5 and 6, our attention turns to the final instance of forming, which comes about by means of interaction. Interactive simulations rely on interventions from the outside in order to come into their full unfolding. Through a concretization, the user makes manifest that which is initially latent. In the given frame, that which is latent (or the virtual) can be tested so that it shows itself indirectly in the interplay with real and simulated components, but in a wealth of facets and variations.

In this cascading view, successively more distinct instances of forming are nested inside each other and ultimately lead to a specific experience of direct and involved engagement with the situation presented in the simulation. In this way, the "designated diffuse latencies and probabilities" of Luhmann's instances of media become "a configuration in which are contained not only iconic possibilities, but also individual concretions."[16] Thus, this book can be counted among those studies that follow an output-focused approach. At the same time, however, the discussion does involve at least a few of the computer's basic operations, without which this type of work could not exist. Noah Wardrip-Fruin also places value here. His book *Expressive Processing* is an attempt to help bridge the gap between the tendency in computer science to discuss software from a more technical, mathematical, and conceptual point of view and an approach that also includes issues of aesthetics as well as audience experience. Wardrip-Fruin has made an important contribution to the understanding of programmed processes as authored "ideas expressed through the design of their movements."[17] I share this view entirely. In company with this undertaking, I would also attempt to build such a bridge—one that seeks to consider created computer-based processes in conjunction with the sensory manifestations they bring with them.

In this way, production- and reception-oriented viewpoints on the object of study are intertwined. An interweaving of aspects of production and reception can often be found in certain discussions in art theory that touch on interactive applications. Here, users are characterized as consummators or even—to the point of exaggeration—the actual producers of the work. In the conclusion of this book, the simulation image is presented as an interface. Thus, it is emphasized that not only are users led and seduced by the sensorially designed aspect; this influence should be seen as reciprocal. The recipient also makes an impact: on the dynamic, possibly also on the iconization and the model, but not on the perspectivation.

Differentiation of Terms

Several terms have already been used in this chapter that to some extent experience a semantic reconfiguration in this study. Therefore, it is beneficial at this point to undertake a differentiation of terms. First, a distinction should be made between a "simulated image" and a "simulation image." Since exclusively dynamic simulations are under observation here, there can only be a "simulated image" when it is executed by a computer through its dynamic formulation. The subject matter of the simulation would have to be the image (in its genesis?) and not what the image shows.[18] No example of this is discussed in the context here. The

"simulation image," however, is characterized by the specific iconicity that appears in the frame of simulations. It is my aim to sketch out rudiments of an aesthetic of this particular iconicity that is unique to the simulation image. The word *iconicity* does not refer to the "icon" as a feature of object relationship in the sign theory of Charles Sanders Peirce or a semiotic orientation following him. *Iconicity* here very broadly addresses the specific, central features of images. Images unfold their statements and effects through their material facticity and communicate in ways unique to themselves. These can be characterized through tensions for which the art historian Gottfried Boehm, in the tradition of philosophical hermeneutics, developed the concept of "iconic difference."[19]

The second pair of expressions to be differentiated consists of "imaging" or "forming" (*Bildgebung, Formgebung*) on the one hand and "iconization" (*Verbildlichung*) on the other hand. The term *imaging* (or *forming*) is employed here in service to the difference of medium and form already introduced and is understood as occurring progressively. Hence, the first "imaging process"[20] is the perspectivation; the final imaging occurs in the interaction with the recipient. The "images" or "forms" referred to here are sedimentary layers of the simulation image, which thus ultimately comprises a dynamic, ephemeral, constantly re-realized, often multimodal presentation to the senses. Such new qualities of the image do not yet resonate in the expression *iconization*. This term more generally designates a sensorialization of calculation data; its function is to replace the more common word *visualization*. The reason is that *visualization* first refers only to the optic sensory channel (while one can also speak of acoustic iconicity, for example), and, second, is often given a servile quality in the discourse. By contrast, my objective is also to point out areas in which the sensorialization becomes autonomous or is given free play.

I follow a systematic approach to the sensory aspects in interactive simulations without aiming for any total catalogue. This study is devoted to the possibilities of the simulation image in general, that is, before a differentiation into various disciplinary fields of application. The catchment area from which the examples are drawn is therefore purposely kept wide. Applications are represented from psychology, biology, computer science, medicine, the military, art, and entertainment. Readers may note that no commercial computer games are discussed as case studies, although they should absolutely be considered since they offer many relevant examples and points of contact with our discussion, and with their sometimes enormous complexity, they would also present additional challenges and starting points for further thought. However, one of the premises for selecting works was to achieve sufficient insight into their functioning or, as the case may be, their development process. The opportunity for this decreases as more patents or confidentiality agreements come into play. For similar reasons, battle simulations from the field of military research could also not be included.

Since works on this topic in the humanities tend to prefer simulations of technological artifacts (e.g., flight simulators), I intentionally place my focus in another area: preference is given above all to biological and sociological motifs, while taking into account various

levels of description. *Levels of description* is intended to suggest a degree of resolution in which dynamics can be modeled in enough detail and complexity for a particular purpose.[21] However, my approach, as well as my conclusions on the general characteristics of iconicity, are essentially transferable to other subject areas. But beyond this, the main imperative is to examine each example precisely to discover its specific attributes.

Since, for an understanding of how sensory elements are integrated into simulations and what their respective roles are, it is important to be aware of certain theoretical postulates, this foundation is placed ahead of the case studies. We begin by positioning ourselves with respect to the philosophical discussions surrounding simulations, before spiraling from medium to form (as medium) to form, in the direction of concretization.

1 Approaches to a Concept of Simulation

1.1 Simulations and Their Contested Representational Capacity

One often reads that with synthetic images in general, but with the images of simulations in particular, the representational function no longer holds. Since in most cases, no further qualification specifies the field of digital imagery more closely, it must be assumed that in order to arrive at this conclusion, the authors believe it possible to abstract from any intention whatsoever and from any particular way the images and the means of representation are handled.

1.1.1 The Basis in Models

One of the cited reasons that the newest image productions can no longer be considered representations is that they are based on mathematical models. This is true (but as we will see, they are also based on a whole lot more). However, adding that therefore they are to be denied any representational function immediately prompts the question of what basis images must have in order to be representations. Often, by way of contrast, the recording media (photography and film) are introduced as the epitome of representation, while no justification is provided as to why images made by these techniques specifically should and can function as a standard of comparison.

The philosopher and sociologist Jean Baudrillard, who has substantially influenced the simulation discourse in the humanities, seems only to add force to this interpretation when he writes, "Photographic or cinema images still pass through the negative stage (and that of projection), whereas the TV image, the video image, digital and synthetic, are images without a negative, and hence without negativity and without reference."[1] By characterizing video through equating "absence of negative" with "absence of reference," Baudrillard separates it as an electronic recording medium from the analogue recording media, which

preserve reference. This truncation, however, makes no more sense with the necessary intermediate step of the copy from film negative to film positive; rather, it should be interpreted metaphorically in the sense of a collapse of antagonistic poles (of the represented and the representing). "Such is simulation, insofar as it is opposed to representation. Representation stems from the principle of the equivalence of the sign and of the real (even if this equivalence is utopian, it is a fundamental axiom). Simulation, on the contrary, stems from the utopia of the principle of equivalence, *from the radical negation of the sign as value*, from the sign as the reversion and death sentence of every reference."[2] This statement proves to be the result of Baudrillard's own theorizing, which defines the electronic media and their products as solipsistically circular.

1.1.2 The Replacement of Reality

Simulation thus opposes representation and—much more important—according to Baudrillard and others, it simultaneously positions itself *in place of* reality. Baudrillard is answered by the art historian André Reifenrath in his historical study on the optical output components of digital computers. With technical simulation applications, it becomes evident that a simulation is not intended to replace reality; vice versa, the objective is the replacement of the simulation *by* reality. Thus, one does not simulate the Mars landing so as not to have to carry it out, but rather in order to acquire the skills necessary *to* carry it out.[3] The aim of simulation research is not the cancellation of reality but, rather, better control. This is also the case when one in fact does simulate situations so that one does not have to experience the corresponding real situation. Many simulations have this preventive and prospective character.[4]

With the idea that simulations replace reality, Baudrillard is not referring to the objective of catastrophe and accident research, which attempts to determine how to confront a disaster in advance in order to prevent it or at least make it less severe. For Baudrillard, the replacement of reality refers to a process of dissuasion of the entire real process by its operative double, whereby the real will never again get the chance to show itself.[5] In this context, the art historian Horst Bredekamp writes, "Computerized entities and situations that are constructed in model form so that they do not have to transpire in reality are not by any means suitable for citation as examples of a total replacement of reality. In their depicting the experience of reality, the latter does not disappear, but rather promotes the development of the new faculty to understand bodily reality as not-simulated."[6]

Presumably Baudrillard would have an answer at the ready, since from his point of view, this passage in fact confirms his thesis of the precession of simulation models. The latter bring into effect "social control by means of prediction, simulation, programmed anticipation and indeterminate mutation, all governed, however, by the code,"[7] and constitute (by corrupting) the field of subsequent events. These necessarily become hyperreal events, with the well-known consequences that can be cited as lacks: the hyperreal lacks difference between the simulation model and the real, and consequently lacks the referential, lacks the

allure of abstraction, lacks the imaginary of representation, and lacks meaning beyond its own logic.[8]

1.1.3 The Lack of Reference

Here, we have arrived at another popular argument: the concept of representation requires something absent for which the representation stands in. But with simulations, not only is there no referent, there is also no reference: "What must be called radically into question," writes Baudrillard, "is the principle of the reference of the image, this stratagem whereby the image always gives the impression of referring to a real world, to real objects, of reproducing something that is logically and chronologically anterior."[9] But nothing external precedes the images of simulation. The absent connection to reality, paired with an audacious claim of validity and an offensively presented "realism" on the part of the images, ultimately leads to a confusion, to an evaporation of the difference between representation and represented (categories that no longer hold), or even to the implosion of image and reality, so that in the end, the image as simulacrum inverts the (actually rightful) chronological causal sequence and creates worlds by doing away with real objects, without ever letting on. Images—and by this, Baudrillard means the medial, technological images of the present—do not refer to anything anymore; reality no longer precedes them.

1.1.4 The Lack of Precession of the Referent

First, we must certainly ask to what extent we ourselves tend to postulate a precession of the represented for the recording media (such as film and photography), which are considered paradigmatic examples of this.[10] To be sure, it cannot be claimed that the image producer creates the representation *in the presence* of that which is to be represented, that is, that these three protagonists come together in the same place at the same time. If this were the case, then the majority of—not only artistic—image production would have to be denied a representational character. But as soon as this strict boundary is softened, one is dealing with fluid transitions, and categorization becomes a futile, easily contested undertaking.

The precession of the referent that is demanded for the representational is founded on a very particular temporal structure. Against this background, one can better understand why Couchot grants particular attention to the temporal aspect of the emergence of digital images. For him, the interactive, language- (or writing-)based matrix image (*image-matrice*) occupies another dimension of time, which he calls "virtual" and "uchronic" (like "utopian"). Even if the matrix image appears on the screen in real time—thus, instantaneously to the human perceptual apparatus—its emergence takes time. It is not always already present to view. This time is neither the present, the past, nor the future, but is located beyond chronological time, in a "uchronia." From Couchot's perspective, in that the matrix image must always be generatively produced anew, it cannot—like (analog and it can be assumed also digital) photography—refer to a Barthesian *ça a été*. Instead, it refers to a *ça peut être*, a

potential event. Therefore, Couchot does not position the matrix image in the domain of figuration, which according to him is proper to representation, but rather appends it to the concept of simulation.[11] In his view, the matrix image introduces a new visual order. An essential feature is that it does not reproduce the object to be presented,[12] but rather simulates it, in that it not only renders its visual manifestation, but also synthesizes the natural or invented laws to which it is subject.[13] According to him, simulations therefore accomplish more than previous sensory presentations (or their accomplishment is different) because they integrate laws and internal connections. Thus, this digital type of image is fundamentally conceived for producibility—that is, it should be understood as generative. Through this basic structure, the digital simulation calculated by a computer opens the field of sensory presentation to other dimensions and the spectrum of relations to infinite variants. It offers an almost "limitless potentiality for manifestations of form" and actualizes itself "under one of its various aspects."[14]

This characterization unequivocally also applies to what we will designate in the following as the mathematical simulation model. Couchot's discussion of the latter under the auspices of forming complies with our own approach. On the basis of the properties he cites, Couchot repeatedly draws the following conclusion, which he articulates quite clearly: "The synthetic image does not represent the real; it simulates it."[15] He arrives at this statement because he is reacting to a dubiously narrow concept of representation.

1.1.5 Construction (Instead of Reproduction)
This meager concept of representation was incurred through the postulating of the obligatory preexistence of a referent in combination with the invocation of recording mechanisms (which specifically do not perform the function of foregrounding a reference to ideas or future events, for example).

In any case, constructions or compositions seem to be at odds with a concept of representation that has been so oversimplified. At this point, it is worthwhile to cite a passage from the philosopher and literary scholar Gérard Raulet, because it stages a tension that is characteristic: "The representation of the world has become possible without a previous recording.[16] The new electronic media no longer reproduce the world; they create it, if not *ex nihilo*."[17] With the implicit assertion of innovation, it is suggested here that the totality of image production before (photographic) recording media should not be termed "representation." But at the same time, Raulet does not in principle deny electronic media—here, computers are intended—the capacity for representation despite their generative quality. This is entirely to his credit, since for many other thinkers, the same initial basis—the establishment of recording media as the benchmark for representation—leads to a different turn: because computer models create "worlds," these are no longer to be regarded as representations but rather as simulations. The difference between this perspective and Couchot's position cited above, which has almost the same wording, lies in that here, the reference to laws is interpreted not as an "in-depth" representation that is also capable of revealing inner connections but rather

as the absence of an authenticating, because technologically or mechanically anchored, relationship of depiction.

A common component of discussions about simulations is the rhetoric of the paradigm shift—easily recognizable in the proclamation of a new "era"—which brings with it a strong delineating tendency. Representation quite prominently falls prey to this and is consequently thought of as in a state of crisis. But in simulation's being opposed to representation antagonistically, it is conceived as an alternative *relationship* to reality.

In a scientific milieu, simulation is instead considered a technique that lies between theory and experiment, whose implementation in most cases is embedded in a "representational context"[18] and directed at an object of research according to its users' intentions. When one ignores the fine nuances of referentiality, one suddenly finds oneself with a concept of simulation that denies the latter a concrete reference. In the opinion of numerous authors, simulation operates purely according to its own laws, and therefore its justification is massively called into question.

Thus it is considered problematic for most areas of application. If one *defines* simulation as referenceless, it would be a logical error to want to shake the foundation of the postulated definition with examples that contradict it, for these examples would then not be simulations. But to assert on the basis of this postulate that all scientific simulations (one does not want to deny them their habitual name) are referenceless is simply ludicrous. There may be a few cases where this can make sense, especially in mathematics. But to designate referencelessness as a defining characteristic does not gain adequate purchase in the case of computer simulations.

If one wanted to exaggerate the situation a little, one could employ a passage from the journalist Florian Rötzer: the belated status of representation or presentation[19] "can also not be entirely annulled by computer simulation in real time."[20] This statement on simulation elicits a number of responses: "Why should it aim to do that?" ask the natural scientists. "Why would it be any exception?" ask the culture theorists.

1.2 Missing Links: Simulations and Simulacra

The insistence on the possibility that computer simulations are in principle capable of representation is not by any means happening here because this study intends to resuscitate the eighteenth-century art-historical theory of imitation or offer its own take on this theory. The insistence is happening in order to advocate for a shift in accent in the concept of simulation and thus also in order to be able to take applied computer simulations into account. This certainly does not mean that the achievement of computer simulations must be exhausted in the representational or depicting function. Here, too, it is imperative to be sparing with blanket judgments. In order to begin the examination of concrete examples, a concept of "simulation" is needed that lends itself to designating the group of objects whose sensorially perceptible aspects are to be discussed.

1.2.1 The Simulacrum in the Natural Sciences

If one aims for one's concept of simulation to apply to numerical simulations, the assertion of an opposition between simulation and representation must be let go. The engineer and communication theorist Gianfranco Bettetini advocates softening the opposition between the different connotations of "simulation." In his view, one could address the semantic ambiguity with the observation that even the so-called exact sciences recognize different gradations (of relationship to a concrete referent); scientific simulation is nevertheless a "fundamental instrument of signification."[21] The increasing percentage of engineers and natural scientists (also those in basic research) who obtain their findings with simulations could certainly not operate within the bounds of the scientific if, with their simulation models, they were referring to nothing, if they had freed themselves from any reference. One can rest assured that approaches without any connection to a research object are rejected in their particular scientific communities and never succeed on a broader basis.[22] However, in the context of research on artificial life and elsewhere, there are indeed discussions surrounding an adequate connection to scientifically evident explanations of phenomena.

As was already mentioned, in the humanities, "simulation" is commonly understood as a *relationship of picturing*[23] whereas the "simulacrum" is thought of as a (quasi-)material object. This tends to be inverted in the technical and natural scientific fields. While there the word *simulation* goes unchallenged in denoting a computer-based experiment, the word *simulacrum* is hardly to be found. In a few rare cases, this exotic term from the humanities inspires reflection on the status of reference.

For example, the computer scientist Ezequiel Di Paolo and colleagues present two interpretations of simulations (and simulation models), understood as "emergent computational thought experiments" or "realistic simulacra." The latter, in other words, are "maximally faithful replicas," while the former are "unrealistic fantasies which nevertheless shed light on our theories of reality."[24] From this it becomes evident that the reference to the object of investigation itself is never disputed. The difference merely addresses a closer or more remote connection to heuristics or the object of research. The theoretical biologist Claus Emmeche also restricts himself, with respect to the concept of the simulacrum, to a gradual difference in reference to the object of study. What's more, here the simulacrum leads to a "critical reevaluation of the logic of research."[25] In order to demonstrate this, he publishes two illustrations. Figure 1.1 is intended to sketch out the traditional conception, which in the light of research on artificial life now seems too simple: from life, objects of research are taken, about which theories are constructed, which are compared with reality via models. Thanks to artificial life research, we have now arrived at a more complex idea of the situation, which is depicted in figure 1.2: to the left, above, we see life, about which we now know that one is always inclined to study it from the perspective of one's own interest,[26] thus adjusting life and creating "framed" objects. These objects are the starting point for the construction of theories and are central in the comparison via models. Theories then also serve as the starting point for other models, which thus have more abstract principles on the research object and

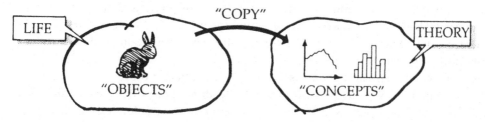

Figure 1.1
Claus Emmeche's sketch of the traditional view of biology and its objects of research. Graphic: Jesper Tom-Petersen. Emmeche, *The Garden in the Machine*, 157. Courtesy of Princeton University Press.

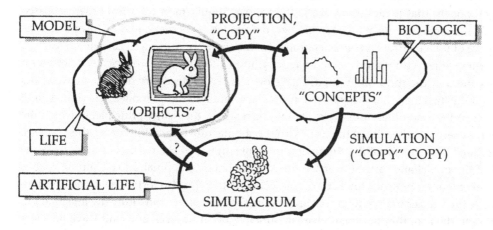

Figure 1.2
Claus Emmeche's sketch of the deconstructed view of biology and its objects of research. Graphic: Jesper Tom-Petersen. Emmeche, *The Garden in the Machine*, 163. Courtesy of Princeton University Press.

whose relationship to life is here given a question mark, indicating a need for clarification. The terms *simulacrum* and *simulation* are misleading in the figure and are better explained in the text. Emmeche intends simulation as the "copy of a copy," a relationship to a referent that seems to diminish a little with each addition of a stage of modeling. Meanwhile, he understands simulacrum as an empirical tool. He distinguishes simulacra of the first and second order. Simulacra of the first order are labeled "concepts" in the illustration, meaning "descriptions of certain previously selected and theoretically colored fragments of the world."[27] Simulacra of the second order are what Emmeche refers to as "simulacra" proper; they differ from those of the first order "because they refer to a more abstract mode of viewing the object than do normal simulated models of given physical/biological systems. They have (more explicitly than we are used to) assumed the task of constituting the objects they

imitate."[28] Emmeche finally adds what the arrow stands for pointing down from "model" (and not from "life") to "simulacrum": "We cannot totally dispense with a reference to bio-logical reality in one form or another."[29] Here, too, the reference to reality, although still not entirely clear, is ultimately undisputed.

It is probable that Emmeche borrows the idea of the different orders of simulacra from Baudrillard, whom he also mentions affirmatively. Baudrillard identifies three. Simulacra of the first order he calls "naturalistic." They are based on the image or imitation and are char-acterized by a technological-mechanical theatricality; they are operatic (*opératique*). Those of the second order are "productivistic." They are based on energy or force and are materialized by the machine. They are related to an industrial assembly-line seriality, are operative (*opéra-toire*), but are dominant for only a brief period because they quickly give way to the genera-tion of models, that is, simulacra of the third order. Simulacra of the third order are based on information, an aleatory metatechnology, the model, "cybernetic play." They pursue the objective of total control and are operational (*opérationnel*). According to Baudrillard, each of these three orders corresponds to an imaginary: utopia for the first order, science fiction for the second. But the third order doesn't have one, since the necessary distance between the real and the imaginary has disappeared in a collapse in favor of the model. The simulacra of the first and second orders are still located in the realm of the reality principle, in which the imaginary serves as the alibi of the real. With the simulacrum of the third order, this changes: it is located in the realm of the simulation principle, in which the real now functions as the alibi of the model and cannot overstep the model's bounds. Simulation is insurmountable, without exterior. The space for a critical projection is thereby also lost: "The models no lon-ger constitute either transcendence or projection, they no longer constitute the imaginary in relation to the real, they are themselves an anticipation of the real, and thus leave no room for any sort of fictional anticipation–they are immanent, and thus leave no room for any kind of imaginary transcendence. The field opened is that of simulation in the cybernetic sense, that is, of the manipulation of these models at every level (scenarios, the setting up of simulated situations, etc.), but then *nothing distinguishes this operation from the operation itself and the gestation of the real: there is no more fiction.*"[30]

1.2.2 Cybernetics in Philosophy

Of course, Baudrillard has in mind a principle of simulation that he believes can be found very broadly in all possible contemporary spheres. Simulation no longer requires a screen: it has stepped outside the computer to conquer "real" life from within.[31] In contrast, this study is restricted to simulations that require a computer basis. Apart from the fact that Baudrillard finds the third order of simulacra the most interesting, it is also precisely these that can be brought into connection with computer simulations.

Baudrillard himself refers repeatedly to the technological level, for example, when allud-ing to "technocybernetics" and "cybernetic machines, computers, etc., that, in their govern-ing principle, depend on the third order."[32] If he is often criticized for decidedly not dealing

with the production of technological simulations, he does point out a couple of their fundamental characteristics, such as the calculability imperative, the question-and-answer mode, and the deindividualizing tendency. In order to underline these aspects, in section 2.4, "A Critique of the Simulation Dynamic," which begins with a technological definition of simulation, we will make repeated reference to passages in which Baudrillard's position proves to be compatible. A more thorough incorporation is impeded because the philosopher leaves readers in the dark about his idea of the origin and creation of the model. It can simply be stated that this is a crucial point that can be located intrinsically in simulations. Baudrillard, who in this respect shows himself clearly to have been inspired by ideas of cybernetics, recognizes and articulates the unique position of the model. He speaks of "a radiant synthesis of combinatory models," which initiates the "era of simulation," which for him of course equals the "liquidation of everything referential":

> Simulation is characterized by a *precession of the model*, of all the models based on the merest fact—the models come first, their circulation ... constitutes the genuine magnetic field of the event. The facts no longer have a specific trajectory, they are born at the intersection of models, a single fact can be engendered by all the models at once. This anticipation, this precession, this short circuit, this confusion of the fact with its model ... is what allows each time for all possible interpretations, even the most contradictory—all true, in the sense that their truth is to be exchanged, in the image of the models [*à l'image des modèles*] from which they derive, in a generalized cycle.[33]

For Baudrillard, the model also occupies an obscure proximity to the code, the "arrested, immutable disk"[34] that as a structural law of value constitutes metaphysics.[35] It is in a simulation's exclusive (!) reference to the model or the code that meaning in the framework of simulations becomes possible.[36] In order to better understand the basis of the generation of meaning, a clear distinction in this thought between code and model would be desirable.

In language that is substantially closer to that of the natural sciences, and coming from a position of much knowledge about the basic functioning of simulation techniques and modeling strategies, the philosophers Manuel De Landa and Gabriele Gramelsberger reflect on different genres of simulation, their ontology and epistemology.[37]

1.2.3 Etymology

Even if there are moments of rapprochement—for example, as discussed, the reception of "simulacrum" in the natural sciences and the absorption of cybernetic thought into philosophy—the assessments of Snow's "two cultures"[38] with respect to the meaning of simulations seem to diverge widely: the one group sees them as the epitome of unbounding; the other group seeks ways make their narrow boundaries wider.

Likely as a result of a simplified rendering or lexical brevity and pointedness, when reading one often thinks one is being confronted with two totally different definitions of *simulation*. The first displays a certain affiliation to medical psychology and criminal law and corresponds to the one Baudrillard places at the front of his book *Agonie des Realen:* simulation

as sham, distortion, deception (or the simulacrum as illusion, copy without original).[39] The other, a technical definition, understands *simulation* as a collective term for "the representation or reproduction in model form of physical, technological, biological, psychological, social, political, economic, or military processes or systems that enables a realistic but simpler examination than the original."[40] In view of these positions, it's scarcely any wonder that the two concepts of simulation do not merge. Not only the sciences themselves but also the philosophy of science are faced with a conundrum in the concept of simulation as deception. This unproductive semantic connotation is often held at arm's length, either historicized as a bygone notion or banished from the scientific sphere in unprofessional everyday use. In dictionary entries of general reference works since the second half of the twentieth century, the two meanings are differentiated through numbering or through the specification of fields of validity or disciplinary affiliation.

To assist in comprehension, Couchot labels the two meanings with different terminology (his word use does not agree with Baudrillard's and shows that he conceives of simulation more "objectively"). According to Couchot, it is easy to confuse *simulacrum*—here understood as an illusion that surreptitiously places itself in front of reality—and *simulation* because of their common root:

> ... (digital) simulation does not aim either to imitate or to feign reality with the secret intention of misleading us. Rather, it attempts to replace reality with a logical-mathematical model that is not an illusory image in the sense of a simulacrum, but instead is a formalized interpretation of reality under the auspices of the laws of scientific rationality. Users of these models are free to place them in the service of simulacra, in the service of illusions, which can be interesting in certain artistic or gaming contexts, for example as is the case in a trompe l'oeil or hyperrealistic tableau. But one should not assert that a simulation is there to produce the false. It also does not produce the true. Simulation is indeed the daughter of cybernetic thought. ... [Simulation technologies] filter reality through the fine sieve of calculation.[41]

Simulation as the "daughter of cybernetics" will be the object of a more in-depth characterization in what follows.

Here, it should first be noted that it is overly hasty to assume, on the basis of this pragmatic solution of terminological differentiation, that the problem consists in two completely different concepts that more or less coincidentally have the same name. Such an easy solution comes at a price, since in this way one gives more emphasis to the differences than to the existing points of contact.

It may succeed in shedding a little light on the matter if, in addition to contemporary dictionary definitions, which (as previously mentioned) often juxtapose two seemingly not even loosely related semantic fields, we also call on the meanings of the Latin root. The media philosopher Lorenz Engell provides a brief etymological foundation: "*Simulatio, simulare, simulacrum* and many related words such as *simulator, simulamen* and *simulamentum* all derive from *similis* = similar. To call something a *simulacrum* (or to call a process *simulation*)

thus means invoking a relationship—that of similarity—between a depiction [*Nachbild(ung)*] and that which it depicts [*Vorbild*]."[42]

These remarks may be confounding, since it was this very structure of depiction/depicted that was granted to the domain of representation and denied to simulation. This relationship of depiction and depicted "also includes the possibility, as is stressed etymologically, of distorting through depiction (zombie), or disguising what is depicted, or even presenting something as a depiction that actually depicts nothing."[43] According to Engell, the concept of simulation in media studies—whose originator he identifies as Baudrillard—has fastened on this last piece of the definition. In Engell's view, simulation has its origin in reality; therefore "in its status [it is] dependent on such a comparison to reality (or to what it depicts). Thus it is only consistent that the (asserted) loss of reality has led us back conceptually to 'simulation' (and not to fiction), since only in the framework of the concept of simulation is the question of the presence or absence of reality even raised."[44]

In light of this observation, an opposition to representation cannot be sustained. But neither should it be assumed that simulation and representation are to be considered synonymous. The only option is to specify the type of representation that simulation is. This is taking place in simulation theory as it is gradually becoming established, as well as and predominantly in model theory within the philosophy of science.[45] The latter is appropriate here because the model is always named (and rightly so) as the basis of simulation. For decades, model theorists have intensively analyzed how the scientific model relates to that which it models: according to criteria of similarity or utilitarian performance,[46] through analogy, isomorphism, or coupling,[47] or other types of correspondence. They agree, at least, that this is not a simple relationship. The literary scholar and image theorist William J. Thomas Mitchell brings it to a point: "It should be clear that it is not a return to naive mimesis, copy or correspondence theories of representation, or a renewed metaphysics of pictorial 'presence': it is rather a postlinguistic, postsemiotic rediscovery of the picture as a complex interplay between visuality, apparatus, institutions, discourse, bodies, and figurality."[48]

1.3 Computer Simulations in Relation to "System" and "Dynamic"

Until this point, a definition of simulations—and especially also computer simulations—in a technical sense has only been suggested. In order to approach such a definition more closely, it is helpful first to place the central concepts into relationship in order to examine them individually. A short definition could read: a simulation is the involvement with and the act of execution of a dynamic mathematic or procedural model that projects, depicts, or recreates[49] a system or process.

Let's begin the clarification of terms at the end. The expression *process* (like *event*) here simply means a successive change in state, and so should not be confused with the concept of process philosophy. *System* in simulation makes a double appearance: both the calculated process and the process that it models take place within systems, whereby "the simulated

and simulating system (the simulator in cybernetics) can be realized on the same or different substrates. If a system is simulated mathematically, we speak of a 'theoretical simulation'; if the simulating system is a computer, we speak of a 'computer simulation.'"[50]

The system is an agglomeration or collection of elements held together through regular interactions or interdependencies.[51] It is a methodological makeshift with great epistemological value and a high level of abstraction, with which, in particular, the functional connections and temporal aspects of phenomena can be conceived in such a way that they can be dealt with numerically through algorithms on a digital computer. The systems-oriented research method is unique in its regarding an object of examination as a system, that is, an "object under the aspect of its internal organization and its connectedness with other objects in its environment."[52] The system, which is the foundational concept in systems theory and the related field of cybernetics, thus exists only as a conceptual aid. By means of its conceptual structure, an attempt is made to describe specific aspects and relationships of our reality. The computer is so well suited as a simulator because, according to the philosopher Jeremy Shapiro, "as computer science defined it from the beginning, in terms of its structure [it] is practically and theoretically a simulation machine." What's more, he asserts "that almost all its functions imply simulation; that it constitutes the world *a priori* as simulatable; that purposive-rational, instrumental rationalization can be conceived as a process that transforms the world into algorithms and data that enable it to be simulated."[53] Now, it is not the computer that constitutes the world as simulatable; rather, it is programmers who seek possibilities for formulating the phenomena under examination accordingly. They have to take certain things into account: for example, that the computer with its von Neumann architecture is based exclusively on the strict logic of event causality and operates functionalistically.[54]

The challenge to computer scientists consists of abstracting a phenomenon in such a way that they are able to describe it as a group of functions and elements. The breakdown that occurs is fundamentally arbitrary. The ensuing discretization of parts allows flexible manipulation and implementation.[55] The reorganization of these parts (elementary functions) is once again designated a "structure" by the programmers. For the same problem, this created structure can turn out differently for each scientist, and the programming language used (be it process-, event-, activity-, or object-oriented) may vary. The languages currently in use require application programmers "to describe the phenomena they handle in a strictly mechanistic and hierarchised way,"[56] and in such a way that the model can be tested unambiguously. Programmers must consider the choice of variables carefully and formulate a precise quantitative description of connections, of which it is assumed that they produce effects.[57] Transitions and the nature of the dynamic are determined by the transformation functions. How these are conceived is therefore crucial—all the more so, since an object can be treated mathematically in different ways.[58] The goal can often be reached by many paths, since "unlike computational or numerical analysis of differential equations, simulation does not have a well established conceptual and mathematical foundation. Simulation

is an arguably unique union of modeling and computation. However, simulation also qualifies as a separate species of system representation, with its own motivations, characteristics, and implications."[59]

Consequently, simulation is, on the one hand, seen as a method that requires its own epistemology, since it goes beyond pure calculation. On the other hand, it is therefore often viewed with reservations: "Simulation is usually described as an art, or a soft science, because the useful results of the study depend on the skill of the modeling team. At the present state of the art, there is no scientific theory to guarantee the validity of the simulation process before the experiment is performed."[60]

Programmers thus create models (accordingly, the electrical engineer and acoustician Abraham Moles calls cybernetics the "science of models").[61] They are set up to present the progression of an object conceived as a system—not in the sense of an animation, but through a description that captures the principles of its change in state according to "systems analysis," a systemic mode of thought and observation. Everything simulated is to be kept calculable/dynamic, that is, formulated as "behavior." Already in the founding article of cybernetics, "Behavior, Purpose and Teleology"[62] (1943), the authors Norbert Wiener, Arturo Rosenblueth, and Julian Bigelow lay a "reading screen" over phenomena that places the focus on behavior—or, more precisely, the structure of behavior patterns—and challenge themselves to determine the logic of events in order to organize them:[63]

> This method consisted, in the study of any phenomenon whether natural or artificial, in privileging its *behavior*, which is to say, in reality, the changes that this phenomenon experiences from the fact of its relationships to its environment. ... Mathematics had been concerned for a long time already with the *relationships* between particular phenomena. ... The novelty of this behavioral method consisted in its true universality and its radicality: *there is no other reality than that constituted through the relationships of phenomena to each other.* This new method, in privileging the view on the behavior of objects—independently of the physical nature of the elements from which they are composed—made possible the comparison between any "objects" whatsoever, and in particular, between human beings and machines.[64]

The transference of this perspective to a mode that the computer can work with occurs through a networking of internal and external influencing factors, the integration of data sets, counting devices, controls, and regulators by means of mathematical functions and circular mechanisms. These circular mechanisms or recursions, for example, copy previous entries, transform them according to the rules, and add a new marking.

"The relationships between system elements as well as between the system and its environment are expressed as a relationship between model variables."[65] This means conversely that the functioning of the computer can fittingly be described as "systemically constructed." Even though systems theory is more comprehensive than can be squeezed into the computer, computer simulations can nevertheless be seen as applications of systems theory. From a technical point of view, a simulation is present when the modeled equations of the underlying dynamic mathematical model are solved. A computer simulation is a computer-based

method for examining characteristics of a mathematical model (in which phenomena are composed according to systemic criteria). It is implemented particularly in situations where analytical approaches are lacking. The objective is often to conceive of the dynamic to be recreated by means of laws in such a way that development of a system over time can be studied under changed conditions. In other words, this entails "the effort to understand how complex systems react predictably when parts of them are changed."[66] Simulation is occasionally applied to static objects, but in the great majority of cases, it involves processes, whether these systems are in equilibrium (stationary) or not.[67] Simulation tends "not just to break down its objects into individual processes, but also to consider these objects as totalities in motion."[68]

For some authors, simulation also includes the modeling process, while for others it consists in executing an existing model numerically and varying the conditions, that is, the decision parameters, in order to study the model in its "behavioral trajectory"[69] or find an acceptable solution to a problem. We will adhere to this understanding of simulation in the narrower sense.

Without any notice, we have switched from aspects concerning the sensory—and primarily the iconic—to simulation. Not every conception of simulation would consider this a switch. According to Engell, "The attested Latin usage places the main semantic field of *simulare* (etc.) clearly in the context of the visual arts, or the visual."[70] By contrast with previous conceptions of simulations, in our context they are not necessarily and automatically tied to an optical phenomenon, but instead are concentrated around cause-and-effect relationships or functional contexts. This is the crucial difference between the natural science definition of *simulation* and its conception in the humanities. The systemic organization primarily concerns nonvisual entities and connections.[71] Therefore, it makes sense to distinguish between a "simulation" and the "image that comes with a simulation."

Until now it has remained unclear how the relationship between image and simulation is understood. Readers may have noticed that we have always spoken of images *coming with* or *occurring in the frame of* simulations; no mention is made of image simulations, or simulations *of* or *through* images. This is related to the fact that computer simulations above all are conceived as the formation of a dynamic. If it is not a case of tables, curve diagrams, or representations that hypothetically code readable values through coloration of the smallest possible formal unit, the pixel (*picture element*), then the realized applications of interest here are never "pure" process formations, but receive an additional spatial form when they are presented to the senses—which does not necessarily have to happen. However, from the already stated technical definition, the conclusion is to be drawn that a "simulated image" is present only in special cases: specifically, when the emergence of the image is being presented for scrutiny.

The forming that is achieved with a dynamic simulation involves the change in behavior of the motifs being shown, which is made perceptible through complicated procedures. It can be typical of iconicity in the frame of simulations that it accomplishes the feat of

movement and thereby undergoes an essential shaping. The definition of the relationship between iconization and dynamic form offers a wide scope for design. Narrower boundaries are set when the calculated dynamic is intended to predominate; there is greater latitude when the dynamic is conceived as one aspect among several. Even if a spectrum of connection reveals itself here, the simulation image is fundamentally influenced by the dynamic and involves the tension of time/form (dynamic/sensoriality).

In order to demonstrate how the relationship of computer simulation and the iconization of its data series—that is not to say "significant differences in voltage"—can be seen, two approaches are taken: the first leads through a comparison with central perspective in order to show how the commonality of individual simulations can be grasped by means of the idea of another type of perspectivation. This general organizing principle that underlies simulations is based on systems theory and here is called the *systems perspective*. It is established in advance and comprises a procedure with which many image worlds can be created. In chapter 3, the second approach sketches out the individual steps in the process of producing simulation models, both theoretically as well as through the concrete example of an application. From this, the role of the sensory aspects that come with simulations, as well as how they relate to the calculated dynamic, will become evident.

2 The Perspectivation of Simulations

2.1 Central Perspective in Discussions on Contemporary Image Production

Before we begin our comparison of the systemic structure of simulation with central perspective—the purpose of which is to illuminate the simulation dynamic that results from this structure and enable examination of how it relates to a simulation's concrete sensory execution—it should be noted that reference is often made to the successful cultural technique of the early Renaissance in discussions on contemporary image production. "In view of the often unchallenged rank that perspective has, also and especially in the latest writings on the development of apparative and now electronic automation of image production, one has every motivation to seek out the bases for this persistent high regard."[1]

Many of these allusions seem intended simply to place the object of discussion within a prominent tradition of development or to dignify the diagnosed new development by styling it as a major upheaval of yet unsuspected magnitude. For example, it can be read that while the central-perspectival window view of the Renaissance[2] is associated with a representation of the absent, works characterized by a "liveness" are suited not to representation (*Repräsentation*) but rather to presentation (*Präsentation*).[3] The debate already outlined in the previous chapter concerning the precession or succession of the image thus also finds points of contact with central perspective. Likewise, the topos is widespread that Leon Battista Alberti's "window" became a "door" (or a French door) that can be passed through in order to enter the pictorial spaces of the so-called "virtual" world. According to the artist and curator Peter Weibel, the window and the door are very much oriented to the recipient:

Perspective constitutes the first idea of the image as a dynamic system, because in the perspectival image objects change from the viewer's point of view. The image is thus already partly variable there. The perspectivally distorted two-dimensional representation of the three dimensions of space constructs a privileged external observer from whose viewpoint the image changes, from whose viewpoint the image is rectified and thus the representation becomes correct. This perspectival image world is thus already dependent on the observer. Thanks to the dynamic retention of information (in the virtual, digital supporting medium) this observer dependence is increased.[4]

At the same time, the assertion is also often made that pure navigability through image worlds projected in three dimensions (i.e., the changeability of the location of the "virtual camera") should not be considered one of the most interesting aspects, since it involves no innovation as compared with classical perspective other than being automatic and interactive.[5] From a reception-oriented view, this assessment misses the mark in that new qualities—such as unique temporal characteristics—can unfold through navigation. For instance, Couchot and the art and communication scholar Norbert Hillaire see the interactor as the source of the process (of perceptible movement). According to them, the situation is comparable to the position of the viewer in central perspective, who can be considered both external to the image as well as simultaneously integrated into the pictorial space through the vanishing point.[6]

Along with references of this kind, there are also positions that, through analogy, propose a new perspectivation and thereby present a fundamentally much more detailed argument. One of them is the communications and media theorist Michael Giesecke. Taking an information-theoretical standpoint, he sees central perspective theory as a linear action theory. Its highly selective approach to the process of visual perception enables it "to operationalize [the latter] so that the essential actions and results can be grasped in geometric rules."[7] According to Giesecke, perspective makes seeing into an active pursuit and is intended to enable a communication, but it is not structured for interaction, since it lacks a concept of circularity and feedback. He sees multimediality, with its inherently holistic approach involving multiple senses, as a new paradigm in "perspectivity."

In his engagement with central perspective, the engineer/artist Olivier Auber also brings the argument of communication into play. Perspective, with its rules, fixed vanishing point, and simple geometric construction, serves as the starting point for his thoughts on "temporal perspective" (*perspective temporelle*), which he develops in conjunction with his Internet-based work *Générateur Poïétique* (since 1986).[8] Because the server on which the work is set up is the site at which all user inputs converge and because it instantly returns an updated image to the user, Auber understands the server as a "temporal vanishing point."[9] He expanded his approach in 1995 in view of the World Wide Web, and from that time on spoke of "digital perspective" (*perspective numérique*), for which a decentralized server network, or the shared digital code, corresponds to the vanishing point. A solution to the challenge of finding an appropriate figuration for peer-to-peer communications happening "at light speed" is

thereby to be offered. In Auber's terms, "temporal perspective," through its relationship to a single server, is a special case of "digital perspective."[10]

While Auber multiplies the vanishing point, the artist Sophie Lavaud places the eye point in plural. She locates these eye points in a space that is not primarily to be understood topographically. It is a "space of dialogue, exchange, relationships, governed by programming language, which alone is capable of giving it the fluidity and instability of the 'living.'"[11] Lavaud rightly emphasizes that this space of interaction is entirely independent of central perspective: "The nature of the *space of interactions* can be defined ... as radically new. From the point of view of mathematics, we can imagine this space 'between' as a space of non-Euclidian geometry, of a systemic nature. It puts into play an immersive perspective that has nothing to do with central perspective anymore: there is no longer any projection screen as in the optical techniques. The shifting and multiplication of points of view, the personalization of the course according to each individual and moment of access makes this space fractal and reiterative."[12]

Lavaud's "space of interactions" (*espace d'interaction*) is similar to the "relational space" (*espace relationnel*) of the artist and mathematician Jean-Louis Boissier. Boissier agrees with Lavaud that interactivity plays a central role in the generation of this space. However, he does not make the eye point or eye points the focus of his thoughts. He understands interactivity as a type of "optics" that designs a vision of things,[13] while taking into view not their external appearance (as in central perspective) but rather their internal and external interactions and relations.[14] According to Boissier, if one considers the structure of relations as a form, the idea is conceivable that the *image-relation* can have arisen from a new type of perspective. Describing the latter becomes his goal. In *perspective relationnelle* or *perspective interactive*—as he calls it—interactivity[15] or programming[16] play the role of geometry in optical perspective.[17] Like central perspective, this perspective also requires frames or grids (*cadres*). For the *image-relation,* the framing conditions are the instrument with which relations are modeled and through which a network of tensions, processes of exchange, behavior, and events that comprise the specific material is constructed.[18] From this, it becomes clear that Boissier is talking not primarily about the optic but rather about the perceivable. He explains his choice of terms as follows: "'Perspective' because the objective is to produce a perceivable image. 'Interactive' because it depends on the observer's play. The perspective integrates not only the will to see, but also the will to interact."[19] Thus, the specific quality of the *image-relation* is its playability. This playability attests to the formability, the figurability (*figurabilité*) of the relations on which the *image-relation* is based, and gives to it its corresponding manifestation. Of the examples discussed, Boissier's approach is the most similar to our own because he understands the perspectivation as an a priori stipulation that spans the entire work, permeating the iconic design without completely determining it.

2.2 A Structural Comparison with Central Perspective

Perspective is to Painting what the bridle is to a horse, and the rudder to a ship.[20]
—Leonardo da Vinci

Lavaud and Boissier are heading in the right direction in that, with the relationality of components, they comprehend an essential characteristic of systems. They do not categorically limit their remarks to simulations. But such a limitation would have made it easier for them to see that the interactions they are writing about could be correlated to a larger topic, namely, time. Simulations design courses of events, and they do so not arbitrarily but with certain restrictions that follow set premises. In turn, these premises have to do with regarding as a system the entity being presented: hardly any technical definition of *simulation* omits the concept of the system. As a conceptual template, the system prestructures what it is being used to examine in such a way that the construct thus conceived lends itself to simulatability because interactions, feedback loops, oscillations, and influence, for example, occupy the foreground. Under the conditions of this perspective, which we will call "the systems perspective" in what follows, there results a characteristic articulation of what is presented—or better, a characteristic articulation of the totality of everything shown. By its nature, the systems perspective always affects the entire complex of presentation—as central perspective also does—but only in certain respects. In our case, that is, in computer simulations, this is through the forming of processes. While central perspective and its related concepts (e.g., angular perspective, divergent perspective) organize spatial phenomena, the systems perspective is primarily devoted to temporal phenomena. Thus, these two perspectives are not at odds and can be combined.

Here, it should be made clear that the systems perspective is not only concerned with processes but, moreover, can apprehend many things in which an organizing structure can be identified. Because of this, in an atemporal boundary case, one could also use it to describe central perspective, for example. But this is not our goal, since we have undertaken to examine the forming of temporality as one of the strengths of the systems perspective. The objective here is neither to specify comprehensively what could reasonably be seen with the systems perspective nor to elaborate this perspectivation with an eye toward previously unconsidered elements. Thus, we are not concerned here with ordering principles beyond explicit sequences, as, for example, the art critic Lawrence Alloway already discussed for painting in 1966 in his exhibition *Systemic Painting*.[21] Rather, with the systems perspective, we are attempting to find an approach to understanding simulations better. In more precise terms, in view of the always singular manifestations of simulation dynamics, we are attempting to extract their commonalities and general preconditions. A means would thereby be gained, beyond the individual cases to be studied in detail, to understanding the relationship of simulations to iconicity. In view of knowledge acquisition through simulations, it is of great interest to plumb the depths of this highly complex relationship. In contrast to

Renaissance perspective, at issue is not the projection of a three-dimensional space into two dimensions but rather a dynamic that operates with a temporal dimension. Differences are necessary so that this dynamic can be perceived. To this end, in the sensory presentation, spatial dimensions are generally brought into play. An arbitrarily dimensional phase or configuration space is defined in which the dynamic can unfold.

But we're already getting ahead of ourselves. First, let's continue the comparison with central perspective that we have already begun. This comparative approach enables examining different facets of the systems perspective according to an—at least in its basic features—already familiar paradigm of presentation. Both perspectives can be understood as media of expression or design, or as procedures that operate in the realm of calculated relationships and in the frame of which images can be created. Both perspectives are attempts to see a segment of reality in a particular way and to deal with it symbolically. Both are feats of abstraction that influence culture as much as they themselves are culturally determined. Both the geometric and the systemic reduction of the complexity of the surrounding world introduce a new quality of misconception, obscurity, and distancing. The criticisms leveled against them remain the same: that the perspective, on the one hand, does not reproduce the material correctly and, on the other hand, privileges a particular view of it. While the first point seems still to demand a Platonic ideal, the second, constructivist argument implies possibilities for a change of view, which the art historian Erwin Panofsky also recognizes: "But if perspective is not a factor of value [for artworks], it is surely a factor of style. Indeed, it may even be characterized as (to extend Ernst Cassirer's felicitous term to the history of art) one of those 'symbolic forms' in which 'spiritual meaning is attached to a concrete, material sign and intrinsically given to this sign.' This is why it is essential to ask of artistic periods and regions not only whether they have perspective, but also which perspective they have."[22]

With the art historian Alois Riegl at the latest, central perspective is discussed as a stylistic undertaking.[23] The art historian Pierre Francastel also finds that it displays all the laws of style formation: initially, it appeared only in isolated cases in a latent form, but gradually established itself as a mode suited to general application, and finally took on the affectation of a restrictive method.[24]

2.2.1 Space and Time

As the previous quotation indicates, in his prominent study of 1927, Panofsky discusses central perspective as a "symbolic form," following the philosopher Ernst Cassirer. These "symbolic forms" or "media"[25] are to be understood as threshold phenomena that in turn are concretized in symbolic schemata with aesthetic, epistemological, and ontological implications, thereby shaping an epoch's understanding of self and world. According to Sybille Krämer, together with central perspective (compare Panofsky) and calculus as a formal language (compare Cassirer), the "virtual" realities of cyberspace also belong under the rubric "symbolic form."[26] These are characterized in their allowing, for the first time, users who intervene in an ongoing manner.

But back to Panofsky: he shows that the central-perspectival space of the Renaissance, which he terms "system space" (*Systemraum*),[27] purports to correspond to natural sense impressions, but in fact reproduces a homogeneous, constant, rational, infinite space that does not correlate with the surrounding world as it is lived and perceived. For the psychophysical space of human corporeality, above and below, right and left are by no means interchangeable. According to Panofsky, two assumptions are tacitly postulated: a single, (at least generally) unmoving eye[28] and the adequacy of reproduction by means of a planar cut through the visual pyramid, which itself is preceded by the idea of visual rays that diverge in straight lines. The eye point determines the ideal location of the viewer's eye, to which every image constructed with central perspective is oriented. Therefore, the art historian Hans Belting asks why his colleague Panofsky, in analyzing perspective, gives preference to the discussion of space instead of to that of the gaze. Belting provides his own answer: we have to look to Cassirer, who, following Kant's model, begins his philosophy of symbolic forms with an examination of space and time. The "system space" of which Panofsky speaks is a continuation of Cassirer's idea that "homogeneous space" is never present but always has to be constructed. "It constructs the world for a symbolic gaze."[29] According to Belting, Panofsky recognizes space as an "autonomous symbolic form" that does not represent any basic empirical experience.[30] Panofsky himself writes that the Renaissance proceeded to "[define] space as a system of simple relationships between height, width and depth."[31] The prerequisite for this is the assumption that not only can things be measured, but so can the empty spaces between them. This means that the identity of space is to be conceived rationally and not substantially.[32]

Even though Panofsky does not refer to them, recent findings on the ideas of the mathematician Biagio Pelacani da Parma may support Panofsky's focus on space.[33] Pelacani, famous in his own day, worked in advance of the experiments carried out around 1420 in Florence by the architect Filippo Brunelleschi, which are widely considered the genesis of experimental central perspective.[34] Pelacani argued that mathematics offers the greatest possible certainty in knowledge acquisition and that the size and distance of things are real because they can be measured (with this position, he made reference to a scholarly argument concerning the experience of sight and cognition). Pelacani discussed the possibility of optical illusion, which he believed could be kept at bay through the use of mathematics. He "concedes that deceptive images can creep in between the visible world and the eye, but he wants to correct them through measurement and knowledge."[35] Everything is quantifiable and therefore not determined through human perception (thus relative). "Biagio combined a 'concrete' mathematics of the physical world with a theory of empty space, which [for him] could be defined only by its extent (*latitudo*) and the location of physical objects in it (*distancia*). ... In Biagio's theory of vision, space was a quantitative dimension that provided [to the visible image] reliable data from the external world. Through the measurement of objects and their distances from other objects, size (*quantum*) and proportion became the cornerstones of visual perception."[36]

Belting continues that in his conception of space, Pelacani breaks with the *horror vacui* of the Aristotelian spatial continuum and introduces empty space, the vacuum, for the first time. In addition, this conception of space is brought into connection with visual theory. If one begins with Pelacani, the idea of a synthesis of mathematics and physics seems a fundamental precondition for perspectival representations. In this way, material bodies and geometric enclosures that are defined a priori can be treated in an entirely equivalent manner. For image production, Pelacani's topology cleared the way for the regulated anchoring of objects that could be designated by numbers and proportions into a superordinate, likewise quantifiable geometric space as such.

In Belting's assessment, the artist and theoretician Piero della Francesca was the most consistent in implementing Pelacani's approach. Empty space "is measured along with physical objects and at the same time related to a human subject, an observer who recognizes it by the things that exist within it."[37] Spatiality is constructed with lines that perform different functions. They serve in "the measurement of space here, the measurement of bodies there, even though Piero has ceased to distinguish between them."[38] This abstract spatial construct must be recreated in reception using whatever is presented, preferably edges and tiles, as evidence of it.

In central perspective, the presenting geometry serves to describe a world of which it can only be assumed that it possesses its own geometry. The transformation from the measurable dimensions of things to their dimensions in the visual presentation is governed by a mathematical operation for which distances are of greater importance than surfaces. Central perspective defines objects as a certain distance away.

This type of "thinking in relations" is thus fundamentally anchored in the structure of an image for the first time. *Proportionality* in the Renaissance refers to a relationally conceived, uniform set of rules governing proportions, which also must be thought of as and proven operant in perspectival space if one intends to adhere to the validity of measurements.[39] The procedure of perspective guarantees, for all possible perspectivally constructed spatial situations, the invariance of the internal structure of objects. With different constructed viewpoints, according to the curator William Ivins, there are only two possibilities: relationships either within or outside the objects are changing.[40] If the first option were true, there would be no homogeneity of space, no uniformity of nature; large parts of the sciences as they exist today (except for quantum mechanics, parts of relativity theory, and ideas in endophysics, which do recognize observer-dependent phenomena) would lose their foundations. Central perspective stands for the second option: "Perspective may be regarded as a practical means for securing a rigorous two-way, or reciprocal, metrical relationship between the shapes of objects as definitely located in space and their pictorial representations."[41] What perspective guarantees, according to Ivins, is an "optical consistency." With the systems perspective too, the consistency of internal relationships remains a fundamental prerequisite, although self-modifying systems are also considered. Here, invariance is not the absence of change, but rather the preservation of constancy under certain aspects within the context of change.[42]

We have suggested that the systems perspective is responsible for temporal organization. With this perspective, phenomena are depicted under the condition of a concept of time informed by physics: postulated as homogeneous, linear, continuous, infinite, and uniformly elapsing, this is the time that forms the basis for classical mechanics. Against this background, the differences are organized that make up the dynamic of the modeled system. The productive "detection" of internal and external relationships and couplings is the central concern of systems analysis in general. Another skill put into practice is a "seeing" of interwoven relationships, a "networking view" that guides attention "to the relationships, connections, and interactions, as well as to the dynamically and temporally mutually correlating activities of collective ensembles."[43]

The object defined by central perspective receives a fixity and tends to be reduced to the character of being there (*Vorhandenheit*).[44] This being-there is associated with a feature that can be linked to temporality: Boehm calls it the "permanence" (*Ständigkeit*) of the objects being shown as extensional, positional entities in space. With the systems perspective, however, impermanence proceeding along regular channels is cultivated and being-there in the presentation is given only through the spatial components. However, in this case, being-there should be understood as a spatial situation in and with which the manifestation of movement is possible. What is the consequence of this? Privileged by central perspective, the idea was long prevalent in art history that images are first of all spatially constructed and that temporality manifests in them at best indirectly. "What thoughts on temporality can be found as a rule are connected with the study of the movement of persons, or living creatures in general. Time was traditionally connected with the ideal canon of the figure. In this respect, at issue was not the formulation of temporality (or iconic time), but rather the time that is proper to an object of depiction, that inheres in human movement as bodily and affective."[45]

Central perspective had the power to shape the understanding of iconic space in a lasting way. One could attempt to devise analogies for the systems perspective: the systems perspective determines iconic temporality, to which, inversely, the spatial constellation of the antecedent temporality is secondary and subordinate. Such "iconic time" would indeed be the quantifiable, linear temporality that the philosopher Henri Bergson criticizes as cognate with measurable, homogeneous space. We will return to this later.

2.2.2 Rules

In central perspective, a set of mathematical rules determines the conditions of appearance of every possible visible object in the defined pictorial space, and thus effects an inherent unification of the shown according to the criteria of the applied organizing principles. The same is fundamentally true for the systems perspective, although the set of mathematical rules for simulations has in some cases grown exponentially. This also means that both perspectives are by and large "universally" applicable. With the systems perspective, one reason for this is that the "system" as a basic conceptual category is robust, which means it is

capable of remaining invariant in the face of a large number of operations that are applied to it. Systems theory was developed with the objective of studying life. But unlike biology, which came before it, it often works with mathematical equations, thus with the methods of physics (the study of inanimate bodies), in order to be able to pursue a fundamental, rigorous, holistic approach. On this point, the biologist Ludwig von Bertalanffy, founder of general systems theory, sees the need to go beyond overly reductionist Newtonian principles of cause and effect that break down phenomena into parts and observe them in isolation in order to comprehend the functioning of the whole. According to him, the essential characteristics of life are its organization and coordination of parts and processes. For Bertalanffy, the main objective of his field is to find the laws of biological systems on all levels of organization.[46] Cybernetics and systems theory could be viewed as the latest optimistic attempts at universal or unifying theories (without already granting this systemic approach an epistemic monopoly).[47] Because of its generality, the concept of the system is capable "of embracing echelons of nature that lie very far apart. A type of 'system' can be hypothesized at every level of the animate,"[48] and "mechanisms" are at play throughout.

2.2.3 Areas of Jurisdiction and Autonomy

One should be aware that this broad basis of application comes at the price of requiring the acceptance of certain principles. Thus, the distinction between technological, psychological, and physiological facts does not matter to cybernetics: "For it, there is only one class of facts: observable, describable, communicable facts."[49]

With central perspective as well, bodies and the spaces between them are subject to the same principles of presentation, "whereby 'bodies' are conceived as that which is defined by its relative position in space—and only by this. Thus, all bodies are treated equally: whether they are people or things, whether they are high-ranking persons or of a lower status, the linear perspectival construction no longer makes reference to the significance of what is depicted. Geometry becomes a 'universal language,' a 'visual syntax' that homogenizes whatever can appear in the medium of the image."[50]

It should be noted, however, that the general validity of a theory by no means guarantees its effectiveness in a particular case.[51] The perspectivation works better in some areas and examples than others. For instance, in a view of parallel, fenestrated walls, one behind the other, if no edges, flooring, or other objects are given as additional reference points, it is not possible to determine the distances of the walls to each other or the size of the windows. Thus, while it is often said that central perspective is best demonstrated using architectural elements, this is fundamentally correct; nevertheless, what matters most is how the individual elements look and how they are set into the scene. Thus, the art historian Frank Büttner finds it improbable that Brunelleschi was familiar with the geometrical relationships of applied central perspective in the construction of his *tavolette*, neither of which has been preserved. For a demonstration of vanishing point perspective, the buildings that he chose for the two pictorial experiments are "totally unsuitable, since both are lacking the orthogonals

that converge at the vanishing point."[52] In Büttner's opinion, the tapering depth lines that could be interpreted as exemplified visual rays are missing.[53] Whether his hypothesis is true for this one case or not is insignificant to our concerns. It may also be said of simulations, however, that some calculated complexes show what simulations can do less well than others. Simulations mainly represent sequences of action. This includes examples in stationary states: although they are continually calculated, their state of equilibrium makes no change perceptible since the same state always results.

Furthermore, what connects the systems perspective with central perspective structurally is the fact that they fundamentally are not tied to any special technique or any material substrate. For them, what is presented in any single manifestation is simply a placeholder, which means that they are not restricted to any particular content. At very least, the realm of possible motifs is large. With central perspective, all visible things of this world are tested for the conditions of their appearance. Potentially everything is concerned "that can be termed an optical fact."[54] How a given spatial situation is transformed falls within the purview of the doctrine of perspective. It determines the sight of things according to the rules but does not offer a comprehensive theory of visual depiction. For example, coloration is outside its domain. The purpose of color is simply to adorn the created tectonics; it does not have its own signifying value in the understanding of central perspective.[55] Only "morphological seeing," the reduction of the surrounding world to contour lines, is modeled through the doctrine of perspective.[56]

While central perspective makes the surfaces of bodies align exactly, in the systems perspective the target of presentation shifts away from the outer extent of an object to the understanding of its network of relationships and pattern of action in temporal sequence. The "space" that is carved from these variables can turn out to be correspondingly abstract (compare Boissier's "relation space").[57] The mathematical treatment of an object, as Couchot says, can of course restrict itself to the reproduction of its appearance. "But the description of the object can be more complete and can provide the computer with additional interesting information, in particular about the object's becoming (transformations, movements and locomotion, relations to other objects, etc.)."[58] The statement that objects are conceived in their becoming is apt; the idea of a greater "completeness" needs to be relativized, at least for simulations, since the form and materiality of simulated objects are not relevant in their systemic construction. Only on the basis of this assumption is the following technical definition of *simulation* comprehensible: "Simulation is the act of presenting an appearance of something without the reality. Modeling implies the generation of a facsimile or representation of something, useful in doing the simulation."[59] Later, it is specified that "a clear distinction will be made between the two words, with *simulation* conveying the action of imitating reality and *model* representing the vehicle."[60] Two interpretations allow these statements not to be written off as contradictory: Either one assumes that "without the reality" is meant in the sense that the simulation is not realized in the original materiality.[61] Or else one views the simulation's presentation as the projection of a dynamic that itself does not

progress in the same manner as that in the presentation. "The perspective distortions are not caused by forces inherent in the represented world itself. They are the visual expression of the fact that this world is being sighted."[62] What art psychologist Rudolf Arnheim writes can be considered valid for both perspectives. Central perspective is itself not a Euclidean projection method that designs something in such a way that the viewer believes himself or herself to be standing before a three-dimensional Euclidean space.

2.2.4 Construction

The philosopher Éric Alliez speaks of an "architectural aesthetic" when referring to both Renaissance and synthetic images.[63] With central perspective, iconic spaces are constructed in which what is shown can be determined in advance. Only what is deliberately included is present. One only incorporates what is considered as essential for the purpose, and this can be only that which produces a noticeable effect.

Assuming that Brunelleschi arrived at the presentational technique of central perspective as a consequence of his involvement with measurement procedures applied to building fragments, he could have devised the experiments in order to make his reconstructions of antique Roman ruins plausible. It is possible that he sought to demonstrate the reliability of the techniques applied in the reconstructions by means of perspective experiments. If this technique could achieve a substitution of the depicted for the eye, as he makes clear in the first experiment, then by analogy, it would have to be able to achieve a restitution of ruins based on the measurements of remaining fragments. Two additional protagonists of perspective, Alberti and della Francesca, also emphasize the constructive character of the procedure in their respective tracts.[64] In his treatise, Alberti foregrounds the question of composition. He devotes extensive passages to the compiling and explanation of rules for the production of images. The stated rules cannot be reduced to the instruction to observe nature; rather, they specifically aim "to create a difference between paintings and that which one would see without them," in the words of the philosopher Leonhard Schmeiser.[65] This explains why Alberti gives so much emphasis to the painter's discretion in the construction of a perspectival space. Nevertheless, especially in book 3, he demands fidelity to nature (but in the *process* of depiction!): "Perspective remains subordinate to them [the determinants of painting] as a means, so that its use does not really aim to deceive the viewer, but rather to make an otherwise determined depiction appear in a way plausible: 'it could be (or could have been) like that,' 'that could really exist.' The purpose is not to elicit an error within the viewer, but rather to initiate a comparison and a judgment: it is about persuasion."[66]

At this point, one recalls the phrase repeatedly put forward with simulations: "as if." The formula "in the imitation of nature, the image is representation; in simulation it is an 'as if'"[67] requires a more differentiated discussion.

If one follows Schmeiser further, Alberti demands of painters that they understand the depiction processes of nature in order themselves to act according to them. "Central perspective is the starting point from which an attempt can be made to reproduce these processes,

i.e., to imitate them, and thus to increase the painter's 'skill.'"[68] This statement could be well transferred to simulations.

Panofsky interprets central perspective as "a concrete expression of a contemporary advance in epistemology or natural philosophy."[69] Art was thereby made into a "science," as Panofsky continues: "The subjective visual impression was indeed so far rationalized that this very impression could itself become the foundation for a solidly grounded and yet, in an entirely modern sense, 'infinite' experiential world."[70] Thus, just as central perspective as derived from optics and mechanics was at the cutting edge of scientific development in the Renaissance, the formalizing mode of the systems perspective laid the foundation for computer science and thereby also computer simulation.

2.2.5 Breaking the Rules

With central-perspectival images, every element is integrated in the unifying, centered spatial logic and is restricted in its appearance in a particular way.[71] Countless painters of the Renaissance were known to have perfect command of central perspective but either did not apply it across the board or else declined to include in their pictures everything that could possibly be depicted.[72] Iconic or iconographic needs and requirements prompted artists to purposely deviate from rules that were highly familiar to them. "Naturally [the artist] wanted to profit from the plausibility that the constructive medium offered to him, but he also wanted to give the picture its due. In short, the perspectival image subjugated the perspectival medium."[73] A relationship of persuasion between perspectival space and perceiving subject was often given precedence over mathematical correctness. These abstract laws were to be mastered not in order to surrender oneself to them, but rather in order to use them as desired—and if need be, where they were disturbing, "to counteract this excess of objective form in aesthetic practice."[74] Thus, Francastel makes the following observation about the mid-fifteenth century: "It is enough to cast a simple glance at the oeuvre of any artist from this time in order to state that the regular utilization of a system—which the famous realistic linear perspective would be—is not in evidence. The system of the open window is occasionally utilized, but more often one finds other solutions being used simultaneously." [75]

In Francastel's view, "Alberti's cold rule" was not sufficient to carry the creative ambition of the quattrocento.[76] It does not support the surface and tends to stereotyping. On this point, the writer Giorgio Vasari already noted that the painter Paolo Uccello used perspective in an overly systematic way. Since he failed to exercise moderation, the depicted scene appears sterile and ponderous. Moreover, intensive study of perspective caused him to neglect the forming of figures.[77]

Central perspective is too static, too monomaniacal and dictatorial. This conclusion colors the metaphors of many interpreters when they write that artists saw perspective as a guide but did not allow themselves to be enslaved by it. Figures of speech revolve around a theme of disempowerment, violation, and betrayal, as well as escape, rebellion, or the act

of liberation: artists were not afraid to "repeal the principle"[78] (e.g., in order to signalize the divine). They "repeatedly ... broke out of the constructive framing conditions,"[79] covering the perspective up or denouncing it entirely.[80] Alberti's work itself could be understood as an attempt "to escape this terrible discipline."[81] Perspective "created constraints. Alberti speaks about the way the visual rays 'form an enclosure around the entire surface like a cage.'[82] The attempt to escape from this 'cage' ended in more or less obvious deviations from an overly rigid geometry."[83]

From the many art historical discussions, one could conclude that it is worthwhile to pay attention to the deviations from the rules of construction, because in these places, an explicit decision in favor of a particular design is being revealed. The use of color- and aerial perspective are prevalent strategies that accompany central perspective. If one wanted to draw parallels to simulations governed by the systems perspective, then *sfumato* could perhaps be considered analogous to random generators, which are occasionally used to produce gentle noise or little irregularities, thus giving a more true-to-life quality. However, the rules of the perspective being applied are generally felt as constricting, no matter what effects can be produced. Thus, in an introductory book for programmers from the mid-1980s, one reads that programming's treatment of things is rather like a "straitjacket." At the same time, however, the author is quick to add that this formalization is a powerful utensil.[84] Couchot implies that a more liberal interaction with specifications of this kind is prerequisite for artistic production. The artist thus has two possibilities (and it becomes clear which of the two gets Couchot's vote):

> Either blindly to appropriate this worldview imposed by simulation models, which make up the very structure of the virtual—thus a highly fragmented and incoherent view—or to alter the original purpose of these models, which were designed to produce *knowledge* and not art. ... Artists have to transcend the models, available ones or ones they themselves devise, have to go beyond their technological accumulation. ... An addition of models is not yet an artwork. For the artist, numerical models are powerful but constricting/compulsive mediums; they must be divested of their scientific and technological performance, interpreted and implemented in the frame of the artist's own symbol system.[85]

Artists today follow this directive and often stretch the bounds of the mode of presentation where it impedes them by using models strategically, mistreating rather than revering them.[86] For example, with the systems perspective one incurs a strict presentness. A transgression that we encounter in the work *fluID—Arena of Identities,* discussed later, consists in introducing another temporality.

The comparison of central perspective and the systems perspective serves to clarify the approach to simulations being tested here. We will be concerned not with their referential character but rather with the aspect of construction. At issue is the construction of dynamics under the condition of a certain regularity. This is equally true for all dynamic simulations. But since we are most interested in the special cases that enable interaction in real time, we

are even more compelled to look out for those equivalences that prove constitutive for what an iconicity of simulations could be.

2.3 The Special Case of Interactive Real-Time Simulations

We are already at the point of addressing the type of simulation that comprises the source material of this study. As can be gleaned from the Introduction to this book, this amounts to a selection of works that derive from a small segment within the totality of simulation production. These applications are definitively oriented to recipients, who follow along with and influence the course of events more or less *in actu*. In order for this to happen, three things must be provided: first, the becoming that the simulation calculates must be made accessible to the apparatus of perception; second, what is presented must elapse at a speed appropriate to the user; and third, the recipient must be functionally integrated into the mathematical structure so that he or she can have an impact there. We will consider these three aspects in reverse order—always in comparison with Renaissance perspective.

2.3.1 Parameter or Variable as Eye Point

With central perspective, by means of a uniformly constructed space, the eye point assigns the viewer a place in an extension into real space. If the eye point is to be seen as in fact allocated to the recipient, but no less certainly as a component of a superordinate structure, then for simulations, this must be a "site" of user integration that simultaneously keeps the user at a distance. While central perspective presents bodies statically and also nails the viewer to a monocular fixed point, the dynamically structured systems perspective generally requires a mobile, active user, but this is often enough a user with only one finger engaged in pressing buttons. The user is decidedly tied in through the site that offers possibilities of intervention. Depending on the application, the user presides over either one or more parameters or variables, whereby he or she can affect the dynamic as a whole or can act locally according to the setup. The place where the user steps in is computationally left out, a blank space that is not computed because user input is expected and taken into account. User actions that do not lie within this anticipated catchment area are not permitted, do not lead any further, or produce unplanned effects. Similar deviations from the creator's integrated intention come to pass when viewers place themselves at too oblique an angle to a picture with central-perspectival construction.

With both perspectives, deliberations are made on the part of the producer as to where the partial user integration should be positioned so that the desired result can be achieved. Thus, Alberti writes, "That this truly happens this way, the painters demonstrate in the moment in which they move away from what they paint and place themselves further back [from the painting] to look for the apex of this pyramid itself, guided by nature, from where they perceive that everything is more correctly judged and measured."[87]

With simulations, the turning over of a variable or a parameter into the custody of the user is preceded by the associated determination of a "level of description." Different processes can be monitored at different levels of description. Accordingly, the user is invited to act as a single molecule, the global rate of plant growth, or the sergeant of a military troop. It may well be obvious that one can have different effects and experiences in each of these cases.[88]

2.3.2 Real Time as Vanishing Point

The counterpart to the eye point is the vanishing point on the horizon line. Following the mathematician Brian Rotman, projected and coordinated space, in comparison to Euclidean space, is "a space in which every position is signifiable in relation to the horizon and centric ray as axes and the vanishing point as origin of coordinates. (Indeed, the mathematical space appropriate to perspectival images is that of projective geometry which, in order to study the effect upon plane figures of changing the position of the point of projection, postulates a point at infinity as its origin.)"[89]

According to Rotman, the vanishing point in perspectival construction is the only point with a privileged status. It is a necessary, abstract metasign, with which an infinite number of images can be organized in the same manner.

If one wanted to look for a comparable entity in simulations, it would have to play an important role that affects all processes. It would also have to serve as the precondition for the user's involvement. Real time (or, for noninteractive works, a freely definable time horizon for all events) most readily meets these criteria. It is repeatedly emphasized that simulations are used for cases that in reality cannot be made available to experience for various reasons. Computer applications enable processes to be transferred to a scale of temporality, spatiality, dangerousness, and financial feasibility that permits human observation. Simulated processes are created in the orders of magnitude within which the observer thinks.[90] While, with central perspective, the size or distance of things is determined with respect to the eye and how far it is from the tableau, with simulations as well, sequences are slowed down or speeded up in accordance with human perceptual capacity. The human being is thus the measure of the speed at which things elapse. All processes are tailored to real time, which is anthropomorphically determined. Real time is the reference point for the most disparate simulated processes. While eye point and vanishing point are related to each other in such a way as to give rise to a unified, continuous space, a similar situation arises with the systems perspective. It effects a synchronization of events in the simulation. With interactive works, this synchronization is also oriented to the user's reactive capacity, so that the user can intervene in the time frame familiar to her or him. A potential break in this focus on real time through the admission of different temporalities is conspicuous and perplexing. However, it is certainly possible for the developer to select different tempos of portrayal in a single simulation. In a single system, there can be structures of higher and lower frequency. It can be that the dynamics of both structures cannot be perceived in the same timescale because one process elapses too quickly or slowly in relation to another. In order to grasp

both dynamics with the presentation in real time, a different tempo will be selected for the portrayal of each in order to give force to the desired sequence. This type of temporal projection in turn has a unifying effect because the workable rendition of one sequence, which is selected so that the human being can register it, becomes the benchmark for all others.

2.3.3 Phase or Configuration Space as the Cut through the Visual Pyramid

It is more difficult to find a parallel to the cut through the visual pyramid, since this denotes a screen that registers the results of the construction in a perceivable field. But since dynamic in itself is not perceivable, it must be embodied. This is not achieved through the one dimension of time that is available to us in the material world (i.e., the one dimension that is understood physically and that can be simulated). Time is not optically perceivable without space, and space can be perceived only through differences (which therefore is also the case for time). Consequently the transformation of the simulation results into the perceivable realm most often happens via a freely scalable phase or configuration space. In these cases, the simulation results are distributed according to their values in a three- or two-dimensional coordinate space. Figure 2.1 is offered as a typical example of the presentation of simulation results in a coordinate plane: it shows a predator/prey scenario calculated on the basis of Lotka-Volterra equations. The x- and y-coordinates do not signify topographical measurements, but rather are the sizes of two populations: on the y-axis, that of the prey, and on the x-axis, that of the predators. The results of calculation are given by the curled line, which one must imagine as a consolidated aggregation of individual values. The simulation begins with 100,000 prey and 2,000 predators as initial conditions. After the predator population grows as a result of the paradisal food resource, the number of prey sinks rapidly, so that the predators consequently also show a decrease in population. The prey population is therefore able to recover. The system ultimately reaches a fixed point: with approximately 40,000 prey, around 1,200 predators are able to subsist, without either group experiencing significant fluctuations. The straight and dashed zero-growth curve connects the "turning point" of increase or decrease of each population size.

Should this type of presentational mode thus be understood as analogous to the cut through the visual pyramid? In any case, the projection screen as perceivable field would, for simulations as well, also have to be the place where the perspective construction in its forming effect can be ascertainable through a "reverse engineering."[91] Although the predator/prey example signifies a dynamic—the fluctuation of the animal population—no process can be seen here. With the systems perspective, mustn't there be a processual situation? Comparable diagrammatic visualizations certainly do exist that show a sequence because they exhibit the results successively.[92] The simulations that will be our primary concern also show uninterrupted intermediate results. To this extent, they accord with diagrammatic simulations exhibited in arbitrarily scalable spaces. With interactive applications, it is not (at least, not only) abstract dimensionalities arrayed spatially on coordinate axes that are fitted with the results of calculation but figurative displays.[93] We will come back to this later.

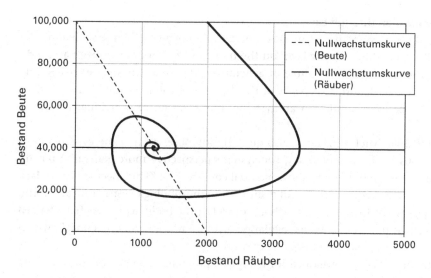

Figure 2.1

Phase space of a simulation portraying a predator/prey system on the basis of Lotka-Volterra equations. The diagram shows the mutual dependencies of the state variables (here, the size of population of the predators and the prey). Note the following translations: Bestand Räuber = predator population; Nullwachstumskurve = zero-growth curve; Beute = prey; Räuber = predator. Source: Timm Grams, environmental simulation with spreadsheet analysis, in http://www2.fh-fulda.de/~grams/OekoSimStruggle/Struggle. html. Courtesy of Timm Grams.

2.4 A Critique of the Simulation Dynamic

It seems clear that simulation can never achieve the complete realism of the operational system. ... However, it appears to be the best available.[94]

—Milton Grodsky

Just as central-perspectival space is constructed through and through, so the dynamic of simulation is manufactured from the ground up. The movement received as continuous is computationally analyzed and discretized, and only through iconization does it undergo a type of synthesis again. A couple of critical observations on the nature of the simulation dynamic point out several of its characteristics, including its perspectivated quality. Again at the risk that Baudrillard is unduly placed at the center of this discussion of computer simulations—where there are indeed many others who have made substantially more grounded statements—each section begins with one of the philosopher's objections. This occurs here in order to elaborate the cross-cultural points of contact in the simulation debate.

2.4.1 On Generalization through Laws

As has already been suggested, the organization of laws in models enables the adventure of generalization. Baudrillard is not very keen on the homogenization of all entities and individuals through the reduction to a couple of generative rules. Since these rules necessarily disregard the individual, Baudrillard speaks of the "specter of the identical."[95] The devised laws that form the basis of simulation are not the idiosyncrasies of individual objects of depiction.

The science historian Michael Hagner also quite rightly observes that the cybernetics of the 1950s and 1960s (and, one could say, the systems perspective more generally) has no body image in the sense that it would show material corporeality: "This specific type of lack of body-image goes along with a purposeful disinterest in morphological structure and form. Its epistemic object is not the body, but rather a model of the body, which is characterized through law-governed processes such as regulation, symbol processing, or feedback, which by no means must only be realized in organic creatures."[96]

With presentations that are developed for computer programs, comparable priorities are at work: descriptions of interactions are illustrated in so-called decision trees (see figure 2.2). These structure sequences hierarchically with decision boxes between generally rectified connecting lines that are, or are to be, transformed into a command to the computer. In this type of flow diagram, information about morphology can be accommodated at best in a rudimentary way.

In both cases, importance is placed not "on size relationships and not on topographical constellations more generally, but rather on dynamic states, wiring, circuitry, and regulation processes."[97] The systemic treatment, through the casting off of organic structure, takes on a cybernetic structure. Questions that transcend functionality are normally not posed in a systemic approach in the framework of dynamic simulations because they are difficult to integrate into a computer program. The uncompromising orientation to function, Hagner continues, in fact does remain related to the body, assuming that the body is treated as a circuit. As might be expected, this technicist view results in circuit diagrams. They exhibit connections and ultimately visualize the modeled functions. In the context of the study of artificial intelligence, artificial life, and systems biology, schematic diagrams with codified symbols (see figure 2.3) do appear that also suggest morphological aspects of what is being modeled, along with functional connections. But even in cases where morphological features are accounted for, these features—the bodies of individuals and their kinetic, mechanical structure—are abstracted for their functionalities alone. All body-related characteristics and their connections to the environment are represented through functions and states and are as abstract as the designer chooses, depending on the selected level of description. For dynamic computer simulations, all bodily aspects are "translated" into functions.

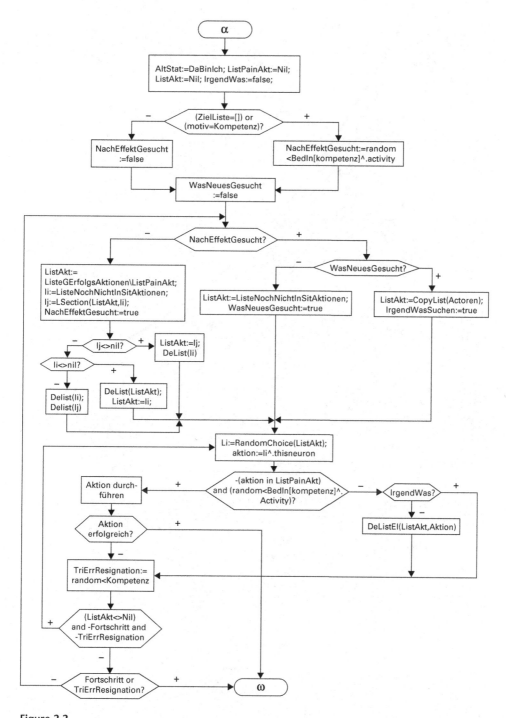

Figure 2.2

Flow diagram for the trial-and-error process for Dietrich Dörner's Psi theory. Source: Dörner, Bartl, Detje, *Die Mechanik des Seelenwagens,* 191. Reprinted courtesy of Verlag Hans Huber.

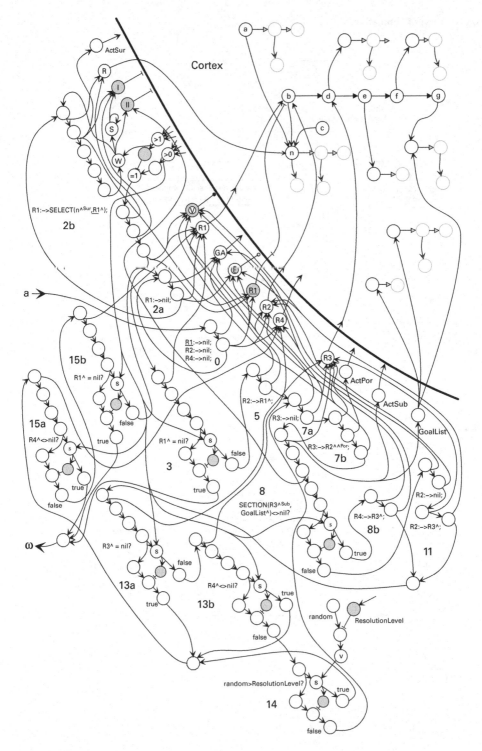

Figure 2.3
Schema for the neuronal network implemented in memory for Dietrich Dörner's Psi theory. Source: Dörner, Bartl, Detje, *Die Mechanik des Seelenwagens,* 133. Reprinted courtesy of Verlag Hans Huber.

What this approximately looks like is explained by the philosopher Gabriele Gramels-berger. She describes the embedded logic of a contemporary simulation model that delivers prognoses on climate change:

> A simulated fish is a rate of change, averaged for the model as a whole, in the appearance of plank-ton. In other words, plankton "die" in proportion to the square of the number of fish averaged in the simulated ocean. Swimming in the simulated ocean would mean swimming through an averaged plankton-ocean-fish soup, whereby "swimming" in discrete worlds is likewise an averaged activity, carried out in jumps from time increment to time increment and interpolated between the points of calculation. Since ocean models are calculated in a grid with intervals of 20 to 150 kilometers at a 10- to 20-minute tempo, one would hence exist only every 20 minutes, in order to swim one stroke in the highly perforated ocean. A rather curious world in which objects are processes that exist in discrete but globally averaged form.[98]

With this by no means disrespectfully intended exposition of the simulation model, it is striking that all involved entities are reduced to their potential to produce effects. In such a desubstantializing and relationing, a concept of knowledge is constituted that, with increasing quantification of the object of examination, forfeits its totality but compensates for this loss through calculability and the enabling of experiments.[99] According to the philosopher Vilém Flusser, in this "curious world," the original *res extensa* is no longer at issue, having been replaced by particle clusters structured in the manner of fields. In light of the "structure of calculatory thinking," the concept of reality almost needs to be rethought. Should one not adjust one's world picture, Flusser asks, "so that something is realer, the denser the distribution [of analytically achieved particles of any kind] is, and more potential, the sparser it is?"[100]

2.4.2 On the Discretization of Dynamic

Fragmentations, discretizations, and idealizations are at work in simulations to different degrees of specification. One cannot get along without such simplifications when one implements a digital computer as the executing machine. A statement by Baudrillard on mathematical idealization is aimed at the correspondingly technical manner in which processes are treated in simulations. The philosopher writes, "It is somewhat of the same paradoxical order as the formula that says that as soon as two billiard balls roll toward each other, the first touches the other before the second, or, rather, one touches the other before being touched. Which indicates that there is not even the possibility of simultaneity in the order of time."[101]

In a computer simulation, contact is calculated relationally: it has occurred when the distance between entities has become zero. In small computational steps, the balls approach each other little by little, in alternation. Computationally, the distance's becoming zero finally occurs through the change in position of one of the two balls. Baudrillard's statement on nonsimultaneity in the treatment of a logically simultaneous occurrence is better exemplified by reference to the subsequent step: the step of determining the respective movement of the two billiard balls after the collision. Here, the calculation is necessarily divided. The

new position of each of the two billiard balls is *successively* calculated (or is calculated *in parallel on different computers,* but this also requires division). The results are only subsequently brought together again and thus form the initial situation for the next stage of iteration. In cases in which the result is invariant with respect to this sequence, a sequence of computational processing is chosen. In other words, everything that can be simulated on digital computers must be subjected to this so-called sequentialization.[102] While, in nature, one assumes continuous development, in the computer one must first proceed analytically:

> For events that take place in one time point (thus without temporal extension), taking the temporal sequence into account poses no difficulty, at most that with simultaneity of two or more such events, this cannot be depicted strictly, but instead one event after the other can be simulated; the appearance of simultaneity is preserved when the simulation clock remains unchanged until all these events have been depicted. For events with temporal extension, however ... it is often the case that multiple events are temporally interlocking. ... A way out of this is to divide such events into partial events that then can be simulated without having to set back the simulation clock.[103]

The simulation clock indicates the interval of time that has passed (which means the step in which the calculation is actualized). The next round of calculation can be initiated by various methods. Either one follows a clock that measures the iteration according to homogeneous time steps or one chooses an event-based trigger. The latter case is referred to as "event-driven simulation." Here, the next round of calculation is initiated as soon as a previously determined condition—for example, reaching a threshold value—has been met. The first case may be seen as a special manifestation of the second.[104] Hence, when the impulse for a new action occurs regularly, this is analogous to the functioning of film projection equipment that employs a stereotypical segmentation independent of the content being shown. When, in the second case, the impulse is related to the content or intention, this is similar to the functioning of the human apparatus of cognition, at least in Bergson's understanding:[105]

> According to Bergson, the intellect does not consider the entire flow of movement, but the mind is carried immediately to the end, that is to say, to the schematic and simplified vision of the act supposed accomplished. Then ... the appropriate movements come of themselves to fill out the plan, drawn in some way by the void of its gaps. The intellect, then, only represents ends to attain, that is to say, points of rest in our activity. And, from one end attained to another end attained, our activity is carried out by a series of leaps, during which our consciousness is turned away as much as possible from the movement going on, to regard only the anticipated image of the movement accomplished.[106]

This requires that one also regard the environment as unmoving. "In order that our activity may leap from *act* to *act,* it is necessary that matter should pass from *state* to *state,* for it is only into a state of the material world that action can fit a result, so as to be accomplished. But is it thus that matter presents itself?"[107]

Probably not. Rather, it can be assumed that the intellect is highly selective. Here, too, Bergson recognizes a strategy that provides a suitable description of the "artifice" of simulations. For the mathematical modeling of all living things, that is, for nonequilibrium thermodynamics, it is the case that only end states are teleologically aimed at, while transience (phase transitions) is not defined. Bergson was familiar with the discussions surrounding thermodynamics in his time and the scientific procedure then current, namely to disregard transitions and consider only end states. This approach also inscribes itself in the format of dynamic simulation. In both the purely computational and the iconic aspect of the simulation, there are orientation points between which movement is handled only summarily.[108] Hence, the movement that is shown is one that is constructed out of states but itself never achieves movement. Bergson's critique of the natural-scientific concept of time that has no "duration" has not lost any validity here.[109]

2.4.3 On the Mode of Communication

The determination of the threshold value in event-based simulations takes place through repeated queries made within the computer. We thus arrive at the third and last point of criticism to be discussed here. For Baudrillard, "the question/answer cell operates like the cybernetic atom of *signification*."[110] He writes, "We live in a *referendum* mode precisely because there is no longer any *referential*. Every sign and every message ... is presented to us as a question/answer."[111] Any discourse is dismembered through the translation of all problems into a play of question and answer. In addition, this play affects our attitude of reception in that "we live less as users than as readers and selectors, reading cells"[112] and we follow previously given, stereotypical reaction mechanisms. How different this harsh characterization is from the euphoric hymns to interactivity that can be found fifteen years later!

In fact, the input/output mode with which a plethora of information is exchanged and processed is one of the central mechanisms of systems. This does not remain free from paradox as soon as these systems are intended to represent organisms. The neurobiologist Humberto Maturana, for example—famous for his idea of autopoiesis as the characteristic organizational feature of living things—is critical of the application of the cybernetic or information-theoretical input/output model to living creatures because many of the prerequisites thus implied, such as an isomorphism between sender and receiver, are not given. According to Maturana, there is no "input" in the sense of information being deposited in the receiving creature. One can never dictate what happens inside a living creature through an interaction with it; one can only induce changes that are determined individually by the structure itself.[113] With his critique, Maturana fundamentally confirms that the world is not how cybernetics makes it appear, that the numeric treatment of the object of examination is (also) a perspectivation and isolation of particular aspects; in sum, the installation of black boxes with input/output behavior.[114] After his critique, he then proposes another description,

which does refine existing approaches but fundamentally meets exactly the same criteria as the systems perspectivation.

The systems theory approach allows an interesting idea of nature to filter through. The technology scholar Jutta Weber writes, "Nature is a diverse, multiple subject, which is in a state of constant motion, is uncontrollable, makes emergent leaps that are completely unpredictable, if reconstructable—and that can be provoked. ... And in this way nature can be, in a constructive manner, alive and self-determining, and at the same time calculable and instrumentalizable, in artificial media, because one assumes that nature always arranges itself according to similar principles or simple rules, in logical patterns and orders."[115] Although Weber's description is satirical, this transference of a technical understanding to the realm of nature is frequently encountered. Thus, for example, in the programmatic statements of the founding father of the research branch of artificial life, Christopher Langton, "Living systems are highly distributed, and quite massively parallel. If our models are to be true to life, they must also be highly distributed and quite massively parallel."[116] From his perspective, broadly speaking, the secret of life is located not in the matter but in the form, that is, the organization of matter.[117] Organization is the systems perspective's special domain. With it and the computer as an executive generator of behavior, re-creations, depictions, or projections (Ab-, Nach,- oder Vorbildungen) can be realized. The constructive aspect is thereby quite pronounced and projections are by no means rare. "The objective is 'to get nature up and running,' to furnish it with its own laws, to arrange the self-organization ascribed to it according to its own purposes and goals—but in any case, to make it fungible."[118] Emphasis is given here to the constructive aspect of simulations as well as to a special approach to that which is subject to depiction. A special description of this special approach is provided by the artist and "zoosystematician" Louis Bec. He distinguishes three symptomatic gestures whereby the living is commandeered: the gesture of forcing down the living, the gesture of filling up the living, and the gesture of attempting to activate models of the living. We will devote ourselves to the first gesture, which already includes the other two. Here is a longer passage from one of his fabulistic, sometimes ironic texts:

> *The gesture of the forcing down, of the flattening of the living consists in pulling off its skin, putting it on show, and reading in the inflicted traces the confluence of two worlds: the *revealed* and the *hidden*. *... This gesture also allows exploring the environment that is expressed on this skin, as well as the inner organic material that finds channels of communication with this environment across the skin. *The crushing, the flattening of the living consists in establishing a frame of intervention, determining a support or an area, making an ideology prevail through violence, measuring and fixing a part of the world, setting up a stockade, a reserve, or a national park, in order to capture and control the fleeting passage of the living into this area.

And further,

> *The support is also the site of representation of the complexity of the living material ... [as well as] the site of the practicing of gesturality, of the concrete seizing upon elements available in the mem-

ory of the one who makes the models. It is thus the site of seismographic inscription of the living, of graphic materialization of the nervous and muscular systems. It involves a gesture that solidaritizes with the organic, but can express the temperament or psychology of the modeling/acting agent. *It is thus the site of the artistic *par excellence*.[119]

The remarks in the following chapter take up this idea of the artistic.

2.5 Perspective and Schematism

Perspicere / means ... / looking through / or looking mightily / whence this art Perspectiva / must first of all be fathomed with the deepest thoughts (before a person becomes full and comprehensible of it). Now, who thinks deeply / also sees sharply / and therefore this art rightly merits the name / Perspectiva.[120]

—Hieronymus Rodler

2.5.1 Procedure

At the start of this section, it is our intention once more to clarify what the comparison with central perspective can give us for the analysis of simulations. We understand perspective as an established procedure of image production:

Based on a copious scientific body of literature, we as a rule associate perspective construction with painting, or the image. Now we are prompted to make a correction, or rather a refinement, of this assumption. Mathematical central perspective is first and foremost a procedure that *makes images possible without itself being an image*. It forms an entirely new kind of medium. Artists very quickly began to make both fascinated and reflective use of it, which involved the situation that only certain characteristics of perspective construction were activated in the image, and others not. *Perspective as a procedure and medium* and *the perspectival image* hence denote very different things. First of all, the perspectival procedure of depiction does not intend a particular image, but rather a possibility that is suited for many tasks of depiction.[121]

Thus, central perspective is designated an "imaging procedure." As has already been suggested, a systemic approach can be applied in many more types of situations than those under discussion here. We have limited ourselves to its implementation in computer simulations. If it is imperative here to differentiate between the perspectivation as the elaboration of guidelines for an infinite number of presentations, on one hand, and the specific, perspectivally constructed presentations, on the other hand, then the former is the systems perspective and the latter is simulation.

2.5.2 Schema

The perspective is not identical with the image itself, but it is inherent to the image, in that it—as a device that lies between surface and reference—designs the manner in which what is presented is brought into view. The rule of presentation is

itself invisible, but guides the emergence of something visible, of a present view [*Ansicht*], in a sub-terranean manner. Kant, referring to rhetorical terminology, therefore called it a "schema" and associated it with the image. He also utilized the rhetorical term "hypotyposis," which literally means "design, outline, fundamental feature [*Grundzug*]" or also "what is underlying." In short, the schema/rule is itself not an image, but it underlies the image in a controlling manner. The verb "to control" is itself not unimportant, since it indicates that we are dealing with a process. In fact, without this transfer, without the transition from the actual to the effect, without this act, then the present view [*Angesichtigkeit*], that is, an image, would never be manifest. By its structure it is not reality, but the realized.[122]

The schema as the manner of creating a view (imaging) is a procedure, and as such "always an action that requires direction."[123] However, one should keep in mind that the sequence of operations and temporality of this procedure are not to be confused with the shown, time-based sequence of operations of the presentation (the simulation).

The schema as rule embodies a general mode of how something must look, or, for dynamic presentations, at times also how something must proceed. With simulations, something happens. It does not simply come to pass but follows on a basic level an implemented conception of becoming as movement. The schema organizes and serves as the means for particular operations of mathematical management of phenomena. The longer one lets the simulation run, and the more attentively and precisely one observes (*perspicet*) the proceedings, the more particularities one will be able to recognize that inscribe themselves and produce effects in what is presented. These particularities have their starting point in the schematic regulation. In the case of computer simulations, they can be designated as the functional mode of a (cybernetic) system. With each example of simulation, the rule is manifest only indirectly in the manner of its control. This directional aspect lies on a more general plane than the concrete model that forms the particular example, the concrete composition. Each simulation can be examined for this rule that glimmers through it. Where is there evidence of the system in the role of perspectivation as schema? "The rule is represented in the 'how' of its regulating, i.e., in how, in regulating the presentation, it inscribes itself into the presenting view."[124] One thus inquires into the manner of a system or, more broadly, a systemic formation, through the individual expression. This means that one schema—according to the basic ideas of the philosopher Immanuel Kant—can characterize a multitude of possible images. It does not correspond to the singular composition standing directly before one's eyes but rather offers a rule for the creation of a view. The schema can have a unifying effect in that it spans the entire complex (or, at least, large enough parts for it to be recognizable as a rule). It can form one unity for many, a "unity which applies to many," as the philosopher Martin Heidegger calls it, a "unity of the synthesis of the manifold of a homogenous intuition in general,"[125] according to Kant.

Once one has recognized the schema, much on the phenomenal level will prove justifiable and will gain plausibility on account of this framework, which itself remains obscured. But how can it be recognized? As might be expected, simple guidelines are not to be had.

The schema of the schema could be the regimentation, and in order to detect the latter, it is helpful to look with two different eyes. The film theorist Raymond Bellour points in this direction:

> By programming limited segments of nature, thus opening an access to the invisible, and by recording this invisibility in the collected time of natural vision, such images show that the computer image proposes the following paradox: *a virtual analogy*. In other words, an image that becomes actual and therefore real for eyesight to the extent that it is, above all, real for the spirit, in an optics which, in the long run, is fairly close to what happened when perspective was invented, unless it is precisely the optics that is relativized. The eye becomes secondary with respect to the spirit that contemplates it and asks the eye to believe it.[126]

The intellect, so Bellour can be interpreted, is above all devoted to understanding the model or an even more general substrate. With simulations, this occurs through observing the dynamic. One looks simultaneously with a sensory and a theoretical eye, whereby the latter tends to focus on what lies beneath. One must engage with the works for a long time if one wants to recognize the hidden but omnipresent armature. It is imperative to comprehend the invisible but fundamentally reconstructable topology behind the image in order to see how the image functions, which design decisions have to be ascribed to the perspective, that is, the schema. Despite the central role that the schema plays in the design, it should be noted that it describes only one particular level of the iconic structure. We agree with Jacques Lafon's statement that the iconicity has by no means been comprehended when consideration is given to the perspectival construction alone:

> Speculations about the model were already made by the first researchers; they brought the discourse into proximity with the image, far from the sensory. To think that just because the synthesis image [*image de synthèse*] consists of basic building blocks (bits, pixels, grids, models ...), its analysis would be that of a construction, a rational combinatorics of form, is to forsake the quality of the image. ... Likewise, central perspective can be understood as a theory of construction whose building blocks are the point (point of view, vanishing point, conic section point ...) the line (visual ray, vector ...), etc. ... It makes certain visual conceptions comprehensible, but cannot easily render what the image conveys to the intellect and, gives little indication of what it offers to sensibility.[127]

2.6 Systems Aesthetics

In an era that is dominated by real-time technologies, no approach to "real-time" art or, for that matter, to any art can be developed without paying tribute to the work of the critic and theorist Jack Burnham.[128] This assertion comes at the head of the artist and theorist Charlie Gere's essay "Jack Burnham and the Work of Art in the Age of Real Time Systems," whose title, alluding to the famous essay by the philosopher Walter Benjamin, also aspires to set a milestone. Burnham's contribution that is most of interest to us here is his development of basic features of a systems aesthetics.[129] As early as the late 1960s, he recognized that art

was experiencing the cultivation of a transition from object-oriented to systems-oriented approaches: the focus of attention was no longer on material objects but rather on how things are constructed and how they happen; not the entity in its form but, rather, the entity in its relationships was now the topic of interest.[130] Hence, problems of organization became central. Burnham drew his ideas not least from those disciplines that could be termed "sciences of organization": cybernetics and systems theory.[131] The kind of organization, as well as the types of elements that are supplied to this organization, comprise the perspectivation or schematization. The individual compositions that build on this perspectivation, and thereby emphasize relationships, have as their "end product" (if there can be considered to be such a thing)[132] nothing that is primarily visual.[133] Rather, in Burnham's view, a constant, mutual exchange of information was becoming the normative goal of aesthetic experience.[134] According to Burnham, systems aesthetics is not based on a "visual syntax"; instead, it makes itself perceivable through the principles that effect a continual reorganization.[135] Like a demiurge, one first designs the conditions of production for something that in its concreteness is yet unformulated. This means that one is first of all engaged in a *"théâtre d'opérations,"*[136] which is to say that computer simulations are calculations first and foremost. The results that are produced are numerical values, which logically are also made accessible. But they do not necessarily pertain to optical qualities. Therefore, iconization must ensue, as well as—particularly with works that have the capacity to be interactive in real time—the implementation of visualization concepts from our sphere of experience, since the viewer is supposed to be able to understand and react immediately to what is offered. One must present the proceedings "as such" for this purpose. As long as one is not showing the simulation results instantaneously, one need not struggle to come up with a design for the dynamic to be shown that incorporates the numerical values provided by the simulation as well as taking the viewer's needs and capacities into account. The task of developing images under these conditions—in the frame of simulations—is complex. These images should not be reduced to an "exclusive explanation of what has been formulated in logic,"[137] that is, in programming.

A central area of investigation revolves around the question of where the iconic resides when simulations recreate processes. How can the relationship between the simulation and its taking on form for the sake of perception be described? What is the iconic based on when simulations are sensorialized? Or to put the question the opposite way, how is simulation processuality manifest? Real-time simulations form dynamics. The latter are then once again subject to a transformation into spatial forms. But the result of this double forming is crucial for interpretation or, as the case may be, interaction. Thus, the sensorialization is central, since it is the only foundation for one's actions. Our objective is to describe the conditions of design and investigate possibilities, characteristics, and achievements of iconicity in the frame of interactive real-time computer simulations.

In examining simulations, it is helpful to be aware of the systems perspectivism of the dynamic. This forms the basis from which the nature of the relationship to aspects of the sensorialization can be conceived. The simulation dynamic, which is formed through mutual influences, is first of all aniconic—here, we agree with Burnham. But we are interested in the interplay of simulation and sensorialization, with the emphasis on the latter. Points of reference for this are revealed in the next chapter considering model theory, which is oriented to the philosophy of science. In a second step, which we undertake in chapter 5, some facets of design are addressed that result from this nexus. It becomes clear that the sensory means that are employed, in harmony or dissonance—in any case, with various attitudes—to the perspectivation, establish other levels of showing.

3 Modeling and Iconization

3.1 On the Position and Role of Models

In order to approach the relationship between dynamic and iconization, it is illuminating to engage with types of models. Models on the one hand define the simulation dynamic, and on the other hand, they fall within a tradition of particular practices of intensive analysis and manipulation. Both aspects—movement and movability or manipulability—are among the essential characteristics of interactive real-time simulations, and their sensorialization inherits some of its features from different types of models. It becomes apparent that the sensorialization of simulations plays a central role in the process of knowledge generation. This is demonstrated through consulting positions on model theory within the philosophy of science.

First, we discuss where a model is located in the case of digital images. The model should be distinguished from the code, even though mathematical models are of course coded. We use the term *code* wherever a machine generates the character set and the resulting description is oriented more to the software packages being used than to the imperative to be user friendly. Conversely, in our view, *models* have content that can be interpreted by humans, so that changes in values, for instance, can be attributed to a component of what is being modeled in a comprehensible way.

3.1.1 The Second Side of the Digital Image

If one reads the literature on the digital image, in the implicit opposition to the "analog image," a bifurcation is often introduced as a new feature, which not least is grounded on a technical level: "In effect, computer images are always simultaneously binary code and manifestation of the screen; their 'immaterial code' is itself not perceivable."[1] The Germanist

Horst Wenzel refers in this location to the computer scientist Gernot Grube, according to whom a computer image is at once an image *and* a piece of writing.[2] In the computer, the image becomes the "doubled image-&-text." This means "that the image component is calculated, while the text component is the calculating entity."[3] In an even earlier essay—with reference to the graphical interface Sketchpad, developed by the computer graphics pioneer Ivan Sutherland in 1963—the computer artist Frieder Nake characterized the drawing on the computer as doubled: "It exists as a *visible* complex of lines on the computer screen and to this extent is analogous to the drawing on paper; but also—indeed, even above all—it exists as an *invisible* model in the computer's memory."[4] The invisible side of the computer image is, according to Nake, an executable description (of the visible). "Generally kept hidden, invisible, the image thus contains conditions that its complex of lines has to fulfill: the description of the image enters into the image itself."[5] That which is to be viewed on the computer screen must also be defined exactly as it is to appear in order to be shown in that way: somewhere the image's code is located, with which the image "is univocally connected in every detail."[6] Grube also notes, "The 'mapping' between the manifestation on the screen and the Turing machine is, mathematically speaking, bijective, which means we always go from this Turing machine to this image and vice versa. It looks as though the digital image leads a double existence, on the one hand as the manifestation on the screen and on the other hand as the character set. The manifestation and the storage of the image diverge. They have a double nature."[7]

In principle, one can endorse the idea that is frequently put forward: that with digital images, both the visible "surface" (*Oberfläche*) and the "underside" (*Unterfläche*), the manipulable part that lies below the surface,[8] need to be taken into account. However, this assumption of a correspondence between the existence of saved image data (the "underside") and its visually perceivable output on the monitor (the "surface") requires that one first of all remain on a technical/medial viewer's level—that one preferably begin with an end product and pay no attention to the many processes that happen in between and the entities that have an influence on what is perceivable.

At this point, it is sufficient to give a basic indication of the ineluctable technical prerequisites and mechanisms (ranging from binary code to the screen-refresh frequency) that enable an image, howsoever generated, to appear on the monitor. This movement of continual updating on the monitor is indispensable for robust perception and is of less interest to us here. It is worthwhile, however, to look at the individual steps of production, so as in reverse to be able to recognize possibilities for intervention in the generation and design of a digital image. Grube's statement leads us in this direction: "When we analyze these images, we first go from their appearance on the screen to a data or character set 'inside' the computer, and in a second step, we go to the programs, also character strings, that transform the data or character sets into images on the monitor. In a third step, we come upon the programs that generate the data or character strings from which other programs generate the images."[9]

Thus, as soon as one looks more closely at the underside, the relationship becomes more complex, as Nake and the media educator Susanne Grabowski suggest in cases of

algorithmically defined images. Here, they no longer assume a simple topos of doubling, but rather speak of the (quite material) multiple existence of the image. In their description, a computer drawing printed in ink on paper is likewise "multiply doubled," whereby the different forms of its being relate to one another in terms of generalization or specialization. Thus, the program punch tape provides the description of a class of drawings, whereas the control punch tape establishes a particular member of this class by making a selection of concrete parameter values. When we get to the next step of image output—for instance, via a plotter—additional aspects have been decided, such as the type of paper and the color, as well as the line width of the concrete drawing implements.[10] The same is fundamentally true for output on a screen. From this perspective, the *Unterfläche*, or underside, unfolds into many undersides; the singular form is only capable of marking the "other" of the *Oberfläche*, the surface. Where there are many steps in the technical implementation, there are also potentially many levels of possibility for intervention.[11]

With the focus on production, in this chapter we are concerned with the motif-related, intended conceptions of what is presented. But first we continue with a simplified description of the methods by which digital images are produced in order to determine, first, where in the design process the following thoughts on calculable models come in and to demarcate, second, in what way the iconic aspect of calculable models differs from that of digital images (as we will now describe it).

Beyond the use of recording devices (e.g., cameras, scanners), digital images can be created in various ways. Here, we concern ourselves with three possibilities.[12] The first consists of using graphics software (see figure 3.1a). The program performs the task of generating a machine-legible coded counterpart to the image created by the user, who in the act of creating the image is oriented to visibility. Through actions with the interface "we simultaneously tell the processor to construct a hidden model."[13] Hence, in this case, the code is only indirectly produced by the user of the graphics software. The user need not have any understanding of the code's structure, since the code is automatically supplied by the program and is not designed for interpretation by the user. The user works directly with the content on the level of the visible. This does not fundamentally change with the second possibility, in which the producer's gestures no longer immediately correlate with the result. Here, more specifically, the definitional origin of the image is shifted into a type of command (generally formalized in writing), which is then executed, and the image that has been induced is shown (see figure 3.1b). Ultimately the user determines the executable model (the image file) "more abstractly," in other words, not on the surface—not within the two-dimensional order. In the production process, through the repeated execution of the file, the user checks the results of her or his actions in the image that appears on the monitor. In the third possibility, unlike in the first two, a single, particular image is not formulated down to the last detail of its appearance; instead, the user writes an executable program. In this conception, the user thus creates a generative matrix in a programming environment, specifying only the "contours" within which specific "forms" are concretized. Figure 3.1c is intended to show that the programmer has for the time being concluded the conception stage (in front of him is the printout

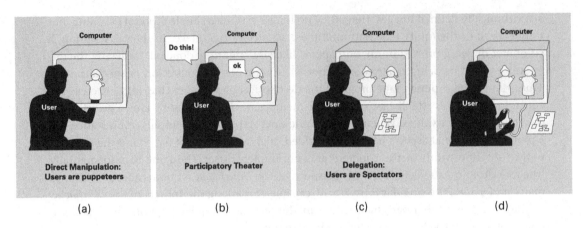

(a) (b) (c) (d)

Figure 3.1
Variants of user interaction with computer contents. (a) Direct manipulation. The user determines right on the surface what will be seen. (b) The user gives (computer) commands in order to determine how something will look. (c) The user has in front of him or her a flow diagram as a hard copy of the written program and surveys the result on the monitor. (d) The user has programmed an interactive simulation scenario and intervenes in it via an input device. Source: Michael Hübner.

of the program code in the form a flow diagram) and is observing the execution of the model.

In contrast to the first case, where graphics programs, which enable control of individual pixels, seem quasi-universal, neutral, or open with respect to what one would like to present, like a white sheet of paper with respect to something two-dimensional,[14] here the model—the delimited conditions—is understood as the entity that bears on the content of what is presented. In the sense of a potentiality, it forms or organizes the manifestation along semantically charged pathways. The created "forms" may vary according to the manner of calculation or through built-in variables.

An example of the last variant can be found in three programs developed at ETH Zurich in the Computer Vision Laboratory to make "virtual" myomas and polyps "grow."[15] Figure 3.2 shows, from left to right, temporally successively viewable stages of growth in the artificial morphogenetic process of a myoma. Student doctors practicing on a medical hysteroscopy simulator then remove the mature formations. An extensive discussion of this simulator will follow later. At this point, we are interested only in the pathology design. Different methods are tested in order to yield the desired spectrum of macroscopic forms, and simultaneously to achieve (through each of the applications) a large variety of slightly different forms without their having to be individually fabricated by hand every time. A skeleton-based design[16] (figure 3.3), a cellular automaton[17] (figure 3.4; see figure 3.2), and a particle system[18] (figure 3.5) are implemented.

Figure 3.2
Four "stages of growth" of a "virtual" myoma after 15, 25, 35, and 43 iterations. Source: ETH Zürich/ Computer Vision Laboratory. Sierra, Székely, and Bajka, "Generation of Pathologies," 208. Kindly made available by Matthias Harders, Institute of Image Processing, ETH Zürich. Reprinted with permission of Springer.

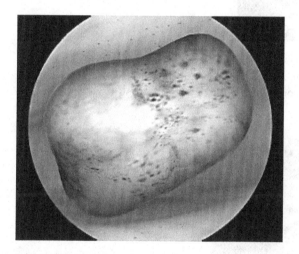

Figure 3.3
A polyp created with a skeleton-based design, 2003. Source: ETH Zürich/Computer Vision Laboratory. Sierra, Bajka, and Székely, "Pathology Design for Surgical Training Simulators," 383. Reprinted with permission of Springer.

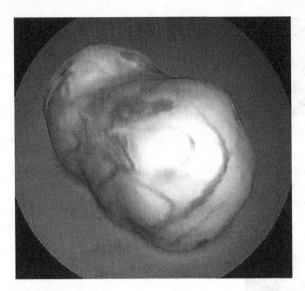

Figure 3.4
A pathology created with a cellular automaton, 2002. Source: ETH Zürich/Computer Vision Laboratory. Sierra, Székely, and Bajka, "Generation of Pathologies," 208. Reprinted with permission of Springer.

Figure 3.5
A polyp created by means of a particle system, 2003. Source: ETH Zürich/Computer Vision Laboratory. Sierra, Bajka, and Székely, "Pathology Growth Model Based on Particles," 31. Reprinted with permission of Springer.

As we see from the examples, not any random form can be concretely produced with these programs. This is also not desirable, since the intention is only to permit such formations as are plausible for the anticipated purpose: in this case, those that externally resemble tumors such as typically appear in a uterus. Whether and to what extent the individual results of calculation of such generative programs resemble each other depends on the procedures and the available selection of design media. The same is true for two-dimensional design, which is often referred to under the heading "generative graphics software."

By analogy, we now transfer this concept from computer graphics to computer dynamics and speak of "generative dynamics software," meaning simulation models. It is evident that their relationship to the artifact that is put on view is qualitatively different from that in the case of generative graphics software, since what is designed is first and foremost a processual construct, to which something sensorially perceptible is appended. In order to be able to discuss this aspect more extensively in section 3.2, "Semiautonomous Iconization," we now undertake an excursus into the discussion of models within the philosophy of science. In doing so, we establish two things: which types of models will concern us in the frame of simulations and where it is that a blind spot in the scholarly debates prompts our own involvement.

Since the 1990s, philosophers of science have indicated that the creation of a calculable model is a complex process, requiring many instances of testing, verification, and expansion. The contents of the model are subject to numerous assessments, which have a determining effect. A focus on the design of conceptual aspects reveals multiple consecutive steps with essential modifications made at each one. Of course, these modeling steps in the production process should not be confused with the previously mentioned steps in execution, by which an image is made to appear in an output medium.

We now describe the role of models from the perspective of the philosophy of science. These remarks serve to identify the role conferred to models in knowledge production. In addition, a current assessment of concepts of models also allows us to position our discussion of the iconization of models in execution.

3.1.2 Models in the Philosophy of Science

Without intending to present even an approximation of the ramified landscape of discussion on models in the philosophy of science, we will at least provide a couple of highlights, against the background of which our analysis of iconization can then begin. Normally the positions in the philosophy of science that are concerned with models place them in relationship to theory and phenomenon.

The concept of the model was unappreciated until the 1950s, when the act of the thinking process in the sciences was first recognized as a legitimate object of epistemology.[19] At this time, the so-called semantic approach replaced the syntactic approach. While the latter marginalizes the role of the model in relation to theory, a transition was then made to characterizing theory by means of models. The view became predominant that models provide the

interpretations of axioms and should be conceived as nonlinguistic entities. In addition, they entered into view as central components of scientific theorization, so that the idea gained favor that theories should be understood as an accumulation of models. Accordingly, all models are models of theories.[20] Exponents of the semantic approach use the model concept to refer to its structure, which has the effect that the relationship between models and reality is seen as structural.[21] When one presents a theory by identifying a class of structures as its models, the result is that the language in which the theory is expressed is no longer critical. One can describe models in different "languages."[22]

Against these semantically oriented positions, it was contended, first, that there are models that are not primarily of a theoretical origin,[23] and thus, according to the argument, this approach is not capable of grasping the entire diversity of models. Second, an inadequate linkage was diagnosed between reflections in the philosophy of science and the everyday world of scientific research, which ought to be taken into account. For example, it could not be explained how models are produced and how they function.[24] Precisely these aspects— model building and function—have been the center of interest for more contemporary positions. Since the 1990s, many philosophers and sociologists of science have been looking into laboratories in order to set aside the view of models as representations of theoretical constructs that stand behind them and emphasize their own domain and role in the research process. Thus, models are in a position to produce self-evidence through making more specific reference to the object of investigation, according to philosopher of science Nancy Cartwright. Theories, by contrast, refer to abstract concepts, which at best designate capacities or tendencies of systems that fall under the heading of these concepts. Cartwright sees parallels in the relationship between "theories" or scientific laws and "models" (in physics), on one hand, and that between "morals" and simpler "fables," as the poet Gotthold Ephraim Lessing develops in his essay on fables (1759), on the other hand.[25] In keeping with our following simulation example, Cartwright cites an aphorism from Lessing: "The weaker are always prey to the stronger." This type of abstract statement is furnished or fitted out in fables. In Cartwright's own words, "Abstract concepts … need fitting out in more concrete form,"[26] since, according to Lessing, "the general only exists in the particular and can only become graphic (*anschauend*) in the particular."[27] In this way, she underlines models' capacity for showing.

Increasingly, aspects of modeling are entering the foreground of the scholarly discourse on models. There is no rule of thumb, no mechanical action or algorithm for making the specifications of theory into a usable model. Or, in a popular saying from the philosophy of science, theory does not act like a vending machine, dispensing suitable models at the press of button.[28] On the contrary, model building often proves to be a laborious process with much trial and error and considerable scratching of the head. One wonders how objects (models) nevertheless are able to represent a phenomenon scientifically. Their frequent characterization as inexact, incomplete, and inconsistent often marginalizes models as pure heuristic aids.[29] If they were only this, models would not need to show anything about how things behave with respect to what is being modeled. To many, this is too weak a concept.

Hence, the idea of representation is emphasized in order to comprehend that models of phenomena act or stand for phenomena. Among the earliest exponents of representation are the analytic philosopher Max Black and the logician Leo Apostel.[30] For them, the central aspect of iconic, analogue, theoretical, or scale models consists in their representational role, which is a product of their "unfaithfulness."

By enriching the scientific concept of representation with pragmatic aspects, the philosophers of science Ronald Giere and Mauricio Suárez take a clearly different stance. They postulate a relationship between model and modeled not on the basis of incompleteness or similarity but, rather, on the basis of their use by scientists.

Suárez finds fault with the semantic approach in that between model and phenomenon, an external connection, such as isomorphism, must be introduced. In his understanding, the representational connection is already inherent in models, in their anticipated use. "When a model is presented, its intended use is given by implicit or explicit reference to the object of its application. Thus, from a historical point of view, a model is a representation, as it is essentially intended for some phenomenon; its intended use is not an external relation that we can choose to add to the model, but an essential part of the model itself."[31]

If the model is to be a representation, then, according to Suárez, it must be conceived as a heterogeneous combination of a mathematical or physical object (a structure or a structure-object) with an intended use.[32] In Giere's equally influential, though at first glance unassuming, formulation, scientists use models to represent aspects of the world for various purposes. He clarifies this statement by asking the crucial questions himself:

> How do scientists use models to represent aspects of the world? What is it about models that makes it possible to use them in this way? One way, perhaps the most important way, but probably not the only way, is by exploiting similarities between a model and that aspect of the world it is being used to represent. Note that I am not saying that the model itself represents an aspect of the world because it is similar to that aspect. There is no such representational relationship. Anything is similar to anything else in countless respects, but not anything represents anything else. It is not the model that is doing the representing; it is the scientist using the model who is doing the representing.[33]

Although he underscores what he would like to say, questions remain open. In any event, it is apparent that intentionality and action play a role. Based on the standpoint of pragmatics, we can pose the following thesis for ourselves: when representations are made through the use of models, the iconic aspect is central.

Furthermore, it becomes clear that models are used to act on themselves. They thus possess a presentational capacity as well as an instrumental component. It could even be said—according to the science theorist Margaret Morrison—that the instrumental/enabling aspect of models presupposes their autonomy with respect to theory: their partial autonomy results from their function in knowledge production; they are not only recognizable from their elements and the manner of their construction but also from how the models function.[34] How are models supposed to be able to test theories, in a scientific sense, if they constitute

them as parts? In fact, this view articulates the active, designing role of models, which can be confirmed through a look at the everyday world of scientists. In the foreword to the widely received book *Models as Mediators*, Morrison writes together with her coeditor Mary Morgan that precisely because of their partial independence—from theories as well as from the world—models can be used as instruments to examine these very realms.[35] They are instruments for producing representations in the form of simulations.[36] Morrison and Morgan continue that when we use or work on a model, its power as a technology becomes evident: we take advantage of its characteristics (partial independence, functional autonomy, and representation) in order to learn something with it through its manipulation.[37] The simulation theorist Eric Winsberg follows Morrison and Morgan to a large extent, but insists on the word *semiautonomous*. According to Winsberg, models generally involve a good amount of the theories with which they are connected. What's more, they normally derive elements—through allusion, inspiration, utilization of materials—from an astonishingly broad palette of sources: these range from empirical data, to mechanical models, to calculation techniques (be they precise or "outrageously inexact"), to metaphors, to intuitions. But consequently to regard models as completely "independent" means in this context to belie their strong connection to theory.[38]

Cartwright concurs with Morrison: theories are not constitutive for models, since the latter occupy a mediating position between theory and phenomena.[39] In referring to both, Winsberg calls for a differentiated view of the model concept. In his opinion, the dismissal of the "semantic" approach (theories are families of models) through Morrison's position (models mediate between theory and empiricism and therefore lie outside of theory) is overly hasty. The seeming irreconcilability of these approaches is a product of confusing two different conceptions of models.[40] Therefore Winsberg proposes taking a closer look at what happens in the modeling process in the daily lives of scientists in order to point out the misunderstanding, as well as the compatibility of these positions (which need not concern us in the following), and to take into view the epistemological potential of every step in the process. The latter directive is of crucial importance to us as well.

3.1.3 The Implemented Model as Referent

Let us now turn to the creation of a simulation model. The *Brockhaus Encyclopedia*, 2003 edition, states: "The development of a simulation begins with the construction of a simulation model, which reflects the essential characteristics of the processes to be simulated and their interactions. ... All the results of a simulation only refer to the underlying model."[41]

It is not theories that are calculated in computers but models. These have to meet many requirements, including theoretical hypotheses. In evaluating the results of calculation, models provide the frame of reference. These specific models are the variants that are implementable in a computer program. They are generally not arrived at directly, but rather through a more lengthy process. Such models often take their basis in theories, but this is not mandatory. Until a simulation can be executed, there are as a rule multiple modeling

stages that build on each other. At times there is a large difference between the theoretically conceived model, in the sense of its hypotheses, and the one that is ultimately calculable.

The philosophers of science Johannes Lenhard and Günter Küppers point out that there is no strict relationship of derivation between a physical/mathematical model and a simulation model. Rather, a certain amount of latitude exists for the creation of simulation models. The two authors emphasize the potential autonomy of models: this is a fundamental aspect of the simulation model because the latter cannot be reduced to purely numerical calculation. Models do not provide a realistic portrayal of the dynamic of existing theoretical hypotheses and are based "entirely counterintuitively upon artificial, physically unmotivated postulates."[42] In order to emphasize these liberties of the processable simulation model as opposed to the base equations, the former should be understood as "second-order modelings" in the sense of an iterated model building.

Winsberg does not present a two-stage sequence of model generation, but rather, in the terminology of Küppers und Lenhard, would probably speak of additional gradations of order. He attempts to distinguish and name different steps of modeling. In his opinion, the individual steps must not be left out of account, since each is an instance of knowledge generation. Computer simulations involve a complex chain of deductions, which on all levels are based on elaborated modeling praxes. These, for their own part, serve to reshape the initial theoretical model into one that is designed to place a representation of the given behavior of a physical system at scientists' disposal: "It is one thing for theory to directly yield a model, and quite another for theory to be able to yield a model for which we can find solutions. ... Successful numerical methods, therefore, invariably require of the simulationists that they transform the model suggested by theory in significant ways. Idealizations, approximations, and even self-conscious falsifications are introduced into the model."[43]

The linchpin of simulation, according to Winsberg, lies in the construction of an entire hierarchy of models (figure 3.6).[44] First, the theory must be articulated by its being related to a real system. This happens in the mechanical model (also called the theoretical model). This in turn is tailored to a particular realm of phenomena through the specification of parameters, boundary values, and initial data, thus becoming a concrete dynamic model. In cases with analytical insolubility—and these are particularly interesting for simulations (numerical executions)—the dynamic model must be subject to another transformation, that is, it must be converted into an executable model. Winsberg presents another step, ad hoc modeling: this generally implies simplifications that serve to make the calculable model easier to manage. In the event that the model is formulated as a definite algorithm, it can be executed. It generally produces a large number of data that have to be interpreted. This interpretation can happen in many different ways, such as through visualizations, mathematical analyses, or other sources of knowledge. All this leads to the end product of these labors, namely, to a model of the phenomena: "A model of the phenomena is a manifold representation that embodies the relevant knowledge, gathered from all relevant sources, about the phenomena. It can consist of mathematical relations and laws, images, both moving and still, and

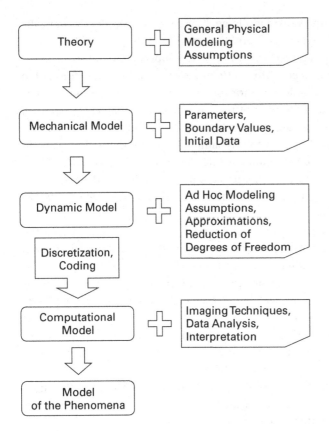

Figure 3.6
Winsberg's hierarchy model of modeling, 1999. Source: Winsberg, "The Hierarchy of Models in Simulation," 261. Reprinted with permission of Springer.

textual descriptions."[45] Even if Winsberg's diagram may suggest another interpretation, this statement should be taken as a summary in which, by way of conclusion, the theorist lists everything that has already gone into every stage of the modeling process, rather than as an exclusive characterization of the final instance of modeling.[46]

Apart from the fact that model building in detail also occurs in successive steps, one can rightly question whether it is necessary or plausible that all simulation models begin with theories, as Winsberg's sketch suggests. The economist Marcel Boumans, in his diagram of modeling (figure 3.7), places greater emphasis on the parallelism of sources that are consulted or that have some influence and excludes hierarchical assessments. His description of model building resembles a certain approach to baking a cake, in which many ingredients (policy views, metaphors, empirical data, analogies, theoretical notions, mathematical

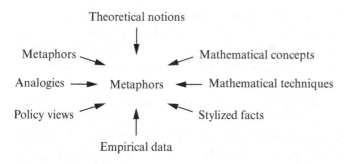

Theoretical notions

Metaphors

Analogies → Metaphors ← Mathematical techniques

Policy views

Empirical data

Mathematical concepts

Stylized facts

Figure 3.7
Boumans's model of modeling, 1999. Source: Boumans, "Built-In-Justification," 93. Reprinted with permission of Cambridge University Press.

concepts and techniques, stylized facts) are available but there is no recipe.[47] With this type of presentation, as with the metaphor of ingredients, Boumans aims for a relativizing of the prominent position that is often granted to theory. For him, models should not be seen as instruments that bridge between theory and phenomenon, since theoretical hypotheses do not comprise a particular point of gravitation, but rather are one ingredient among many. Their integration requires a translation of the disparate elements into something with a compatible form, for instance, in his term "pieces of mathematics." Moreover, they have to be joined together so as to form an equation that can serve as a representation of what is being modeled. According to Boumans (and Winsberg),[48] Cartwright wrongly assumes that theories already specify a mathematical framework. In doing so, she overlooks the entire intermediate step of mathematical modeling.

As important as this is for model theory, for our concerns it suffices to be aware of these modeling steps. We will concentrate on the last stage of the mathematical model: the model that is executed. This last stage, the calculable, mathematical, or procedural model, is crucial for simulation, since the results of the simulation refer to it, at least if one performs the calculation without taking the viewer into account.

3.1.4 Assessments of Iconization in the Context of Simulation

In simulations, these mathematical models are executed. However, the results thus achieved are not automatically illuminating. This is also confirmed by William Kaufmann and Larry Smarr, the authors of the popular book *Supercomputing and the Transformation of Science* (1993). They write, "The numerical solution by itself is of little use. Today's supercomputers are capable of performing one billion arithmetic operations per second, and a typical simulation runs for hours. Even a small portion of the results comprises billions of numbers. No scientist could digest the vast columns of numbers that stream from the computer programs used in simulation were they not transformed into images."[49]

As unanimous as the currently high ranking of the epistemic status of models in the sciences are passages on the "visualization" of calculated results: its relevance appears uncontested. For instance, Küppers and Lenhard write, "Classical procedures of numerical mathematics are implemented as programs in the computer. Through the use of additional visualization software, numerical solutions can then be made visible in their spatio-temporal structure. In this way, computer simulations contribute to a better understanding of complex phenomena."[50]

For the philosopher of science Stephan Hartmann, the visualization of simulation results on the computer screen only has advantages: it is capable of increasing understanding of a system—and more so than complicated formulas on paper ever were.[51] Winsberg also states, "Visualization is by far the most effective means of identifying characteristic features out of complex dynamical data sets, and so it is the most, if not only, effective means of judging the degree of calibration a simulation enjoys with other data sets and with analytical results. Thus visualization plays a crucial role in sanctioning as well as in analyzing simulation results."[52]

The philosopher Paul Humphreys rates the iconic presentation as indispensable and as part of simulation:

> It is partly because of the importance for humans of qualitative features such as these that computer visualizations have become so widely used. ... Yet graphical representations are not simply useful; they are in many cases necessary because of the overwhelming amount of data generated by modern instruments. ... A flight simulator on which pilots are trained would be significantly lacking in its simulation capabilities if the "view" from the "window" was represented in terms of a massive numerical data array. Such data displays in numerical form are impossible for humans to assimilate, whereas the right kind of graphical displays are, perceptually, much easier to understand.[53]

This word choice—they are (not "easy," but only) "easier" to understand—already implies that the iconic presentation should not be regarded as automatically comprehensible.

Its role is thus generally by no means marginalized but rather is considered central to insight, understanding, analysis, evaluation, validation, substantiation, and so forth. The almost ubiquitous emphasis of benefits or indispensability has until now been out of balance with the scanty attention that has been paid to the iconic presentation in a scientifically founded way. It is striking that many philosophers of science who concern themselves with simulations minutely trace the development of models and emphasize their autonomy, but then lose this differentiated view when iconic elements are introduced. In general, no detailed analysis is made of what happens between the processed algorithm and its results in the form of columns of numbers, on one hand, and their iconization, on the other hand. This is the case for the frequently encountered abridging formulations that refer to the "transition" from data (which symbolizes the dynamic and in some instances is made accessible in rows of numbers[54]) to the iconic presentation. The absence of scrutiny often seems to imply the assumption that this transition is automatic or that the semantics remain constant.

Evidently the opinion prevails that the visualization, through other, graphic means, brings into view that which is also contained in the rows of numbers.

Although Winsberg elsewhere devotes himself more extensively to the iconization of simulators,[55] which he explicates using an example from meteorology, with him, too, in the brevity of his descriptions, eliding formulations creep in, such as "images created by simulations" or "direct visualizations of data sets."[56] With Kaufmann and Smarr, one reads of the "transformation" of computer-generated numbers into images on a computer screen;[57] Helmut Neunzert speaks of transmuting calculated numbers into images[58] or of back-translation into real images;[59] Humphreys writes of "convert[ing] numerical results into graphic form" and of "shifting from one representational mode to another";[60] Mark J. P. Wolf refers to it as "translation of the invisible into a visible analog."[61]

These are figures of speech that at least are capable of suggesting how the relationship is envisioned. However, they also imply many things—and what they imply generally remains implicit. But the most common term, *visualization*, hardly takes a position. We have no objection to this as long as one only wants to denote that with available data that serve as the frame of reference, an optical impression is also being offered. Without further specification, however, the term suggests that what is at issue is just a small step and a transparent, simple, almost natural process of transference that does not entail decision making and in the course of which nothing is set in motion. In the context of computer simulations, "visualization" plays the role of a crowning conclusion that is highly useful and (or because it is) necessarily faithful to the data, while its own potential for producing results goes unrecognized. Because of its general application, or, rather, applicability, as well as its tendency to subsume many techniques and approaches, *visualization* as a term does not seem predestined to reflect the problematics and explosive power that will concern us in what follows. In conscious avoidance of the term *visualization*, we will use the word *iconization* in order to demarcate that the sensory presentation of simulations beyond rows of numbers is associated not only with visuality and visibility, but also with iconicity and the power of the image.

In order to discuss the partial independence of iconic components, we can in principle pursue a manner of argumentation analogous to that employed by Winsberg for the concept of the model: sensory presentations are not congruent with the calculated rows of numbers and are also not simple derivatives of the rows of numbers. Just as, when dealing with complex systems, one cannot assume a simple correspondence between theory and the calculable model, which, while drawing from theory, is also mixed with many ingredients and produced through multiple steps, so the relationship between model and sensorialization is likewise not trivial. As we have seen, models are not the results of theories, just as the sensory components of the presentation are not results of the calculated model. Something has been added, as De Landa rightly recognized: model makers "give this series of numerical solutions a visual [spatial] form."[62]

3.2 Semiautonomous Iconization

Most treatments of computer simulation in the philosophy of science do not open up a field of research on the junction between calculation data and the result of sensorialization; rather, they smooth away unarticulated irregularities and ambiguities. One possible route is suggested by Gabriele Gramelsberger, who in her dissertation conceives of computer simulation as a new epistemological instrument (alongside theory and experiment). In the chapter "Heuristics of Color and Form," she emphasizes the role of imaging and recognizes its areas of free play, though without pursuing the goal of exemplifying the latter more closely: "The empirical substantiation [of the mathematical model] occurs extraformally, be it in the scientist's interpretation, or in the visualization, which presents a computer-supported scientist's interpretation. Since there is no univocal relationship between the selected empirical substantiation and the representing mathematical structure, a validation of the numerical model and its simulation results with real systems and measurements is more hypothetical than the calculability ideal (mathematical—true—calculable) promised."[63]

Thus, if the empirical substantiation (e.g., iconizations) shows no univocal relationship to the mathematical level, how one formulates the relationship between the two will, first, be essential. Second, the sensory elements that have been applied are to be taken centrally into view for the research process as a whole. [64]

3.2.1 Shifts between Dynamic and Form

At this point it is necessary to demonstrate, on the basis of multiple aspects, why and to what extent an iconic presentation that accompanies a simulation is free-standing. In the context of numerical simulations, Gramelsberger poses an important question that implies the problematics involved in assuming that the sensory presentation is a simple translation of data into the visible: From where does the form get its shape? From the data values or from the programming that relates specifically to iconic design?[65] The question is particularly interesting in the special cases of simulations that do not make a visually perceivable presentation of data after the entire calculation is concluded, but rather, in which data are ongoingly conveyed into a perceivable presentation while the calculation is being carried out. This is not least because in these real-time simulations, the resulting iconic expression necessarily entails movement. The physicist Fritz Rohrlich struggles with translation and thereby provides an explanation that is all the more precise: "Simulations thus permit *theoretical model experiments*. These can be expressed by graphics that are *dynamically* 'anschaulich' (a difficult to translate German word that means literally 'visualizable' and that is best translated as 'perspicuously clear,' 'vivid' and 'graphic' but connotates an intuitive perception). Such 'pictureableness' is psychologically and intuitively of tremendous value to the working scientist. It confirms (or corrects) his preconceived ideas and shows directions for improvements, for better models, or even for better theories."[66]

The statement is important that iconic presentations of simulations are useful because of their dynamic *Anschaulichkeit,* whereby what is intended is the making visible not of an end product in the form of a diagram or graph but rather of a process as it is being carried out. Here, let us once again recall the definition of simulation: according to Brockhaus, for the natural-scientific and technical fields, simulation is "the presentation or depiction in model form of a cybernetic system or process that either already exists or that is yet to develop … , in particular also its behavior in time."[67] Simulations thus are fundamentally involved with dynamics. The dynamic of data structures as the real result of the simulation process are intuitively graspable in the iconic presentation alone, according to Gramelsberger. The dynamic shows itself as a whole only in the sequence of images. "The transformation from solution values into color values makes the structures that unfold in the change of numeric values visible as a form in time, and thus enables statements on the solution behavior of the equation under specific conditions."[68] If one excludes tone colors, then structures, delineations, and arrangements assembled from color values on a flat surface may be considered typical optical configurations. When these structures are modified over time, the relationship of the iconic to the explicit dynamic requires more thorough investigation.

The philosopher R. I. G. Hughes suggests that a challenge is posed in an integrative understanding of iconicity and change. With the three components denotation, demonstration, and interpretation (DDI), Hughes attempts to analyze step by step the (theoretical) presentation mode of (physical) models. In doing so, he follows the approach of the analytical philosopher Nelson Goodman, according to whom, on the one hand, a representation need not have any similarity to the represented and, on the other hand, elements of the represented are denoted by elements of the representation.[69] Hughes speaks of "theoretical representations," meaning the kind of representation that a mathematical model supplies: "On the DDI account, however, theoretical representation is distinguished from pictorial and cartographic representation by the second component in the process [demonstration], the fact that models, at least as they are used in physics, have an internal dynamic which allows us to draw theoretical conclusions from them. We talk about the behaviour of a model, but rarely about the behaviour of a picture or a map."[70]

In fact, one crux of the problem is that the conception of an idea of the image that can encompass *explicit/dynamic* aspects in a synthesis for the most part continues to be lacking; this challenge presents itself when one is attempting to speak about the iconicity of simulations. Finding a plausible close correlation between manifest dynamics and iconicity turns out to be a challenging task. Moreover, closer examination is needed regarding which dynamic is calculated versus which dynamic goes beyond this to unfold iconicity and how these different types of movement, along with the recipient's actions, are linked to the iconic. In addition, it should be taken into account that images that present a dynamic are not automatically those with dynamic iconicity.

If one accepts the thesis that dynamic simulations are above all to be understood as reproductions of dynamic, it can be deduced that a dynamic presentation is appropriate for them.

In their information technology textbook *Seeing between the Pixels* (1997), which is structured as an overview, the industrial designer Christine Strothotte and the computer scientist Thomas Strothotte emphasize the components that are to be presented temporally using the term *animation*: "The animation always has an obvious raison d'être, since it has to give the user a feeling for what is going on in his or her model during the simulated time and to uncover the problems of the dynamic behavior of the model."[71] Without concretely making the relationship between animation and dynamic into the subject of discussion, in this context the authors introduce entities that need further clarification. For instance, what is meant by "graphical data" should be specified. At first, the task seems straightforward enough: "Animation is based on the simulated numerical results and has to display them." But immediately following, they write, "Additional graphical data are necessary to describe how to express the different kinds of simulation results. For example, the appearance of a fork-lift truck is defined by the additional graphical data, but the information pertaining to when the truck has to move and from where to where will be part of the simulation results. The graphical data is responsible for the appearance and the simulation results for the content of the animation; they do not overlap one another. The simulation results form the basis of the animation and are the driving force."[72]

Appearance and content or, in other terms, information seem here to be completely separate. From the perspective of production, this may be self-evident, but it becomes inaccurate as soon as one takes the reception situation into view and the design of meaning, which results from both components.[73]

Here, we view these graphic elements, from the standpoint of simulations, as additions, which means nothing more than that they are not defined in the dynamic model: in this respect, something is added as soon as the dynamic is to be made perceptible; or something is designed in parallel if there is no such strict sequence. In any case, it can be assumed that from a particular point onward in the modeling process, sensory presentation and dynamic are synchronized, if only in that the iteration speed is regulated on the basis of the type of sensorialization, keeping in mind that the system dynamic and the calculation dynamic are not interchangeable. The reason that these graphic elements are needed is simply that dynamic in itself (without reference points) is not perceivable. It has to be embodied in a sensory presentation.

In order to trace the relationship between dynamic and image or form on this basic, syntactic level, we will turn to an example from the research on artificial life (AL) and examine the "graphic elements" employed there.

From a master's thesis produced at the Institute for Computer Design and Error Tolerance at the University of Karlsruhe, a predator/prey scenario (figure 3.8) was first available in a platform-independent version in Java in 1999–2000 and has been further developed since 2006. It is characterized by a user interface with real-time capability. The researchers emphasize the utility of their "intuitive" graphical interface.[74] In a left-hand window, it offers the possibility of observing directly how simple artificial organisms (often called "agents")

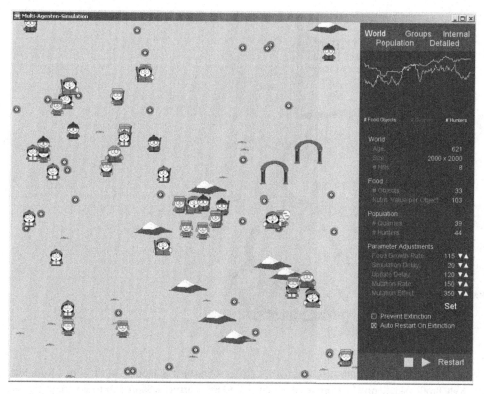

Figure 3.8
Predator/prey scenario, since 1999. Source: University of Karlsruhe. Author's archive. © University of Karlsruhe/Püttmann, Artificial Life.

form complex communities while evolving and adapting to the environment. Set apart from this field, on the right side, controls allow the simulation to start, stop, or continue, the animation speed to vary, and the environmental parameters (e.g., rate of plant growth, life expectancy) to change, even while the simulation is running. This user interface is intended to ensure that even laypeople can work with the application easily and comfortably. Various statistics enable an intelligible analysis of the experiments executed.[75] Along with vegetation, two types of life forms exist, "primitive" herbivores and "advanced" carnivores, which together form a small food chain. The overall objective of the living individuals consists in becoming as old as possible and reproducing during their lifetime to the best of their abilities.

As becomes particularly obvious in this case study, it can be assumed that the appearance of the two-dimensional cartoon-like agents is not directly the product of an algorithm. The computer scientist Dietmar Püttmann, a crucial collaborator on this application, took the

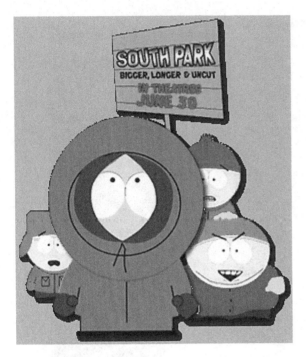

Figure 3.9
Matt Stone and Trey Parker's *South Park,* since 1997. Poster with the protagonists of the series, from left to right: Kyle Broflovski, Kenny McCormic, Stan Marsh, and Eric Cartman. Source: Author's archive from the Internet.

figures from an iconography that was current at the time.[76] Those familiar with the animated series *South Park* (since 1997), from which the characters are borrowed, will enrich the simulation with their own associations. The sociocritical series directed by Matt Stone and Trey Parker episodically portrays the experiences of a group of so-called friends from the primary school of a fictional American city, who by no means deal gently with each other. Even if, in figure 3.9, Kenny looms large in the foreground, it is no accident that he symbolizes the prey in the predator/prey scenario. Perhaps Kenny is classed as an herbivore because he is always so quiet and, among the available characters of the series, seems the most predestined for this role. One would think him least capable of highly developed social behavior as is requisite in the predator population; he is simply always hanging around. In addition, in the series he displays a rather different nature from the rest of the protagonists. As a running gag, the buttoned-up, silent Kenny, who is in fact always protected by an orange overcoat, rarely ever survives the animated sequences up through the fifth season: whether he is struck by lightning or laid low by illness, whether the space shuttle falls on him or he suddenly and without apparent cause goes up in flames. These scenes could be continued ad infinitum.

Presumably in order to differentiate the herbivores more clearly from the carnivore population, only Kenny's head is used—the head that so often rolls. Kenny is even smaller than in the series. There, too, he is the weakest member: we are reminded of Lessing.

It is characters such as these that are used as graphical elements in the simulations in order to show the calculated process as it elapses. The sequence, one could argue, can just as well be presented in and read from graphs—the most widespread solution. Certainly it is true that much information of statistical value can be taken from them. Different presentational modes emphasize different (or differently emphasize) correlations in the data, so that one rightly asks what each presentation adds. For example, the graph that is published along with this application (figure 3.10) lacks any reference to movement, location, action, profession, and groups. Also, the number of agents in relation to the available surface area of the world and other characteristics is not provided. All this could hardly be incorporated in a single presentation of this kind. Only with the graphic elements are (at least) two spatial dimensions unfolded along with the temporal, enabling relationships and global behavior patterns to emerge.

Thus, when calculation data are being treated for the purpose of perception, a utilization of form cannot be avoided. The variants with a minimal utilization of form are oriented to the idealized entities of geometry, such as points and lines, which in the depiction on the

Figure 3.10

Graph showing the number of "grass elements," herbivores, and carnivores over time in the predator/prey scenario, since 1999. Source: University of Karlsruhe. Syrjakow et al., "Simulation and Visualization," 268. © University of Karlsruhe/Püttmann, Artificial Life. Reprinted with permission of CRC Press.

Figure 3.11

Graphic user interface (Java applet) for supporting favorable parameter settings in the frame of an optimization problem. The effects of current settings on the population dynamic can be seen in the right-hand window in actu. The screen shot shows a state after ten generations. The single individuals are portrayed as small black circles that move in a space with different grades of attraction, which are color-coded. Source: University of Karlsruhe. Syrjakow, Berdux, and Szczerbicka, "Interactive Web-Based Animations," 1656. © University of Karlsruhe/Püttmann, Artificial Life. Reprinted with permission of IEEE Press.

monitor correspond to pixels or lines with the width of a pixel. Continuous entities such as densities or concentrations are unambiguously allocated color-coded pixel segments (as a random example, see figure 3.11). On the monitor, a pixel is thus the smallest site of transfer—a *minuscule échangeur*[77]—between image and number. In all other cases, for the iconic realm, a more complex change in form ensues. Against this background, what is characteristic of sensorially presented real-time simulations now becomes clearer: they process a movement that is made perceivable. This sounds unproblematic as long as one does not keep explicitly in view which entities are seeking coexistence: image/form and explicit dynamics. On a medial level and from a production-oriented viewpoint, there must be a negotiation between these components. Of central concern to us here is a consideration of the relationship of the

re-creation of the dynamic to the sensorialization—in particular to the iconic presentation, but in some cases also to acoustic and/or haptic components. Through closer observation of individual examples of simulation, one receives the impression that this relationship is not one of duplication, not only because one is confronted both on the surface and the underside with a *multiply* interdependent conglomerate, but also because the aspects of manipulability in the form of implemented models and the presented visuality cannot simply be converted into one another. One has to wonder what sense of correspondence can be intended here (in an unquestioned affirmation of visualization) in the first place and what role processes of translation play in it.

3.2.2 Deviations between the Calculated and the Shown

The matter is not comprehended solely by examining an attempted translation from the dynamic into the perceivable on the syntactic level. In addition, between modeling and iconization, data are also abbreviated, enhanced, transferred, and so on. Many decisions are made in the arrangement and sorting process that cannot be denied a certain autonomous status, since there is no calculated or calculable indication for them. In cases in which modeling and sensorialization deviate from one another, since reception is tied to what happens on the surface, the rifts are not necessarily recognizable as such unless the underlying model is also present at the same time. In comparison to significations that are attributed to the model, the sensory presentation fills in blind spots, ignores calculated information that can no longer be coherently integrated into a scenario, and concretizes areas that are not explained by the algorithm itself.

In the predator/prey scenario, it is readily apparent that a selection is occurring as to what is shown and how, as well as what with respect to the calculation remains concealed from "intuitive" perception. The hunter population for both genders is differentiated into more corpulent group leaders and thinner attackers and paralyzers, whereby the clothing and appearance clearly identify their gender and specialization. Therefore, there can be many very similar-looking agents who are not necessarily related or do not belong to the same community of hunters; these communities specifically require different professions. It is interesting that among the different characters, only the group leaders are highlighted through their stature, since paralyzers and attackers are equally tall and thin. Thus a hierarchy is introduced rather than a differentiation between professions.

Each point in space can be occupied by only a single agent, but the agents' graphical extent (they are always shown frontally) far exceeds this point. So a virtually infinite number of characters can optically overlap. In the figurative field, a few simple, static symbols denote what action the individuals of the predator population are engaged in (this means, for example, that no status characteristics of individuals are conveyed; see figure 3.12). Thus, when they are hunting, they are given a stick; when they are sleeping, a speech bubble appears with "zzhhh … zzhhh"; when they are in the act of reproduction, their eyes are half closed and two hearts appear on their chest; a visibly contented facial expression with the

Figure 3.12
The carnivores in the predator/prey scenario show the following actions, from left to right: "normal," hunting, eating, reproducing, sleeping. Source: University of Karlsruhe. © University of Karlsruhe/Püttmann, Artificial Life.

tongue in the corner of the mouth symbolizes ingestion. If the "detailed" view is chosen in the menu at right, the individual that is marked with the mouse in the "world" is shown in duplication with its action attributes (see figure 3.12). What the character is doing at the moment also appears in writing to one side. The viewer soon realizes that not all actions are given a distinct visual demarcation: the "normal" state without additions stands for walking, transporting, looking, and applying (figure 3.13). Conversely, it is interesting that for "applying" (the top picture in figure 3.13), no written distinction is made between applying for team membership or applying for a reproductive partner. Thus, with respect to the interpreted calculations, a selection is made as to what the viewer can receive in the course of the simulation.

As was already suggested, information is also conveyed that is not expressed figuratively. By no means independent of how "receptibly" the figurative presentation has been conceived, some aspects are taken out of the scene and put into tables. The popular solution of dividing the optical workup into two sections is also employed here: the macroview, a global overview of the action, is separated from the microview, which, in an adjacent column, gives information alphanumerically about the inner state of individual agents. For this mode of presentation, other applications in artificial life also use different monitors or projections (see the work *double helix swing,* to be discussed later). In this case, the figurative field and the tabular description are brought together on one monitor (figure 3.14).[78]

In the figurative field, the agents are almost always on the move. Only when sleeping—which, interestingly, is the top-priority action, in order to save energy and increase vitality when nourishment is momentarily sufficient—do the characters remain in a location. Sleeping or energy conservation is doubly coded: symbolically (through the speech balloon) and in the type of dynamic (through remaining stationary). Remaining in a location can also be observed in group leaders after they send their troop on the hunt.

Through the intensive study of events, a number of peculiarities become evident that attest that the logic of the data and its iconic presentation allow for the emergence of gray areas. In the definition of the sensory workup, these are interpreted from case to case. This has the consequence that different degrees of precision exist side by side. For example, the paralyzers as well as attackers do not have to come into direct contact with their prey, since

Figure 3.13
Portrayal of the group leader in the predator/prey scenario under the "detailed" menu point. Four possible activities can be seen that are (not) expressed with the "normal" symbol: applying, looking, transporting (=beaming), walking. Source: University of Karlsruhe. Author's stills.

there is a radius of effectiveness for their actions. This could be explained through the use of tranquilizer darts. But this type of narrative enhancement is not supported on the visual level. If the viewer omits making this mental enhancement, the impression arises that the characters are not crossing distances consistently; hence, the presentation seems half abstract. In this way, in the course of action, it cannot be ascertained what stage of the hunt a group is in. The viewer must already have been following events closely in order to recognize what particular herbivore is their target. Many actions can be carried out on the go, for example, eating. This at first sounds unspectacular, since on the basis of our daily experience, we do not necessarily categorize eating and walking as exclusive activities. But how does an agent manage to consume the portion of slain prey that has been allotted to him *before* he arrives at its location? This too suggests a remote effect and calls the stringency of locomotion into

Figure 3.14
Screen shot with detail of the "detailed" view in the predator/prey scenario. Source: University of Karlsruhe. Author's stills.

question. Another result is that when an agent is moving in the field, the "normal" image (for "walking") does not necessarily appear. The recognizability of events is complicated in that communication between agents (e.g., applying and answering, the command to hunt, the distribution of food) is never made visible.[79] The acoustic dimension has so far not been exploited in this predator/prey scenario.

The herbivores are given even fewer possibilities for articulation than the carnivores. For them, eating becomes evident when clumps of grass in their vicinity shrink. Unlike with the carnivores, ingestion is not perceivable in the herbivores' visual presentation. The same is true for reproduction, which in this case occurs through cloning. Evidently it is not an objective to study the herbivore population more closely in each of its actions. From the different treatments of their presentation, it can be concluded that primarily the social cooperation of the carnivores is intended to become observable. Only what is relevant to the carnivores—being a mobile food source—is displayed in the herbivores. The only allowable states are existence, deadness, or nonexistence; the status "paralyzed" was in fact envisioned but has not been implemented in the current version (figure 3.15). Dead herbivores are presented as flattened. This graphical solution is remarkable in that flattened carnivores do not appear. When the latter die, they suddenly and totally vanish from the figurative field. What does this difference reveal about the mathematical model, and what about the interpretation? Herbivores that have starved to death or have been slain continue to show a small amount of (successively decreasing) energy, which can be absorbed by the carnivores. By contrast, the "carcass energy" of the carnivores is not channeled back into ecological circulation; they do not fertilize the vegetation, nor is cannibalism practiced in this world. A presentation of the carcass of a carnivore would thus only mark and emphasize its death but would not have any other function. In general, however, the concentration on functionality is a prominent criterion for simulations.[80]

In sum, here are the previously suggested incongruences between the calculated and the shown: a selection is made as to what is presented and what is conveyed (in writing, in tables, graphically, figuratively); events that are interpreted as equivalent are treated differently in the portrayal; judging by how they are weighted, functionality and presence can diverge

Figure 3.15
The following modes of expression can be used by herbivores. Left to right: "normal," dead, paralyzed.
Source: University of Karlsruhe. © University of Karlsruhe/Püttmann, Artificial Life.

markedly; some elements are doubly coded, while some differences are not conveyed. A uniformity of iconic attributions is not sustained.

3.2.3 Iconic Effects

As long as one is describing which aspects appear in the presentation as compared with what is calculated, one has not necessarily arrived at the unique ways the iconic operates.

What are they? But before we answer this, it is advisable to differentiate. First, which design strategies tend explicitly to use spatiotemporal structures in order to convey information? Second, which occurrences often become apparent only through the iconization, although they could primarily be categorized as emergence effects of the calculation? And third, conversely, what effects and significance can be achieved purely through the iconic design?

First, on information design: Although the so-called observation mechanisms that are introduced purely for the figurative presentation vacillate between the points that were just now heuristically separated, we will discuss them here. In our example, in order to best follow the dynamic group formation processes that ensue among the hunters, visual aids are introduced that use two dimensions. Thus it is possible to highlight one or all existing groups (figure 3.16) with semitransparent polygons by taking all the positions of the continuously moving group members, connecting these with lines, and shading in the resulting interior area semitransparently. One active group can be distributed across the entire world; it does not operate as a closed formation. Since two-dimensional, transparent shading has been chosen, it comes to pass that other agents—agents of this group, as well as agents of other groups or solitary agents—can be found within the area of the shading. Hence, it is only the thin, white lines connecting the group members and their group leader that definitively specify inclusion and exclusion. The more an area of ground is simultaneously covered by these mobile attributive polygons, the darker it appears (see figure 3.16). These observation aids, which mark a proposed grouping as interesting, also make clear that the application offers three levels of focused observation and three types of movement.

First, one can concentrate on an individual agent and his or her movement in space and follow the sequences of the agent's actions. An agent often walks for a long time without changing directions. A slow circling or meandering does not occur. In following the individual, one will certainly also take in the situation of the agent's immediate surroundings. However, it is advisable not to stray too far from the individual, because then one will quickly have trouble with identification. There are only six different character types for the hunter population, and with a possible number of approximately fifty carnivores simultaneously swarming around, they are easily "confused." At any rate, in practice, it will be the case that one gleans the agents' modes of behavior generally from an overall impression. The fragments of movement of different agents, who also have a short life span, are accumulated and the total impression is conferred on the species. Nevertheless, to make it easier for the

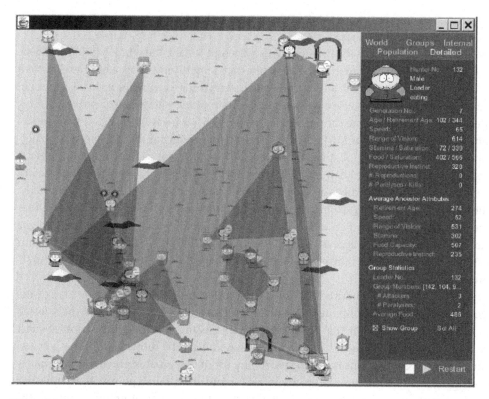

Figure 3.16

Highlighting of all currently existing groups in the predator/prey scenario. Source: University of Karlsruhe. Syrjakow, "Web- und Komponenten-Technologien," 140.

viewer to observe a single character, one can select this particular individual with the mouse. Then it is first marked by being framed in black, and second, one can have its "inner values" dynamically listed on the right (see figure 3.14). Because movement from place to place is not shown in this list, the agent's written actions seem threaded on a time line. Third and finally, with this selection, all other agents who do not belong to this one's group are given a slightly weakened presence by being shown as faded. Semitransparency is thus brought in as another optical organizing pattern.[81]

In addition, viewers are free to accompany the agents not only with their eyes but also with the mouse in their hand. The iconic realization influences interaction directly and in this case, directs attention to the group leaders. Leaders are selected most often because they move around the least and thus are the easiest to nab. The agents with other special skills most readily incur selection in their sleep. For interactive variants of simulations, two regulatory components are therefore anchored in the sensorialization: it is the hinge in which

the data find their expression, while the offer of action that is extended to the viewer in the presentation also takes on its specific shape.

Beyond observing an individual, one can also attempt to take the whole world into view. Inevitably disorientation ensues. It is clear only that something is happening everywhere at once, so one cannot grasp it all. On this level, everything is moving most of the time. Infrequently, the bustling mass accumulates in a certain place, followed by a striking movement of disbanding, while one cannot immediately say what is causing this. At first glance, it is not even clear in the swarm whether the agents are traveling at different speeds. Generally no particular, repeated global pattern takes hold. At different places and at unforeseen moments, certain individuals change direction or stop. A fragmentary circulation with seemingly erratic pauses of generally very brief duration can be made out. Although the same situation never appears twice, the movements seem, if not uniform, then highly similar after a while. This is the case regardless of the longer-term vacillations that result from the fragile equilibrium of the simulated ecosystem, which can also lead to the extinction of one or both populations (unless, in the right-hand column, one has chosen the rather "supernatural" option that prevents this).

A group can thus be emphasized by making the rest semitransparent. The overlay of the polygon that connects all group members enables increasing the articulation of the selected group further. The movement that strikes the eye in this presentation is the most abstract of the three. To a great extent, it has a life of its own, in that the movement of the polygon resulting from the connections is not logged in any list of coordinates: the figure constantly changes form, with as many edges as there are agents at its outer points; sometimes it's a triangle, sometimes a heptagon. Without respect to the number of group members, the polygon is small and inconspicuous when they put their heads together; it expands, shifts, and contracts without interruption. The movement takes place as a presentation of the relationship of the agents to each other, and it tends to be oriented to the center because of the fact that agents cannot step outside the outer boundaries of the world, which appears as a quadratic area. The polygon of a group is never divided and touches the edges of the pictorial field at most at specific points when agents are positioned there. If an agent then steps out, the area of connection recoils to the agent who is nearest at that moment in time. Simultaneously, another arm of the polygon leaps to the opposite side of the pictorial field in order to capture the same agent who has just appeared there. These abrupt leaps in the otherwise gliding shifts in length of the polygon's sides ensure that the areas are always located inside the world and the edges do not overlap. In this way, the two-dimensionality of the projection is emphasized, as well as the fact that the field is bounded, for the edges are cuts in an only conceptual, but not depicted, continuum. They result from a type of projection. Since the whole pictorial field that can be seen is a nonoriented topology, all life forms are always shown. As with a flattened torus, the figures that exit at one edge of the picture appear at exactly the same height at the opposite edge. It is only because of this that the group membership image (the polygon) also jumps when the optical boundary (which,

on a conceptual level, doesn't exist) is exceeded, which would not happen in a toroidal presentation.

To conclude the discussion of this predator/prey application, I describe one element of iconic design that can no longer be explained with calculated emergence effects. This involves a tilting in the conception of space in the vicinity of the gates. This movement develops purely from the iconic level and is closely tied to the agents' movements that trigger it. At first glance, the viewer is presented with a markedly opaque, homogeneous, flat view of a world that is studded with gates and hills. The figures can run across all parts of these gates without any difficulty (figure 3.17). The arches do not conceal them at any time, and hence the interpretation as the projection of an architecture that actually extends upward, toward the viewer, does not function. Thus, evidently these places are to be understood in the same way as all the rest of the world's terrain apart from the hill crests. The world proves to be observed vertically, in a bird's-eye view, whereby the manner of depiction of the gates is indeed strange and should be seen as a demarcation. However, in the case of certain actions, these sites function differently. The sizes of the gates are fitted to the figures, so that the latter can position themselves "underneath" them or—in two-dimensional terms—so that they can insert themselves into the arch and appear framed (figure 3.18). If they do so, they become successively transparent, until they can no longer be seen. Through the figures' becoming transparent, one has the impression that they are vanishing, as in fog, so that the gates now indeed seem to lead into a depth of space. An arrangement of adjoining though not visible surfaces or spaces would also be conceivable, so that the gates could be interpreted as doors. Science-fiction films may also provide helpful associations, such as in scenes where

Figure 3.17
An agent runs from lower right to upper left across a gate. Source: University of Karlsruhe. Author's stills.

Figure 3.18
An agent approaches the gate from lower right and then disappears under the arch. Source: University of Karlsruhe. Author's stills.

people are disintegrated in order to be beamed to another location. In fact, the gates in this predator/prey scenario are conceived as sites that open up the space to networked computers. According to the idea, at these sites, the figures move into a parallel world that is similar to this one but elsewhere, in the hope of finding better living conditions there.[82]

But what does the iconic level show us? If the figures are running across an arch, then the area is flat. If they are fitting themselves into the curve of an arch, it could still be lying flat on the ground as a demarcation. But nothing prevents interpreting the situation as if the figure were going underneath it. This interpretation is supported when the figure becomes transparent. Its vanishing is understood as a passing through. Equipped with daily experiences of spatial openings and our going through them, the viewer perceives a reversal, imagining the arch that was just now lying flat as standing up, positioned orthogonally to the ground. A standing archway reveals a further, unexpected depth of space beyond it, since the figure does not appear behind the gate but rather vanishes to a place where he or she can no longer be seen. On the basis of this detailed observation, in a second step the viewer's attitude to the whole scenario also tilts. A standing gate implies an oblique view. One no longer believes oneself in possession of a godlike overview but instead interprets the terrain as a random section seen through a quadratic window opening. As soon as the figure can no longer be seen and others are running across the gate as usual, the enchantment has passed; the brief, startling unsettlement subsides; and the impression of two-dimensionality prevails once more. It is the *behavior* of the figures *with respect to the portals* (going over, into, under, through them) that as microevents are capable, like shock waves, of changing the perception of the entire spatial constellation.

The transformation from a surface to a spatial opening supports our understanding of the course of events: if the agent stays in the world that is presented to us, then the gates behave as a closed, patterned floor; but if the objective is to leave the world, then the gates and the surrounding terrain briefly take on an ambivalent opening and a dimension of depth.

3.2.4 Iconization as the Field of Reference for Interventions

These observations, which are intended to demarcate a certain area of free play in imaging, serve as a backdrop for the following thoughts. Here, the focus shifts to interactivity, which itself is closely tied to the perceivable. Only through the sensorialization of the calculation results is it possible to intervene in the ongoing operations of the simulation. This means, conversely, that during all real-time interventions, the sensorialization is the critical field of reference for the user.

It was already discussed as essential that executed dynamic/mathematical models are dependent on their perceivability if their changes are to be communicated. Iconic elements explicate the data and thereby serve an important purpose. This can best be demonstrated in the areas of research on artificial life and simulations of social structures. The philosopher of science Sergio Sismondo writes,

In most social simulations, for example, the researcher defines "agents" with fixed repertoires of behaviors. Those agents are then set to interact, responding at each moment to the actions of others. The goal is to see what, if any, social patterns emerge, or what assumptions are needed to create particular social patterns. Social simulations are analogues, then, because components of the program are analogous to individuals, and those components interact in a timeframe that is analogous to a sequence of moments in real time. Simple one-to-one correspondences between virtual objects and real ones (however idealized and simplified they might be) can be easily drawn. For most non-computerized mathematical models such correspondences are more difficult to draw, because preferred mathematical styles occlude individuals in favor of aggregates or larger-scale relations. The components of an equation can only rarely be neatly paired with obvious objects in the world, instead following a logic defined by relations among objects.[83]

If Sismondo stresses that in some cases it is possible, based on our real-world experience, to aggregate entities and conceive them as individuals, how can this happen in a running simulation? During the execution of the simulation, it is not beneficial to present the functional relationships that were ascertained in a model. They can only be reconstructed indirectly, through the results of the simulation. An agent may indeed be determined as an encapsulated set of characteristics in a mathematical model, but in a numerical simulation, data are produced. The data may be clearly correlated, but where, when faced with the continuously calculated columns of numbers—which indicate changes on the basis of interactions—can we get hold of the individual? What specifically have we understood when we select a value? A momentary state of one aspect in a stage of iteration? In the execution of the model, the individual seems anything but undivided. In this conception and without a stabilizing, summary presentation, everything that is associated with an identity-founding unity disappears.

Sismondo does not explicitly write that a sensory presentation is required. As though Paul Humphreys wished to complete his statement, he writes, "Such dynamic presentations [of simulation results] have the additional advantage of our being able to see [in them] which structures are stable over time. This is also true of many agent-based models—if we display the results of such models numerically or statically, we cannot 'see' the higher-order emergent patterns that result from the interactions between the agents."[84]

What is accomplished through the iconic aggregation of data should not be underestimated. In this context, the polytechnician Philippe Quéau speaks quite rightly of understanding (*com-prendre*) through an aggregation, a taking-together (*prendre ensemble*).[85]

Through a gray outline and their distinctly compact appearance, the individual agents and objects on view in the predator/prey scenario from the University of Karlsruhe are very clearly distinguished from the light-colored, homogeneous ground and from each other. As a result, it is possible, when faced with a potentially large number of individuals, to follow, select, and, as the case may be, observe a single one up close. How many of the data from the mathematical model are being presented depends on how transparent the presentation is conceived to be. In this predator/prey scenario, very little is portrayed: in principle, there are the five states of action (see figure 3.12), the gender, and, for some agents, the profession.

In addition, an overview of all agents is provided, without which it would not be possible to comprehend the particularity of the current situation of an individual and its interactions with the others in the course of action. In interactive applications, the idea is not only to see what happens; one also wants to see that something happens by intervening. One learns more about how the application works through intervention than could be deduced through pure observation, since one can try to induce certain situations (this will by no means always happen as desired and envisioned) and can stage trials for the purpose of evaluating influential factors. Only the visible mapping of a field enables access to an agent. The possibility of selecting an individual does not sound like very much, but it implies a manner of interaction that is not available for every type of presentation to the same extent; hence, for statistical presentations by means of graphs (see figure 3.10), it is not an option.

At least in the act of an involved encounter with a real-time application, the calculation data no longer necessarily comprise the reference points for the viewer's interpretation. Fundamentally, simulation theorists who strongly emphasize visualization also support this thesis—for instance, Gramelsberger: "The visualizations generate more or less strongly structured images according to the solution behavior. Statements about the behavior result from the identification of form-giving elements that emerge through visually perceivable relationships, delineations, and arrangements."[86]

On this basis, it can be concluded that the central role of the sensory presentation is to be found not only in the interactive real-time simulations described here; rather, imaging is the critical factor in interpretation for simulations in general. It makes no sense to want to watch the computer as it outputs numbers. As well, the programs are generally too complex to be followed in detail while they are running. This suggests considering these processes as sealed and treating them as a single entity, according to the sociologist Lucy Suchman.[87] As opposed to many nonscientific computer programs, however, these black boxes are only temporary in scientific basic research, since it should not be forgotten, of course, that along with the mode of access via the figurative field, there are others of an entirely different nature. An overenthusiasm for iconic components based on incorrect understanding should not be permitted to obscure the fact that the numerical level can also be opened up to scrutiny.

According to the science theorist Deborah Dowling, the process of computer simulation requires both an analytical understanding of the mathematical principles that are programmed into the machine, as well as a temporary setting aside of these principles in order to interact with the computer as if it were a black box.[88] On the basis of this observation, in the context of computer simulations Dowling speaks of two modes of interaction, which she takes from the work of psychologist Sherry Turkle. On a very general level, Turkle talks about a calculation mode and a simulation mode.[89] In the calculation mode, the user is familiar with the inner mechanisms of the machine, and in the simulation mode, he or she is occupied with the user interface without paying any attention to the programming. According to Dowling, both modes of interaction are necessary for a competent professional employment of computer simulations. Scientists have, and need, by turns both access to and the ability to

manipulate the simulation on different levels. Dowling states further, "The program is 'open' at a level through which a general analytical grasp of the theory is possible. At another level the program is sufficiently 'closed' that … the abstract mathematical theory can be manipulated as if it were a concrete, physical object. … A sense of direct manipulation encourages simulators to develop a 'feel' for their mathematical models with their hands and their eyes, by *tinkering* with them, *noticing* how they behave, and developing a practical *intuition* for how they work."[90]

Here, it becomes apparent that with the iconization, something is added that no longer can be aligned with the idea of a simple correspondence or conversion from data sets into iconicity. How do iconic components contextualize a simulated "behavior" by drawing on something perceivable, and how do they simultaneously lend themselves to "playing around"? How is the latitude that they enable exploited? Logically, this would happen according to criteria of utility. What are these criteria?

Thus far, the fundamental differences between data and presentation have been the main subject of discussion. Such a focus does not provide an adequate basis for an explanation of questions of this nature. Hence, another interpretive template is now needed in order to characterize iconization. It is imperative to attempt to explain what these differences mean, where they originate, what they are good for. We will approach the problem complex that is associated with the mathematical model's need for visual manifestation via a detour that identifies another need elsewhere—the need for dynamization. In both cases, interactivity enters the background. Then it will become evident to what extent one can speak of a mutually enhancing "crossing" of the entities associated with these needs. Through a description of diverse sources of design, we then discuss their interweaving and show this through the example of a medical simulator.

3.3 Sources of Design

With very few earlier exceptions, computer-supported simulators have been developed for human and veterinary medical concerns since the 1990s, with frequent reference to previously established applications in air and space travel. Using interactive simulators with real-time capability, doctors-to-be learn single maneuvers, entire surgical interventions, and diagnostic examinations. For surgical training, most often a section of the body as the ensemble of affected organs plus the necessary operative instruments are created digitally. All the elements are available that are involved in the action necessary to carry out the operation.

Because, as a rule, it is a complex situation that is to be simulated, construction is necessarily begun before all open questions can be answered sufficiently through scientific analysis despite the considerable demands that will be placed on the application. In order for a simulator to be employed for training, it is requisite that it displays a certain completeness with respect to fundamental areas (optics, acoustics, haptics, occasionally also olfactorics). Here, much basic research is still needed. With reference to analogous processes in anatomy,

computer scientists Michael Lawo and his colleagues think that a formal language of virtual reality simulators will be developed in the coming years.[91]

Very explicitly, it is imperative to be able to work with the provisional. Not infrequently, holes are filled with standard assumptions, so that parts from different sources ultimately produce the overall impression. In all, one has to deliver a finished product, which entails that some areas—and these areas differ according to focus and laboratory culture—can be more professionally and soundly compiled than others, in which there is more improvisation or more drawing from previous work done externally. The guiding principles used in producing a simulator can have different relative importance. At times, one works with data from a single patient or draws from a normed average anatomy, for example. Solutions of various kinds are needed in un(der)determined areas.

For the parts that are grounded in scientific measurements, it is imperative that they are not direct abstractions of the seen but rather, resynthesizings from previously gathered analytical data.

This process is related to Flusser's idea of the gesture of image making that is enabled by the computer for the first time, which the philosopher described as early as 1988. Flusser sketched the series of gestures as follows: "What we seem to have here is a sort of loop: first, images produced by the old imagination were analyzed into lines by writing, then those lines were analyzed into points by calculus, and now those points are being resynthesized into images by the new imagination."[92] This last gesture of image making is intentionally directed against the two preceding ones, since it is not—as previously—abstracting and regressive but, conversely, concretizing and projecting. He writes further, "The old imagination withdraws from the world into a nonplace from which it produces pictures. It thus describes a motion of abstraction: from the world, from the three-dimensional, it abstracts the two dimensions of the picture surface. The new imagination advances from the points of the calculus toward the production of pictures. It is thus a motion of concretion: it projects from the abstract, the zero-dimensional, into the two dimensions of the picture surface."[93]

Although Flusser admits the oversimplication of his classification and stresses that these gestures of image making do not replace one another but rather exist in parallel, for structural reasons he locates the last gesture in the realm of the digital computer. So that these ideas do not terminate in the all-too-obvious conclusion that, in principle, in the computer, everything is calculated, it is worthwhile to take one step back, before calculation by the computer, and make some mention of the form in which the information exists that then is given over to computer execution. In this way, it is possible to differentiate between those areas in which, for example, previous empirical collection of numbers plays a role and those areas in which it is necessary to make experience-based adjustments (of parameter values) that have not been or cannot be quantified in advance. In particular with collection of data from living tissue, one quickly runs up against ethical and technical boundaries. In areas that cannot be tested with experiments, one relies on doctors' estimations. Their understanding, over years of practice, of previously seen and felt individual manifestations,

is based on an act of abstraction. Unlike the areas that are grounded in the collection of data, the detour here with an instance of definitive quantification is not taken. Even in cases where one can provisionally take measurements—for example, on animals—these measurements first of all serve in the creation of a model of a behavioral dynamic. Since one cannot automatically surmount the differences between species, one consults experienced, specialized surgeons in order to adjust some of the parameter values according to their input. Beyond this, pedagogical, economic, and many other factors come into play in the creation of a training simulator, which do not immediately relate to the anatomical structure.[94]

3.3.1 Excursus: Stages in the Creation of a Simulator

In this section, we undertake an excursus into the production of a surgical simulator in order to supplement the theoretical ideas put forward through a look at the practice of modeling. Through a single example, the individual ingredients will be pointed out that lead to the production of a simulated scenario generated for the express purpose of perception and intervention. With reference to this example, we will trace the individual steps of production that are necessary for mathematical modeling and iconization. The range of necessary skills will thereby become apparent. A complexity is revealed that on the one hand relates to the modeled anatomical structure and on the other hand always implies the trainees and the action to be executed. Finally, the assembling of the simulator leads to the seemingly incidental "special effects" that are produced in it. These prove to be key moments for a particular approach, which is then proposed, to the relationship between modeling and iconization.

First, we use this example to sketch a basic outline of the assembly of a simulator without going into technical details. Our example is a hysteroscopy simulator that was developed from 2001 to 2007 in the Computer Vision Laboratory at ETH Zurich in cooperation with other institutions.[95] With this application, examinations of the uterus as well as related surgical interventions are practiced through the organ's natural means of access (figures 3.19 and 3.20). Since the simulation scenario is used for the rehearsal not only of basic maneuvers but also of entire procedures, considerable demands are placed on the sensory impression, according to the developers. This research project pursues the "greatest possible realism" of the presented scene as an explicit goal.[96] Optic, acoustic, and haptic sensory impressions are offered.

The simulator, constructed of plastic and metal, has a prepared surgical instrument, two pedals, and as a computer with monitor and loudspeakers. The hardware construction integrates a plastic female pelvis made by the company Limbs&Things that has been converted for the purpose of receiving various appliances. Two plastic legs made by Rüdiger-Anatomie GmbH complete the external appearance (figure 3.21).[97] The trainee holds in her or his hand a real resectoscope, connected to a light source and optics, with four degrees of freedom. It is equipped with position and force sensors in order to be connected to the simulation. During the training session, the instrument is introduced into the hardware construction. It is then invisibly (it is concealed from the trainee's eyes by a plastic torso or surgical drapes) coupled

Figure 3.19
View of the operating room furnished for an experiment with the hysteroscopy simulator. Source: ETH Zürich/Institute for Image Processing. Harders et al., "Highly-Realistic, Immersive Training Environment," 177. Courtesy of IOS Press.

Figure 3.20
The surgeon Michael Bajka operating on the hysteroscopy simulator. Source: ETH Zürich/Institute for Image Processing. Harders et al., "Virtual Reality Based Simulation," 457. Reprinted with permission of MIT Press.

Figure 3.21
Hardware construction of the hysteroscopy simulator. The instrument to be inserted is lying on the drape. The attached hoses can be seen through which the rinsing fluid is regulated by means of valves. Source: ETH Zürich/Institute for Image Processing. Harders et al., "Highly-Realistic, Immersive Training Environment," 178. Courtesy of IOS Press.

to a mechanism for (motor-driven) haptic feedback. Simultaneously, the simulated scenario, which can be followed on the computer screen, begins. In the visual field of the monitor, part of the instrument, a curved, metal electrode, can be seen that can be extended or retracted during use with a lever on the instrument. The electrode enables cutting and cauterizing of tissue. This occurs when the instrument touches the tissue and the operator sends power to the electrode using a foot pedal. When the kind of tumor cannot be determined on the basis of its form, the haptic impression reveals what type of growth it is (a hard myoma or a soft polyp) and what treatment technique should be implemented. The haptic feedback is conveyed to the doctor through the instrument.

At the start of every training session, a new scenario is generated so that the trainee does not perfect his or her skills on a single situation, but rather encounters different challenges each time. For this purpose, a number of programs are needed in order to provide a large spectrum of variations for all necessary aspects.

Creating organs—in this case, a uterus—in many slightly varied forms with an algorithm requires anatomical reference points. To this end, magnetic resonance images are gathered

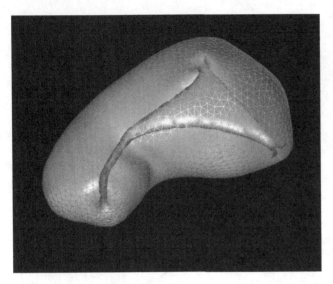

Figure 3.22
Presentation of a uterus from the surface. The outer contour is kept transparent here in order to show the inner cavity, presented as opaque. Source: ETH Zürich/Institute for Image Processing. Sierra et al., "Hydrometra Simulation," 581. Reprinted with permission of Springer.

from twenty-six healthy volunteers. The organ boundaries are determined through a combination of manual and automatic segmentation.[98] In this way, a "statistically average" organ is achieved (figure 3.22).[99] At the same time, various parameters are specified for the description of the organ's surface in order to be able to generate new, plausible organ forms by varying the parameters.[100]

The generation of surfaces is not sufficient for the simulation scenario, because no satisfactory impression can be obtained from them through interaction. A technique is developed with which, on the basis of a closed, triangular surface, a volumetric net of tetrahedra can be made.[101] The uterus is just one application of this technique. Two different geometries are thus employed here: a high-resolution, triangularly organized portrayal of the surface and a coarser tetrahedral configuration for the computation of collision detection as well as deformation.

With simulated tissue (constructed as a net of four-sided units), the processing of collision events happens in three steps. In the first step, one identifies the dynamic behavior of deformable structures, taking into account conditions for maintaining distance and volume. Here, one considers the change in position of individual nodes of a tetrahedron and the associated effects on the volume of these units. In the event of a deformation, two scalar potential energy functions produce forces that depend on user-defined rigidity constants. Without being linked to real data, however, this undertaking is not adequately verified, according

to the researchers. For the precursor project laparoscopic surgery simulator (LaSSo) measurements were made on living tissue during operative interventions performed on female patients.[102] The results thus obtained can be transferred to this second simulator. Even with existing measurements, linkage to the employed net topology is not straightforward. So-called spring-mass systems are used, in which one defines a net of nodes as mass points, which are tied to one another through elastic connections ("springs"). These spring-mass systems have the advantage of being quickly calculable. Their disadvantage is that specifying parameters (rigidity, length, transfer function of the springs, mass distribution, and net topology) is difficult for this application area because this type of discretization does not allow any simple correspondence to measurable biomedical data. To validate the newly developed genetic algorithm for the production of the three-dimensional net topology and its deformation behavior, standards are needed; some possibilities are established spring-mass systems[103] or finite-element-method systems,[104] which as a rule are more accurate but (too) calculation intensive.

In the second step, the space is divided into cubes (the image-space technique) in order to detect optimized volumetric overlappings of the organ's surfaces. This enables accounting for instances of contact of the deformable object with itself (self-collision) and other objects, including the depth of penetration.[105] In this way, encounters in the simulator between the simulated surgical instrument and the generated pathologies are characterized.

In the third step, this is used to generate reactions to collisions.[106] One possible reaction is being cut. A calculation mode is developed that enables the three-dimensional tissue to be severed evenly. This means that individual tetrahedra are not simply deleted, which would give the cut an uneven edge. Instead, the tetrahedra themselves are divided (figure 3.23).[107]

In this setting, the adept's task is only to sever or shave off tumors. In order to be able to create slightly varied scenarios for each exercise, also beyond the uterine cavity, the researchers develop an algorithm-based genesis of pathological structures such as myomas and polyps. The different approaches have already been discussed elsewhere (see figures 3.2–3.5). The pathologies that are generated with a cellular automaton or a skeleton-based approach must be "implanted" in the computer-based uterus after "growth." With the product of the cellular automaton, which has a voxel basis, this involves a conversion problem with the uterus, which is conceived as a triangulated surface.

With tumors, too, it is not enough only to create the form. Blood flow and biomechanical qualities are also needed, since these pathologies projecting into the uterus are to be removed in training and must behave accordingly. Living tissue is nonlinear, nonhomogeneous, and anisotropic. This means that in the simulation, different types of tissue must also be reflected, since a muscle behaves in a different way than a vein, for instance, does. Blood vessels have a threefold significance in the simulator: because of their haptic qualities, because of the possibility of complication in the case of injury, and because ramified microvessels fundamentally inform the overall visual impression of the scenario.

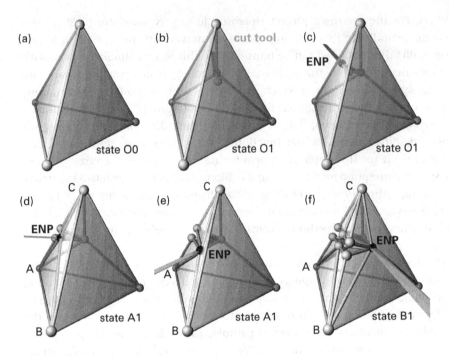

Figure 3.23
Cutting through a tetrahedron produces additional, smaller units of volume. Source: © Daniel Bielser, *A Framework for Open Surgery Simulation*, 33. Courtesy of Daniel Bielser.

Hence, it is little wonder that a distinct module is programmed for the vascular system. In order to recreate blood vessels, a macroscopic simulation of angiogenesis is the chosen method. The simulation model consists of two parts: the generation of a capillary plexus and vascular growth based on biophysical and hemodynamic rules.[108] To this end, a general network generator is produced, whereby the algorithm is equipped with information on the tissue's metabolic map (oxygen use and waste collection). Every blood vessel, treated as a straight, elastic tube, is ascribed a flow conductance based on its geometry. Through the modification of an existing approach to nodal point analysis from the theory of currents, hemodynamic variables (flow, shear stress, tension of the vessel walls) are identified that influence the growth of blood vessels. This macroscopic approach is joined with a microscopic approach in order to better comprehend tumor growth as conditioned by blood flow, since these are precisely the scenarios that will be employed in the hysteroscopy simulator.[109] In addition, the interaction between a fluid as a particle system and a deformable object such as a blood vessel is also implemented.[110]

During interaction with the real-time simulation, the viewer is looking not at three-dimensional projected net constructions (figure 3.24) but rather at textures covering the

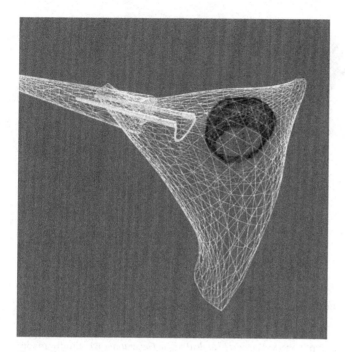

Figure 3.24
Net constructions for the hysteroscopy simulator presenting the uterus (triangular structure), the instrument (on the left), and the myoma (spheric structure inside the uterus). Source: Kindly made available by Matthias Harders, Institute of Image Processing, ETH Zürich.

objects. Since the opinion is held that in surgical simulators it is not sufficient to generate these textures completely artificially, images from ten hours of video recordings of different interventions are incorporated in the production process.[111] For example, figure 3.25 shows the successive stages in the texturing of a polyp: panel 1a shows a video still from a real intervention. Areas that give views of characteristic tissue are sought out. The stills, acquired in vivo, are edited by deleting areas that are too brightly lit or removing undesired forms or distortions, so that a usable view of the surface composition—in this case, panel 1b of the uterus wall—remains. Taking this visual template as a basis, a texture is generated through a pixel-based approach (panel 1c).

In texture acquisition, care is taken to ensure that nothing is there that will be subsequently added dynamically: conspicuous lighting effects, shreds of tissue, bleeding, blurring. However, as a result of the use of video recordings, the perspectival and lens-induced distortion of the camera has to be accepted. Through a number of modifications, the video recordings (actually projection views of a surface) become the surface directly. In this way, a database of different templates is created for different body parts. In order to lay a texture

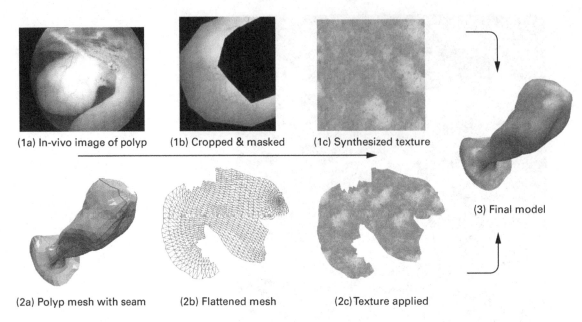

(1a) In-vivo image of polyp (1b) Cropped & masked (1c) Synthesized texture

(3) Final model

(2a) Polyp mesh with seam (2b) Flattened mesh (2c) Texture applied

Figure 3.25
Different stages in the texturing of a polyp. Source: Harders, *Surgical Scene Generation,* 61. Kindly made available by Matthias Harders, Institute of Image Processing, ETH Zürich. Reprinted with permission of Springer.

over a three-dimensional object, the surface net of the object is flattened into two dimensions (panel 2b in figure 3.25), and the texture is cut to size (panel 2c) and placed on the object. The seam in the texture that necessarily ensues, marked in panel 2a, is then concealed through overlapping and the modulation of transparency values. But that's not all: in this hysteroscopy simulator, the desired "photorealistic" portrayal of the surfaces of different materials is achieved by layering three graphics (initially). First, a surface is filled with a rough-looking texture (figure 3.26a). Then it is illuminated with a small spotlight, which is located on the instrument and thus is guided by the user's movements (figure 3.26b). Accordingly, light reflections are perceivable on the anatomical structures. Finally, the texturing is added (figure 3.26c) whose production is outlined in figure 3.25 (panels 1a–1c). The result of this layering can be seen in figure 3.27.[112] It shows an artificially produced polyp to whose surface generated vascular structures have been applied. Since pathological structures display prominent blood vessels and therefore look different from the uterus wall from which they have "grown," blending is used to make the textures merge smoothly into one another. The pathological structures are also textured volumetrically, which can be seen only when they are cut into (figure 3.28). Volumetric textures for their own part present different challenges from those used for surfaces.

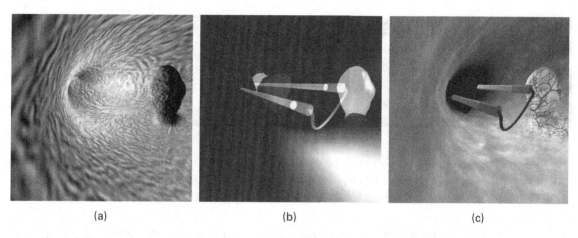

(a) (b) (c)

Figure 3.26
(a) Layers of texturing, bump mapping. (b) Light effect. (c) Textures and environment maps. Source: ETH Zürich/Institute for Image Processing. Bachofen et al., "Enhancing the Visual Realism," 33. Courtesy of IOS Press.

Figure 3.27
Overlay of the image layers in figures 3.26a to 3.26c. Source: ETH Zürich/Institute for Image Processing. Bachofen et al., "Enhancing the Visual Realism," 33. Courtesy of IOS Press.

Figure 3.28
View through the virtual endoscope of a polyp with vascular structures grown according to a model-based approach. Scene in which a polyp is shaved off. Stills. Source: ETH Zürich/Institute for Image Processing. Kindly made available by Matthias Harders, Institute of Image Processing, ETH Zürich.

Before this simulated mise-en-scène, which is intended to convey the impression of an endoscopic camera, is displayed on the monitor, the lens distortion of the virtual camera must be built in. To this end, the entire impression is rendered, transferred to a square, and broken down into subunits of 20×20 pixels each that are altered according to the characteristics and settings of the camera. In order to avoid undesired pixilation, it is possible either to use a higher resolution than is necessary for the display or to employ simple anti-aliasing processes. Then the outer areas beyond the circle of the camera are blacked out. The arrow pointing inward facilitates orientation. In an actual intervention, it is possible that the camera might not be focused sharply. In order to generate this impression in the simulation, the view transferred to two dimensions is used multiple times, each one slightly offset.

The total impression is also supplemented with acoustic feedback that is produced from short samples. These are taken from recorded, typical signals from the electrocardiograph, the hysteroscopy pump, artificial breathing, as well as warning tones when the electrical current is deployed (for electrotomy and coagulation). The acoustic components are assembled in real time according to each simulated situation.

Particular attention should be paid to the design element that the Zurich research group alludes to with the phrase "additional visual details": the portrayal of floating material from the uterine mucosa, fibers of tissue, sediment, air bubbles, or bleeding is realized using two-dimensional, rectangular tags—"billboards," in the developers' terminology.

The simulation of bleeding in the uterus is an indispensable event for a hysteroscopy simulator.[113] Depending on the type of injury and the size of the affected blood vessel, a trickling or a spurting, a focused or diffuse bleeding is generated. The bleeding is calculated by means of a particle system that effects the desired movement and interaction with the surroundings. This movement is shown using animated tags (figure 3.29) whose variegated texture contributes to the complexity of the overall appearance. The tags are attached to the particles and are built up in layers. With the type of and stage of bleeding, another layer

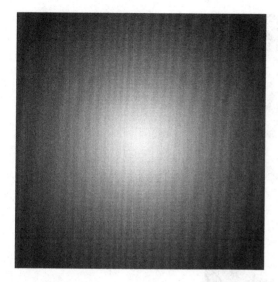

Figure 3.29
A single blood tag that is used in the hysteroscopy simulator. What appears here as a black edge is actually transparent. Source: ETH Zürich/Institute for Image Processing. Kindly made available by Matthias Harders, Institute of Image Processing, ETH Zürich.

successively becomes visible so that the size and texture seem to change over time. Through the semitransparency of the tags, an additional volumetric effect is generated.

These tags—small, two-dimensional surfaces supporting textures—constantly keep their front side turned toward the endoscopic camera. Figure 3.30 shows the view that the trainee experiences in the simulation. Floating fragments of tissue appear in the visual field. In figure 3.31, the same scene is shown from a viewing angle that is not possible in the simulation. One can make out that the tiles are flat and always position themselves orthogonally to the inserted instrument with the camera. This design solution is motivated by its generation of the appearance of three-dimensionality without necessitating the correspondingly intensive calculation. Nevertheless, more movement is present than the trainee can see, since his or her own change in camera angle makes all the tags react, while conversely ensuring a constant appearance for the viewer. The movement carried out by the tiles with respect to their orientation keeps them facing the viewer; with respect to their locomotion, they obey gravity (bubbles rise) and act according to the movement of fluids in the uterus, in cases where a particular technique is simulated in which the uterine cavity is filled with fluid during the operative intervention.[114]

The presentation of small graphical entities that take into account the simulated dynamic as well as the movement of the camera is widespread. As with the hysteroscopy simulator at ETH, with URO-Trainer Pro[115] (1999–2005) from Karl Storz GmbH & Co. KG, one sees on

Figure 3.30
Floating fragments of tissue from the "virtual" camera view. Source: ETH Zürich/Institute for Image Processing. Kindly made available by Matthias Harders, Institute of Image Processing, ETH Zürich.

closer scrutiny that the blood is composed from particles in the form of semitransparent, quadratic graphics: here, a tag is not constructed uniformly and concentrically, but follows a different template. In their overlapping, the tiles produce a finely gradated, at times intense, red. Because of their small size and often fast movement, it is apparent that they are rectangular tiles only when one zooms in very close with the endoscope.[116]

3.3.2 Special Effects

When one reconstructs the process through which surgery simulators are made, it quickly becomes clear that all their components are of a highly artificial nature. Surprisingly, in the related trade publications, some of their elements are identified with the term *special effects*. At first, this seems absurd. Then one notices that the term is never applied to the organs of the surgical situation; rather, it is consistently used for something fluid, gaseous, or granular. In any case, it is something that does not have any larger, fixed corporeality but rather is released (smoke, bubbles), secreted (bone graft, blood), or introduced (water for rinsing). Special effects refers to the mobile entities that enhance the relatively immobile aspects of the scene. The term may suggest that in these places, a luxurious, impressive

Figure 3.31
Floating fragments of tissue orient themselves to the "virtual" camera on the instrument. Source: Kindly made available by Matthias Harders, Institute of Image Processing, ETH Zürich.

perfectionism has been practiced in order to create a visual spectacle. To some extent, this is the case, but special effects in simulations primarily promote interactivity. They not only complete the visual impression, but also facilitate understanding of events and at times elicit actions. Special effects can indeed be employed as something materially consequential; for instance, an accumulation of thick smoke can compel cleaning of the impaired camera lens, or bleeding can necessitate interrupting the planned step in the surgery in order to suction the fluid.

However, the riddle of this term has not yet been solved. The appearance of the expression *special effect* in completely artificially generated scenarios becomes comprehensible only when one assumes that this terminology has been adopted by computer-based modeling, but originates in practices and models in which the movement of fluids in fact required special tricks. This thesis can be confirmed. A further excursion into medical pedagogy demonstrates the interest in incorporating dynamic situations into static, haptically tangible models in order to enhance their use. Even before the introduction of computer technology, attempts to "dynamize" material models are in evidence. Traditionally, students learning surgical sequences practiced on animal models, cadaver models, or plastic dummies.

These three-dimensional life-sized models allow for important impressions, such as touch and occasionally smell, as well as multiperspectivity. Dead animals or humans as well as plastic products, however, have the considerable disadvantage that their tissue does not display any of the usual bodily functions. In order to compensate for this deficiency, they are combined with mechanical, hydraulic, or electronic equipment, such as pumps, hoses, pneumatic bladders, or fiber-optic cables. These enable the registering of changes or the animation of artificial tissue and allow the generation of physiologically interpreted processes such as heartbeat, breathing, or blood flow.

An example of the latter is the training unit compactEASIE (Erlanger Ausbildungssimulator für die interventionelle Endoskopie).[117] This analog training station enables practicing minimally invasive interventions in the field of gastroenterology, and thus pertains to the digestive system. It consists of a blue, horizontally mounted plastic underlay in which a simplified human outline can be seen in high relief (figure 3.32). In it are recesses for the stomach with the beginning of the intestines and the esophagus, into which a specially prepared group of pig organs can be inserted and attached with sutures.

It is crucial that this training unit made from artificial and organic material not be considered a so-called static model. Its unique feature, according to its developers, is the generation of pulsating bleeding, which for the first time enables step-by-step training in the endoscopic treatment of a potentially life-threatening acute situation.[118] In the exercise (whose physical

Figure 3.32
Training for endoscopically executed hemostasis with the CompactEASIE. Source: Institute of Medicine, University of Erlangen-Nürnberg. Courtesy of Jürgen Maiß, Erlangen.

setup can be seen in figure 3.32), student doctors are confronted with bleeding in six different places in the stomach. To prepare this exercise, the pig stomach is perforated, and segments of splenetic arteries are sewn in terminally. These tube-shaped lengths of blood vessel are connected on the outside—thus invisibly from the perspective of the students, who are looking through the endoscope—to a cannula. This in turn is attached to a system of hoses leading to a roller pump, with which artificial blood is set in motion.[119] With the Erlangen training unit, the built-in pump thus enables introducing movement. A "special effect" is thereby rather laboriously generated for these preexisting materials—thus, an effect that the dead or artificial organs no longer can produce "on their own."

These enhancements attest to a demand for sophisticated techniques in the design of reactions and consequences. And it is precisely this, the preparation of reactions, that is a strength of dynamic computer simulations. The computer enables the generation of increasingly complex dynamics and on this basis compensates for its substantial shortcomings in the creation of tangible materiality, so that even a "materials-based" discipline such as medicine relies on it. Dynamization is therefore an important aspect and the second need that we discussed above. In computer-generated scenarios the need for dynamic has by no means diminished; dynamization is taken up by the mathematical model. The excursion to previous, analogue training units enables better understanding of why the term *special effects* is used within a completely artificial world.

3.4 Two Types of Models

3.4.1 Two Needs and Two Types of Models

If the need for dynamization is met by the mathematical simulation model, which entity meets the fundamental need that was first brought into discussion: the need for sensorialization? We have been extensively concerned with showing what the partially free-standing nature of the iconization consists of. We have also suggested that the iconization is essential for access to the data. The question posed here aims at the basis of the sensorialization, which enables the latter to be brought into a situation in which the viewer can act.

We posit that the consideration of another type of model can give information on how the iconization functions with respect to interactions because a pragmatic characteristic can thereby be introduced. This other type of model appears in the medical examples already discussed. In the crude division of models that is frequently undertaken, this type is identified as the "other" in opposition to the mathematical model (in the scholarly discourse, no unified terminology exists for it). While this type of model is given different names, its characterization implies that nonetheless, the line of thinking being pursued is similar: the idea involves those haptically tangible objects that are constructed with the intention of making a model. These are called "physical models," "material models," "phenomenological models," or, in the case of shifts of (every conceivable) scale, "scale models."[120]

Ian Hacking, for example, finds suitable language for these two model types: "Some nineteenth-century physicists made similar hold-in-your-hand models of the inner constitution of nature, models built with pulleys, springs, string and sealing wax. Most generally, however, a model in physics is something you hold in your head rather than your hands. Even so, there is an odd mix of the pictorial and the mathematical."[121] Unfortunately, he does not explain further what he means exactly by an "odd mix of the pictorial and the mathematical." However, it can be gleaned that both model types stand in close relationship to "something you hold in your (mind's) eye."

We are primarily concerned with computer-based models. Until this point and also subsequently, when the "mathematical model" is discussed, this is intended to mean the executable simulation model that in English is often—but not always—referred to as the "computational model." The type of model that is opposed to this is spatially distinct in its functioning and defines the geometry of objects. To contrast this second type of model with material precursors[122] and emphasize the transfer into a "virtual" realm, through however complex means, it is often called a "computer model." "If virtual modelling claims to surpass and threatens to efface physical modelling, at the same time it draws on the earlier techniques and lends enchantment to their products. ... The displays owe much to physical models and their depictions in print."[123]

This is a crucial observation. If it is said that computer models in general are based on material precursors, this is not meant in the literal sense, as a direct line, and also not as a mandatory reference to some particular preceding real or haptic variant. Computer models seem able to draw from these "handy" objects although they are generally received on a monitor screen (at best, as projection views of a 3D object).

3.4.2 Two Modeling Traditions and Practices Come into Contact

The appearance of aggregations and tangible entities in the frame of computer simulations allows for practices that are familiar from another, though related, context: modeling with materials. This related cultural technique provides modes of use and approach along with strategies for making the invisible visible, which, for instance, are conditioned by materiality and relate to the models' tool and object character. Through a point of view that accepts a connection to computer models, iconization can be annexed in relation to cultural techniques with a longer development. It no longer stands alongside mathematical operationality without its own specific operative capacities. What possibilities for manipulation are also offered when calculated data sets take visual form on the monitor cannot be defined in general; they must be ascertained in detail in each individual case.

Although computer models appear on the computer screen, compared with mathematical models, they are more strongly associated with an objecthood that enables interactive testing and exploration. If the objecthood of these computer models encompasses more than simply being a three-dimensional impression of the items shown, then this would imply their being outfitted with further characteristics. Equipped with these characteristics, the models

are accessible beyond mere (circum-)navigability, and along with the advantages offered by a basis in material agency,[124] they also facilitate research in that these characteristics serve as the reference points for calculation. Simulations are different from "inanimate," reaction-free, "virtual" objects or spaces that are placed at the user's disposal in that they possess a central (additional) component: the mathematical model, which defines those characteristics and relationships that imply transformability.

In the very short text "Where Now with Simulation?" from 1987, the mathematician Bob Blightman predicted integrative attempts to combine complementary software systems. He envisioned that simulations would be linked to computer-aided design (CAD), for example.[125] Both his assessment of complementarity and this prognosis would be proved right.

A good fifteen years later, the philosopher of science Mary Morgan reported that a similar alliance had been realized—except that in this example, it was not CAD but rather medical imaging procedures being used. In a simulation of a steer's hip bone, two types of models were combined: first, the dynamically calculable (mathematical) model that underlies simulations; second, the physically extensional, phenomenological illustration and research object that is specifically created in order to be handled, and which Morgan associates with an experimental setup: "Yet the demonstration … also requires a computer-model representation of the bone, the material to which the mathematical model was applied in conducting the experiment. Thus, models come in twice: there is a model of the intervention and a model of the object, and it is the behavior of the object that is of interest and that forms the subject of experiment."[126]

One is reminded of the denotation-demonstration-interpretation approach of Hughes, who stated that with images (unlike with dynamic models), this second step of demonstration normally cannot be executed because images lack the dynamic from which conclusions can be drawn. But here, the dynamic is present in a visible presentation of bone, thanks to the mathematical model. Conversely, for the purpose of illustration or demonstration, the mathematical model needs a computer model to which it can attach itself, so that both together can show behavior. Thus, the computer model's need for dynamization and the computational model's need for sensorialization intersect here. Meanwhile, these two needs are not located at the same level. The difference lies in an essential aspect of iconicity: perceivability. When one begins with the computer model, this latter is the integrative component in which the mathematical model can lodge itself at different places. The computer model thereby undergoes an expansion into dynamic but is not subjected to any restrictions, since the task areas are separate. For the mathematical model, however, only the iconization allows fundamental perception of the dynamic as an occurrence that can be taken in and comprehended. Unlike in the first case, this has repercussions, in that the iconization massively compromises what aspects of the mathematical model can be perceived.

For an illustration of these thoughts, let us once again turn to the expression *special effects*. Here we should point out a seemingly tiny but important difference. This term is generally used in the theater and film industry and means mechanical techniques with which

particular effects are generated on location, in some cases so that they can be recorded (as we have seen, with simulators these are fluid dynamics). These are contrasted with what in cinematography parlance are called "visual effects," originating in postproduction. In simulations, too, one can also speak in a certain sense of "secondary" design steps. In our cases, this is primarily meant not as a gradation of value but rather in reference to these steps' building on previous ones. In scholarly publications on simulations, expressions such as "secondary visual effects" or "additional visual details" are common. They carry the reference to visuality and hence rightly recall the visual effects of the film industry. It is overly hasty to equate these visual effects with special effects. In simulations, "special effects" denotes the dynamics in certain scenarios for which a topological tectonics is first of all in place. The tags or, as the hysteroscopy simulator's developers call them, "billboards," that go hand in hand with these calculated dynamics are actually visual effects; in a manner of speaking, they are iconization procedures for special effects. In other words, as visual effects (or graphic elements), the image tiles facilitate the sensorialization of special effects such as the movements of fluids.

We have thus stated that in the frame of interactive simulations, two needs emerge, each of which is taken up by a type of model or an entity based on this model type. While the barely discernable corpuscle images are swept along in the flow of movement of special effects, with larger corporeal units, dynamic deformations are enmeshed in their "tissue," so to speak. Despite this interlocking of image and movement—broadly speaking—the primacy of perceivability in interactive simulations weights these two elements differently.

Philosopher of science James Griesemer also sees this close interweaving of image and possibilities for intervention in what he calls "interactive computer graphics" as the continuation, with other means and possibilities, of the tradition of models that can be experienced haptically. Griesemer detects a shift in meaning when computer simulations begin to make use of practices that typically are carried out with three-dimensional models. The reference then shifts from spatial, material objects to two-dimensional representations that are visual portrayals of three-dimensional information, in particular in the case of interactive graphic presentations on computer screens. Griesemer stresses that the use of a language of three-dimensionality for the description of images that are effectively flat, as well as the associated, mutually interconnected visual and tactile experiences, are a challenge for philosophers of science. In his opinion, interactive graphics conceptually fall between the static, two-dimensional depictions of traditional graphics and the dynamic interactivity of three-dimensional objects. The new graphics are distinguished in their freeing the user from the restriction of a compulsory single viewpoint and permitting rotations as well as other manipulations on the computer screen. Tactile and visual impressions can be linked through input media. Griesemer writes further, "Although interactive graphics extended the tradition of physical modelling, they also constituted a new mode of interaction with numerical data, allowing users to intervene kinaesthetically in the simulation process."[127] Two model traditions are thereby also combined in their different priorities and goals, with their different predispositions, attitudes to materiality,[128] and techniques of manipulation, in order to supplement

each other, without their needs being exactly complementary. Through dynamic models aspiring to perceivability and computer models to dynamization, in their fusion, something with new qualities emerges. In that regard, in discussing interactivity, Griesemer says, "This is terra incognita for conventional philosophies of scientific knowledge."[129] The product of this fusion is above all characterized by sensory aspects. The reasons for this are, on the one hand, because the spatial/sensory aspect of material models is necessarily transferred into a mathematical formalism in the computer, but in the process does not entirely lose its sensory qualities; and on the other hand, the mathematical constellation is made at least partially perceivable through its execution. Our objective is not to attempt to draw the boundaries between the spheres in which the mathematical and the computer-based/haptic model can have an impact. It is more exciting to ask what ensues from a view that assumes that here, two fundamentally different model types come into contact, with the assistance of the computer. It would also be an exaggeration to assert that in real-time simulations, both aspects (model types) as they are used also stand alone and can be isolated as fully fledged types of models.

When we take the mathematical model as the starting point, then, for example, the individual figures that are used in the population simulation are certainly not free-standing computer models in the sense of complex spatial configurations with model character; what matters is their combination, that is, their grouping with other agents and the dynamic aspect. But they manage to aggregate a particular set of numerical values and characteristics, make this set of values addressable as an identifiable entity, and, in combination with the overview that is also provided, enable a meaningful intervention that is relevant to the content.

Conversely, when we take the computer model as the starting point, it is striking that often, different mathematical models are welded together in a way in which they never would be combined without that particular modeled scenario. This implies that they tend to serve as auxiliary to the other components. They too make their contribution to interactivity, in that through enabling reactions (e.g., in the form of special effects), they expand the possible spectrum of intervention.

Mathematical and material variants of models existed long before the computer era and are also the especial benefactors of interactive real-time simulations. In comparison to the ancestral forms in which they originated, these model types are able to profit from one another in combination. In observing the applications, one can certainly detect which of the above outlined model types serves as the starting point from which an "enhancement" is then sought.

4 Iconicity and Dynamic

4.1 Figurative Displays

I realized, I say to Blum, that a dog's head was sticking out of the wastebasket there—I think it was a gigantic wolfhound, with big pointed ears that kept changing color.
—Friederike Mayröcker[1]

In chapter 3 it was stated that between simulation dynamic and image, the process of sensorialization needs to be taken into account: if one wants to follow the sequences of events, they must be put forward by means of sensorially perceptible elements. This rather production-oriented approach started with the calculation data and moved to the iconization. We underlined "graphic elements" as aggregating image particles by means of which the dynamic "takes action." These particles allow the dynamic to take place as a spatial distribution. However, it is not always (or only) the case that a change of location is presented by means of elements that are static themselves. In cases where these elements themselves are transformed by the calculated data, we speak of "displays." By exploring another aspect of the presentation of simulation dynamics from a function-oriented standpoint, an additional qualitative characterization of the relationship of iconization and calculation comes into view.

The simulation dynamic is one possibility of temporal formation: the calculation results mean changes, of whatever kind. Very different things can be in progress and be shown by means of displays. For instance, if one simulates an agent's moods, this is what is shown and, not infrequently, through a depiction of the agent's body. Thus, it can happen that "internal" factors are revealed on a figure's exterior. A discussion on the relationship of morphology and function in iconization could be tied in here, as is particularly pressing in fields such as systems biology; however, we cannot engage in this discussion now. Instead, in the second

part of this chapter, we will identify additional sources of movement in simulations. Then we will look from the opposite direction—from the standpoint of movement—and ask what causes it. Generally, there is not only one single kind of dynamic in simulations, and therefore also not only one cause of events. The idea of movement as a design element places the creation of sequences at the center of focus. In order to pursue the implementation of movement as a component of design, various aspects and types of dynamic must be individuated. In addition, in some cases, it is important for a critical assessment—or for a responsible approach—to be aware that in sensorialized simulations, not all perceived dynamics refer back to the simulation model.

We will approach the function of displays with an example from research on artificial life (AL), since this field offers ideal material for studying how internal states and morphology can be connected.[2] Many evolutive approaches in AL research combine the development of the "brain" and the "body."[3] Karl Sims's approach in his work *Evolved Virtual Creatures* (1994) is famous.[4] Here, predators, in this case compound formations of rectangular blocks, compete for prey. Sims's work has served as inspiration for countless successor projects. One of these is the simulation environment *Framsticks*, developed since 1997 by Maciej Komosiński and Szymon Ulatowski at Poznan University of Technology, based on a graph theory approach. The individual agents live in a three-dimensional world that users can design as they choose using flat surfaces, hills, and lakes. The world is governed by simple physical laws such as gravity and buoyancy (figure 4.1), with which the creatures have to contend in the course of walking, jumping, throwing objects, swimming, and taking nourishment. Although this world is extremely simplified, in execution, phenomena are very quickly generated that are so complex that—regardless of the fact that the presentation of movement is tailored to the speed of human perception—one can no longer automatically follow. Since an understanding of events is considered central for the further development of the simulation, it is essential, according to Komosiński, to make as many supporting programs available as possible. A comprehensible "visualization" is one of the most fundamental means for understanding artificial life forms because, as Komosiński says, they can be observed in their development across generations or in their individual actions.[5] It is for this reason that interaction on the part of the user is also allowed, although evolution in principle should happen by itself, and although it could be rightly asked what role external intervention (in the picture, as a mechanical arm from above) can play in this world (figure 4.2). In the name of the advancement of knowledge, users can design their own creatures or interfere with existing ones: bringing them to life by introducing them into the world; killing them by removing them from the world; feeding them by placing energy sources; provoking conflicts. "As *Framsticks*'s interface may show simulation in real time, responses to user actions are instantaneous and highly visual. … Through the process of interactive experimentation, users can develop an understanding of some of the fundamentals of evolutionary dynamics."[6]

Figure 4.1
A sketched example of forces in effect on an individual in *Framsticks*. Source: Komosiński and Rotaru-Varga, "Comparison of Different Genotype Encodings," 398. © Maciej Komosiński and Szymon Ulatowski, *Framsticks* website: www.framsticks.com.

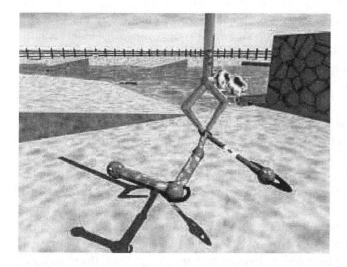

Figure 4.2
The user moves a creature in *Framsticks* by means of a "robotic hand." Source: Kindly made available by Maciej Komosiński, Institute of Computing Science, Poznan University of Technology. © Maciej Komosiński and Szymon Ulatowski, *Framsticks* website: www.framsticks.com

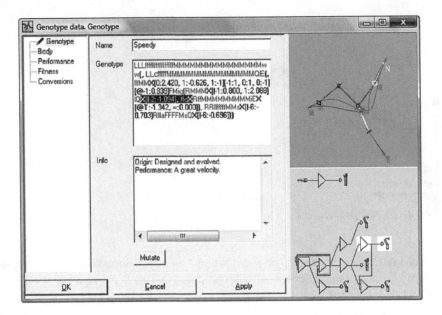

Figure 4.3

In *Framsticks*, the windows in the center give the name and the coded genotype, as well as a brief description of the creature. Next to them on the right, above, the creature is depicted in its neuronal connections and its body. Source: Kindly made available by Maciej Komosiński, Institute of Computing Science, Poznan University of Technology. © Maciej Komosiński and Szymon Ulatowski, *Framsticks* website: www.framsticks.com

In general, the creatures of *Framsticks* consist of a set of standardized components (figure 4.3), including a "body" and a control system called a "brain." The windows in the computer program are correspondingly titled (figure 4.4). In the "world" window the user can watch the creatures encounter, shove, injure, or even devour each other (figure 4.5).[7] The particular calculation results are demonstrated in the agents' perceivable form as actions being carried out (figure 4.6).

In addition, on closer observation one notices that for each individual creature, there is something to be deciphered: skills are externalized so they may be "read." This means that the bodies and everything applied to them are invested with meaning.[8] Thus, the observer is given some symbolic reference points. He or she can gain a better instantaneous understanding of the creature's movements by decoding their underlying characteristics. It is intended to be evident, for example, why a fight turns out the way it does and not differently, and to what extent a characteristic proves itself, from an evolutionary perspective, on the basis of the movements it determines and their cause. Those characteristics—parameters (or potential criteria of evaluation) that are to be seen as significant and thus are definitively being put on display—are cataloged in a graphic summary (figure 4.6).[9]

Figure 4.4

Program view in *Framsticks* with the embedding of the creature in an environment. The diagram at right shows the neuronal network, composed of triangles symbolizing neurons. To the right of the neurons are icons of effectors (rotation and bending muscles), and to the left are icons of sensors. What is selected is shown on a white field. The particular effector is also indicated on the creature's body by a small white circle. The four smaller windows show signals produced by neurons (that the user selects). Source: Kindly made available by Maciej Komosiński, Institute of Computing Science, Poznan University of Technology. © Maciej Komosiński and Szymon Ulatowski, *Framsticks* website: www.framsticks.com

In the iconic presentation, there is no clear qualitative distinction between attributes of morphological parts and those of neurons. Neuronal and bodily/kinetic structures merge as if they were of the same kind. Thus, muscles, here conceived as neuronal elements, are to be seen in both the "brain view" (where they belong) and the "morphology view." By means of structures that are visible on the body (which is the depiction of "external" features), the presence of "internal" functions is shown. Through number or size, it becomes evident what is present as a predisposition in what quantity or strength; in this way, the mode of presentation accommodates the parameter settings. As noted, we will not carry the debate about the blurring of morphology and function any further here. Rather, we are concerned with another difference: the demonstration enacted on the body that there are characteristics or functions (as evidence of a skill), and the showing of their effect in the form of the

Figure 4.5
Antelope (left) attacks Spider in *Framsticks*. After the deadly collision, Spider is presented as ash gray, broken into pieces. The dead creature (right) gradually changes into nourishing balls of energy. Source: Komosiński and Ulatowski, "*Framsticks* Pictures," in Komosiński and Ulatowski, "Framsticks: Artificial Life for Real People," in http://www.framsticks.com/a/al_pict.html. © Maciej Komosiński and Szymon Ulatowski, *Framsticks* website: www.framsticks.com

Figure 4.6
Top row, from left to right: "Average" stick without specialization in *Framsticks*; specialized for adaptation; specialized for taking in food; robust stick; rough stick with a good grip. Bottom row, from left to right: smooth stick with little friction; stronger muscle for fast movements; equipped with a sense of balance; equipped with touch-sensitive feelers; equipped with a sense of smell. Source: Komosiński and Ulatowski, "*Framsticks*: Visualization Explanation," in Komosiński and Ulatowski, "Framsticks: Artificial Life for Real People," in http://www.framsticks.com/a/al_visual.html. © Maciej Komosiński and Szymon Ulatowski, *Framsticks* website: www.framsticks.com

movement of this structure, are not the same thing. For the dynamic presentation of conse-quences, the "display" is put forward as an entity in which the calculation results can play themselves out through their embedding in a motif.

Here, the term *display* designates an iconic element that exhibits a variability in what it shows demonstratively. The concept draws from the term's connotations in the four fol-lowing contexts: in technology, it refers to a "device for the optical signalizing of states and values";[10] in sales, the elaborate packaging of small articles or shop window design, which as a rule changes seasonally; in biology, a special behavior pattern for communicating by means of optical signals;[11] and in medicine, "to display an illness" is to manifest the symptoms phe-notypically. It is constitutive of the display that it varies. It changes by taking on different formations that are applied to it from somewhere. It is important to note that it is one iconic element, not many, that appears in various stages or states.

One prominent site of displays is advertising for mass consumer goods. For example, when a whole range of versions of a product is presented by means of a single photograph, this is a display in our sense of the word. To show a spectrum of variations or to demonstrate the effects of use[12] (as in before-and-after comparisons), it is often not one item of each sort or each test phase that is depicted; instead, a photograph is edited in a graphics program.[13] This principle is most readily exemplified in a practice that is widespread in analog and digital mail-order catalogues: from the drape of furniture upholstery or clothing, it is plainly evident that one source image is being used multiple times. Changes are made with respect to size, color (figure 4.7, also common in laundry detergent advertising), form (diet advertis-ing), and other characteristics. Even when these images, in pairs or multiples, appear next to one another in printed matter, through the obvious use of a single basis, their fundamental suitability to exemplify these variants one after another is underlined. One could also say that the initially cited semantic nuances (of "display") have in common the presence of an entity by means of which something is explicitly given to be seen. There is a site or ground with the function of a formed standard in relation to which some selected characteristics are varied.

The recognizability of a body or form under the auspices of temporality and virtuality is quite complex. Its being possible in the first place is credited by the philosopher Hans Jonas to the unique quality of the eye: "The sense of sight allows the greatest freedom of representation, not only through the wealth of data to choose from, but also through the number of variables that admit its identities. [... These can include location and perspec-tive, size and completeness of details, variations of color and brightness, etc.]. Through all these sensory variants, the form remains identifiable and constantly represents the same thing."[14]

As Jonas himself notes, this thesis is accompanied by an idea of "form" whose identity is based only on the relationship of its parts. Jonas's observations relate to perception, through the constitution of which one is able to cope with images' showing of only some aspects. However, daily experience is the reference point for the frame of transformability. "What is

Figure 4.7
Detail from an advertising flyer showing the very same photographic image three times, as the magazine lying on the lounge chair reveals. The color and size of the source are altered on the computer, and the three images are then placed side by side without regard for implausible overlappings. Source: Euro-BRICO advertising flyer for South Tirol, products on offer from April 20–May 11, 2007, p. 9.

equated in such acts of recognition are not similar conglomerates of sensory data, but rather variant phases in the constant transformation series of a 'gestalt' or configuration. ... The sameness of the configuration as such is perceived through the entire spectrum of its *possible* optical transformations—and this multi-dimensional series, which has its formal and qualitative laws, itself represents a gestalt of a higher order."[15]

In the display, this "sameness of the configuration" is also present, even if the changes to it that are exposed cannot be explained purely by the different "gestalts of vision" that could result from changes in lighting or point of view.

These iconic instances of showing also occur in simulation. The particular changeability of displays in simulation scenarios can be attributed to this form's complex relationship of parts and the relations of the dynamic model. Despite the generosity of the eye, the limits of recognizability are reached here when the changes result from parameters that do not correspond to anything in perceptual experience. For instance, when "internal" force impulses are exhibited on the exterior of a bodily form, a testing of exactly this limit of recognizability can ensue.

Figure 4.8

In Mathias Fuchs and Sylvia Eckermann's *fluID—arena of identities* (2003), the user-avatar receives different identities in the form of clothing and hairdo. This montage of stills from different points in time shows how a user maneuvered her avatar into the "River of Heraclitus." Source: Courtesy of the artist. Screen shot © fuchs-eckermann, 2003.

In simulation scenarios, displays overtly present different successive states. The temporal sequence of events as the type of movement that will now concern us responds to various types of driving forces. In the game *fluID—arena of identities*, which we will examine more closely at a later point, movement (the avatars' costume changes) is caused by visiting particular locations in the scenario, for example, by stepping into the "River of Heraclitus" (figure 4.8). In some cases, the changes to a given figure are initiated by scripts (as with patients of *Virtual Emergency Room*);[16] in others, by dynamic models. The latter are of particular interest to us. In these cases, the figures change when the data flowing into them change.

Unlike in *fluID—arena of identities*, where prefabricated textures as articles of clothing surround a clearly discernable volume (head, torso, legs), in places where simulation data can come into appearance, the display in some circumstances is much more closely interwoven with its different expressions through changes of form. This makes it easy to forget that data are behind it. Even if the mise-en-scène of a figure may conceal this fact, the main purpose of the display as an element of short-term data storage is to be consulted about the data.

One example of an applied dynamic model is the simulation *Psi 4.9.1.310 Random*, which was made public around 1998 at the Institute for Theoretical Psychology of the University of Bamberg.[17] Its conception serves the investigation of hypotheses on the interactions of cognition, emotion, and motivation. The application simulates the decisions of James, a

Figure 4.9
The group of windows on the left in Dietrich Dörner and Jürgen Gerdes's *Psi 4.9.1.310 Random* (ca. 1998)
shows motives, emotions, and modulations. In window at bottom left, the coded emotions can be seen
in the pull-down menu. The large window in the middle depicts the overall topography of the island.
The networked dots are places that the agent can occupy; here, his position is indicated with a shaded
dot and with a vehicle. The neighboring white dots indicate which positions are reachable with a single
move. What exactly can be found there is shown in various zoom shots in the small windows flanking
the face. The image of the face codes the emotions. To the right, a description in key phrases presents the
agent's decisions. Source: Author's screen shot. © Dietrich Dörner, University of Bamberg.

"virtual" agent equipped with artificial intelligence, who is living on an island and is solely
responsible for his own energy supply while attempting to complete his mission: to gather
as many "nucleotides"[18] as possible. The simulation results can be instantaneously followed
in various windows on the computer screen (figure 4.9). During the simulation's execution,
the user can track many different values, including those of the emotions, using graphs or
bar charts. The emotions are also portrayed in a model with a human face, including facial
musculature. The face is constructed from 262 points, 35 lines (Bézier lines, each connecting
four points), 138 fibers (consisting of a beginning and an end point), and 14 muscles (con-
sisting of multiple fibers).[19] In constant frontal orientation, the face is two-dimensional and
makes do with a few characteristic features (figure 4.10). In this way the objective is pursued,
on the one hand, of examining the relationship between internal emotional parameters and
states of the body's musculature and on the other hand, of giving the user an inside view
of the agent's state of mind while he carries out his mission. The user can observe changes

Figure 4.10
Different facial expressions of Psi. Source: Kindly made available by Dietrich Dörner, Institute for Theoretical Psychology, University of Bamberg.

in facial coloring (white at the outset, flushed when ready to act), shifts in position of the eyebrows and corners of the mouth, the appearance and disappearance of wrinkles, and the opening and closing of the eyes and mouth, for example. Eight "constellation values" flow into the emotion model (*EmoRegul*):[20] pain, activation, surprise, anger, happiness, fear, sadness, and helplessness. These are parameters that bring many hybrid emotions into expression by means of the facial form. The modeled concepts determination, skill, and affiliation add their governing influence. Values from the implemented emotion model are multiplied[21] with additional factors, and the result is conveyed to the virtual facial muscles, so that the positions of the points change with changes in value. The facial expressions are based on the different states of contraction of the facial muscles. Figure 4.11 shows three states, whereby the applied circles and lines are "either attachment points for muscles or component muscle fibers, or else the points of skin fold lines, which result indirectly from the contraction of certain muscles."[22]

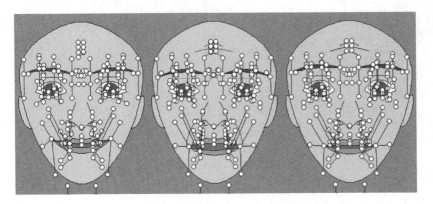

Figure 4.11
The position of the tips of muscle fibers in different emotions in a two-dimensional face, 2002. Source:
© Dörner et al., *Die Mechanik des Seelenwagens*, 222. Reprinted with permission of Verlag Hans Huber.

The manner in which the window with the face is embedded in the program's user inter-
face reveals that this is just as much a display as the windows with graph diagrams. In fact, it
is also described as such.[23] The information in the individual graph diagrams comes together
in the face. One may realize that the data are brought into a certain light through this inter-
pretive aid. The display is the site at which the values of the simulation are guided into
predetermined channels. Harald Schaub, a psychologist at the Institute for Theoretical Psy-
chology in Bamberg, also addresses this: "If a theory, or at least a part of one, is formulated
directly in the form of a computer-simulated model, along with the total formalization of
the theory, possibilities also (almost) automatically result for making the postulates of the
theory more readily comprehensible and for finding ways to relate the theory to reality, for
example through the means of *graphic illustration*, demonstration of the *temporal dynamic*, or
the production of *behavioral data* by the computer model."[24]

The reference to "relating the theory to reality by means of graphic illustration" gives
emphasis to an essential point: it stands to reason that the display—beyond standard-
ized diagrams—is chosen so that it already situates the data to be presented in the con-
text that is desired or that is assigned to it in order to facilitate interpretation. It thereby
represents a metaphorical visual variable wherein the data are expressed. In cases of figu-
rative displays, the recipient will fuse these data with the particular form of the display,
making a no longer separable unity. It is precisely for this reason that the nature of the
given ground is so important. It shapes the impression that the data are able to convey. This
is best seen through a comparison in which different displays are supplied with the same
data.

In 2005–2006, in her master's thesis, the computer scientist Irene Schindler attempted
to take the same model for emotions that serves as the basis for *Psi 4.9.1.310 Random* and

Furcht

Figure 4.12

Comparison of the two-dimensional face with the corresponding three-dimensional variant, 2008. The 2D face is intended to express fear ("Furcht" in German). This emotion is not strongly conveyed in the image; with the 3D face it is no longer possible to depict this emotion with the same parameters. Source: Schindler, *UNIQUE,* 107. Courtesy of Irene Schindler, University of Koblenz-Landau.

apply it to a three-dimensional depiction of a face.[25] For the virtual head, she modeled three layers: a rigid skull, the skin on the surface, and in between a spring-mass system of so-called action units, which aggregate bundles of muscles for a facial expression according to the standardized Facial Action Coding System. It is interesting that Schindler was not able to adopt for the three-dimensional variant the parameter settings established for the two-dimensional face because these settings did not allow the intended expression to appear. A comparison makes this evident (figure 4.12). While in the two-dimensional face, devices—such as lines for creases—can be employed for an optical transformation of facial features, these techniques in a three-dimensional face are not accepted by the viewer. But without the assistance of such measures, according to Schindler, with the same execution of surface deformation, the three-dimensional face remained inexpressive. Hence, it was necessary to recalibrate the parameters, whereby photographic comparison pictures were useful.

According to which display is used, whether it is oriented to two or three dimensions, the data sets come to bear differently. Therefore, adjustments have to be made to suit the selected ground.

The role of displays in simulations cannot be overestimated, since these are precisely the entities that bring the calculated dynamic into appearance. With displays that operate through a figure, it becomes clear complex processes are involved that exceed the notion of a simple transfer of data into the sensory. The simulation results undergo a "trans-appearance,"[26] a "trans-figuration"[27] into a perceivable mode. This is a gestalt, speaking with the psychologist Wolfgang Metzger, which, as the form of a structure, "rests on an equilibrium of forces (tensions, etc.)."[28] These forces can shift in relation to each other, but they always remain within a certain frame. The display is connected with indeterminacy in order to be able to take on "expressions." As a figurative medium, it has a strong preforming tendency and will not absorb everything. What it does absorb is necessarily viewed in the context of its gestalt. Specifically of interest about the display is that it exhibits changes only within its own formal boundaries. These can delimit a very general form, as is often the case with technical displays or shop windows, or it can take on a figurative character, so that the "frame" as the mise-en-scène or stage of expression has a stronger preforming tendency. The display is an "event-object." This means that like any other body (or form), it has characteristics that remain constant over time. However, in another respect, related to its dynamic nature, it changes, is an event. In this context, the philosopher Roberto Diodato raises the fundamental question of what conditions give rise to changes that are things.[29]

When a figurative display appears in a larger figurative configuration, intra-iconic differences can be marked. The insertion of displays as "showing grounds" in a sensorially presented, simulated scenario and the resulting consequences should be examined more closely from the standpoint of iconization and situation formation; they do not, however, essentially contradict unity in mathematical modeling. The idea of the iconic preforming of what appears in these displays could be extended to the simulation as a whole and simulators understood as "electronic display windows"[30] that show postulates that can be comprehended visually.

4.2 Movement as a Design Element

The following sections are dedicated to case studies of various real-time simulations that promote discussion of the use or generation of movement as a design element. Where do dynamics appear? What combinations occur? What is their effect? The following analyses permit substantial insight.

In the first example, the elements of presentation for the agents are fixed. Thus, the calculated changes can only be inferred from the manner of behavior that the rigid graphic element carries out as a whole. At the same time, in a particular mode of presentation,

something else is in constant turmoil, so that it becomes clear that the display should not be imagined in exclusively anthropomorphic form; rather, it can also be conceived entirely differently, for example, as the ground. The fact that the ground reflects an agent's concerns also raises the question of where the body ends. Why should the conception that computationally relates to the body end at the surface of the skin in the sensory presentation?

The second example, *double helix swing*, brings this problematic forward in a more pointed fashion, in that environmental forces—and thereby also a principle of construction—are made qualitatively visible in the "animats."[31] These displays serve as bodies and at the same time reflect the calculation values pertaining to them at the moment. Thus they also have a quantitative aspect.

4.2.1 Spatialized Abstractions in Motion

The presentation often stays close to the calculation data of the mathematical model. These data do not by any means have to correspond to what is experienced as changeable or mobile in reality. Changes can also be put on view that do not correspond to any real movement. How two fundamentally different occurrences are twinned, through the mode of presentation, to one type of parameterization is well demonstrated in an early and very simple simulation of social behavior. The structure of the simulation discussed in what follows roughly corresponds to that of cellular automata.[32] The classic situation of cellular automata, along with the "game of life" and the "prisoner's dilemma," is the "party." A simulation of this type was also developed by the computer artist Richard Goldstein (alias Rich Gold) in 1982. His *Party Planner* was presented by Alexander Dewdney in the latter's magazine column, "Computer Recreations,"[33] along with two illustrations. The first appears as a series showing different stages of calculation. To be seen is a grid structure—as is standard for cellular automata—of 20×30 units (figure 4.13). The coordinates of the topological structure correspond with quantities that are negotiated in the model. The grid is called "space."[34] The plus and minus signs on the corners and edges, respectively, show that this is a closed space with no escape. To the left of center is an immobile, rectangular table (with refreshments, as can be read in the accompanying publication). Each person is represented typographically with the initial of his or her first name—which is also the initial letter of the person's occupation (Arthur the artist, Bernie the businessman, Dennis the dentist, Millie the model, Penelope the princess, Susan the stockbroker, Viola the violinist, and Wally the weightlifter)—in a shaded box (cell), and each has a preferred distance to the table and the other people. For each step of iteration, the people can move one box in eight possible directions. The simulation can be described as a search for social equilibrium in which each person strives to attain his or her optimum; because of their conflicting desires, this cannot always be conclusively achieved. Whether the dynamic reaches a stable state depends on parameters established at the outset.

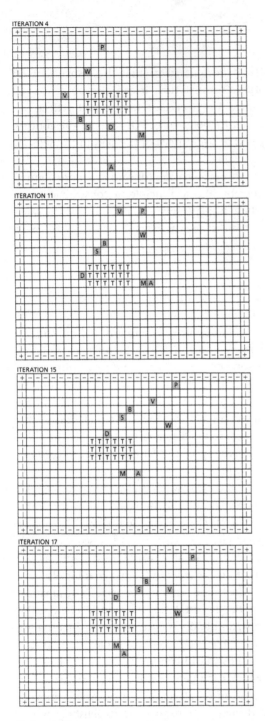

Figure 4.13

Four phases of the program for Rich Gold's *Party Planner* (1982) as it runs (1987 image). Source: Dewdney, "Computer Recreations," 105. Reproduced with permission. © 1987 Scientific American, a division of Nature America. All rights reserved.

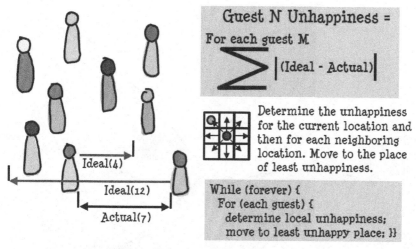

Guest N Unhappiness =
For each guest M
$$\sum |(\text{Ideal} - \text{Actual})|$$

Determine the unhappiness for the current location and then for each neighboring location. Move to the place of least unhappiness.

```
While (forever) {
  For (each guest) {
    determine local unhappiness;
    move to least unhappy place; }}
```

Ideal(4)

Ideal(12)

Actual(7)

The Party Planner.

Figure 4.14

Sketch that explains the engine of movement for *The Party Planner*. The actual and ideal distance of the guests to each other often do not correspond. Source: Goldstein, *The Plenitude*, 92. Courtesy of Marina deBellagente LaPalma.

In any case, Dewdney describes the eight "virtual" guests that he loaded into the program as constantly in motion. In figure 4.13, only movements are shown, not the parameters that crucially influence the dynamic, which in this case are the desired distances to the individual persons, as well as to the table. For the experiment that Dewdney carried out, these are recorded in a separate illustration (figure 4.14) but are not conveyed in the movement shown. However, one should bear in mind that the program was developed at a time when the artist-programmer still had no access to a graphical monitor. Goldstein had the results of the individual steps of calculation plotted and inspected them on paper.

In his article, Dewdney published a second graphic (figure 4.15), which at first glance one would not think of as a dynamic presentation of a simulation but which he describes as "undulating."[35] How do these types of presentation relate? The differences between the figurative and diagrammatic output seem pronounced. For one thing, the table is no longer present. Further, the sketch is neither clearly oriented to coordinates and divided into separate squares, nor would one have identified it as a depiction of a social gathering. In contrast to the grid, which one could see as the ground plan of an interior space, one imagines oneself here in an open outdoor area. The point of view cannot be located definitively, but is probably to the side and slightly obliquely above the surface of the ground, so that the dimension of height can be deduced. The figures are no longer designated with letters and are also not dressed in party attire but rather are outfitted with the attributes of their profession. They are

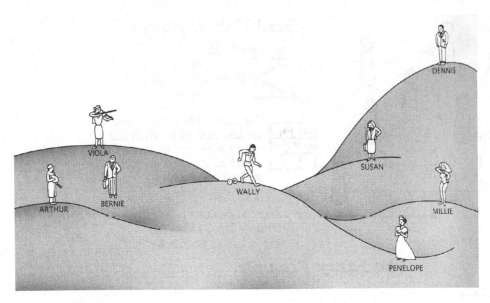

Figure 4.15
Sketch of potential planes, made to illustrate the rationale behind *The Party Planner.* Source: Dewdney, "Computer Recreations," 106. Reproduced with permission. © 1987 Scientific American, a division of Nature America. All rights reserved.

standing still and separate, and thereby convey the impression of having found *their* places, each of which is also marked as such by the hilly terrain (except perhaps in the case of Bernie, who is the only one not standing on an implied platform). Apart from him, however, one could for the time being conceive that in principle the same content is being depicted, with the additional information that the hills might represent.

The drawing makes it seem that as in the case of the cellularly structured depiction, one is looking objectively, from the outside, at the social scenario. In a text about the simulation, Goldstein indicates that this is not so:

> One way to look at the motion of any individual guest was to picture him or her as standing on a surface of hills and valleys. Stated mathematically, he or she was standing on a potential plane. The guest was like a ball bearing and would slide down hillsides into the nearest valley. I called them valleys of happiness. The interesting thing, both mathematically and metaphorically, was that the potential planes undulated based on the positions of the other party goers, who themselves were sliding around on their potential planes. For a party with ten or so guests this was very complex motion.[36]

The illustration is therefore an individual view of the situation, in this case, that of Wally the weightlifter. He is prominently positioned at the center of the drawing and thereby brought forward as the protagonist. It is not for nothing that he is the only one shown in a

The social dance

Valleys of happiness /
Hills of unhappiness

The Party Planner could be re-conceptualized
as a dynamic potential plane problem in
N-dimensions.

Figure 4.16

Sketch for *The Party Planner* that attempts to bring the movements of individual guests into connection with the potential planes. Source: Goldstein, "The Plenitude," 94. Courtesy of Marina deBellagente LaPalma.

walking pose. Wally seems to be heading single-mindedly in the direction of Penelope the princess. If he stops when he gets near her, then he will be located in his personal "valley of happiness," while from the princess's point of view, at exactly that moment, she will be high on a hilltop, wishing herself far away. Every individual at the same moment has a different landscape before him or her, depending on the attraction and repulsion potentials to all the others. If one mentally reads the verticals as depictions of potential values, then a mountain represents a high value in the horizontally imagined carpet of cells and a valley a low value.[37] Like all the others, Wally too always wants to get to the lowest value that he can achieve by constantly descending (figure 4.16). But this goal can shift on account of the movements of all the other participants. In this case, everyone except Wally himself plays a part in shaping his landscape through their location, while he always moves within this landscape in the most downward direction possible. The stationary figures simply demarcate individual hills and valleys in order to indicate the reason for this distribution of forces. They don't climb these hills; they *are* these hills. Therefore, with respect to the other figures, the illustration does not show any information that is due to themselves beyond their relative location. The height of their hills has to do with them only indirectly and can be characterized as the degree to which they are considered appealing by the particular person whose "emotional

economy" is being depicted. "The height of any point in this dynamical landscape is the value of the potential function for the token. The value is simply the sum of the differences between the token's matrix distances and actual distances to the other tokens."[38]

This degree of appeal in the form of optimal distances—given by the number of cells or steps—is defined and recorded in a table. In technical terms, "potential planes" and "potential valleys" are spoken of as "local minima" that are aimed for.[39] The absolute distance between two neighboring locations seems greater when a steep slope appears between them. Through the incorporation of forces into a topological situation, the optical impression wrongly arises that these hills also have to be crossed. This is not the case, since what is at issue is not a third topographical dimension but a motivation. Two different plotting factors that are responsible for the change get mixed up: the translocation of the party guests and their relationship to the protagonist of the illustration. The sympathy values, which in an extended sense can be interpreted as environmental forces, are assigned a spatial dimension and are plotted vertically. Goldstein is willing to accept this distortion in order to evoke the everyday experience of gravitation as a metaphor for the urge to take the less difficult path that leads downhill. The height coding brings to light in the illustration the position that an individual is aiming for, whereby his or her route can be assumed to be the shortest path. Figure 4.15 thus shows the parameters that concern Wally, distributed across the entire space. The reason that only an individual depiction is shown is that to register the world-views of all the other party guests, it would be impossible to remain in a comprehensible realm. One would need a 2 (degrees of freedom) n (per person) + 1 (potential)-dimensional depiction. In the given case with eight people, the result would thus be a 17-dimensional depiction.

Goldstein calls his program *Party Planner*, the most elaborated work of an art form that he terms "algorithmic symbolism." In his pointed summary, "*Algorithmic Symbolism* is a form of art where the underlying procedures of generation contain meaning that interplays with the surface meaning."[40] Both the underlying procedures and the surface are involved in the genesis of the meaning that is conveyed. As Goldstein rightly formulates, the surface interplays with the dynamic level or interacts with it, but they do not become one. This is demonstrated by the different possibilities for presentation of the same calculation results.

This type of programmed situation is characterized in reception by a spatiotemporal quality. In order to be accessible to perception, even abstractions or nonvisualizable (*unanschaulich*) processes occupy spatial and/or temporal dimensions. As we have seen, this must not necessarily involve an intuitive space (*Anschauungsraum*) or time as we normally conceive of it (*Anschauungszeit*), since even an abstract space or an abstract time can be depicted in intuitive space when it is set as a parameterization. What is shown here for the third spatial dimension—that the subjectively optimal distance is expressed through height—is in principle also conceivable for the temporal dimension: processes can be shown in which no temporal parameters exist.[41]

In the next example, we pursue an idea that first arises here. Specifically, if the shifting landscape of hills is to be identified with the motivational circumstances of an individual, the question is raised as to the extent of calculated beings and their depicted bodies. Furthermore, this question conversely implies another one: what environmental factors are brought into play in body depictions. All this can be seen under the auspices of a powerful foregrounding of dynamic.

4.2.2 Multiple Modes of Movement

The predator/prey scenario from the University of Karlsruhe discussed in chapter 3 shows, along with population vacillations and other global changes, the changes in location, states of action (i.e., not the execution of the specific actions), and the rather infrequent changes in occupation for each individual creature. Here, too, multiple movements are interwoven in one view and one overall sequence. At times, in casual observation one sees similarities—for example, agents moving around en masse—where in fact very different activities are being shown.

We present the work *double helix swing* here, which was made in 2005–2006 and conceived by the artist Ursula Damm, in order to elucidate this problematic.[42] Only a detailed study succeeds in demonstrating that many different types of movement are intertwined and together produce a constant flux. Bergson, who speaks of an undifferentiated combination of heterogeneous movement types, would feel confirmed here. Genesis, becoming, change, evolution, variation, alternation, modification, growth, translocation, deformation, transmutation, morphogenesis, transformation, metamorphosis: these are categories of movement that Quéau addresses in his book *Metaxu* (1989).[43] Most of them can also be found in *double helix swing*. This indicates that in this work, an attempt is being made, through the integration of mobility from many different sources, to take the state of constant change to an intentional extreme.

This "installation for insects and people," in Damm's words, "is intended to guide our attention to global relationships in the hope of providing an aesthetic argument for doing so."[44] It is thus important to the artist to demonstrate a strong mutual dependence and influence of nature, culture, and computer technology.

One part of the work is located in an interior space, the other, where the insects prefer to spend their time: by a shallow body of water. In the open air stands an arrangement composed of a weatherproof video camera mounted on a metal post, five loudspeakers positioned in a semicircle in front of it, and a console (figure 4.17). With the controller on the console, users can set the frequencies of the wing beats of various female insects (fruit flies, moths, midges, mosquitoes; figure 4.18), which are reflected in the sounds coming from the loudspeakers. The purpose of the artificially generated sound is to attract swarms of male insects in order to then record them with the camera (figure 4.19). A transmitter module sends the live video to the second station of the work, in an interior space, where it (or alternatively, prepared video material from a database) is fed into a computer,

Figure 4.17
Outdoor setup of Ursula Damm's installation *double helix swing* (2005–2006). A passerby at the console determines the frequency of tones that are broadcast over the loudspeakers in the water. Next to her at left is the camera. Source: Ursula Damm, *double helix swing*, in http://www.ursuladamm.de/projects/inter_double.html. Courtesy of Ursula Damm.

Figure 4.18
Console in *double helix swing* with the possibility of varying the tones in imitation of various insects. Source: Damm, *double helix swing*, in http://ursuladamm.de/double-helix-swing-2006/. Courtesy of Ursula Damm.

Figure 4.19

Sketch for *double helix swing* that shows the position of the camera and loudspeakers. Source: Damm, *double helix swing,* in http://ursuladamm.de/double-helix-swing-2006/. Courtesy of Ursula Damm.

edited, and linked to a microbial "virtual" population. Visitors see the result projected on a wall in the indoor installation (figure 4.20). In front of it is a slender, white console with a small monitor that provides information about the digital creatures (figure 4.21). With the mouse, visitors can select a creature in the projection and change its "gene code" with a slide control in the user interface on the small monitor in front of them. The effects of the interventions can be examined immediately in the wall projection as macroscopic phenomena. They give insight into how this world functions: specifically in order "to demonstrate the mutual dependence of form and movement characteristics of the virtual creatures and the nature of the insect swarms, there is a control terminal at which visitors can influence the installation."[45]

In the wall projection, the presentation of a simulation of artificial life can thus be seen, in which multiple species reproduce when there is adequate nutrition available but show respect to one another (the insects' trails, which are recorded with video technology, serve as food). Members of a species can be identified by their similar appearance.[46] The colors are not assigned in a species-specific manner, although there also may be some creatures that do not change their color because they lack the "color-changing gene." The bodies of the creatures are composed of a variable number of polygonal, three-dimensional cells, connected by limbs (figure 4.22). How many limbs can grow per cell, and how long these can maximally be, is "genetically" determined. For the time that a creature is young, it possesses only a few or a single cell. Ideally, it grows into its proper form until it has reached an energy threshold at which it can reproduce. Each individual cell of a creature can act independently within a certain frame; the multiplicity of limbs in itself allows a complex movement. If it gets to

Figure 4.20
Installation view of *double helix swing* at the Wallraf-Richartz Museum, Cologne, October 2006. Visitors use the small terminal. At right, on the wall, the projection of the view can be seen. Source: Damm, *double helix swing,* in http://ursuladamm.de/double-helix-swing-2006. Courtesy of Ursula Damm.

the point that the forces of the individual cells pull too strongly in different directions in the search for food, then a "tearing force" decides whether the animal will break into two parts, which from then on will each have its own life. With newly produced creatures, one often observes patterns of movement (e.g., a steady circling) that are not found with those that have been able to sustain themselves for a longer period of time. Along with the creatures moving at different speeds, other, explosive convulsions also occur—often en masse—in which yellow, parallelogram-shaped bands extend. This fulminant movement, which is often observed when the population increases, is faster and more captivating than the moderate seething that follows. Some occasionally rather volatile limbs reveal themselves as abstract forces. Thus, ultramarine needles designate the predisposition of the direction in which an organism is heading.[47]

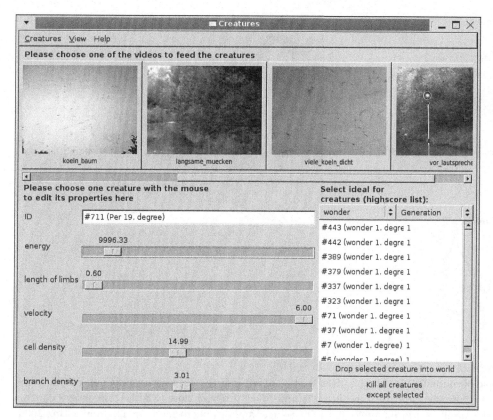

Figure 4.21
Screen shot of the small monitor for *double helix swing* on the console. Source: Courtesy of Ursula Damm.

The forces that are in effect show themselves as elongated elements extending from a cell (blue needles, yellow parallelograms, fans of vision) and have different lengths according to their present intensity. This variable length enables quantitative values to be illustrated. The dancer and musicologist Emanuele Quinz would term the organisms' bodies "fields of action or interaction" on which a multiplicity of forces are vented.[48]

However, any attempt to differentiate these abstract external influences from the morphological structure on the grounds that they fluctuate more proves not to succeed. Under the conditions of the programming, the organisms' bodily boundaries become negotiable and are closely tied to the environmental conditions. Thus the cells also swell and shrink. Their size is temporarily variable and encodes the current degree of satiation of the individual. When food is found, the cell's radius grows very quickly up to a factor of ten. But the size of the cells does more than signify the coding of values; it also has effects by marking the

Figure 4.22
Instead of continuous insect trails, there is a trail of rather large spots reaching from upper left to lower right because the particular insect being recorded flew past very close to *double helix swing*'s outdoor camera. Detail, still in the projection view. Source: Author's photograph, Ars Electronica Linz 2006. Courtesy of Ursula Damm.

cells' boundaries: larger cells cover more ground, which is advantageous during feeding. The length of the legs is also a factor in being able to reach nourishment. It thereby represents a framing condition for the locomotion to be calculated, influences the concrete course of the simulation, and is critical for reception. Along with these dynamics that immediately concern the "virtual" organisms, the other dynamics should not be forgotten that come into play in the four other levels of the image structure (figure 4.23).[49]

At this point we will devote ourselves to another detail in which is demonstrated that an internal characteristic—the radius of vision—is expressed through the body. This characteristic is not only marked as "present," but is also furnished with a statistic that pertains to it at the moment. In general, the range of vision is defined as inversely proportional to the speed of locomotion. This characteristic is materialized in the form of a fan of rays and is always combined with the direction of sight. In this way, the situation is avoided that only the long-limbed creatures dominate the terrain through their greater ability to extend through space. Through their stronger perceptual capacity, which is iconically presented, slow organisms are

Figure 4.23
Sketch of the four layers of the image structure in *double helix swing* together with their sources. Source: Drawing by the artist. Courtesy of Ursula Damm.

also given a greater range by means of an optical compensation.[50] The fans, which combine the direction and radius of sight, change constantly. Figure 4.26 shows that the "visual rays" are literally fixed on the insect trails that can be found nearby. Conversely, sight is turned away from other creatures, since wherever they are, no more food can be found. In the case of the fans of vision, a function or capacity (range of vision) has been plausibly connected to the presentation of an action (current direction of sight); moreover, the action is successfully shown in such a way that the viewer can understand it (figure 4.27).

In summary, in *double helix swing*, the bodies of individual organisms show, along with morphological characteristics and human interventions, (1) actions (eating, looking, walking);, (2) changes in size (swelling and shrinking), (3) capacities (radius of vision), (4) mechanical forces, and (5) internal states (hunger). Also shown are global vacillations and ongoing changes for the "virtual" population (overall patterns of movement, expansion, evolution) and food source (availability, consumption, freshness).

In *double helix swing*, everything is mobilized that can be mobilized. This approach could be characterized using a term from the philosopher Umberto Eco: his coinage, *movimentazione*,[51] has been inadequately translated into English as "motion," because his emphasis

Figure 4.24
As this projection view shows, in the case of correspondingly optimal food supply, the "virtual" creatures in *double helix swing* occupy the entire screen. Source: Author's photograph, Düsseldorf 2007. Courtesy of Ursula Damm.

on the action of setting into motion is thereby not reflected. The sheer mass of dimensions of movement leaves no doubt that Damm here has specifically intended to offer a sensory impression in which everything is given over to transience.

The emphasis on dynamic goes so far that even the abstract influencing factors to which a "virtual" creature is exposed become perceivable to an extent that is relative to their momentary dominance. In the wall projection of the installation, every creature embodies its personal statistics, even taking into account the given environment. How, if not in this manner—by means of the presentation of as many influencing factors as possible—can causal connections be investigated? And how, if not by means of the portrayal of calculation data, can users gain insight into specific states?

In earlier work, Damm had already intensified the principle of massively integrating calculation data through her decision—contrary to the standard practice of statisticians and computer scientists—to present certain calculated values in multiple ways. While technically-oriented practitioners as a rule consider this superfluous from the standpoint of efficiency

Figure 4.25
A close inspection of the projection view in *double helix swing* reveals that an insect trail is laid over the cells in horizontal, pale lines. Source: Author's photograph, Düsseldorf 2007. Courtesy of Ursula Damm.

Figure 4.26
The visual rays of slow organisms turn away from other organisms and peer at nearby food sources in *double helix swing*. Details, series of stills of the projection view. Source: Author's photograph, Düsseldorf 2007. Courtesy of Ursula Damm.

Figure 4.27
Lichenous formation of slow creatures in *double helix swing*. At the top are many overlaid insect trails
that serve the simulated creatures as food. Still in the projection view. Source: Author's photograph, Düs-
seldorf 2007. Courtesy of Ursula Damm.

(because a univocal presentation is already in place with one allocation), the artist, in her
liberal treatment of state information, is aiming to reinforce a particular process. The avail-
able numerical values lend themselves to this treatment of multiple iconization. The redun-
dant coding is intended to facilitate understanding through emphasizing a particular aspect.
It establishes a stress within the variable formations and hence allows the viewer's attention
to be—though in association with the rest of the dynamic, very subtly—guided. Hence, in
double helix swing, the width of limbs and the size of cells stand for the same dependence on
the food supply, in other words, the state of hunger: a small cell also has a very thin arm. This
visually conveyed fragility is carried through consistently, in that a thin arm forms a poten-
tial breaking point, allowing the organism to get rid of the unsuccessful limb if it continues
to be unable to obtain any nourishment.

All of these movements that are kept separate in our analysis occur in many multiple
instances simultaneously. From this, the impression first arises that there is a variable, never
exactly repeating, inscrutable pattern. But the console in front of the wall projection then

conveys the sense that this world does not have to remain hermetically sealed: visitors can assist their comprehension by intervening and observing. In order to learn more about how this world works, they can adjust the parameters or switch to another video recording and, on the basis of the difference, see what the impacts of the particular settings are. If the idea behind the programming is "to generate various animal forms and to test different local behaviors,"[52] one would like to get a handle on this, and so one proceeds investigatively. With the few intervention possibilities, one can deliberately carry out experiments in order to explore the laws of the artificial world. Without already knowing what something means and what factors it may be owing to, one gathers together whatever strikes the inquiring eye and forms hypotheses about connections. The simultaneous, spatially extensive, and ongoing course of events that cannot be interrupted is overwhelming in its complexity but at the same time offers many points of entry: one can pursue the patterns that are indicated through coloration; one can look for a corner that the virtual population has not yet taken over in order to see how the local economy develops there. One can also accompany an individual on its way and see how it subsists under the given local conditions. This concentrated observation cannot refrain from digressing now and again in order to consider another species or to study the entire population, its composition and relationships. One alternates between observing the individual and the whole. In principle, everything is always present simultaneously, but focusing on one detail reveals different insights than an overview does. After a period of playful interaction, one thinks one has understood the mechanisms, at least crudely. But the work is not exhausted at this point, since some secrets of self-organization can be uncovered only through long, patient observation. Hence, one notices, for instance, that the mass of creatures—or maybe it is only one related family group?—seems to show a slight tendency to upward movement. Some phenomena and colors develop only after the simulation has run for several days (e.g., long needles; see figure 4.28).

Even with a precise knowledge of the model of simple constellations, interactions lead to such complex behavior that events—especially when they appear on different levels—can often not be predicted. In addition, in *double helix swing*, because of the insect trails, uncertainties external to the model are preserved. Here, chance comes into play, though without making the work to lapse into arbitrariness. Even without the incorporation of these uncontrolled real data, however, the constellation is too intricate to be imaginable in detail through the course of its progression. It is exactly when the concrete manifestation in the case of a certain type of interdependence of conditions cannot be anticipated that the need arises for an explicit execution of calculation on the part of the researcher.

Since simulations are computationally irreducible, there is no closed solution. Upon execution, the patterns of movement that can be discerned are informative. The film scholar Thomas Koebner terms a "living rhythm" one that occupies a "flexible space of play through alternation." It is a "repetition of the similar, thus neither the schematic and rigid repetition of the same elements or accents at regular intervals that produces monotony, nor free-roaming movement without any echo effect."[53] Constants in reaction are necessary so that one

Figure 4.28
The base layer in *double helix swing* shows through these cells. Detail, still in the projection view. Source: Author's photograph, Düsseldorf 2007. Courtesy of Ursula Damm.

can manage to sort through what is produced. Despite and thanks to consolidating sensory entities, one can recognize certain instances of interplay and can seek to investigate reactions that one has not understood.

This aggregation happens in everyday perception as well, but with artifacts such as sensorialized computer simulations, it is already performed with respect to the data that have been produced (the ordering activity on the part of the recipient is then added). Hence, we can presume to borrow a statement from the following quotation from Metzger, replacing the term *manifold of stimuli* with *manifold of data*:

> Through the certainty with which this selection occurs under everyday conditions, we are completely prevented from noticing that each manifold of stimuli is nearly infinitely open with respect to the possible consolidations. ... We now come to an expanded, and simultaneously more in-depth, interpretation of the concept when we observe that, besides the laws (of selection) of the gestalt,

there are also the gestalt's *tendencies,* which can be universally observed where a higher degree of organization is achieved in the visual given than one might expect from a familiarity with the configuration of stimuli.[54]

Determining this higher degree of organization, and its nature, can be a goal. With the work *double helix swing,* in which so many types of movement interlace, a large number of orderings could potentially be found. With works such as this, the viewer—who in an exhibition context as a rule keeps to the presented iconic and acoustic aspects—will presumably arrive at other orderings than a (fictionally postulated) scientist of complex systems who takes the scenario as an object of research and attempts to identify the systems-perspectival formalism in effect there.

4.3 An Increase in Movement

With computer simulations, researchers gain the previously unknown freedom to produce and examine systems with many mutually interacting parts, according to the computer scientists John Bryden and Jason Noble (speaking about research on artificial life).[55] Above all in the case of agent-based approaches, on account of their complex interactions, these newly achieved possibilities also require a suitably informative sensorialization. The constant stream of data from the executed model lends itself to the exploitation of the temporal component in the presentation. This can be gleaned from a text published in 2002 in which Richard Nance and Robert Sargent provide an overview of developments in the field of simulation. Under the heading "influences by other computing technologies" is the bullet point "computer graphics." Here, it is stated, "Color and motion were prominent in depicting product transformations during execution of the simulation model."[56] Along with color, motion is presented as a design element that influences simulations.[57] If this assertion is correct, then one could set out to determine what is illustrated in the pictorial field by means of motion. It is not only the case that categorically distinct properties (internal and external) are fused together in one graphical element (as in *Framsticks*); the reasons for a perceivable motion can also be qualitatively different in origin. In a simulation, many different types of movement can be in progress and can possibly interfere by overlapping. It is worthwhile to critically analyze the movement that is being perceived in order to rid oneself of the simplifying notion that the movement of a presented simulation is solely the product of its mathematical model. In the following, it will be shown that motion in real-time simulations comes about in different ways and can be placed along a spectrum between the two poles of greatest fidelity to the data, on the one hand, and an intensive engagement with the viewer's expectations or sensory physiology, on the other hand.[58]

Previously, in the analysis of patterns of movement—which indeed can also be motivated by the gestalt—we have almost exclusively limited ourselves to the allocation of content—in other words, calculated values—and thus have stayed close to the pole of fidelity to data. However, the sensory presentation of different strands of successively different numerical

values is not the only reason for the movement that occurs in the frame of simulations. For an approach that places iconicity at the center, movements that cannot be explained or justified by direct correspondence are of particular interest, since their motivation does not lie in the deciphering of available information. Furthermore, in question are not iconographic elements but, rather, the manner of the sensory portrayal through which an increase in movement is offered. What is the developer intending to achieve here? The simplest and most logical assumption is that movement or change has "life" as its imaginary and that "aliveness" is the objective. Whether something is deemed to be "alive" in turn influences how the viewer conceives of the agents' motions.

4.3.1 Translucent Layers

In *double helix swing*, the dynamic simulation only calculates active forces, intra-individual and evolutive processes, and the locomotion of individuals in search of food. In this work, there is another type of movement, however, that does not belong to any subroutine. It results from the decision to render all artificial creatures, including the forces and capacities that are made visible in them, so that they appear semitransparent.[59] Through the many different transformations on all iconic levels, the individual body parts also remain susceptible to modulations (figure 4.28). Overlapping parts thus produce new color combinations, which can be seen particularly well in the cells because they often form larger connected entities. Different effects are achieved depending on the situation. When there are very few organisms, these blend into the background: by taking part coloristically, they become embedded in what lies behind them. However, when there are many organisms, the overlapping of the translucent cells, if they have the same color, causes an intensification of their color and thus an accentuation of their presence. In addition, the artificial computer animals in the presentation are illuminated by a fixed, diffuse, white light source and thus are accentuated in their corporeality. The translucence is shown to particular advantage because the polyhedral cells, which appear with a hexagonal outline in the projection, can have multiple colors. In addition, as a function of their possible speed of locomotion, they constantly show a slight basal rotation (figure 4.29). As intentionally selected design elements, the extension in three dimensions and the shimmering appearance—a product of the cells' own coloration, the background that shows through them, their overlapping, and the "virtual" light source—do not follow a concrete mandate to refer to something univocally

Figure 4.29
The individual cells of a creature rotate constantly in *double helix swing*. Series of stills and details of the projection view. Source: Author's photograph, Düsseldorf 2007. Courtesy of Ursula Damm.

designatable, but, rather, are characterized by their capacity to register a collective dynamic. On the one hand, an openness to influences is thus signaled: one makes the association with a semipermeable membrane. On the other hand, the creatures profit from the changes to the environment that are depicted as happening around them, in that these changes are absorbed and appropriated to contribute to the visual effect of the creatures' own diversity of expression.

4.3.2 Reflective Surfaces

A-Volve, an early artwork by Christa Sommerer and Laurent Mignonneau from 1993 to 1994, presents a design solution that is comparable in some respects.[60] Here, the virtual organisms comprise the food source for each other. Along with independent reproduction among the organisms themselves, the interactor is also given the power to generate new organisms. For this purpose, users draw with their fingers the longitudinal (left) and transverse (right) sections on a pressure-sensitive console (figures. 4.30 and 4.31). The outlines are filled out

Figure 4.30
Touch pad interface for creating a creature in Christa Sommerer and Laurent Mignonneau's *A-Volve* (1993–1994). Source: Author's photograph, Van Gogh Museum Amsterdam, 2006. Courtesy of Christa Sommerer and Laurent Mignonneau.

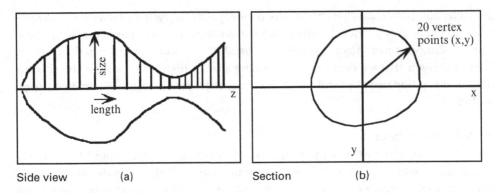

Side view (a) Section (b)

Figure 4.31
Sketch of an outline in *A-Volve* showing (a) longitudinal and (b) transverse sections of a creature. Source: Sommerer and Mignonneau, "Interacting with Artificial Life," 15–17. Courtesy of Christa Sommerer, Laurent Mignonneau, and John Wiley & Sons, Inc.

axiosymmetrically and made to intersect so that a volume emerges, which then turns into a locomoting bundle of muscles equipped with functionalities (figure 4.32). For each animal, the underlying schema is thus a simple geometric figure. This law and the scope of its variations become evident through the prompt to create organisms. The interactor, however, is given only a view of the outlines on the console and, in the adjacent tank, the finished creature, whose form is now accountable (figures 4.33 and 4.34).[61] The creatures' surfaces are smooth and shiny. They are randomly given a color—often multiple colors—and a texture. The latter depends on the pressure applied to the touch pad while drawing or, as the case may be, on the "genetic" disposition of the parents, consisting of ninety parameters, and the specifications for crossing, which are sketched in figure 4.37.[62] Purely from this exterior—apart from the alimentary canal and a certain symmetry—the figures really do not look very zoomorphic. Although compelled by the polished surfaces to look for associations in the mechanical world, one is ultimately convinced precisely because of the regular rotations that affect the whole organism when turning, and its elastic contractions during locomotion. From the outset, the artists pursued the idea of projecting on water, and therefore they aimed for an artificial ecosystem in which the individual creatures would resemble aquatic life forms without being too descriptive or figurative. Through the way they move, that is, through a type of fluid pulsation, the idea of aquatic creatures is evoked in the viewer, even when they occasionally look much more abstract—even when they look a little like a box or a tube—according to Sommerer. The creatures exhibit their fabricatedness on the iconic level; they do not conceal their technoid character by any means. The impression that they are metallic is inevitable. This impression arises because, on closer observation of the life forms in action, their texture does not seem to adhere to their bodies. The texture changes in

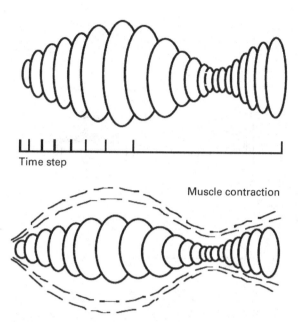

Muscle contraction

Figure 4.32
A three-dimensional volume in *A-Volve* is calculated from the outlines of the longitudinal and transverse sections. Muscle contraction in a forward movement with time steps. Source: Sommerer and Mignonneau, "Interacting with Artificial Life," 15–17. Courtesy of Christa Sommerer, Laurent Mignonneau, and John Wiley & Sons, Inc.

the course of movement in such a way that one hesitates to ascribe it purely to the change that results from surface bending (figure 4.38). Rather, it looks as if the shining surface were reflecting something not visible—a reflection that, on account of the moving form of the body, is repeatedly distorted.[63] As is familiar from daily experience, even the smallest displacements can result in a completely new mirror image because of the laws of reflection. This is what seems to be happening with these creatures' texture: on their surface, more is always changing than would be the case if the texture were dull and opaque.[64] This situation cannot be conveyed in a single snapshot, but in reception it is very present because the figures are constantly carrying out a rhythmic peristalsis whose frequency depends on the current stress level. Through the fluid pliancy and elasticity of the bodies, the impression is strengthened that their skin is reflective, and, vice versa, this reflection strengthens the impression of movement. The reflection serves optical enhancement, since even the smallest bends result in highly visible, glimmering, and glittering changes in color.

Figure 4.33
Plan of the installation arrangement in *A-Volve*. Source: Susanna Schoenberg, "re-active platform (octo-ber 04 – februar 05)," in http://www.khm.de/mk/seminar/export/re-active/re-active04.html. Courtesy of Christa Sommerer and Laurent Mignonneau.

As well, the interface of the water-filled tank into which the viewer reaches in order to come in contact with the creatures connects the real with the "virtual" realm and increases the impression of aliveness. By using one's hands to bring two creatures together, one can incite a coupling, while it is possible to fend off an attacker with a protective hand gesture (figure 4.39). Through the viewer's participation in shaping the destiny of the tank's current residents, the fluid medium is quickly stirred up. The resulting waves are readily attributed to the swimmers, with the effect that one imagines them as even more physical.

Thus, here a movement or a transmogrification becomes perceivable that no longer seems to depend solely on an action of an individual organism. Thanks to the structuring of a receptivity into the presentation—through reflection (in *A-Volve*) or absorption (in *double helix swing*)—there emerges another type of movement. With the creatures' shining surfaces in *A-Volve*, this is a hybrid phenomenon that vacillates between a patterning of the creatures' skin and an implied reflection. If here, everything deliberately plays out on the exterior and is directed outward, in *double helix swing,* by contrast, the environment permeates the crea-tures' interior. They are shown to be cohesive entities by means of thin lines and points, but beyond this, they leave space for the optical integration of their surroundings—all the more so when they are better fed (one could say, better adapted or more "fit"), since then they are larger. The animated quality—in other words, lifelikeness—does not solely depend on the

Figure 4.34
Vertical view into the tank in *A-Volve*. The creature at left in the image is still in the place where it was just "born." Source: Sommerer and Mignonneau, "Interactive Art Works 1992–2006, *A-Volve*," in http://www.interface.ufg.ac.at/christa-laurent/WORKS/IMAGES/A-VOLVE_PICTURES/A-Volve05.jpeg. Courtesy of Christa Sommerer and Laurent Mignonneau.

Figure 4.35
One creature is eaten by another in *A-Volve*. Meanwhile, a third one is born, which will also fall victim to the successful hunter (see figure 4.50). Source: Author's stills, Linz 2006. Courtesy of Christa Sommerer and Laurent Mignonneau.

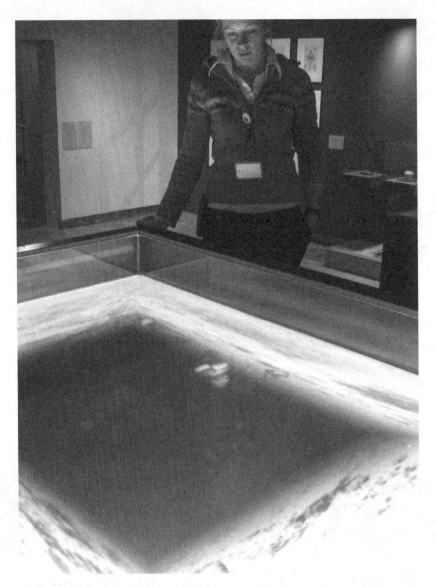

Figure 4.36
Installation view for *A-Volve*, Van Gogh Museum, Amsterdam, 2006. The visitor is looking at the tank with the "virtual" population. The touch-pad interface for generating creatures is located behind her. Source: Author's photograph, Van Gogh Museum Amsterdam 2006. Courtesy of Christa Sommerer and Laurent Mignonneau.

Figure 4.37
Sketch on crossing the gene codes of the parents in *A-Volve*, including the rate of mutation. Source: Sommerer and Mignonneau, "Interacting with Artificial Life," 19. Courtesy of Christa Sommerer, Laurent Mignonneau, and John Wiley & Sons, Inc.

Figure 4.38
Because of the reflective surface, each tiny movement makes the creature appear completely new with respect to its color palette. Details, series of stills from *A-Volve*. Source: Author's photographs, Van Gogh Museum, Amsterdam, 2006. Courtesy of Christa Sommerer and Laurent Mignonneau.

Figure 4.39
Direct interaction with the creature in *A-Volve*. Source: Author's photograph, Van Gogh Museum, Amsterdam, 2006. Courtesy of Christa Sommerer and Laurent Mignonneau.

individual creature or its proximal microstructures, but more complexly, on the dynamics that surround it. If movement is most often generated by the individual creature, it is also the case here that, conversely, the animated quality of the creature is also constituted by adjacent mobile phenomena.

4.4 Designing the Experientiability of Events

These thoughts, which bear on an emanation of and penetration by the surrounding depicted environment, could be carried even further by taking into view the entire design, grasping the ensemble in its interplay, and accounting for the user's access. The design of the view that is offered also determines the quantity of perceivable movements and influences the manner of their appearance. The presentation can thus not only add its own movement beyond the calculated dynamic, as described; it can also restrict the portrayal of the calculated dynamic by not reflecting it or making it difficult to access.

In a comparison between *double helix swing* and the installation *lifeSigns* (2004)[65] by the artist Troy Innocent, the entire structure of simulations and the design of the experientiability of their presentation of movement is now to be placed under scrutiny. The evocation of aliveness depends on the experientiability of movement, according to our thesis. Our intention is to elaborate design measures that afford the recipient more or less effective access to what happens. These presentation strategies are simultaneously to be examined for their influence with respect to how much they support a "biological" interpretation of computer events.[66]

At first glance, both installations show a similar structure: a wall or, as the case may be, a floor projection including a generative soundscape offers an overview of the entire population; visitors can make interventions at separate, small terminals by selecting creatures and inducing changes in them. On closer observation, however, differences become evident that are of central significance for the evocation of aliveness.

While with *lifeSigns,* two to four people simultaneously enter into direct exchange with one creature each (figure 4.40), with *double helix swing* there is only one terminal (see figure 4.20). If in the latter case, multiple users took command at the same time, this would interfere with the "experimental setup," since the one projection screen in its entirety serves as the test environment. The organisms are presented in action only on that screen. Hence, the wall projection in *double helix swing* is the more important view, since here all the organisms are as visible as possible in their external structure. Some cells may overlap and thus partially occlude each other; however, a more precise view is not offered.

Figure 4.40
Installation view of Troy Innocent's *lifeSigns* (2004) with four terminals at Australian Centre for the Moving Image. Source: Troy Innocent, *"lifeSigns*: Installation," in http://iconica.org/lifesigns/installation. htm. Photograph: Greg Ford. Courtesy of the artist and Hugo Michell Gallery, Adelaide, Australia.

Figure 4.41
Screen shot showing the overview of the entire world of *lifeSigns* in the projection view. Source: Troy Innocent, *"lifeSigns*: Images," in http://iconica.org/lifesigns/images.htm. Courtesy of the artist and Hugo Michell Gallery, Adelaide, Australia.

It could be said that the opposite is the case with *lifeSigns*. Unlike in *double helix swing*, the overview does not offer any detailed information beyond the positions of all creatures, shown in two dimensions (figure 4.41); it is therefore rather secondary. The figures in this overview are presented, by means of an optical abbreviation, as flat and uniformly sized (with the exception of the creature with which one is interacting (figure 4.42). This creature can be seen in the overview in its three-dimensional mode of appearance, only miniaturized: figure 4.43). A definitive allocation of an abbreviation to a sign is highly difficult and occurs only through setting one's own position in relation to it. The interactor is represented as a three-dimensional eyeball. The user will look at this world now and again in order to assess whether the total population has changed. It facilitates inventory of the world in its current state but does not offer any alternative possibilities for intervention. The attempt to get one's own bearings in order to navigate—for example, by judging the distance to the edge of the overview projection—loses relevance in light of the fact that here, the three-dimensional space is an unoriented, unbounded topology. "The space appears to be infinite as the player may continuously navigate and search in any direction—there is no up or down. Although it

Figure 4.42

Another *lifeSigns* player has selected a creature, which is located at left, framed with four corners. The series of empty frames allows the interactor's direction of sight to be reconstructed. This is slightly confusing with respect to the interactor's own distance to the object that the interactor has selected. Detail, still from the screen view. Source: Author's photograph, Ars Electronica Linz 2004.

is a three-dimensional representation there is no horizon line or indication of linear perspective, but instead multiple layers of abstract form, colour and movement."[67]

One is therefore not compelled to pay attention to the edges. Hence, one generally concentrates on one's "own" small terminal. Here, the feeling is conveyed that one is traversing the space from an interior perspective, as if one were navigating through the expanse of the universe (figure 4.44). In the view that the terminal screen shows, the viewer is in the same space as the signs, can look around, and like them must cross distances, in that he or she invests time for this purpose and is offered the corresponding view of the route taken.

Hence, the viewer is more actively involved than in *double helix swing,* where the feeling of traveling through space does not arise.[68] In the insect installation, along with the table-format catalogue in the small user interface, the user is given only the distanced, external view of the entire available world, in which a single creature therefore occupies only a small fragment of the surface area. Never will the creatures show a significant difference in distance to the point of view. When they are depicted as small, they are not farther away; rather, they

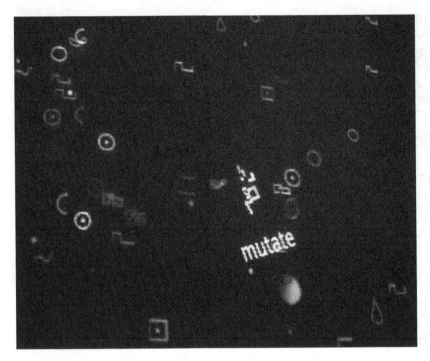

Figure 4.43
Interaction with a lifeSign with the label "mutate" in the overview of the projection. Still, detail. While in the overview all creatures not being played with are portrayed with simplified symbols, users recognize the creature that is selected by its form and because of the attribute that is also indicated. The viewpoint of the interactor is represented by a spherical eyeball (below). Source: Author's photograph, Ars Electronica Linz 2004.

are hungry. The mouse in the user's hand is closer to the action than the eyepoint. It is a navigator between different worlds and can pass seamlessly from the terminal screen to the projection. It is instructive to ascertain what one can do with the mouse and where. On the small monitor, one either operates globally by selecting the amount of food (video segments) or locally by influencing one aspect of an individual (e.g., length of limbs, speed of locomotion, maximal number of cells, number of possible ramifications). A knowledge of these parameters is useful because they show what fundamentally affects the organisms' behavior and what can be changed. Meanwhile, in the wall projection, the middle "resolution" is possible. There, one can operate on the level of individuals. In the projection, the micro- and macroregulation of the terminal merge via the individuals' forms. Therefore, the projection view is indispensable for an understanding of the manner of interaction of the three components: food source, individual, single aspect of an individual's genetic makeup.

Figure 4.44
View of a section of the screen for *lifeSigns* when the interactor has not selected a creature. Still. Detail.
Source: Author's photograph, Ars Electronica Linz 2004.

With *lifeSigns,* conversely, the projection's overview relates to the views at the "private" terminals more as a zoom than as an interweaving. How large the lifeSigns appear has to do (at the terminal) with their distance to the mobile eyepoint of the user and plays a role in locating them. By clicking on the mouse, the user from time to time succeeds in snapping up a creature and holding it. The four white corners of a square appear, framing the lifeSign, which can be seen in the middle. One can also navigate further with the captured creature. In this case, the corners mutate into arrows pointing outward. By means of four pressure-sensitive buttons at one's terminal, one can play with the selected creature, thus eliciting technoid sounds and a few, often jerky movements (figures 4.45). That the creature gains energy through the interaction can be gleaned from the intensification of its colors and, at different intervals, its sending out signals in the form of spherical, glowing packets of energy in a particular direction that depends on its own present movement. When another lifeSign is nearby, these abstract, different-colored balls of light pick up its trail. This is evident in that their trajectory can suddenly change. If the nearby creature is hit, its colors also briefly flare up and it can also send out its own signal. A chain reaction carries the interactor's

Figure 4.45
Visual reactions in *lifeSigns* caused by interactions with a lifeSign (cf. figure 4.42). Source: Details, series of stills of the screen view. Source: Author's photographs, Ars Electronica Linz 2004.

involvement out into the dark universe. In this way, the creatures are loaded with energy and emit "signs of life."

Nevertheless, an impression of aliveness does not predominantly take hold in *lifeSigns*. There are multiple design-related reasons for this. When the figures have been "sighted" and captured, they prove to be highly passive: they are required to stay in place; in addition, a "meaning" can be imposed on them (for instance, in figure 4.45, "reproduce," and in figure 4.46, "artificial"). They do react with visual and acoustic expressions, but this occurs mechanically, at the press of a button. The impression of a dialogue is not felt.[69] This behavior is thus easily ascribable to a simple stimulus/reaction schema, which one might also recognize as operative in machines. One sees the sending of energy packets to neighboring signs only when one "plays the signs"[70] oneself, as if playing an (inanimate) instrument. But even here, the abstract packets of energy guard the secret of their functioning and are apparently not intended for a particular creature. An individual motive is not in evidence. Perhaps, on account of their imperceptible individual initiative, the lifeSigns could most properly be described as "sleeping signs" (*signes dormants*) following the art theorist Jean-Louis Weissberg. According to Weissberg, such signs are ready to be awoken in the event that a hand and an attentive, interested eye administer to them.[71]

However, a self-directed course of action on the agents' part is seen as a fundamental characteristic in the artificial life discourse. According to the technology journalist Andrew Leonard, autonomy in behavior is the crucial aspect that determines whether one perceives something as "dull computer clay" or rich digital life.[72] Only when the latter successfully occurs, according to Bec, is the "bio-logical"[73] perceivable, for in the discourse of the alive, artificial life is made to appear as an acting entity with an experimental intentionality.[74] Since in *lifeSigns*, indications of a will are largely not to be found, one cannot automatically assume that the signs are acting "in the wild" at all, or in this way. One has leisure to examine them only when one selects, and thus isolates, them. But this is precisely an unusual situation for the signs, so that one experiences only a partially informative, exceptional case. They either prosper from the intensive interaction, or—if one does not play with them—they are energetically deprived since they are kept from going about their business. The manner of presentation separates two different behavioral modes: if one interacts with a sign, it does

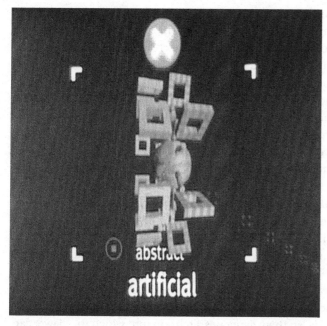

Figure 4.46
Interaction in *lifeSigns* with a hostile sign (as can be recognized from the red circle with the ×). The color scheme gives some indication of the basic disposition: predominantly red tones suggests a strong readiness to attack. Still, detail from the screen view. Source: Author's photograph, Ars Electronica Linz 2004.

not move, precisely *not* doing what can be observed in the signs that go tearing around freely. By the same token, independent of the user, contact between two free signs can hardly be observed, since they change positions constantly and too quickly for them to be followed long enough. Because of the endless universe of which one always sees only a tiny section closely enough, the interactions are not accessible to observation. Of the creatures' eight different types of behavior among themselves (attacking, leeching, commanding, messaging, joining, befriending, reproducing, mutating), the user is unable to learn anything more specific despite lengthy observation. Because of their solitary and nomadic appearance, one does not judge them as particularly related to each other.

When it is said that in their interaction with people, the lifeSigns only seem to receive and to react reflexively, this is also the case for the creatures in *double helix swing,* where one even makes deep incisions and putters around with their "genetic" disposition. Here, too, one does not see any direct, individual interaction between the creatures (they seem only to comprise one another's environment); cooperation does not necessarily occur even between a creature's own limbs. But one can assess their living conditions since they show themselves as sensitive with respect to their surroundings. With small cells, one actually sees the urgent

need for food intake. A similar situation is for the most part lacking in *lifeSigns:* except during a user's interaction with a sign, which makes its color palette flare, they all appear with grayish coloring. In addition, there is the differentness in these creatures' appearance, which does not allow any common features to be read as values. In *double helix swing,* the state of hunger looks the same in all creatures, and hence they can be compared with respect to their current condition. This information uses the presented body as a display. By contrast, in *lifeSigns,* difference of form predominates, which facilitates distinction but does not promote the immediate comparison of momentary states. In addition, because the signs always stand still only briefly, one does not have time to study them more precisely in order to take note of possible gradations of color intensity. Thus, it does not become clear which sign needs attention most urgently, if one wanted to sustain them all.

By contrast, the organisms of *double helix swing* make known what they are looking for and express their pursuits and their needs. Their ambitions can be verified in their behavior with respect to a goal. A goal is easier to perceive when it is not a strategy or evolution in itself, but instead is embodied in a concrete object of desire. Often it is identified with something precious, such as nugget-esque nucleotides (figure 4.47) or the white diamonds in *Wriggraph*[75] (figure 4.48), or given a tantalizing animation, as in the case of the shimmering bubbles of energy in *Framsticks* (see figures 4.2 and 4.5b). When a creature and its goal are visible at the same time, the gap between them generates a tension into which the viewer can interpret intention and initiative. The spatiality that an iconic presentation brings with it is exploited in order to mark a distance that is to be overcome. This constellation captivates the

Figure 4.47
Psi in Dietrich Dörner and Jürgen Gerdes's *Psi 4.9.1.310* (ca. 1998) finds a nucleotide in the rocks. Screen shot, detail. Source: Author's photograph, 2013. © Dietrich Dörner, University of Bamberg.

Figure 4.48
A simulated creature (composed of four cubes in a tetrahedral arrangement) in Koji Sano and Hiroki Sayama's *Wriggraph* (2006) tries to reach the white diamond, placed near the horizon below the heavenly body. Screen shot. Source: © Sano and Sayama, "*Wriggraph*," 82. *Wriggraph* website: http://coco.binghamton.edu/sayama/wriggraph/. Reprinted with permission of the MIT Press.

viewer who is following the pursuit, as with time-critical sports events. "The comprehending that plays out in the interactive functioning of the work," says Jean-Louis Boissier, "is already a way of *giving life,* of *bringing the real* into the computer image. Seen this way, the computer image is an interactive stage."[76] Precisely in observing the pursuit of a goal, the moments ensue that potentially entail a strong emotional involvement of the viewer. On this point, we will return to *A-Volve*.

First, however, we are still concerned with a few observable elements that contribute to the lifeSign's seeming distanced. As was previously mentioned, this effect is at times produced by the fact that their needs and ambitions remain largely concealed. But this is not all. Since the decisions attributed to the creatures are not transparent, the user resorts to investigating the laws that govern their world. But here, too, it remains a mystery when, why, and where birth or death happens in *lifeSigns*. The creatures come into the world in solitude somewhere; the parents are not in evidence. It plays an important role in this situation that here, apart from slight nuances of color, the space seems to be homogeneous and the individual creatures distribute themselves relatively evenly throughout it, according to the overview.

In *double helix swing,* too, one can identify which creatures are parents of which offspring only when there are very few in total; when there are more, attribution is no longer possible without keeping track of them and in the absence of individually unmistakable differentiation. Especially creatures with many limbs are often overlapping, not compact, and the boundaries of their bodies are not emphasized (figure 4.49). Nevertheless, a pattern gradually

Figure 4.49
With many-limbed creatures in *double helix swing*, it is no longer possible to determine where a creature begins and where it ends. The extent of a particular creature becomes evident only when the user selects it with the mouse, since then its cells become outlined in black. Still, detail of the projection view. Source: Author's photograph, Düsseldorf 2007. Courtesy of Ursula Damm.

becomes evident. First, the creatures reproduce whenever and wherever food resources allow. Second, the creatures appear in groups because even the fastest move at a pace that is moderate by the viewer's standards, and a birth always takes place in an existing population. These two laws yield the tendency that births happen at the edges of groups. In *double helix swing*, the available two-dimensional space is not uniformly attractive (because of the distribution of food) or reachable. The entire sequence of events depends essentially on this. Similar organisms must appear together when the objective is to determine patterns of behavior by means of comparison.

With short spans of observation and isolated positioning—as in *lifeSigns*—this can happen only slowly and labor intensively, because interaction is taking place across great distances. Because of one's own restricted view, one cannot have sender and receiver close enough in sight at the same time, and thus cannot perceive the effect of communication in a detailed

manner. The isolated positioning of the creatures thus specifically does not conduce to emphasizing their autonomous action.

To recapitulate: the fact that the assessment of aliveness in *lifeSigns* remains ambivalent depends on many factors originating in the iconic design. Thus, the impeded observation of the activities or intentions of the lifeSigns is produced by, for example, the expanse and the homogeneity of the space, the fragmentary nature of the view, the isolation and the emphasized individuality of the creatures, and the role of the projection overview.

The inappreciable evocation of aliveness thus fundamentally has to do with how the user is given a view of the action, and thus is less connected to the fact that Innocent, in his (as he calls it) "ecosystem for signs and symbols," interweaves two different approaches, producing a highly complex mutual relationality. Along with biometaphors, he primarily also uses metaphors from semiotics. One the one hand, each sign possesses a number of characteristics that connect it to an artificial life approach and make it come into and out of existence in the manner of organisms. On the other hand, an approach from symbol processing is made a basis in the concern with signification, signal transmission, and conversion of data and information into text and image.[77] These processes are highly compatible with a functionalistic understanding of artificial, computer-based life. Information exchange and information processing as analogies for metabolic processes by no means contradict many artificial life approaches that conceive of life primarily as an ordering function and the "organism as a field of information."[78] Here, one should be mindful that the "organizing, saving, modification, and transfer of information ... are declared as the indispensable characteristics of the living—characteristics that are conveniently also displayed by computers."[79]

So as not to give the impression that we are aiming to present Innocent as having chosen disadvantageous design solutions, it should be emphasized that it is also by no means his main objective to evoke aliveness (although we profit from the comparison). Rather, he is pursuing an encyclopedic project that shows the implemented design strategy as adequate. In this work, he is examining how processes, generative media, and evolutionary algorithms can be presented so that language can be seen as a form of "semiotic life."[80] The objective is the emergence of a continuously developing, symbolic computer language in which genuine characteristics of digital media are inscribed. These combine a plurality of their traditional data forms, such as code, pictorial signs (glyphs), basic geometric forms, links, networks, and information topologies.[81] The forms of the atoms of the lifeSigns are also determined in accordance with this frame of reference.[82] In addition, every atom has a behavior. The atoms assembled in a lifeSign, thus the types of behavior, determine the unit's general strategy for action. However, actions are not carried out in general but on the basis of abstract, conceptual stimuli. Each sign is provided with weighted vectors of significance. Choosing from an inventory of 64 possible terms designating actions, structures, and attributes, the visitor to the installation can assign one to an organism.[83] Every sign is unique and is saved with the corresponding information. In order to be able to locate it in the quickly growing database, it is categorized according to the model of a symbol lexicon. All signs ever in existence are

indexed according to structural characteristics. Thus, soft and hard lines, symmetries, and other formal characteristics serve in classification. From this, it can be concluded that here (as in *Framsticks*) much more than in *double helix swing*, the interest is in individual form and an "evolutionary body building."[84] Therefore, it can be concluded that the work is not set up for tracking the biological or even the social mechanisms of an autonomous system. Rather, the interest behind it is directed at what formations may develop through the given constellations in the course of time. In *lifeSigns*, this is to occur with the help of human networking. Hence, possibilities for interaction are offered to the user; however, he or she is not distracted by being tempted to observe exciting events taking place elsewhere in the calculated system. The fact that evolution and the fate of the signs are partially determined by the interactions of the user as well as of the Internet community through the work's website is consistent as a utilization of the characteristics of the employed media. As in earlier projects,[85] it is important to Innocent that meaning is embodied in the logic and structure of a world that is inhabited by "media creatures" and is developed further through interaction and play. It would thus be inappropriate to judge *lifeSigns* solely according to the criterion of its evocation of aliveness.

4.5 Excursus: The Rhetoric of the "Alive"

With "aliveness," a criterion has silently inserted itself that elicits flights of metaphoric extravagance in the literature. The art historian Hans-Peter Schwarz begins his description of Bernd Lintermann's "evolutionary web sculpture" titled *Morphogenesis* (1997) with a dry statement: museum visitors interact "with the computer-object that is generated as an image."[86] In texts on works such as this one, it is rare to encounter such a distanced formulation. Much more often, the "computer-object" is conceived directly as a "creature." A mythos in media art is thereby employed such as is diagnosed by Schwarz's colleague Richard Hoppe-Sailer: a metaphorics of nature, in other words, a topos of aliveness.[87] Nevertheless, in his further remarks, Schwarz too reverts to this topos:

> It "lives," in a manner of speaking, from moment to moment and reacts to the visitor's actions in real space. That the object generated in the installation *Morphogenesis* "'lives" results from the manner of its generation: the description of the object consists of a set of building blocks that, very like the genes of an organic cell, generate different three-dimensional geometries—forms, as it were—as dependent on the specific function and the set of parameters inscribed in them. From these basic building blocks of life, through multiplication, mutation, or cross-breeding, an infinite abundance of forms with different chances of survival and characteristics can be generated in the virtual space of the computer. The demiurgic dream (or nightmare) of the early twentieth-century avant-garde is here equaled and surpassed. Not only can the artist define the conditions of living for his or her "living images"; the artist's accomplice, the visitor to the virtual or real museum, assists the artist by creating his or her own creatures or influencing their fate.[88]

The statement that aliveness results from the manner of its "evolutive" generation is not entirely convincing, since the creatures in both *double helix swing* and *lifeSigns* satisfy this criterion, and nevertheless the impression of aliveness comes to bear differently according the design of each. How this impression is successfully conveyed, and to what degree, is to be examined on a case-by-case basis.[89] It is not a certainty that a simulated creature can be perceived as "alive" in the first place, even if it looks very "natural." If it can, then with the media theorist and designer Stephen Boyd Davis, one must inquire as to the design implications that enable this: "What does it take for a pictorial technology to seem transparent? It is not simply a matter of making the depiction more like the optical stimulus of an actual scene. Filmmaking, even when it aims to evoke a sense of effortless access to what is depicted, employs pictorial strategies which have little basis in natural vision. Often, the viewer mistakes demonstrable artificiality for naturalness, and it is important to ask why."[90]

Bec made exactly this into the objective of artificial life: "The trace of something alive can manifest at any time, in a single zoosystem or in multiple zoosystems simultaneously. The trace is an illusion, as it were, the fusion of the designer's and the biomass's strategies, a point of convergence. ...* This trace must be scented through a complex approach that detects hidden tracks. ... [It is necessary] to isolate and decipher the individual traces, which for their part appear as a xenoplastic identity, an animal being that embodies a large number of parameters originating in the designer or zoosystematician and in the biomass."[91]

In the Becian mode, zoosystematicians "thus have the task of studying this design that searches for zootraces—by bringing it into existence."[92] Further, it can be read that the zoo-systematician "must constantly envision that the paradigm of animality in general is much better designated or presented through a plural semantics than through the scientific components of an objective zoology."[93] He does not explain what exactly is meant by "plural semantics." It must be gleaned from his artistic work, an endeavor that will not be made here. However, at this point, the viewer takes on an important role for Bec. He recognizes the viewer and familiar life as the measure and standard for the body that is simulated and shown:

> Every artificial organism or virtual space, modeled and saved in the depths of an algorithmic syntax, swims in a technological universe. It obeys the rules of construction and adaptation of the environment in which it has formed. In order to arrive at the pixelated interface of the computer screen, it passes through electronic circuits and components from the underside. When it is set afloat again and as it glides away across a luminophorous sea, it must go through other phases of adaptation and interaction. It must put on display determinants of life that are intelligible to the living one. Without this "technozoosemiotics," it would only be one design object among many others. The living one must be able to grasp it for identification by identifying his or her own self. For this reason, through an algorithmic language, a clever dialogue of the living with the living must develop, in order to make the features that are put on display appear authentic and in order to classify them in the categories of life that have been expanded to include the artificial.[94]

In the concept of that which has been "set afloat again" (*das Wiederflottgemachte*), Bec brings together this double orientation—which is typical for interactive simulations—to the calculation and the recipient. For him, the production of an intermediate object between data and modeler is the goal of modeling in both scientific and artistic contexts.[95] He advances the thesis "according to which the fundamental question for any modeling of artificial life belongs to the realm of the aesthetic and shows [a] particular form of the aesthetic: the question of that which has been set afloat again. [The aesthetic of artificial life] is a mode of expressing the totality of variable relationships of all heterogeneous components of the system, of behaviors that develop in it, of skills and technologies that are utilized in it."[96]

For Bec, the aesthetic of artificial life is that of autonomy:

> This aesthetic is the form of expression of the interactions between different components of the apparatus, the treatments and the forms of behavior that take place there, the information that is in circulation there, the processes of learning and adaptation and the interactions with the milieu that ensue there. It is an aesthetic whose symptoms are successive states—to be made visible through certain behaviors, traces, trajectories, morphogenetic transformations. It is an aesthetic that testifies to the capacity of a system to express new information that is not recognizable in the environment. It is a semaphoric aesthetic that displays the determinants of the living for the living.[97]

Nevertheless, an investment from the other side—that of the viewer—is also necessary. Here, Bec and Boissier agree.

With many different kinds of interactive simulation applications, it is repeatedly confirmed that movement as well as the behaviors and modes of reaction that are shown are more important for an empathetic response than optical perfection. The creatures in the simulation *Ménagerie*, the subject of discussion later, are kept intentionally simple in their corporeality according to the developer's specifications in order to give more emphasis to movements and less to outward appearance. Although weight is not given to realism in the portrayal of surfaces, the feeling of presence proves to be exceptional on account of the "realism of the interaction."[98] Thus, with many commercial computer games, the level of detail of surface textures can be set in advance using a menu to suit the capacities of one's computer. But there is no provision for economizing in the range of the characters' reactions. Against the background of the user's knowledge of the artificiality of what he or she is confronting, the responsiveness to previous input that is produced through a simulation is what amazes the viewer and constitutes the immersivity: it is the movement of what is presented, but to a much greater extent, it is specifically the self-induced "answering" movement that follows the user's input.

For some theorists, a recursive aspect—an answer's referring back to what precedes it—is central. Others emphasize a plausible causal relationship of events to existing characteristics: "[T]he fact is that, thanks to well-internalized dramatic convention, we can enjoy (and believe in) even one-dimensional dramatic characters ... when—and only when—even the surprises in a character's behavior are causally related to its traits."[99] A rudimentary presentation of the

creature does not detract from the evocation of aliveness. "If the responses to their actions are intelligible and instantaneous, participants will be pleased, even if the actual feedback is crude. On the other hand, if there is no relationship between a participant's actions and the system's responses, completely convincing graphics are irrelevant."[100] The interface designer Ann Lasko-Harvill argues in the same direction: "Radiosity and texture mapping do enrich images with lavish details, but nevertheless, it is above all gestures, timing, and the linking of sound and movement with the image that make it into a reality."[101] One is amazingly quick to speak of aliveness as soon as something appears to be reacting to one's own action. Hence, it is plausible to posit that computer simulations offer a "functional imitation or immersion" rather than a "visual imitation."[102] This is related to the fact that here, the idea of the incorporation of elements shifts to less direct and more strongly constructive connections, according to Boissier. In his view, through the programming of a flawless calculation, what ensues is not so much the capturing of an image (*prise de vue*) but, rather, something like the capturing of life (*prise de vie*).[103] Astonishingly, the impression of viability succeeds despite massive abstractions in the iconic depiction of the scenario. It is not the "referential illusion" that is the strength of the new technique, according to the art and media theorist Margaret Morse, but rather the "enunciative illusion," whereby with the user's input, in a quasi-performative manner, a world or a reaction is called to life.[104]

Although one is aware of the wealth of prerequisites under which computer simulations are made, there are moments in simulations that cause one to forget their artifactuality, at least for a time. What happens then is the fascination of iconic genesis[105] that takes hold when there is a successful coherence in the interlocking of elements. But it should not be forgotten that this too relates not to the optic level but rather to the dynamic. When one speaks of the immersive and illusive aspects of dynamic simulations, these aspects are should not be sought in a visual naturalism. That is, simulation is not responsible for the detailed rendering of visible surface quality or the manner of its being set into the image in the sense of a point from which the scenario is viewed. These areas go beyond the jurisdiction of simulation. Simulation-specific illusionism can be found, if at all, in *its* domain, that of movement. Simulations do not create illusion in the same way as trompe l'oeils, and not with regard to the same aspects; for example, depth of space in the central-perspective image is analogous to reaction capacity in a simulation. For immersion in the simulated world, dynamic is more important, but at the same time, it is clear that this presence cannot be achieved at all without the sensory aspects.

4.6 Temporal Components and the Modulation of Experiential Time

The recognition of the aliveness of simulated entities should not occlude that fact that there are differentiable movements. In the previous section, it became clear that the analysis of movement must not remain limited to a single figure. The presented environment plays an indispensable role, specifically through a mutual influence. In addition, the recipient should

also be taken into account, since it is for him or her that events are designed. Even if two of these events were computationally identical, it cannot be assumed that one sequence would always be perceived in the same way by the recipient, regardless of all the previous actions and circumstances that he or she has also "experienced." The perceived flow of time can vary in the interplay of individual elements with the specific composition of the environment in its current state. The design of a movement that also accounts for the process of perception is capable of charging uniform dynamics with additional valences,[106] thus downplaying their uniformity. In this way, the aspect of temporality is given the possibility of entering the viewer's consciousness more prominently. What design strategies enable the sensations of time and dynamic in simulations to be perceived differently than "objectively" given and shown?

4.6.1 Optical Deceleration through Foreshortening of the Spatial Presentation

An optical deceleration of the flow of time can be discussed using the example of *A-Volve*. As we already know, the work offers a view from above into an "inhabited" tank of water. Because of the specific spatial definition here, the viewer experiences horizontal movements differently from those directed toward the bottom of the tank. While the viewer can make a good assessment of the former with respect to distances, this is not equally the case for the latter because of perspectival foreshortening. In general, one tends to follow sequences in which at least two creatures are involved, since it is from these that something exciting may arise beyond pure locomotion. For instance, when one creature is pursued by another, in cases where the prey is fleeing toward the bottom of the tank—toward the center of the depiction—the two creatures seem to be traveling more slowly.[107] This is not least because the overall space is depicted in a highly undifferentiated fashion. There are only a few, weak reference points for judging at what depth the creatures are momentarily positioned. The perspectival manner of the portrayal of space, through the movement along the depth axis, causes a temporal inhibition and a spatial diminution of both the distance traveled and the creatures. It seems as though, despite evident efforts, they are being impeded in their movement forward. Optically, they seem to touch each other for a long time or even to overlap. Thus they approach a standstill, seeming not to move from their spot. Only the bodily movements of the individual figures signalize that locomotion is being continued.

One expects that something will happen at any moment, but the pursuit can be quite drawn out. The suspenseful anticipation that the hunted creature could still get away increases until resolution. That time seems to dilate for the viewer in these moments is a result of his or her directing complete attention to the situation in order not to miss the outcome of the struggle. But simultaneously, as time goes on, less and less seems to be happening at the bottom of the tank. With the philosopher Wilhelm Keller, one could say that a strong protention (intensive scrutiny) in the case of a simultaneous dearth of content results in an excess of expectation, and time dilates for the viewer.[108] The impression of this discrepancy, that figures making great effort are getting nowhere, is heightened since both pursued and pursuer pulsate more rapidly than creatures in the tank who are not fighting for

Figure 4.50
These series of stills of *A-Volve* serve to compare the amount of time taken by a chase (bottom) and a death (top). The stills were taken at two-second intervals. Series of stills, details. Source: Author's stills, Linz 2006. Courtesy of Christa Sommerer und Laurent Mignonneau.

their lives. But if the latter are moving at the surface of the tank, they seem to cross distances relatively more quickly. Comparisons of this type make clear that time and space take on subjective dimensions and intensities in the viewer according to the iconic configuration. These can be seen in the context of the specific event that is guiding one's attention. In addition, there is another movement that is directed downward: dying. In a series of still shots, figure 4.50 shows a pursuit and the disappearance of a dead creature. The stills are taken at equal time intervals (every 50 frames, corresponding to 2 seconds). It thus becomes clear that after only 10 seconds, the dead creature can no longer be seen, while the pursuit—the progression of which, of course, depends on the swimming capacity of the participants— can last 30 seconds or more with utmost exertion.[109] Ironically, dead, motionless creatures seem effortlessly to be able to overtake the fleeing and pursuing creatures in sinking to the bottom.

4.6.2 Time-Based Figure/Ground Oscillation
Another example can be brought into the discussion of this topic. Once again, it involves a bewildering movement, this time an increase in tempo, which would not come into play without the environment and its specific design, and therefore can be perceived only with the sense of sight.

In the 2005 installation *Blue Moon* by the design collective ART+COM, one finds oneself on an inhabited moon that revolves around a gas giant (figure 4.51).[110] The moon is not visible in its entirety; rather, visitors look from above at one narrow strip of it. In places, this view seems to have been taken by an orbiting satellite scanning the moon slowly. The section of the world is projected on an installation architecture that curves upward on one side, so that through a conflation of multiple viewpoints, visitors view the world close up and from high above (figure 4.52). As the projection surface enters the vertical, first mountains and finally the moon's curvature, along with the neighboring planet and the two suns, can be seen. By placing one's hand directly on the curved installation architecture, which is oriented below the projector, one can select individual moon inhabitants—specifically, those that are indicated with a yellow circle. To the circle is attached an icon with a gray/white

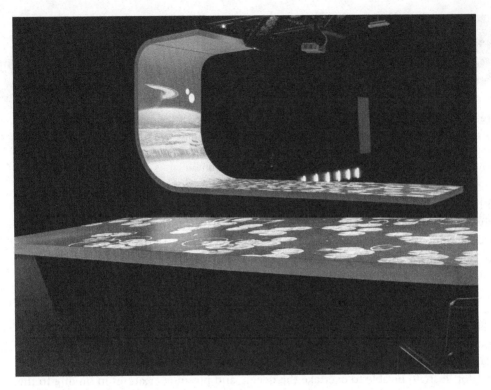

Figure 4.51
Installation view of ART+COM's *Blue Moon* (2005). Source: Author's photograph, Science Museum London 2006. © ART+COM.

silhouette of the creature, which one can cover with one's hand. A video-based tracking system interprets this as selection. There then appears a menu with a varying number of items that allow inquiring about further specific characteristics of the creature. Here, through an animation or two to five lines of text, one is given information on particular topics related to each species or to the moon overall. The window can be closed by clicking on the "×" in the field. In addition, the individual inhabitants of this world are briefly characterized in information panels (figure 4.53).[111] The animals whose information one is retrieving seem fixed to the spot. In other words, one can interact to the extent that through selection, one can prevent the animals from leaving the visible section of the world. Thus, it can happen that one selects the largest and most peaceable creature, the skywhale (figure 4.54), and is in the process of inquiring about its mode of living through the small information window. Because of the dense atmosphere prevalent in *Blue Moon,* even the moon's largest animals can fly. The blind giants orient themselves by echolocation and nourish themselves on the plankton flying past them. Only stalkers can harm skywhales. After a while, the unexpected

Figure 4.52
Overview of the entire section of the world in *Blue Moon*.
Screen shot. Source: Author's photograph, Science Museum
London 2006. © ART+COM.

Figure 4.53
Visitors can read on information panels what is also revealed in the *Blue Moon* installation interactively in information boxes. Source: Author's photograph, Science Museum London 2006. © ART+COM.

message, "Your skywhale died," can suddenly appear (figure 4.55). What happened? Clues about this can be retrieved in the same manner: by selecting a stalker. Even in dense woods, they are able to keep the skywhales uninterruptedly in sight using one of their three eyes, which enable 360-degree vision. Although they are greatly inferior to their prey with respect to body size, they can hunt successfully through their quickness and division of labor. After scouts have marked their victim with pheromones, the fleet of warriors can find it anywhere and can attack collectively. The skywhale can evade the attack only by flying higher. If this is not possible, it is injured more and more gravely by the attackers' offensive. If the gigantic prey is slain, it is divided up and brought to the stalker colony.

The whale's being cut into pieces cannot be seen in the simulation, only read about in the information windows. What can be seen instead is a design solution that also appears in early computer games. Whenever a creature dies in *Blue Moon,* it blinks motionlessly for a short time before it finally vanishes—in other words, it is visible, then invisible, then visible again. Movements of this type are effective means of fixing one's attention. With this blinking, the message is conveyed that now there is a fundamental change in the ecosystem. One is made aware that this element has departed from the dynamic context and is no longer interacting with the environment.

Figure 4.54
This detail of the projection shows a skywhale in *Blue Moon*. Source: Author's photograph, Science Museum London 2006. © ART+COM.

In principle, the death of the skywhale follows the same pattern (figure 4.56: the flying giant, aggressively hemmed in by stalkers, sinks down to the supposed height of the plants. This can be inferred from its shadow. In sinking, the skywhale does not make any other movement. Then it starts to blink. The skywhale alternates through visual presence and absence, quickly, about twelve times. Suddenly one realizes that the skywhale is communicating optically with the ground below it and that the presentation is sliding into an ambivalent relationship of figure and ground.[112] Thus, beyond the factual movement, another one comes into play that is generated by the whale's simultaneous appearance/disappearance and descent before a figurative, vegetative ground. As soon as the skywhale blinks out of sight, one is staring at the background; one has this pattern before one's eyes, and then the whale appears—which, with its size, makes a considerable difference in the overall impression—and makes its imprint.[113] The longer one sees the whale in one phase of visibility, the more similar it becomes to the ground, since through sinking down, it comes to match the scale there, until the blinking again removes it from its surroundings.

Figure 4.55
General information about the selected animal in *Blue Moon* can be read in information windows like this one. In this case, the message "your skywhale died" can be read. Photograph, detail of the projection. Source: Author's photograph, Science Museum London 2006. © ART+COM.

Figure 4.56
Screen shot series of *Blue Moon* with the sinking down and blinking of the dying skywhale. Source: Courtesy of ART+COM. © ART+COM.

When it vanishes once again, one thinks for a moment that one can still make out the whale, see its outline. Thus—as enhanced by the frequency of appearance and disappearance—the respective retina-based afterimages blur into each other. Through spatial and temporal extension, there results a jarring triple movement, since in the intervals when the whale is not present, there is in fact no movement (apart from the incessant, slow shifting of the entire scene sideways). The recipient is always dealing with the echo of what was there, the "hole," now filled with background, of the absent creature, whose form one is not seeing but which one has imprinted in one's mind's eye. The farther down the whale has sunk, the more intense the conflict becomes of distinguishing it from the ground because the animal's proportions come to match those of the leaves more and more closely. Also, the grayish-blue coloring blends in well. Through blinking, it is optically a simple task for the whale to avoid a collision with the large water trumpets of the pagoda trees, to find itself suddenly below them and finally to remain caught in the branches—still blinking. Incorporation into the ecological economy happens symbolically, without decomposition, through adaptation to the environment. This presentation is also remarkable because the television program *Alien Worlds* (2005), on which the simulation is based, in its animation sequences that illustrate the corresponding research, "parks" the dying and dead skywhale on top of the reservoir of pagoda trees (figure 4.57). Here, too, the trees are undamaged, but they support the whale.

Figure 4.57
The skywhale lies on the trumpets of the pagoda trees. Still from animation in the documentary film *Alien Worlds*. *Alien Worlds: A Spectacular CGI Documentary*, DVD. Source: Still image of skywhale courtesy of Big Wave Productions / Alien Worlds.

While the majority of events in this world cannot be anticipated in detail, the manner of presentation rarely contains a mystery. However, in some small fragments of action or events—as in the case described above—something disconcerting happens, something that cannot be forced into one absolute term; something of a peculiar quality that is not immediately attributable to the clearly nameable or identifiable. Here, the design has been successfully conceived in relationship to the eye so that through perception, there results an interesting interference of two modes of movement: the first is computationally verifiable, while the second can be perceived only together with the first. This unexpected event accelerates the perceived changes in such a way that the process elapses too quickly for the viewer to grasp the first time what it is about the occurrence that seems so different and so captivating. At these moments, the recipient is strongly challenged, since a definitive interpretation is not to be had. Through its temporal bounding, the optical event enters the viewer's awareness as soon as it appears. Because of the temporal component, one then has to wait repeatedly in order to experience the brief moment of the bewildering split. This proves to be the cleaving of the evident and another, though hidden, order. A particular constellation is necessary for its emergence. But as soon as this constellation falls into place, the ambivalence becomes certain, even if it remains intangible. There, far from evident activities, through a death the iconic presentation unfolds its movement and fascinates because, in beholding it, something happens that is not easy to get a handle on, that is uncanny because it cannot be explained causally. The dynamic cannot be adequately justified with the underlying "rationalization of iconic representation."[114] The presentation breaks out of the supposedly mystery-free Darwinist narration and impresses the viewer on an entirely different level because it is not understood. Only in retrospect does the suspicion begin to grow that the background perhaps in fact was not designed simply randomly as vegetation, but rather takes into account this integration of the whale.

Through the slight shifting of the view of the moon, the dead whale gradually moves out of the shown lunar section. After having observed its dying, one finds oneself unwittingly searching for traces of the whales that have sunk in the past, scanning all possible positions. The only possibilities are the places that are not covered by the reservoirs of pagoda trees, that is, the dark spaces in between them. Thus, one takes a closer look at those areas of the presentation that have previously received little attention because "life" is not playing out there. Although no formations that one encounters are convincing, one is not sure whether to trust one's eyes. Something remains suspect, because the previously experienced movement has shown that one possibly does not have everything in such sovereign view as one had thought. Is it that one just can't recognize the whales anymore? Or is the narrow section of the shown world empty of the creatures that were there? Has the past been extinguished? There remains some residual uncertainty.

When one places simulations at the center of focus, it is reasonable to take the dynamic that relates to the data as the starting point and "prime mover" of the temporal experience. Changes are thereby made manifest. However, as should have become clear in this section,

the calculation data are by no means the only entities that induce movement. Other types of movement are mixed in. The art historian Christian Spies speaks of the dimension of time as a crucial design factor:

> An appropriate corrective for the question of time in the different iconic forms is thus necessary: it is imperative that this question be oriented not solely to the movement of the image, but also to the visual conditions of the artistic image as the basis for an experience of time in the visible. ...
>
> For possible temporal experiences of perception, the iconic as well as the representing visibility values [*die bildlichen als auch die abbildlichen Sichtbarkeitswerte*] must be included and must be oriented to the question of how the two enter into a mutual relationship in the image.[115]

When transferred to our object of research, the "representing visibility values" originate in the calculation results. Beyond this, there transpires in the viewer a mixing of manifest movements and latent ones that come into being only through reception. If, with film images and later with electronic video images, not only did an explicit flow of time become visible, but also time became a manipulable accoutrement that could be functionalized for the image's artistic potential of meaning, this must also be taken into account for simulations, where temporal phenomena can be overlaid in complex ways. It is illusory to think that here, the mathematical model forms the only reference point for the perceivable dynamic. The identification of different types of dynamic, as well as their "location," can be only a first step in order to get a critical handle on iconized simulations.

5 Characteristics of the Iconicity of Simulations

5.1 Approaches to the Iconicity of Simulations

In the preceding chapters, an attempt was made to investigate the progressive transformational conditions of simulation images (in the perspectivation, in the model, in the iconization). In addition, until this point, we have pursued a production-oriented approach and have held image and movement apart, from an analytical standpoint, in order to be able to identify different sources of movement. However, if the intention is to distill characteristics of the iconicity of simulations that also include the potential inherent in an interactivity, then a more comprehensive approach leading to a synthesis seems more promising. Potentiality distinguishes a conception that displays an indeterminacy and only collapses into a concretization through a catalyst—for instance, through the execution of the model. How can one come to understand these realms of latency in simulated image worlds? Where are they in evidence?

In search of answers, one could start again with Boissier's *image-relation*. Boissier attempts to explore the new qualities of such an iconicity by orienting himself to the philosopher Gilles Deleuze. In his books on film, Deleuze develops a "time-image" that shows time directly.[1] By analogy, with the *image-relation* Boissier conceives an understanding of the image that is the direct presentation of interaction. He stresses this in distancing himself from an understanding that would enrich images with interaction after the fact.[2] Boissier makes multiple attempts at interlacing interactivity and the image according to his conceptions: "Interactivity is constitutive for the image. It continues, to one degree or another, to 'live' in the image [*dans l'image*], to make the image live, or better, to live through the image [*par l'image*]. With informatics, interactivity entered into the image. Even minimalistically, even in a homeopathic dose, interactivity characterizes the image that has become involved or that will become involved with informatics."[3]

If we follow Boissier's line of thinking, we arrive at the statement that aspects such as interactivity (or also multimodality) are not to be thought of as additive with respect to the iconicity in question; rather, they are implanted in it intrinsically. However, this initially remains an allegation that, when taken by itself, hardly seems self-evident. How can a dynamic/potential iconicity be made plausible? Even if we do not succeed from the very start in finding satisfactory answers with respect to simulations, we will at least be on guard for clues that allow some characteristics of interactive real-time simulations to be extracted.

Some of these characteristics result from following the rules that the artist Antoine Schmitt published in 1998 in his manifesto for computer-based artworks. In this text, he demands a type of purism in order to do justice to a computer aesthetic and lists a number of guidelines that should be taken into account:

—Use no images, sequences of images, sounds, music, words, phrases, in short, any formation that could be qualified as a signifier in itself with respect to the totality. Only include microfragments, microphonemes, microsamples.

—The assemblies, transformations, metamorphoses, transitions, juxtapositions, evolutions of fundamental images and/or sounds are fully controlled by the program or programs. There is no pre-written score or scenario.

—The artwork is constituted mainly by the temporal process implemented by the program (realized from the model). The process, the visual and auditory forms through which it is perceived, and the stimuli that it can receive, all contribute symbiotically to the totality of the artwork. If there is a signifier, it cannot be exclusively attributed to the forms, the stimuli of the process; rather, it results from the relationships between these. In particular, the process *does not generate* forms (images, sequences, sounds, music, words, phrases) that are signifiers themselves relative to the totality.

—The process is immersed in real time. It exists here and now.—The process is essentially autonomous. It is neither a purely controlled instrument with which one plays, nor a purely reactive system. In particular, it can include elements, fundamental or superficial, that are random.

—No technological criteria are needed except that the artwork must exist on one or more computers.[4]

With these strict specifications, Schmitt has fundamental properties of the simulation image in mind. We now pursue several prominent characteristics of sensorialized simulations: these include manifold variations, the creation of situations with copresence and contemporaneity of events, a certain unity of the entire constellation, as well as its rupturing with montage-esque cuts below and on the surface. It will thereby be suggested what type of composition simulations present, where their limits and their strengths lie.

5.2 From Results to Events

The model in motion is like an agitated insect.[5]
—Philippe Quéau

The calculable simulation model, as a set of prescriptions, delineates a spectrum that possesses a uniformity in the sense that the prescriptions remain constant from the moment the program is executed.[6] Nothing has happened in the program yet, but everything that could happen is given a form there, including all possible variations. Before execution, only a text-based, abstract outline is modeled that leaves the specifics of what will happen in a state of latency. This definitional bounding only states in principle what reacts where, when, and how and what the results will be: it is prefiguring (projecting). The mathematically expressed behavior will take on a concrete form under certain premises and only in the process of computational solution—in becoming. In computer simulations, beyond what occurs in the sensorialization, events take place only within the previously established specifications. In the examples under discussion here, an event whose basic features are defined through influencing factors and functions can then be followed in its unique manifestation.

But what exactly can be followed? Using design elements, in the iconization the designers craft a sequence of events that is based on previous and actualized passages through the model. In order to demonstrate this, we first turn to another type of presentation that is frequently encountered in publications but not in simulations themselves. In its principal form, a model as the structured specification of a sequence is often presented in flow diagrams—schematizations of chains of causality—in a pseudo-code that is independent from any particular programming language.

Figure 2.3 shows a detail from the neuronal network that is implemented for the memory of Psi, an artificial intelligence developed by a team led by the psychologist Dietrich Dörner. How Psi's brain works can be seen only through the agent's actions; its precise functioning is not revealed in the sensory depiction. In figure 2.2 the decision tree is shown for a single behavioral module among many. It outlines the routine that is implemented when Psi has no plan for what is the best thing to do in his current situation. In these cases, the agent activates the trial-and-error mode. How this proceeds in principle for any situation whatsoever can be read from the diagram; however, the concrete dynamic for a particular situation cannot be seen here. Conversely, in the presentation of the simulation in execution, the running through of these functional sequences of instructions, or of the program in its entirety, is never shown. The formalized passages through the source code or through these diagrams is too fast and too complex for the individual results of decisions to be clearly distinguishable by human beings. This discursive, diagrammatic presentation as a sequence in time relates differently to temporality than more simultaneous, iconic depictions. The external progressions function as "abbreviations" of internal ones and are often, in the words of the programmer Brenda Laurel, "artful orchestrations of stereotypes."[7] The internal progressions, the

agent's thought processes and predispositions to action, form the basis for his or her actions and choices. The behavior that is shown does not have to match the calculated sequence.

Thus, different sequences take place in the formalized model and on the iconic level, and it is for this reason that the negotiation that occurs between the two of them in the design is interesting. This does not mean, however, that calculated information is withheld. As a rule, an attempt is made to show what the mutual influences are able to bring about: one simulates, generates, in order to show.[8] But this concerns only the results of a section of program. The way to those results (the running through of the decision tree) is not reflected. The manner in which these results are constructed is not evident on the iconic level. In order to give a more informative view into Psi's "cognitive" processes, the developers chose to exhibit a keyword-style record (see figure 4.9, right-hand column) of decisions that cannot be exactly deciphered in the visual portrayal they selected, showing the island overview. But this list, too, should not be confused with the sequence of computational operations. The running list of decisions enables the recipient to participate more closely in the action. He or she is shown internal values in the diagrams, the related decisions and actions in text form, and a selection of these in the depicted island scene. Everything occurring in the individual windows happens practically simultaneously at each moment. Along with contemporaneities that function through a spatial configuration (in our example, the island with its locations in the overview), there are also those that are structured temporally.

5.3 Building Actions and Situations

What does it mean for an iconicity to contribute continuously to supporting and constituting this instantaneity? In the case of graph diagrams, values are entered in an abstract coordinate system. But what must be ensured if the intention is to present iconically the agent's decisions and actions that are recorded textually in figure 4.9? What is the essential difference in the depiction of calculation results by means of a scatter graph, for example, or a portrayal as an action?

In general, with interactive dynamic simulations, the focus is generally not placed on integrating prefabricated views, since it is precisely what happens that is the achievement and strength of simulation. The design concentrates on this, as well as—in the case of interactive applications—on the possibilities for action in the perceivable scene. By referring to Aristotle's drama theory (in which not characters but actions are central), Laurel develops an approach aligned with theater studies in order to describe human/machine interactions, particularly in computer games. Programs create the potential for special actions "that are performed by people and computers working in concert."[9] Laurel locates the unique quality of these applications in the management of contingencies, as well as, above all, in the forming of these actions. The action of a game (as of a drama) consists of a series of events that are causally connected. Since the design of action is given the top priority, the design of objects, environments, and characters is ranked as subsidiary to the main goal. In this way,

the delimitation of the duration of an action, for example, becomes important as an aesthetic and cognitive aspect. Laurel uses the phrase *situated actions* to emphasize a dynamic portrayal of changeable constellations. These are not withheld from participants but rather flow back into the total complex so that participants may be informed and correspondingly adjust their future decisions.[10]

5.3.1 Contemporaneities

Interactive applications should offer the opportunity to make consequences observable as they come to pass—in other words, to show them at a resolution that is adequate for the human sensory apparatus so that at any time, a renewed involvement or new intervention on the part of the user is enabled. Actions require calculation, and their presentation is based on the latter. In other words, the shown actions depend on what is calculated as the result of a causal nexus.

Users would like to see what is similar, but never the same, to cope with the unforeseen and, above all, to lend a specific note to the whole through personal input. If the essential aspect of interactions is not reduced to a purely selection-based decision cascade, then it might be the handling of or the performance with what is presented. Providing something that is uniformly prepared after every choice and for every run is a solution in which the manner of execution itself, excellence of craftsmanship, can hardly play a role. Through this type of design, the user's performance falls into the narrow gap between two preplanned views that were created apart from the context that is specific to the moment. They are in any case bridged when the user makes a decision, but in themselves nothing is done, so that these depictions function only as springboards. In these simulators, the showing of closed-off effects is insufficient; one might as well present something prefabricated at every step; the feeling would be of changing television channels or navigating a slideshow rather than really taking part. The more of the sensory component that is determined in advance, the less flexibly can things and events be presented. In order for simulation results to come into appearance, the pictorial set pieces have to be kept as small and brief as possible; they have to be agile. This is exactly what Schmitt is demanding in the first point of his manifesto. Only in this way can what is shown in the simulation continually be ready to embody interaction. By contrast, animation sequences tie up time.

While it was previously stated that only simulation results are integrated into the sensory aspect, this by no means contradicts the fact that the iconic level shows a becoming. In what way the becoming constantly becomes remains unappreciable because the becoming, and not the running through of the program that determines the becoming, is of interest. When we speak of "dynamic" here, this refers to the becoming that is shown in the sensory aspect. This becoming, in other words a presence or copresence, is required by the user for his or her interventions: the user needs something to observe, something that unfolds in front of him or her, in order to be able to react to it. The sensorially accessible real-time simulations that interest us are characterized by an unfolding of relevant events. This temporal configuration,

a contemporaneity, ensures the mutuality of an action. How the temporal composition plays out—for example, whether it hinges on a simultaneous appearance, a coinciding, or not—has an impact on the action and interpretation. In light of interactive works, it is not by chance that unmediatedness, immediacy, instantaneity became important fundamental concepts of media (art) theory.

5.3.2 Situationality

According to the philosopher Brian Massumi, the strength of art lies in making a situation in all its complexity—and not a function, a practice, a behavior, an action and reaction—into its object. In his view, the challenge with which interactive art must present itself is the puzzling out of how to subdivide an interaction so that its event character is emphasized. The difficulty lies not in initiating an interaction, but rather, in how to break down an interaction so that it can be managed by the user step by step, how to dynamically smooth it out so that the relational potential that is its tendency emerges. Thus, in Massumi's summation, how can one create the semblance of a situation? To this end, a framing is called for that not only is capable of eliciting a behavior but also expands the situation by its relational architecture to the qualitative level of thinking-feeling, where a diffuse potential is consolidated, so that in the act of becoming, being emerges.[11] To grant the user an experience (as active involvement) in a calculated world means, for Roberto Diodato, translating the environment into a "situation."[12]

But how is a situation built? Brenda Laurel makes the following statement: "An obvious but easily overlooked element of situation-building is the fact that all of the relevant aspects of the situation must be successfully *represented*."[13] Here Laurel, who introduces situation building in the context of opportunities for interaction, means that for the user to understand the offer that is being made, corresponding sensory provisions must be in place. Situationality is typically brought into connection with interactive applications or actions. In Massumi's writing, it is implied that a situation relates to action insofar as the latter takes place within the former. One could describe interactive simulations as situations in which something happens and which one explores. It could also be said that a situation is generally characterized by its allowing only a limited repertoire of gestures to occur. And it could be inferred that simulations are concretized with respect to the action to be carried out, or the intended effect. Simulations are centered around events. The repertoire of actions is focused on intended interventions; "purpose filters" are built in, to borrow a phrase from Neunzert. Only "what is important for the achievement of a previously defined purpose"[14] is shown. Nothing superfluous is present, which conversely also means that as a rule, there is an explanation for everything present.

Now, on what level is a simulation a situation, and on what level a behavior or an action? We have already often stressed that a simulation is the presentation of a process. On the level of the mathematical model, we can reconcile ourselves to the idea that a "situation" is defined as a delimited field of potential activities within it. However, if one looks at the

images associated with these models—and these are typically graphs (see figure 3.10)—then one is perhaps less inclined to relate these to a situation. What are they lacking? What separates them from a situation?

It's possible that here, different actors need to be differentiated in their respective situations. The mathematical model could be understood as the situation for the calculated dynamic. The situation for the active recipient, however, is established through a spatiotemporal continuum without gaps, since such a continuum is most conducive to the recipient's observation and action. Establishing a connection between the two situations is one of the greatest challenges for developers of interactive real-time simulations. The two have in common that they offer opportunities to change something within them. Often this entails a reduction of indetermination. Displays, for example, are entities where data are situatively staged but do not necessarily extend the possibility of interaction to the user.

5.4 Manifold Variations

By shifting the focus of design to the creation of situations (of both kinds) within which there can be events that vary to a greater or lesser degree according to the modeling, one is choosing not to create an exactly determined sequence that serves the purpose of expressing something with this particular formation. It is not the specific events to be seen that are determined exactly in advance but, rather, the overall structure. According to Quéau, it is the situation that possesses a fundamental form; this form has a more placid nature than the fugitive images that the work in action (*oeuvre en marche*) presents to be seen.[15] Programmability thus enables keeping the determination more general than the individual states that will then be generated. In 1962, in the foreword to the catalogue on an exhibition curated by Bruno Munari and Giorgio Soavi, Eco used the newly coined term *programmed art*. He defined this as a "field of events" (*campi di accadimenti*) that unfolds between conception and unforeseen processes.[16]

With fields of events, the developers specify not a specific sequence but rather a specific sequence generator. The latter makes it possible, through changes in the settings, to produce countless variants as results. Within "open artworks," Eco delimits a narrower category that he terms *artworks in motion* because of their capacity to embrace different, unforeseen, physically not yet realized structures. These are works that are never received in the same way and "that possess something like a mobility, a capacity to form themselves kaleidoscopically in the viewer's eyes as constantly new."[17] Eco imagines a critic from the future who takes a close look at the art of the twentieth century and makes the following statement:

> In the frame of occidental culture of the twentieth century, according to a dialectic of programming and chance, and beginning with movable objects, a creative practice asserted itself that the public or a part of the public normally "consumed" as art, in using it as a concrete stimulus for form-related observations to satisfy imaginative conceptions and—often—for epistemological reflections. This is an indication that in this culture, aesthetic pleasure was not—or at least not always—derived from

the contemplation of complete or completed organisms, but from the consideration of organisms located on the way to an undetermined completion; and the quality of a work was not to be judged from whether it conformed to a law on the basis of which it was immutable and inviolable, but from whether it inherently contained a type of "propositional function" that continually prompted it to attempt the adventure of mutability, albeit according to particular guidelines.

With his own voice, Eco then continues,

The critic of the future who will compose this definition—by means of which he will then re-shape the concept of form and art that is standard in his time—will by no means be perplexed by this. He will think it right that the people of the twentieth century took pleasure in considering, not a single form any longer, but multiple, simultaneously present and simultaneous forms, since this fact does not by any means indicate a degeneration of taste, but rather implies its adjustment to a complex dynamic of perception that was fostered by the new technological and social conditions.

And in conclusion, he adds, "What the critic will have to recognize is the fact that art in the twentieth century undertook to offer people the simultaneous view of multiple forms that are caught up in a permanent becoming, since this is the condition to which their sensibility was exposed—and to a constantly growing extent."[18]

Precisely the implemented rules that comprise this "idea" open up "a bounded and at the same time immeasurable field of freedom."[19] A slight modification within a serial repetition leads to repeatedly different results. This gives a "foretaste of the noise that becomes more homogenous the more patiently one exposes oneself to the work, in days- or months-long viewing."[20] The art historian Christian Janecke writes this about a film that in its montage is put together from a certain number of filmed set pieces so that it is different every time. His observation can be transferred to interactive simulations with a view toward the generation of similar, but rarely exactly the same, configurations. Through the inclusion of alternatives in combination with frequently encountered iterations, recursive loops are generated and the action evens out. Events are closely linked to circuits so that what happens can be contoured in a generally closed form by means of underlying stipulations. Within one session, the patterns that occur are always similar, as with each new start of the simulation. In interactive simulations, these spatiotemporal events overall form the specific nature of the presented scene with which one must contend. In their dynamic-based situationality, simulations are not endowed with an unlimited ability to convey arbitrary contents. Simulation models serve both to explain behavior[21] and to limit it,[22] in the sense that this behavior is governed by laws and is not available at the will of the user.[23] The composition is far from random, but can depend on a whole array of influencing factors and therefore can be manifest in fine gradations. The overall regularity of simulations also means that it is often insignificant for an understanding of the involved mechanisms at what point one begins observing the simulation. Repetition with slight variations produces two results. On the one hand, the user gradually deduces the laws whose effects he or she is observing. On the other hand, with the circularity of repeated loops, the linearity of time is undercut, even if the dynamic is in fact carried out continually.[24]

Psi's internal monologue (see figure 4.9) also demonstrates this. There are a limited number of "deliberations" and actions that are performed: moving toward, not knowing, trying, shaking, detecting need, moving away, moving ahead, moving toward, taking, moving away, moving ahead, detecting need, moving ahead, moving toward, drinking, moving away, moving ahead, moving toward, shaking, taking, lighting on fire, moving away, moving ahead, and so forth. The agent drives around in his vehicle and draws from his limited repertoire of actions. The actions in building on each other (i.e., when one action forms the basis for the next) achieve a succession of four or five steps maximum. The action is thus flat in the sense that the basis that gives form to the behavior, to which the behavior always remains closely connected, shows through.[25] In the modulated repetition—which, incidentally, is often reflected in the user's interaction—beginning and end are relativized. Nevertheless, in evolutive scenarios or "learning-capable" systems, there are developments that extend across long stretches of time and do not betray anything like a uniform or cyclic character.

In general, however, simulations are well suited to presenting a diversity, performing a continual movement, and reflecting the current status quo of user actions as long as these remain within the frame of what has been anticipated. Their strength lies more in the breadth of variations than in the depth of the events that follow one another successively. This means that they seem less predestined to thematize what has happened in the past or to offer complex narration, as is suggested in the prefabricated video passages in computer games, which are there to motivate the action and task at hand by illustrating events that could not be "played out."

If the developer does not want to make use of such aids, then he or she has to accept that a single frame will define everything that could possibly happen. This one frame, the situation, opens up a type of *Spielraum*: a space in which something plays out and a type of zone with "play" (in the sense of "room for negotiation") that—through a combination of influences and mechanisms—a palette of related movement patterns is concretized. On the idea of play as used here, the philosopher Hans-Georg Gadamer writes, "The movement of playing has no goal that brings it to an end; rather, it renews itself in constant repetition. The movement backward and forward is obviously so central to the definition of play that it makes no difference who or what performs this movement. The movement of play as such has, as it were, no substrate. It is the game that is played—it is irrelevant whether or not there is a subject who plays it. The play is the occurrence of the movement as such. Thus we speak of the play of colors and do not mean only that one color plays against another, but that there is one process or sight displaying a changing variety of colors."[26]

The "performances or realizations of such a structure" (i.e., play) are not a question of a subjective variety on the part of the player, but rather of "the work's own possibilities of being that emerge as the work explicates itself, as it were, in the variety of its aspects."[27] These general characteristics of play can easily be recognized in simulations (and specifically ones that are not interactive). Playing also includes the rules of play, by which the involved parties have to abide. And here too the following is true for simulations: it is a requirement that

events depend on defined influencing factors. And above all because these events are derivatives of an overarching context wherein each part has a role and multiple parts in operation always contribute to determining a "result," events are kept in check. The more specifically a sequence is defined, the smaller the deviations are and the more precisely interventions can be allocated. What form can the simulated take on if essential ingredients for the simulated reaction have to come from calculation results that are extracted from the model? The events that are simulated have a foundation in the calculated. In addition, they have to be seen as a reaction to what was previously the case. Their coming to pass must be explainable and retraceable on the basis of what is present. They do not appear ex nihilo, since nothing can come in from outside the delimited field of conditions. Even so-called open systems have regimented guidelines for the admission of data (e.g., as produced by the interactor).

5.5 Degrees of Freedom, Calculability Problems, and Levels of Description

The diversity and breadth of variations discussed above have nothing to do with omnipotence. The association of simulations with utterly unlimited possibilities is rarely made by those who themselves are involved in creating simulations. From the developer's perspective, as a rule, one comes up against incalculable problems all too quickly when one has decided to examine more intricate complexes or to transport differentiated contents. Stanislaw Lem, a medical scientist who turned to literature, introduces a figure of thought "that makes literary propositions or aesthetic ideas and actual simulation models comparable as well as distinguishable,"[28] according to the literary scholar Peter Gendolla. With a technological metaphor, Lem answered the question as to why he not only practiced science but wrote novels: "Scientific constructions—which are bound to natural laws, empiricism, conceptual/logical validity—and literary ideas differ in their maneuverability [*Bewegungsspielräume*] as the robotic arm, with currently something like five degrees of freedom, versus the human arm with six. Literature enables at least one degree more."[29]

Gendolla continues that in literature, "dimensions or 'relationships of influence' are permitted that ... would immediately lead to incalculable complexities, loops, or feedback with inexact, constantly changing, chaotic, in any case not unambiguous results. In this respect, literature—this literature in any case—is not precise, even if it speaks of precision. It builds metaphors with which it trims down complex circumstances or processes to exactly those things, relationships, and effects that *cannot,* or cannot yet, be calculated. If scientific simulation filters the calculable parameters out of a system and plays them through, so literature also engages in this playing through, but with the incalculable parameters."[30]

The author Dieter Hasselblatt calls Lem's approach "experimental literature," "specifically, a visionary idea conceived from imagination and calculation, an experiment with extraordinary, indeed outrageous situations that serve as the testing environment for the behavior of the persons called upon to act in them."[31] In order to describe what Lem offers, the literary scholar Christian Thomsen adopts Hasselblatt's concept of the "situation model": "Here, the

most imaginative Lemian fantasy, in the sense of game-theoretical variations of futurological prognoses and possibilities of thought, is able to take concrete literary form in situation models of illimitable acuity and contingency."[32] It is no wonder that these "situation models" become "simulation models" for Gendolla and that he brings the aspect of calculation into discussion.

In fact, the problematic of calculability, following Lem's statement, is omnipresent in the simulation sciences as one of their greatest challenges. For interactive simulations, two aspects are interesting. The first has to do with the selection of the level of description, insofar as the user should be able to perceive what is happening in the simulation. For example, in the case of a simulation of molecular dynamics, it would not be very informative to show as its iconic presentation the surface of a hand that can be recognized as such, since on this level, the calculated movement is not visible. Simulations thus operate at certain levels of description in that they break down what is to be presented, according to the investigation, in such a manner that the interplay of these parts can be revealed as a sequence. The second aspect makes clear that levels of description also are combined (i.e., at times they *must* be combined) in order to be able to offer an "ample" scenario for interventions.

So what is meant in this context by the technical as well as the iconic design problems related to levels of description? In 2002, under the title "Disruptive Visions," the military surgeon Richard Satava published his idea of medical examination of the future, conducted on a continuously updated substitute body: "It is an avatar, a human surrogate in cyberspace, an electronic computer representation of a person based upon patient-specific data from historical, genetic, molecular, biochemical, physiological, and digital imaging sources."[33] In the same journal column, Satava lamented two years later that medicine did not yet possess this useful diagnostic apparatus. However, first steps in this direction had been made by younger disciplines such as computational biology or "in silico" biology: "There are some early successes in simulating specific parts of humans, such as the virtual heart, the virtual cell, etc."[34] Since here, Satava speaks of the "virtual heart" and the "virtual cell," and the former possesses millions of the latter, it becomes clear that in the desire for a detailed, integrative presentation of the body, beyond the problematic of calculability, one encounters substantial challenges at latest on the level of iconization. The computer scientist Peter Oppenheimer, who also works in the medical sector, illustrates this in an instructive manner: in everyday experience, a mountain seems very solid and dense. From a subatomic viewpoint, however, it proves to be composed mainly of empty space. Through a responsible use of visualization technologies, one can change the focus as needed and in this way arrive at new conceptions of everyday objects, according to Oppenheimer.[35] The point of view should therefore also be correlated with a level of description. With dynamic aspects as well, the description of the same object at different scales, without a zoom function, has competing, mutually exclusive possibilities of presentation.[36] The "observable" movements are always located somewhere else according to the level of description. In biology, one is familiar with different hierarchical levels. Finding the most favorable level of abstraction for a particular concern is not a

simple task. And if the intention is to make computer models, the first order of business is to select a level of description. Dörner formulates the rule of thumb that should be followed: "In general, the degree of resolution should be chosen so that the dependencies of the particular 'target variable,' i.e., the variable that one wants to influence, are made clear."[37] Further, he advocates for a unified description:

> Hybrid systems are theoretical systems that mix different levels of description. If, for example, one were to describe a chemical process partly on a molecular level and partly on the level of a cooking recipe, this could lead to dangerous confusions of terms. In some cases, there is a doubling of reality. One the one hand, one says that when subjected to heating, certain molecules behave in such and such a manner (for example, they undergo a conformational change), and on the other hand one says that egg whites, when their temperature is kept at 100°C for ten minutes, become hard. The two statements sound very different but describe the same process.[38]

Dörner is not talking about exceptional cases here. In fact, the combination of levels of description, and thus of models, is frequently encountered. It is impossible to fuse two different levels of description in a single application without employing a so-called model splice. Hence, in addition to successions of models in the production process, and in addition to a coexistence of aspects of computer models and dynamic models, simulations can also exhibit multiple mathematical models in parallel, which are responsible for parts of the simulation.

5.6 Cuts below the Surface

The consequences of images … will be the images of consequences.[39]
—Marshall McLuhan

In the sciences, there is often a need to define an interface at which two models are joined. Thus, the change from a deterministic to a stochastic mode of calculation is a compromise solution when departing from the jurisdiction of macroscopic approximation; in so-called multiscale simulations, a micro/macro segue marks the change in the employed resolution. These model combinations are accepted in the sciences if, for instance, they are justified by means of consistency theorems. For Eric Winsberg, these "models … are sewn together into one unified simulation with 'handshaking algorithms'"[40]; the molecular biologist and philosopher of science Hans-Jörg Rheinberger speaks of the "grafting" of different models;[41] Richard Hughes, of the "nesting" of models, whereby one represents the internal dynamic for another (figure 5.1).[42]

5.6.1 Model Splices: Continuity of Reaction on the Surface
In surgery simulators, for example, one begins on the macroscopic level of the organs. But when two or more phenomena are to be shown whose causal nexus is actually located in the "underlying" microrealm, one makes do with model splices.

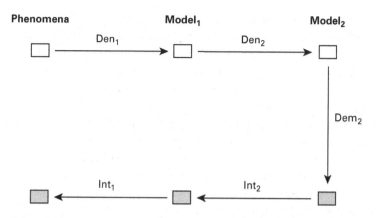

Figure 5.1

Diagram of the denotation/demonstration/interpretation approach of R. I. G. Hughes. In this variant, a model (model₁) is the object of a second model (model₂). The latter is executed (demonstration) in order to form the basis for the interpretation of the model, as well as in a second step, the phenomenon. Source: Hughes, "Models and Representation," p. S328. Courtesy of Richard I. G. Hughes. Reprinted with permission of University of Chicago Press.

At particular places—for example those that are not laid open to inspection in the simulation—such "abbreviations" can be made in that the calculation is omitted. Thus, one defines model splices at the interface of visible and invisible areas. The models that are added on are responsible for generating effects or consequences that are to be interpreted as results of a process that is not present—because its calculation is intentionally left out. For example, when smoke is produced in a medical simulator, this is owing to a command chain that could be summarized as follows: when the coagulation instrument is activated and collides with the tissue, then the previously created model for the generation of smoke is incorporated into the calculation process, which subsequently allows the effects to be shown, taking the location of the collision into account. The smoke is therefore not caused by modeled cell molecules being induced by a temperature increase to make other bonds, for example.[43] Precisely in order to spare this long detour on the atomic or molecular level, a model splice is employed as an abbreviation in the depiction of real sequences. These cuts are urgently needed so that the model complex does not explode into the realm of the unbounded and the no longer calculable. To quote the poet Rainer Maria Rilke, the realities are "*unbeschreiblich ausführlich*": at once "indescribably detailed"[44] and executed to a degree that defies description.

With the change of model, the attitude toward what is shown (the shown dynamic) also changes, but such "model splices" are not necessarily perceived in the presented simulation. Model splices as a rule are techniques for the simplification of the treatment of dynamic, which do not in principle have to bear on the iconization at all, and also with sensorialized

simulations are not to be located directly between the model and the iconization. In the latter case, with sensorially accessible interactive simulations, the reason for a patching together of mathematical models often lies with the requirements that hold sway here, which are closely tied to calculability and interactivity (as the two paradigms of computer science[45]): Since the possibility of observer interactions entails a sensorialization of processes, it is necessary to offer a continuous view, free of gaps, or, when possible, even multiple sensory channels. Without this type of orientation, a meaningful intervention cannot be made, and without model splices, certain phenomena of visibility or, above all, of manipulability cannot be brought in. As breaks on the level of calculation, model splices on the level of reception create a detailing or differentiation against a backdrop of apparent seamlessness. This continuity can be expressed as a cascade of consequences or generally as a rounding out of functionality. It also enables expanding the spectrum of actions and reactions: it is possible that in simulations, interventions and their consequences or causes are not contained in a single dynamic model or that with respect to their perceptibility, they occupy different levels of description. So that movement can be continued, at the end of one model's jurisdiction, the next model has to pick up the thread and, if necessary, spin it out further on another level. These often inconspicuous compoundings of different models are semantic propositions that serve to enrich and expand the situation's content. Here, "expansion" is not meant as a quantitative extending, for instance, in the sense of an enlargement of area, but rather as a differentiating gradation in the depth of potentially ensuing events. It is precisely through consecutive events that the scenario becomes more ample for intervening in a qualitative sense. Achieving this depth is labor intensive. Why? Leaving aside the aspect of iconization for a moment, with simulations in their "pure form" the mathematical model is the only permitted deliverer of consequences. But the networked structure of the model produces the previously discussed flatness of events. In order to show successive events that build on each other, carrying the situation further or conveying it into a transformed situation, it is necessary under some circumstances to set up and calculate a whole new set of connections.

In order to get from the initial situation to new ones, the generation of consequences and effects is central. It is not always enough to *show* consequences. If one wants to continue to ensure interactivity in a situation that is itself a consequence, its elements must also be backed with the definitional postulates of simulation models. The more refined the manner is in which the consequences are not only conceived but also mathematically derived and realized under a particular constellation, the more gradations are enabled, which in turn enable more striking possibilities for expression and more targeted user reactions. But the showing of consequences or reactions is also crucial for the potentiality of interventions. From this viewpoint, "virtual" buildings (such as architectural renderings) in which the possibility of navigation alone is provided, are characterized by an absence of consequences. In the opinion of simulation designers, this should be developed further: "A visually complex and realistic scene is of little more than aesthetic value without the ability to manipulate, navigate, and control the environment. How the user interacts with the system is an

important consideration with any computer system, and with VR packages this importance is magnified."[46]

One need not arrive at the same conclusion on all points. However, if the intention is to examine the design of intervention in interactive simulations, it is necessary to explore the features that dynamic simulations in particular have to offer—for instance, immediate reciprocal reactions of the system and the user to one another. Under this aspect, computer-based navigation through a structure as the shifting of the viewpoint has nothing new to add.

With respect to an expansion of the scene by means of a model splice, the *Limb Trauma Simulator* (since 1996) by MusculoGraphics provides a good example (figures 5.2 and 5.3). In this application from the field of orthopedics, users practice the emergency treatment of gunshot wounds in a military context. Here, at the moment at which the user cuts into a

Figure 5.2
Here, treatment of a gunshot wound to the upper thigh is to be practiced with the *Limb Trauma Simulator* (1996). At right is a tray with several medical instruments for first aid. Source: © Satava, "Accomplishments and Challenges," p. 235; Delp et al., "Surgical Simulation: An Emerging Technology for Training in Emergency Medicine," p. 151. The image was reflected vertically so that it corresponds to the original orientation. Reprinted with permission of Springer.

Virtual surgical tool

Stereoscopic viewing

Virtual human

Force-feedback interface

Figure 5.3
Sketch of an interactor with the *Limb Trauma Simulator*. Source: © Delp et al., "Surgical Simulation: An Emerging Technology for Training in Emergency Medicine," p. 157. Reprinted with permission of MIT Press.

"virtual" tissue, the tissue is portrayed as cut. From the standpoint of everyday experience, this is banal. In the simulation, however, with the action of cutting, a new view is generated, namely, another surface of tissue that runs along the edge of the cut and corresponds to the cut's depth. According to whether the polygons of the new surface lie within or beyond the previously calculated boundary of healthy or cauterized tissue, they are detailed and textured accordingly. It is the sensory impression that motivates further interventions.[47] What is not seen or observed cannot in itself be the driving force of an action. The slogan "what you see is what you get" (WYSIWYG) advertises that software is easy to use, but at the same time it "all too clearly" stipulates "the opposite: 'what you don't see, you also don't get.' The function of graphical interfaces cannot be described any better."[48] Whatever is not presented to the user is not present for him or her and does not happen. How, if not through this sensory feedback, is one to know whether and how the scenario has changed following one's own intervention? How else does one determine what should be done next? If, when cutting into tissue, a blood vessel is compromised, other measures are to be taken than if it is unimpaired. Therefore it is important to show whether, that, and how much

blood is escaping in order in some cases to signal the need to act swiftly and prompt a new diagnosis.

So that this can succeed, two models are spliced together in the *Limb Trauma Simulator*. As long as arteries, veins, and capillaries are intact, the first of two components calculates the circulation of blood as the stationary flow of a viscous medium that obeys the principles of conservation of mass and energy. The second component is deployed at the moment of injury to this closed circuit and describes the transient reaction of various hemodynamic characteristics in light of the loss of fluid.[49] Two models are needed when in reality, the two processes are interrelated, because the calculated chains of causality proceed in a manner that is completely different from natural processes. This is something that distinguishes simulations from experiments, according to philosopher of science Francesco Guala: "In a genuine experiment the same 'material' causes as those in the target system are at work; in a simulation they are not, and the correspondence relation (of similarity or analogy) is purely formal in character."[50] The deciding factor is often simply the reproductive or predictive capability of the simulation results—in other words, their performance.[51] And even without consideration of structural similarity (homomorphy), a satisfactory correspondence is achieved only in partial areas. Therefore, multiple dynamic models are often joined together. The second reason for a combination of models, particularly with real-time applications, lies in the possibility of saving computing power without exacting a toll on the sensory impression. In support of streamlining content, composites are accepted on the mathematical level that from a purely mathematical viewpoint do not produce any justifiable or logical conceptual formulation. As semantic propositions, model splices strengthen the scene that is shown, making it richer in substance, more diverse, more eventful.

5.6.2 No Connection to Another Model: Reaction Omitted

In a first approximation, without thereby taking into account the fine and possibly crucial nuances produced by the iconic design, one could see the design of interventions in real-time simulations as characterized by the range of presented consequences as well as their prevention or omission. The scenarios must be fabricated in such a way that something results from the user's intervention. Every permitted interaction has to induce a perceptible change so that it can be regarded as meaningful. This means that in every instance, a view must be presented that follows as consistently as possible given the context. A solution must always already be provided for. With this in mind, it comes as no surprise how limited and closed the conception of these worlds tends to be.

The openness of an interactive entity need not be interpreted as indeterminacy but can be perfected with respect to its internal relationships.[52] The more complexly and densely the structure of relationships anticipates the eventualities of interaction, the better equipped the work is to handle the problem of presentation of consequences and the less that interactions

have to be guided into particular predesigned channels (which could be termed a restriction of openness).

Another challenge fundamentally lies in offering a view—which if possible should be interpretable *as a result*—for all allowable interventions. In any case, it would not make any sense to allow interactions that are never employed because their situation or constellation of conditions can never arise. At first glance, it would be equally nonsensical to provide more opportunities for interaction than corresponding effects. This is because, in the simulated world—even when manipulating real interface instruments—one cannot be sure that one is doing something unless one can see, hear, smell, or feel it: in short, unless one receives corresponding sensory feedback.

If cutting and bleeding in the *Limb Trauma Simulator* was an example for showing a consequence (through a model splice), a similar action in the same simulator provides an example of the omission of consequences (through the absence of connection to another model). Too strong pulling and pushing of the tissue is prevented by the program in the following way: beyond a certain point of distance, which the developers establish separately for each tissue, the real instrument interface is uncoupled from the "virtual" instrument. Hence, the simulated instrument in the presentation cannot go beyond the defined outer limit.[53] Consequently, in the visible depiction it is "stalled," while the user can continue to move the hardware interface in his or her hand. Thus, the user experiences a discrepancy between his or her hand movement in guiding the interface (i.e., the instrument) and its optical portrayal as having "jammed." In this way, developers dispense with the challenging task of having to show what overstretching or tearing would look like for the particular constellation. Containment methods of this type are employed in the form of local or action-specific delimitations in order to prevent an exponential expansion of intervention possibilities and the resulting need for views that would follow consistently when it is no longer feasible or desirable to provide them. Every tiny additional expansion of intervention exponentiates the requisite labor. The limitation of possibilities for action should not be understood as exclusively a problem of calculability but serves other intentions as well. For example, when it is not in the inventor's interest to allow, during a gall bladder operation, the possibility—which would be absurd for a successful intervention—of cutting the liver into pieces, then this possibility is not provided for. It would have to be deliberately permitted in order for the user to be given the corresponding depicted sequence.

To recapitulate, we have stated that breaks below the surface can be differentiated. One possibility is the model splice, which creates a continuity on the surface by enabling reactions that in turn permit interventions. The other possibility is the absence of connection to another model, with one of the two following results: either no simulated reaction is offered or perceived—which does not mean that no view can be seen but instead there is no *new* view, or—and this will be the subject of discussion in what follows—something new is shown that is not based on a mathematical model. For instance, instead of another model, a static sensory set piece is adjoined.

5.7 Cuts on the Surface

In contrast to the subdivisions that occur below the surface, we use *cuts on the surface* to refer to phenomena that are explicitly accessible to the senses. In cases of visual elements, they often affect the entire projection or the entire computer screen. Two fundamentally different approaches are now discussed that, each in its own way, undermine the unity of the simulation scenario postulated above. While the first design solution is fundamentally there in order to stop progression or intervention on the part of the user, the second opens up a new situation.

5.7.1 Inserts: Slides That Mark a Boundary

In a simulation, when no consequences are simulated at a particular point because there is no connection to another model, in some cases inserts of a pictorial, acoustic, or textual nature are introduced in place of the running presentation of the simulation results. These are indeed to be understood as the executable model's answers to an action, but they cannot be interpreted as reactions of the simulated. Such inserts are sensory presentations that themselves do not provide any opportunities for action; they even block action from occurring.[54] When these inserts are presented, as when reaction of any kind is omitted, no motif-based interaction will ensue. The boundaries of the calculated are left intact, and for the interactor, one of potentially multiple "ends" of the simulation becomes discernable.

The utilization of pictorial slides is popular. The simulator URO Mentor made by the firm Simbionix for bladder and kidney examination does not provide any force feedback. Consequently, it can happen that the user pokes the "virtual" camera through the tissue without any resistance. In light of this problem, the team of developers opted for an abrupt fade-in of a static image in the event that the tissue is penetrated. These slides—there are five different ones (figure 5.4)—show a basically inconspicuous possible view of a bright membrane. The fact that these slides no longer belong to the interior view of the urological scenario, but rather obey other laws, can be seen as soon as the user turns the camera (figures 5.4e and 5.4f). Normally the view must behave statically relative to the spike at the margin of the image; in other words, it must also turn. But with the slides, this is not the case. As long as the user's instrument is located within the tissue, the slides remain fixed, no matter what maneuver is performed with the camera. Through the introduction of these set pieces, two discrepancies arise for the user. First, it would be expected that instead of the illuminated slide, the camera view would darken when the instrument bumps against the wall, since the light source would be covered up through contact with the tissue. Instead, as the user moves toward the interior bladder wall and approaches the membrane, the depicted scene brightens according to expectation (figure 5.5); however, contrary to intuition, after contact with the tissue, the scene changes to an even brighter, fixed image (one of the pictures shown in figure 5.4). Moreover, the stasis of this slide is irritating, since all further interaction with the hand guiding the camera in the wall of tissue is not portrayed.

Figure 5.4
Masking images for Simbionix's *URO Mentor* (n.d.). Stills. Source: Author's photographs, Mannheim 2007. © URO Mentor, Simbionix, USA.

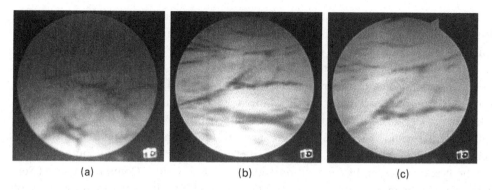

(a) (b) (c)

Figure 5.5

Stages of movement of the camera in the bladder with the *URO Mentor*. (a) The scene is dark because the camera with light source is located far away from the skin. (b, c) As the camera approaches the bladder wall, the tissue gets lighter because of the illumination. Stills. Source: Author's photographs, Mannheim 2007. © URO Mentor, Simbionix, USA.

As long as the instrument is calculated to be in the tissue, the user's own manual interaction is suspended in the visual depiction. During this time, the tissue cannot be injured with any instrument. Thus, any action that happens now is not only not viewable but also has no effect.

Thus, interactive real-time simulations can be examined as balancing acts between what is calculable and what is conducive to imaging, since, first, everything calculable must be conveyed to iconicity if the results of calculation are to guide the user's actions, and, second, that which is no longer calculable in detail is for its own part possibly (only) still presentable in an image. This could mean, for example, that it is in fact still shown (or indicated), but any explicit content-related intervention can no longer be carried out. To present something prefabricated is to present something showable. However, only that which is also iteratively calculated is conducive to interaction because it is capable of reaction. Without calculation, no computer-based situation can be made that reacts sensitively to interventions, and without presentation, there is no possibility of involving a user actively in what happens. Consequently, only the combination of the calculable and its presentation yields the possibility for an interaction.

5.7.2 Scene Change: Montage of Different Situations

Beyond the signalized "ends" of simulations, we have previously spoken of a spatial and temporal unity in simulations' sensory presentation. Because of this, one is inclined in spite of a decidedly created sequence of events to bring real-time simulations, for the most part and in general, into closer association with the impression of daily experience than with, say, a film. Although simulations fundamentally display a continuous occurrence, in some cases there can be one or several abrupt changes in the presentation. In addition to the slides that were

just analyzed, which are briefly put in the foreground, there can also be scene changes spanning the whole computer screen that offer new sensory arrays and extend new opportunities for interaction. In contrast to the inconspicuous model splices that were already discussed, these action-expanding measures that will now be analyzed are impossible to overlook.

The next example demonstrates how, by means of the available hardware as well as the sensory depiction of the scenario, the possibility for intervention changes in the middle of a task in the process of completion, through a complete break. We are speaking of a surgical simulator by the name of *VR-FESS* (for virtual reality–functional endoscopic sinus surgery), which was developed from 2003 to 2006 at the Institute for Applied Computer Science, Karlsruhe Research Center, in cooperation with Innovation Center Computer Assisted Surgery in Leipzig. The exercise involves a so-called partial-task trainer with a narrow scope of activity, simply encompassing a man's head and immediate "air space" against a dark-blue background.[55] Here, a visual replacement and a fragmentation of mobility occur in the simulation, where in everyday experience a greater coherence would be felt. The user connects with the application by means of the *PHANToM*, a penlike haptic input device manufactured by SensAble Technologies (figure 5.6).[56] The view of the simulation is presented on a normal computer screen. When the program is started, the initial situation appears: a monitor divided into four fields (figure 5.7). In the user's taking hold of the input device, his or her hand movements are reproduced in all four views. While a rod-shaped instrument appears in three of them, the section of screen at the lower right reveals that the user should interpret the "device" in his or her own hand as a camera with which to explore the surroundings. Furnished with a black circle, this camera image already sets itself apart optically from the other fields. While the user has this view in hand, it appears that rigid, not-influenceable recording devices are mounted (or are to be imagined as mounted) along the typical section planes of imaging procedures: at the upper left of the screen, we see a frontal view of the head; at the upper right, a side view; at the lower left, we are looking from under the chin. With respect to point of view, the surgeon could perceive the two views on the lower half of the screen approximately as they are shown. However, two additional external perspectives are patched in as if on a surveillance monitor. In these images, the user can certainly see what he or she is doing—specifically, having identified the device's functionality after a brief collation phase, he or she is guiding it around the head in order then to insert it into the right nostril (on the left in the image)—but can see nothing that is essential for the intervention there. Only the window at the lower right is capable of showing something that must be seen for the intervention that is to be attempted. It offers the most interesting view, the one that shows the most movement and draws attention to itself: in contrast to static shots, the "moving camera … [takes] my eye, *and thus my consciousness*, along with it: right into the image, into the thick of the scene of action."[57]

The writer and film critic Béla Balázs's observation about the cinema image is all the more true when the viewer is holding the camera. However, in this situation the eye has its own, active role and is indispensable for orientation: it can find out where the hand is needed

Figure 5.6
Hardware interface (*PHANToM* by Sens-Able Technologies) used in the simulator *VR-FESS*, (2003–2006) developed by ICCAS Leipzig in collaboration with the Institute for Applied Computer Science, Karlsruhe. Source: Author's photograph, Leipzig 2006. © Uniklinik Leipzig/Forschungszentrum Karlsruhe.

Führen Sie die Kamera mit 30° Optik in rechte Nase ein
und blicken Sie auf das Operationsareal (bestätigen mit Schalter 1)

Figure 5.7
Approaching the operation site with the "virtual" camera (window at lower right): *VR-FESS*. Institute for Applied Computer Science, Karlsruhe. Source: Author's photographs, Leipzig 2006. © Uniklinik Leipzig/ Forschungszentrum Karlsruhe.

and how the hand can serve the eye simultaneously to the mobility of the field of view. A double containment results: the eye wanders within the camera circle; the hand camera moves within the fixed, haptically bounded space of the computer model. In order to catch sight of the location to be operated on, eye and hand have to help each other.[58] This is due to the fact that the simulated endoscopic camera is guided not by the gaze but by the hand of the interactor, and the film image does not correspond to natural perception. Arnheim elaborates the difference between the bounding of the film image and of the visual field: they cannot be compared "because in the actual visual space of a human being, the visual image is not bounded at all. For us, this visual space is unbounded and endless; for instance, we can indeed take in an entire room as a unified visual space, although our eye cannot survey this space with a single 'shot,' since while we are looking, our gaze does not tend to be fixed, but rather moves freely. Our head and eyes move and we thus take in the entire space as a closed image. This is not the case with the film image or the photograph,"[59] because these have a fixed frame. One result of this is "that when the camera moves, new objects constantly

appear within the margins of the image and then disappear again, whereas for the moving eye, a whole, undivided space lies before it, through which the gaze wanders freely."[60] The bounding of the visual field in the small, round camera view is strongly present, but on the whole it also corresponds to the experience that doctors have with real endoscopic camera images.

The patient's head was developed for a brain ventricle operation simulator and was slightly modified for this reuse. The color was removed from the irises of the eyes in order to avoid disturbing the trainee and to approximate more closely the actual goal, closed eyelids. In addition, a light-colored tube can be seen passing through the right eye. "The tube in the eye," as the doctor Antje Pößneck, a participant in the simulator's development, explains, "is simply the cylinder that we set for simulation's first function. The trainee has to approach the operation area from a particular angle in the endoscope view. When he or she then clicks on the button on the PHANToM, it will only switch to the 'large,' fixed endoscope view if the endoscope is positioned within this cylinder."[61]

Thus, here we have a rule for action that has become visible. If the hand camera is placed as has been allowed for, that is, obliquely in the direction of nostril, then when the button is pressed, the navigation phase with the camera ends and the intervention phase begins. Since the one interface instrument has to embody all "virtual" instruments, the developers selected a choreography that separates the stages of action and arranges them temporally one after another. This means that the one input button is assigned a different function for the different actions. Since the user needs this one button to operate the "virtual" instrument, there is also no possibility to reverse. The sequence of allowable actions can only be carried out progressively.

In the phase of intervention, the provision of views that show the head from the outside becomes obsolete, since the operation takes place inside the nose. What is needed instead is a detail view. Hence, the endoscopic camera window suddenly fills the whole screen (figure 5.8a). This is a fourfold enlargement of the window view at the moment of the switch.

With this change, the viewpoint of the camera image becomes fixed. The section that it shows from then on remains unalterable for the duration of the exercise. In switching to a single view, the transition from changing the depicted section by means of the camera instrument to changing the depicted motif by means of the pincing instrument is realized. It is no longer possible to switch to the mode of the panning camera. In this way it is also made clear what the user should now be concentrating on. The blowup of the view prevents the impression that the other three views (that show the head from the outside, coronally, sagitally, and transversely) are—on account of the now immobile camera—frozen. In addition, what view, if not a stationary one, should be presented so that the interface instrument in the trainee's hand can assume the function of a pincing instrument?

As the trainee, one does not necessarily expect on the first try to be instantaneously taken out of the role of the filmer and placed into that of the actor who is seen through the camera (figure 5.8b). Specifically, from this moment on, one's hand movement no longer causes the whole view suddenly to change. As if relieved of a burden—that is, the challenge of

(a) (b) (c) (d) (e) (f)

Figure 5.8

(a) After switching over, the *VR-FESS* camera view fills the entire screen. (b) The trainee uses the pincing instrument in the detail view. (c) The pincing instrument no longer interferes with a supposed camera, since it can also be seen from behind. (d) The central nasal muscle (here, at right) has to be pushed gently to the side in order to reach the cyst that is to be removed. (e) The instrument has become lodged in the tissue (right). (f) At the nasal opening, the rigid external skin (upper diagonal line) and the malleable internal skin (lower diagonal line) can be seen. Screen shots. Source: Author's photographs, Leipzig 2006. © Uniklinik Leipzig/Forschungszentrum Karlsruhe.

the constantly shifting video image—one seems to be holding a more slender instrument, moving more deftly, almost weightlessly. One achieves a liberating new kind of lightness, although the interaction device in one's hand is still the same. Through the more restful image, the eye is also more relaxed and more independent of the hand. First, the eye is now no longer restlessly scanning the edges of the visible section in search of a direction or a segue that promises to be interesting, in order to instruct the hand to move the camera accordingly. And second, the situation no longer arises that the eye has nothing else to do but to follow the camera's movement overall. The constant, arduous adjustment is no longer needed. Now that, with the fixing of the camera position, there is no longer any point in watching the margins, the eye of its own accord discovers the center of the image. It shifts from the eager desire to take in everything not visible beyond the shown section, to the exploration of interior structures, which assists the further proceedings with the instrument. The movement switches from the global shifting of the view (of something relatively static) to a movement within the image, which now adheres to a fixed section. What is thus gained is the capacity to act within this section with a new instrument. In the nose surgery, it is also noteworthy that the camera view seems disembodied from the moment that it passes out of the user's hands. In that the user can see the pincing instrument that he or she is holding, from that moment on, from all sides—including from behind (figure 5.8c)—it must be assumed that the instrument and camera cannot get in each other's way.

The surgeon's task now consists of scraping away the fine bony structures. By pressing on the button, he or she clicks away the cyst with the forceps, which technically means "erasing" nodes of a textured surface. Optically, through this type of realization it can seem as if some "virtual" scraps of tissue are hanging in the air without any motivation. In order to get to the bony cyst in the first place, it is necessary to push the central nasal concha, which is attached to the lateral wall of the nose, to one side (figure 5.8d). In the attempt to accomplish

this, it is all too easy to move the pincers outside the visual field, not infrequently lodging them in the tissue (figure 5.8e). If this happens, the user will then be occupied for a while with mastering the pitfalls of the choreography rather than with removing the remainder of the chronically inflamed ossicles. He or she is presented with the difficult task of locating the instrument again without any direct (i.e., orientationally conducive) relationship between the position of the camera and that of the instrument. This is made more difficult because the user cannot move the instrument as freely as he or she would choose to, since the built-in force feedback for the resistance of the tissue keeps this movement in check. In the search for the user's own instrument, an angular, flesh-colored *something* often becomes visible. In this case, the gray-black pincing instrument is located behind the severely stretched skin, so that the latter takes on its form.[62] This can happen because the patient's head is defined by two surfaces (figure 5.8f): the exterior skin is a rigid, immobile, and penetrable computer model, while the interior skin is equipped with physical characteristics, hence deformable (figure 5.9). If the user "gets lost," this often leads to the conundrum of having to "feel" for the hole through which the space between the skins was entered, all the while being compelled to look in the other direction. At this point, the user has no recourse but to orient himself or herself from the haptic impression that is offered. It is indeed possible to guide the instrument manually into the rigid visual field, but not to look for the instrument with the camera (which also at one time had been held in the user's hand). Normally, one would attempt from both sides to bring viewer, camera, and instrument into line so that the latter

Figure 5.9

The inner skin can be pulled over the outer skin with *VR-FESS*. Detail from the navigation phase. Source: Author's photograph, Leipzig 2006. © Uniklinik Leipzig/Forschungszentrum Karlsruhe.

could be seen. In situations such as these it becomes clear how much—no matter how badly the eye wants or needs to wander—one is dependent on, caught inside the camera section.

The peculiar aspect of this application is that one instrument in the trainee's hand takes on different, mutually exclusive functions that replace each other: the guiding of the camera is suspended as soon as the trainee is performing the surgical intervention.[63] Such "task areas" can indeed also be combined, as is the case in many computer games. For example, players of *Myth: The Fallen Lord* (1997) can command a troop of soldiers while simultaneously, from an elevated perspective, changing their viewpoint on the events of war. Hence, the communication theorist Etienne Armand Amato speaks of the "player's two bodies": the "body of action" (*corps d'action*) in the form of the corps of soldiers and the "body of vision" (*corps de vision*) that corresponds with the "virtual" camera view.[64]

We maintain that the discussion of breaks or cuts presupposes a fundamentally recognized unity or uniformity that is then broken down. As we have come to understand, the most fundamental standard that gives rise to unity is the perspectivation. The cuts that we have just addressed have to do with this, but they also refer to further unities: the fusions on the level of the model, which are concealed, are there in order to ensure a unified situation for recipients. The fusions that are evident, however, relate to the scope of models (as unified situations for dynamics). The fact that models have something like a limited scope can be understood in terms of their formation. In the following, the question of form leads us to the question of the sites of forming.

5.8 Reforming Forms

In Brian Massumi's assessment, the concept "form" enjoys no great popularity in the current art theory that deals with contemporary art. Many critics and scholars interpret the artistic impulse to the effect that a combinatorics with at most associative connections is favored. Massumi himself denies that the category of form is obsolete in contemporary art: rather, "form" is wrongly associated exclusively with something static. Instead, it becomes apparent that static forms in the manner of objects do not correspond to the impressions of perception, but rather are a human construct. Therefore, "form" can also be conceived differently. From the philosopher and mathematician Alfred North Whitehead and the art theorist Susanne Langer, Massumi adopts the view that we imagine objects in an act of abbreviation, where there are really only constellations of relationalities. "The form of the object is the way a whole set of active, embodied potentials appear in present experience."[65] A parallel comes to mind here: Aren't computer simulations essentially constructed relationally? Under these auspices, their iconizations seem to continue the human habit of discerning objects instead of relations through an act of synthesis. For example, in the context of clearly circumscribed "graphic elements," we spoke of their aggregating function. And it became evident that these fabricated aggregations, as the designers' decisions about what is encapsulated as an entity

and how, are crucial for the recipients' interpretation. These solidifications support and restrict interpretation simultaneously.

We have digressed. Massumi is precisely not talking about this type of solidification into objects when he reinforces the concept of form in contemporary artworks. The art critic Nicolas Bourriaud also defends the concept of form by advocating an expanded understanding of what form is. He insists on the instability and diversity of the concept of form, which he understands in general as a "prolonged encounter." "Form" must not necessarily encompass an object, but can designate an entire setting in its dynamic coalescence. It can be dialogic and essentially relational. In artworks, where form mainly occurs in motion and in dynamic connections with other entities, Bourriaud prefers to speak not of "form" but, rather, of "formation" in order to emphasize the process.[66] In many accounts, the concept of form receives a modifier that attempts to capture the condition that the "aesthetic of form" increasingly has to do with an "aesthetics of *mutable* form."[67] According to the artist Richard Brown, artworks that change their form, movement, and materiality according to the user's manner of viewing are characterized by a "dynamic form."[68] Temporal form as specifically designed, time-based change corresponds to an aesthetic of experience and behavior.[69]

We have come to the understanding that in the case of simulations, production is defined as the generating of a situation. What is determined is not any specific sequence, but rather the context for an infinite number of potential courses of action yet to be calculated. But at the same time, the forming of the dynamic is what the simulation accomplishes. So is an explicit movement formed, or simply the potential for one? The answer is "both," if we remember Luhmann's medium/form distinction. If becoming—or for the artist Nicolas Schöffer, time—offers the material for a formation,[70] temporal plasticity does not exclude the transformation of (dynamic) forms itself becoming the object of design. With simulations, the formable "matter" is form itself, on a symbolic level. The models as forms are limiting (or more generally, determining) factors for further forming.[71] Here, forms as force fields in constant negotiation give shape to other forms.[72]

Forty years before Massumi, Eco found himself prompted to defend the concept of form when considering Art Informel. With his conception of the "open artwork," he did not intend "to declare the death of form overall," but rather "to construct a more articulated concept of form, that of form as a field of possibilities."[73] Hence, what is being formed is a potential that is "rationally organized, oriented, and endowed with organic developmental urges."[74] Between the first form and what it forms, a process of generation takes place. The designations "formation" and "dynamic form" already indicate this movement. We will now attempt at least briefly to suggest the underlying movement here and to ask how this genesis comes about and, above all, how this genesis is recognized as such.

5.8.1 Consummation as Movement between Virtuality and Actualization

The conceptions of form addressed above—the frames of which become ever more elastic and which on the one hand make up a unity, while on the other hand also containing a

multiplicity of forms—pose methodological problems for critics (and nevertheless, Eco will likely prove to have been right when he says that critics of the future will have no trouble coming to terms with them). Should the essence of such a work also be described as something accessible to the senses, or is it necessary to retreat to a catalogue of variables whose theoretical spectrum the critic then expounds? Is this a work that must be imaginatively assembled into a whole through the particulate views that are themselves experienced, so that the work should be seen as the sum of all its possible views? These two questions mark the poles of a field of tension within which we are obliged to navigate. The phrase *catalogue of variables*, on a definitional level, refers to a point before an ensuing concretization: it is the realm of the virtual or the potential. *Particulate views*, however, indicate actualizations of these latencies. If an attempt is made to survey the entirety of the constellation, one sees either the concept that represents the potential, or the alternatives—in other words, the mass of experienced or experientiable manifestations, which in sum and taken in the abstract allow a field of possibility to appear. But in execution and interaction, one does not constantly have this potentiality and tumult of all options before one's eyes, since one is not given access to all producible states but rather is presented with a single situation or view. As the recipient, one experiences a sequence of events. Therefore, the concept of nonlinearity should be postulated only from the standpoint of the one who has a privileged overview (i.e., the developer).[75] As a rule, programmers are highly familiar with the model they are implementing (to a certain degree of complexity) and the iconization. But even those who have conceived the often immeasurable totality of theoretically existing combinations are not capable of anticipating how it will be realized when it is viewed.[76] They know the mechanisms on the basis of whose "regularity" something is "carried out," and are nevertheless not in a position to predict how the dynamic will unroll. Ultimately what sets these "demiurges" apart from the divine perspective of the "landscape of events"[77] in Virilo's mold is the necessity for executing the simulation. They bring the results into view, and yet at no point do they have the impression that what plays itself out there is like a film.

As a recipient of simulations, one comes to understand the state of affairs little by little. If one wants to grasp the distinctive quality of simulations, it is important not to succumb to the impression that what is at issue is *one single* view (or as well, *one single* sequence). The simulation is nevertheless just *one* work, albeit an "always unfinished" work, which in all probability could also have elapsed differently and would also look different a second time. This is an iconicity whose progression is never already determined and linear. Rather, it is set up as a potential progression that is actualized differently each time through each distinct interaction.

The philosopher Jean-Paul Sartre differentiates a "situation," in emphasizing the possibility it contains, from a "state." Nevertheless, "Every choice is the choice of a concrete change bestowed on a concrete given. Every situation is concrete."[78] Thus, if simulations are considered prospectively, they show themselves in their potentiality or virtuality; if they are considered retrospectively, a particular manifestation has been actualized.

In art-theoretical discourse (and for the most part only there), completion by the recipient is often spoken of. This marks an important point: while a simulation's authors form a virtuality, its viewers perceive a dynamic via its actualization. These are different stages of forming, each of which makes itself evident on a different level. Just as the recipient knows that that which is transpiring before his or her eyes is nothing like a film because what is being offered is interwoven with something that is always also there as a formal foundation, the programmer also not only has the exact form of the potentiality in mind, but also aims for its execution indirectly through his or her actions. This has consequences for the task of designing. The mediatedness of forming via a potentiality entails that developers aspire to perfect not the individual still images but rather the movement of their production. According to Quéau, it is a deep necessity of systemic interdependency that simulations (models in execution) do not stop reforming themselves. Their condition is that of permanent metamorphosis, incessant becoming. Hence, the genesis of this progression becomes central. With this statement, Quéau stresses that the objective is not the completion of individual views but rather the consummation of the work: "The virtual work does not complete itself in order all the better to consummate itself."[79]

The nature of the movement of this consummation of a perpetual genesis can be imagined as a permanent oscillation between the realm of the potential or the virtual and the realm of actualization, whereby both are always present at once. One may have noticed that until now we have generally placed the word *virtual* in quotation marks. Its use in expressions such as "virtual cell" or "virtual reality" indicates only that what is being referred to exists exclusively on the computer, which is not the sense of virtuality that is intended here. This conception of virtuality—as has already become clear—has as its complement actuality or actualization. The latter implies the idea of a process. Virtuality carries the conditions of its own actualization within itself. Therefore, with this constellation, one is already located in a context of generation. In the execution of applications, one is dealing with actualizations; one does not experience the movement of the genesis or the virtuality directly, and yet they are somehow present. In order to get an idea of what this generative movement, which is simultaneously also a movement of enunciating the virtual, could look like, we will consult the phenomenologist Maurice Merleau-Ponty, who takes as his subject another not directly accessible entity, time: "Time understood broadly, that is, the order of coexistence as much as the order of succession, is a milieu to which one can only gain access and that one can only understand by occupying a situation within it, and by grasping it as a whole through the horizons of this situation. The world, which is the nucleus of time, only subsists through this unique movement that simultaneously separates and brings together the appresented and the present."[80]

Thus, a specific situation is postulated that can allow an experience of that which is not immediately accessible (in our case, the virtual). We have attempted to outline a few of the horizons of this situation in their becoming tangible: contemporaneity, manifold variations, the flatness of events, and cuts.

Following Deleuze, virtuality can be thought of in *difference* to what is being offered in the moment. For his remarks on the virtual, he interestingly and fittingly alludes to the cut through the visual cone in central perspective:

> The Bergsonian schema which unites *Creative Evolution* and *Matter and Memory* begins with the account of a gigantic memory, a multiplicity formed by the virtual coexistence of all sections of the "cone," each section being the repetition of all the others and being distinguished from them only by the order of the relations and distribution of singular points. Then, the actualisation of this mnemonic virtual appears to take the form of the creation of divergent lines, each of which corresponds to a virtual section and represents a manner of solving a problem, but also the incarnation of the order of relations and distribution of singularities peculiar to the given section in differenciated species and parts. Difference and repetition in the virtual ground the movement of actualisation, of differenciation as creation.[81]

A single run of a simulation that one perceives as a recipient is therefore to be conceived, like a conic section (one of many that are to be and have been generated, all of which are in a manner of speaking structured into the work), as an actualization of something virtual. The latter could here most readily be identified as the mathematical model together with its iconization.

Nevertheless, the question of how we recognize that what users perceive is an actualization of a virtuality has not yet been answered sufficiently. In what way exactly are potentials, as de facto invisible qualities, conveyed? What does a phenomenology of the virtual look like? What are virtuality's discernable traces? For Merleau-Ponty, the multiplicity of points of view (and, we would add, of manifestations of formations) is "only suspected through an imperceptible slippage, or through a certain 'indeterminacy' [*bougé*] of the appearance."[82] Eco speaks of a poetics of the suggestion of something indeterminate, which only "makes" itself when we take it into sight. It is necessary to comprehend the nature of this suggestion by which the virtual entity shows through the actuality as it transpires.

In any case, according to Deleuze, virtuality is not connected with actualization through a resemblance (this is precisely what differentiates it from "the possible") and therefore also cannot be recognized through resemblance. In his view, actual terms never resemble the virtuality that they actualize: the qualities and species do not resemble the differential relationships that they embody; the parts do not resemble the singularities that they embody. "In this sense, actualization or differenciation is always a genuine creation. It does not result from any limitation of a pre-existing possibility. ... For a potential or virtual object, to be actualized is to create divergent lines which correspond to—without resembling—a virtual multiplicity. The virtual possesses the reality of the task to be performed or a problem to be solved: it is the problem which orientates, conditions and engenders solutions, but these do not resemble the conditions of the problem."[83]

If one is most readily inclined to identify the virtual with the mathematical model, then one can agree with Deleuze that the virtual (e.g., a system of equations) does not resemble its results (the solutions to the problem). In addition, in our examples, the actualization comes

into negotiation with the possible (particles of iconization that are prefabricated and then provided) at times to a greater and at times to a lesser extent.

At this point, we will refrain from taking a logical next step, the further delineation of the relationship of model and sensorialization using the terminological pairing of the virtual and the possible. Also, after these intimations, a further elaboration of an aesthetic of simulation iconicity is still left to future work. Instead, we will devote ourselves in the final chapter to the relationship between simulation image and recipient. Design solutions will be discussed that allow pointing out the specific iconic means through which the situations take on their contours for the user.

6 Iconicity and Interactivity

6.1 For an Interweaving of Iconicity and Interactivity

Following Quéau, with computer simulations, there is no choice but to acknowledge the systemic basis through the aspect of the modeling of interactions: "The model must formally capitalize on the ensemble of collective potentialities of these meta-images, the programs that generate and manage them, and the machines that materialize them. ... Indeed, the 'new images' are, so to speak, nothing other than the protruding tip of the 'iceberg' of formal systems."[1]

However, in chapter 4 it became clear that it is far too simple to assume that all potential manifestations of a simulation are concealed and contained *in nuce* in the model, since with this assumption, the aspect of the iconization is left out. With the metaphor of the iceberg, two saliences of the simulation image are suggested: one could be related to what lies "below the surface" (Quéau makes this connection); the other involves the recipient and is analyzed in this chapter.

In discussions of computer-based technological artifacts that as their defining feature allow the recipient to make an explicit intervention, critics are all too often willing to let the matter rest with a description of the concept of the work together with a survey of the technical *dispositif*—in other words, the input and output devices (e.g., video tracking, cyber helmet, joystick, monitor, microphone), as well as their interaction. Even here, in spite of the widespread notion of an interchangeability of input media ("device independence"), it would be desirable to make a more precise account of the utensils being employed. Thus, for example, the musician and computer scientist William Buxton rightly observes that different muscles of the hand and arm are engaged depending on the length of the lever of joystick.[2] Correspondingly, the required amount of force can also vary. Does this not belong just as much to the overall complex of a work? While we acknowledge that a more precise

account of the hardware is desirable, in the following, in support of the concentration of our argument, we will nevertheless continue to place our focus on the sensory/iconic design of computer-based image worlds.

Under discussion are works in encountering which, and by means of which, the user can intervene in simulated scenarios, leaving traces of himself or herself there. But what does it mean exactly to speak of an "interactive iconicity"? How does the concept of interactivity relate to iconic qualities? We touch on several positions that attempt to devise a concept of interactivity. Then we consider those tendencies and sectors in which interactivity and image do not simply stand side by side or function in alternation but rather are interwoven. Finally, in a third section, we examine how the sensory design, in terms of the forming of interaction, is carried out in individual cases.

In the search for existing theoretical approaches to the concept of interactivity, one encounters grounded debates that have been in progress for decades in media and communication studies. We will not attempt to reproduce even the most important of these approaches here, especially those that do not discuss interactivity in association with sensory aspects. Certain strains of research in computer science or engineering make this connection more readily. At the Imagina conference in 1992, with the overall subject "Images beyond Imagination," a section was presented under the heading "The Interaction of Man and Images." Despite this promisingly capacious title, the selected approach was highly specific, concentrating on the arsenal of devices that are intended to ensure communication between humans and computer images.[3] The majority of contributions in the field of applied research known as "interaction design" are concerned with the development of hardware and software components. These are endeavors that could possibly also have to do with pictorial user interfaces. But how these influence interaction is rarely the object of intensive analysis beyond ergonomics. Concepts of interactivity in this context often revolve around technological categories. The disadvantage of this is that their relationship to the iconic qualities of an application is rarely taken into view.[4]

Just one point of discussion that is frequently raised in this context suggests the direction we are also taking here: the question of to what extent it is necessary for interaction to represent the user's own hand as the entity of showing or indication in the "virtual" sphere.[5] However, technological and aesthetic aspects of real-time interactivity ought to be reflected to an equal extent.[6] If one were to locate interactivity more strongly in the content and consider the whole work, including its subject matter and formal design, then, according to our thesis, one would be in a much better position to discover subtleties that unfold in the concrete engagement with the particular image world.

It's possible that positions that make a point of discussing artistic works have more to offer the subject of iconicity. For example, the art historian Kai Uwe Hemken develops his distinction between primary, secondary, and tertiary interactivity in view of the avant-garde

movements of the early twentieth century. According to him, "primary interactivity" desig-
nates the traditional stimulus/response relationship between artwork and viewer. "Second-
ary interactivity" heightens the immediacy between work and viewer through changing the
aesthetic language. Finally, "tertiary interactivity" allows the art status of an object to be
questioned by the viewer. Hemken is concerned with "discussing significance, participation,
and reflection on the conditions and possibilities of meaning production."[7] Therefore, he
rejects as an overrestriction the limitation of the concept of interactivity to electronic media.
The literary scholar Christiane Heibach views this critically: Hemken's definition does not
differentiate between the degrees of action with which the recipient is involved in the art
and limits itself—in a very traditional way—to designating "interactivity" as construction
of meaning by the viewer. This has the consequence that the term forfeits its sharpness
of distinction, since it can be applied to all art forms, from the book to panel painting to
digital art. "Definitions seem more promising," Heibach states, "that link interactivity to
forms of recipient integration that go beyond the cognitive act of meaning construction."[8]
Heibach identifies gradual differences in interactivity, measured by the amount of free play
(*Handlungsspielraum*) afforded to the user's actions. With "initial interactivity" the user sets
off a process that cannot be influenced or navigates through a VR environment; "reactive
interactivity" also includes a higher degree of interactivity, changing the process that has
been set off. Finally, "creative interactivity" generally results from a linking of real and elec-
tronic spaces, which, in expanding the space of action, makes it possible "for the user to
change the processes in unpredictable ways."[9] Like Heibach, a majority of writers locate the
concept more strongly in the context of new media and hence tend to follow the orienta-
tion of informatics. One of these is the art historian Hans Dieter Huber. Under the head-
ing "Reception-Oriented Approaches," he elaborates the categories "reactive," "interactive,"
and "participative" in order to demarcate that works differ substantially in their change-
ability—in other words, the extent of impact of interventions.[10] Reactive works permit a
navigation, interactive works enable a temporary influencing of the work by the user, and
participative works allow a lasting change of form. In her early texts, Brenda Laurel sketches
interactivity as existing in a three-dimensional continuum that can be characterized with
the variables frequency, range, and significance: these variables account for how often the
user can interact, how many possibilities the user is given to choose from, and how strong
an impact the choice makes.[11] Later, however, she judged this approach as in need of sup-
plementation, because the feeling of participation is not adequately encapsulated in these
coordinates.[12]

As already becomes evident from this small selection, these and many other classification
systems attribute fundamentally different degrees of user involvement to artifacts, which
accords with the view presented in the *Dictionnaire de l'informatique* in 1981 that the "degree
of interaction" is often expressed with the word *interactivity*.[13] Conceiving of interactiv-
ity as a quantitative measurement is a dominant approach, to the extent that the media

archaeologist Erkki Huhtamo feels compelled to point out that such a measurement should not always be the main criterion for the evaluation of interactive art, since "there are works which deliberately restrict the possibilities of interaction as part of their artistic strategy."[14] We would concur with this.

Since it is not our objective to name other or additional factors and designate works accordingly, such a typological manner of investigation can be only a first step in the direction of studying how sensorial design forms interaction. The examination of user involvement thus does not end with the question of how much interactivity is present; rather, this is the starting point of analysis if interactivity is regarded as a constitutive artistic component of a work. More specifically, it is crucial to examine precisely what note colors a work through the overall design and what factors give shape to an interaction.

The approach being pursued here can be understood in yet another way through reference to the communication scholar Jens Frederik Jensen. In his analysis of definitions of *interactivity*, he distinguishes three ways of conceptualizing the term: as a feature that is present to a greater or lesser degree, a prototypical example, or a criterion that must be met.[15] While the positions summarized thus far can be assigned to the first group, the last option is favored here. But according to Jensen, a disadvantage of this is that when posited as a premise, this option makes it impossible to differentiate forms and levels of interactivity. This objection presumably makes sense only if one is attempting a comprehensive definition that is designed to take into account all phenomena that can be regarded as interactive; in this case, it would have to be supposed that if the third option is posited, much will be excluded from the outset.

However, such an attempt is not the goal here. Rather, we are taking the field of real-time interactions as a starting point in order to discuss individual designs and, in a next step, specific qualities that result from them. Interactivity is thus a characteristic of a constellation that promotes and allows interactions—hence, actions—and absorbs them as an influence. This view permits outlining the conditions that are responsible for the specific shaping of interactions.[16] At issue are variants of interactivity that enter into a symbiosis with the sensory aspects—thus, examples where iconicity and interaction condition each other reciprocally. Is it any wonder that in most cases, they correspond with the variants designated as the "highest" or "most intensive" forms of interactivity on the typologization scales? First, on the basis of an important difference that some of the summarized typologies also register as such, we will devote ourselves to the question of how a high degree of interactivity makes itself apparent.

6.2 Prefabricated Paths versus Designed Situations

These fundamentally different variants with respect to interactivity have already been pointed out many times in the discourse on media art. The art historian Frank Popper roughly divides computer-based works between those that administrate a collection of digital(ized) material

and those in which interactive real-time image worlds are calculated.[17] The media theorist Lev Manovich follows suit: "Finally, the idea of content preexisting interface is challenged in yet another way by new media artworks that dynamically generate their data in real time. While in a menu-based interactive multimedia application or a static Website, all data already exists before the user accesses it, in dynamic new media artworks, the data is created on the fly."[18]

This distinction seems imperative above all against the background of the differences, which should be viewed as symptomatic, between the art historian Söke Dinkla and the theater expert Brenda Laurel. With regard to Laurel's book *Computers as Theater*, Dinkla observes, "Whereas Laurel attempts to develop [... a robust and logically coherent understanding of structural elements and dynamic], in interactive art strategies are emerging specifically to avoid logic and causal connections. At the same time, as a result of the inappropriateness of Laurel's theory for interactive art, its fundamental differences from computer games, which form the basis for Laurel's considerations, become evident."[19]

This separation into computer games on the one hand and interactive art on the other hand can no longer be upheld now that there are artistic computer games.[20] Dinkla's assessment betrays that she is starting from the concept of the multi- or hypermedial, of works made from networked image, text, and sound materials, as could be realized using video disc technology since the 1970s. These works are characterized by the fundamental features of interactivity that the media art theorist Gene Youngblood postulates for the 1980s: "interruption," "selection," and "creative conversation."[21] With these projects structured around databases, a choice is given to the user simply with respect to the sequence of previously recorded sequences within a determined scope.

One example is Lynn Hershman's videodisc installation *Lorna* (1983–1984), considered one of the earliest artworks using this technology.[22] *Lorna* takes as its subject the life story of an agoraphobic woman who has not left her apartment in years. The visitor enters a furnished living room similar to the protagonist's (figure 6.1). The armchair invites getting comfortable in front of the TV, where written instructions appear (figure 6.2). If the visitor follows the instruction at the lower right, he or she is given a confirmation that the interaction has been carried out correctly and is then encouraged to continue to apply what has been learned. After this, the protagonist and her living room are introduced, and finally, a menu is shown that is incorporated into a video still (figure 6.3). There, an assortment of everyday objects can be seen. The connection to the remote control in the interactor's hand is given in white writing: the individual objects are shown, named, and numbered. Through the number that is keyed in, a narrative thread begins in the form of a video that then ramifies, prompting the user to make a decision. The unfolding of the story repeatedly calls for interventions at certain points in order to set in motion predefined elements.

With respect to the interactivity, two questions are central and should attend upon the following considerations. First, how does the sensory configuration prompt the user to make

Figure 6.1
Installation view of Lynn Hershman's *Lorna,* (1979–1983). Source: © ZKM | Zentrum für Kunst und Medientechnologie Karlsruhe, photo: Philip Radowitz.

the decisions that he or she makes? (To answer this, isn't it necessary to examine in its design aspects precisely the moment that leads to the choice or interaction?) Second, what happens in the imagery at the moment of interaction?

In answering the first question, when looking at the video menu in *Lorna,* one has the feeling that it is more the user's associations and interests, and less the design, that determines whether the user chooses the watch or the telephone. In particular in early works—in a gesture of "democratization" of the author/user relationship—the openness of choice was demonstratively foregrounded through the developer's not giving any intentional weighting in the presentation of items to choose from.[23]

With so-called multimedia works, the design of the transition from one segment to the next assumes a suspension because it first has to be signaled to the user that he or she now can and should become active. What happens when a sequence has played through to its end? Is it the case that this very last still in an uninterruptable sequence will display

Figure 6.2
Starting view of *Lorna* with an explanation of how the user can interact. Still. Source: Hershman, "The Fantasy beyond Control," 236. © *Lorna* by Lynn Hershman Leeson, programming: Ann Marie Garti.

Figure 6.3
Menu in *Lorna* that leads to ramifications. Still. Source: Popper, *Art of the Electronic Age,* 112. © *Lorna* by Lynn Hershman Leeson, programming: Ann Marie Garti.

interaction-forming qualities? Not infrequently, icons, writing, or spoken words convey a clear prompt to make another decision. This type of prompt, which in the subtlest example is present through an inconspicuous pause in the movement of what is shown, cannot be omitted. Only the background against which it occurs can vary: through the transfer to an often uniformly animated "standby mode" or through the freezing of the last view of a video sequence, which reveals some "sensitive" spots. In works that alternate between parts that progress in a linear fashion and parts that signalize ramifications, it often does not seem critical how exactly the moment is configured that allows the user to intervene. This instance of possibility of choice by no means has to correspond to the impulse that motivates the user to make a particular decision. The impulse is difficult to determine, since the user always has to wait for the sequence to play through to its end before he or she can become active; and then it still depends on what directions are open to choice. Often the manner of the transition does not have much to do with what is experienced before and after it in terms of content. This is not to say that choice and the creation of lateral links between sequences do not carry any meaningful significance in themselves. Rather, the manner of production of interaction via an iconicity is less central and other fields of discourse become more prominent—which one associates in this context with the terms *nonlinearity, discontinuity, combinatorics, aleatorics,* or *modularity.* The focus of our argument at this point is simply that what changes visibly following an intervention most often concerns the entire picture surface, hence a rectangle. This change along the boundaries of the computer screen or projection is of a very great generality. Thus, without intending to assert that (filmic) montage, for example, does not have a constituting effect on the content of what is shown, it can nevertheless be rightly asked whether the user's intervention—the selection of a demarcation as the choice of a segment (which takes up a previously established span of time and fills the screen entirely)—makes reference in its execution to what the user experiences. Rather, it seems that here, the interactivity consists exclusively in the access to the image, in the way that the image sequences can be presented, as Couchot puts it. The computer is not prompted, on the basis of the effected interaction, to modify the (programmed model structure of the) pictorial elements, but rather shows exclusively prefabricated elements (that themselves are generally not supported with programming) in a corresponding sequence.[24] As is already noted with Couchot's phrase *accès à l'image,* the image in these cases is clearly separated from the interaction: when the one has occurred, the other can begin.

The media designer Andrew Polaine also draws a distinction between this interactivity, which is understood as a passageway to the actual content, from that which itself makes up the content. With respect to "interactivity as turnstile," he pointedly states, "[T]his ignores the experience of the moment of interaction and relegates it to a mechanism of control at best and something to be mastered and 'got through' at worst."[25]

With many works structured around databases, the images, contrary to expectation, do not stand in a close relationship to the selected intervention strategies. As a result, they are not well suited to studying mechanisms of steering the user and tactics of temptation that

come into play in sensory design. Computer-based works are able to make stronger use of iconic means for the design of interactions, and to structure interactivity in a more differentiated way, than merely through producing links. According to our thesis, this is particularly successful when images go through transformations, which, for example, can be ensured when the sensory presentation is generated instantaneously. It is the transformability that is crucial in this differentiation and not simply that the work is being assembled from different parts.

Lorna is accompanied by a diagrammatic networking map that contains and connects thirty-six sequences (figure 6.4). One is struck by the apparent similarity of this connection map to flow diagrams that illustrate the routines of computer programs. While flow diagrams of computer programs normally are read from top to bottom, here, the starting point is positioned at the left ("1: credits"); the sequences with the three possible ends ("end A. S.") are given at the right. To the right of the long vertical line, the video sequences contained in figure 6.3 branch out, from top to bottom: watch, mirror, (television), wallet, phone, fish bowl. The numbers in this networking map correspond to the numbers in the video menu. This map, the arrangement of which is evidently based on a human figure, is theoretically available to interacting installation visitors, even if hardly anyone without professional interest would proceed "according to the map," instead preferring to experience a sequence through the free exploration of the forking or circular pathways.

An essential difference in the diagrammatically suggested organization of data lies in that with computer programs, the successively required "decisions" are made and executed by the computer. As a rule, these stations are not accessible to the recipient, who perceives only the results that ensue from the iterative and high-frequency processing of the decision tree—results that in turn are mediated by forming-giving entities. Since variables are in play, this leads to a dynamization and myriad nuances within the results. From the viewpoint of the computer, the interactor's interventions function exactly like the changes that are induced by the model: the user is assigned a precisely defined area of influence. Here, he or she is a cog in the machine of the program structure and plays a role in determining the calculation results. As a component of the system, the user is permitted to have and is involved in far-reaching consequences, as the biologist and science historian Donna Haraway also writes: "Human beings, like any other component or subsystem, must be localized in a system architecture whose basic modes of operation are probabilistic, statistical."[26] Haraway's diagnosis for society as a whole in the late twentieth century can be taken literally for human-computer communication.

However, it would be totally inadequate to conclude that by identifying the parameterization of the user, the discussion about calculated image worlds is brought to a close. This would mean separating them from the complex dimensions of experience and ignoring the sensory constellations that are created for the very purpose of experientiability.[27] The specific constitution of the sensory data that come with simulations means at least two things for reception: because, through the ongoing process of calculation, a sequence is potentially

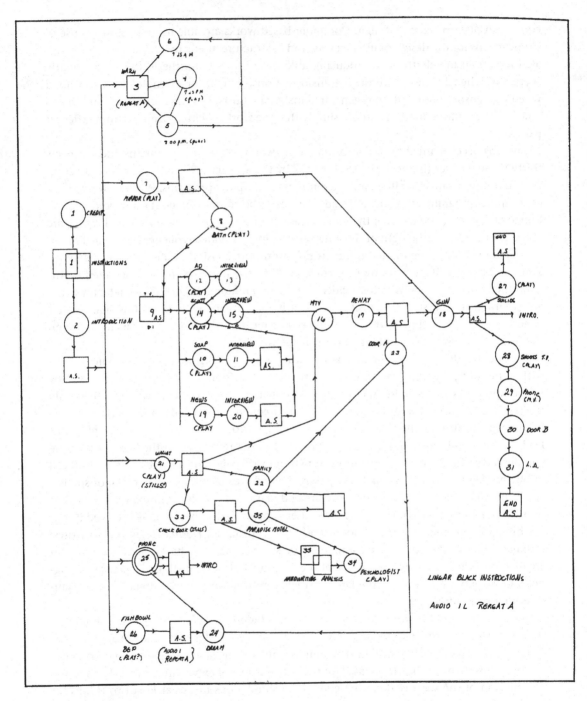

Figure 6.4
Sketch mapping the ramifications of *Lorna*. This video disk design was developed by Lynn Hershman
and Ann Marie Garti in 1984. Source: Hershman, "The Fantasy beyond Control," 271. © *Lorna* by Lynn
Hershman Leeson, programming: Ann Marie Garti.

always being created in the portrayal, the works are characterized in that, first, they make the transitory accessible to interaction, and second, they can explicitly reflect the user's actions instead of obscuring them with metaphors.

6.3 Approaches to Iconicity in Computer Simulations

If one surveys the discourse on interactive computer simulations, in the scholarly literature on their characterization, two topoi repeatedly surface that reinforce the aspect of interactivity while simultaneously neglecting the role of iconicity. On the one hand, there is the emphasis on the active user. Many analyses outline where the user can intervene or what the user can influence and what can be changed. This underscores the interactor's determining capacity for action, while the image worlds seem to receive his or her directives passively. On the other hand, the mathematical basis of the digital works is repeatedly foregrounded. Interestingly, one feature of the lively discussion about calculated images is that it all too quickly loses sight of the still present iconic qualities and discusses the significance of the image solely in terms of binary coding, storage, and processing. What's more, universal codification is often cited as a crucial criterion, so that "any interest in the visible surface of the image [can ultimately even be] understood as an obfuscation of its media-technical structural characteristics."[28]

But also with demonstrably iconophilic approaches, the idea is sometimes also implicitly conveyed that in this context, iconic qualities can be counted among the disposable or supplanted elements. In the words of Couchot, for instance, the mode of reception of digital images is called "interactive" or "conversational"—or, "one also speaks of the 'dialogic' mode in a more theoretical sense, in order to insist on the presence of a *logos* (a no longer graphical but informational *reason*) through which the processes of exchange between the observer and the image are established."[29]

The grounding for the assertion that with these artifacts, "graphical" logic is no longer present requires an explanation that is never given. In a narrowing of focus on the completely new, when the computer basis comes up for discussion, the image and its guiding of the user's attention is often left out. Meanwhile, not only does the mathematical foundation theoretically assume a complex, explicit interaction with images; the images that come with simulations gain new expressive possibilities precisely through their unique technical constitution—for example, because of the need to design them so as to make them receptive to diverse influences. Since this influencing comes not only from the interactor but also from the models, the user often experiences the events arising from the potentiality as something distinct and surprising.

In simulation-based works, when interactions cause a change that affects the object of interest, solutions are demanded in the iconic (e.g., acoustic, haptic) presentation that can give expression to these changes. One requirement, as we have already noted, is the fine articulation of elements. This granularity is not meant to refer to the ineluctable three-dimensional

grid structure of the computer monitor—the two-dimensional pixel matrix and the image refresh rate—but, rather, to a motivically organized flexibility within the models inherent in the image worlds. "The image transmogrifies from a rigid surface into a dynamic system, a dynamic, holistic image field, a field of variables that can be guided locally [or globally, that is, at specific points or overall],"[30] in the words of Peter Weibel. The image spoken of here is not an arrangement of static icons geared toward univocality, as is familiar from everyday involvement with user interfaces, but is made up of dynamic elements that have to do with what they are presenting because they embody something transformable. In this regard, in the frame of the sensory scene, they are motivated by and linked to their content. Their form, and thereby also their form in the temporal mode—their movement—has very much to do with what they are showing.[31] The calculated and shown dynamic that is accessible to interaction is the dynamic of the motif, and therefore the movement that is brought about with the intervention is also connected to it. This iconographically motivated type of interaction is linked to internal figurative differentiations. The shown objects that are the target of an interaction are therefore only in the rarest cases four-sided entities that correspond to the dimensions of the computer screen. It is just as unlikely that these objects can be transformed through an all-encompassing change that takes in all four edges of the screen. If movement nevertheless did proceed along these edges (the rectangle), as is often the case with videodisc works,[32] the transformation would have nothing to do with the form of what is shown. Only the computational basis, by means of models as the forming of content, creates an entity that allows touching and affecting what is presented through the nature of the manipulation.[33]

Even in game studies, the fledgling discipline whose focus is to engage with these types of phenomena, it is remarkably difficult to interweave dynamic and interactivity with an iconicity. Gonzalo Frasca makes an exemplary attempt at this not trivial undertaking.[34] He is ranked among the "ludologist" faction within game studies and has sought to understand the new qualities of computer games by explicating a four-layer schema. According to him, the first level is characterized by sensory elements (figures, background, setting) and has this in common with traditional forms of presentation (such as narratives). The next three levels mark the innovative aspects "dynamic" and "interaction." But they are conceived as rules; in other words, they are located beyond a direct perceptibility and precisely not in the iconicity. Specifically, they include manipulation rules (what the player can do), goal rules (what goals are set in order to win), and metarules (possibilities to modify the game).

Andrew Polaine also argues from the standpoint of production when he writes, "When creating an interactive, often the actual objects (the graphics on the screen or the sounds, for example) are the least important. The key to creating engaging interactivity is setting up the correct rules for a playful flow experience."[35] The literary scholar Espen Aarseth follows a more strongly reception-oriented approach in his widely read book *Cybertext*.[36] Here, he states that computer games have "description" (by which he means graphics and sounds) in

common with narrative, while he uses the term *ergodicity* to refer to the formally innovative component "action." Moreover, he characterizes "description" as "textual" and subordinates it to ergodicity: "The ergodic level usually dominates the descriptive ... while depending on the descriptive elements to concretize the path through the event space."[37]

These and similar assessments, in which iconic facets play a distinctly subordinate role in the design of interaction, are widespread. The idea is common that the control of interactions is achieved through rules that are not iconic. Thus, the sensory presentation is given a curious status, first embodying the connection to traditional modes of expression and second—in view of the postulated innovations—precisely for this reason having to play the conservative role. It almost seems to be regarded as given that with the computer basis, no new features or functions are to be educed from the iconicity.

6.4 Iconic Modes of Control

While the function of control is in most cases associated with hardware and software, the media theorist Claus Pias focuses on the image when he recapitulates the beginnings of pattern recognition: "This relationship [between user and computer] is called 'interactivity' and describes the specific instability of the image as instrument of control. For in a cybernetic arrangement, the image changes with each intervention of the user and elicits new interventions."[38] Here, the accuracy and efficiency of image use is central because the discussion involves the constraints of missile guidance in a military context. Pias does not state how images control, by means of what specific design solutions; only images in principle and in their entirety are presented as guiding actions.

In many studies, even the idea *that* images influence interactions remains unarticulated; it has to be assumed that this idea is hidden behind the formulation of the feedback loop. Only what the user can perceive is fed into the circuit, which in turn often activates and involves the user in a very physical way.

What can be discovered about the sensory dimensions of an interactive image if less attention is paid to how users can change the images, and instead the opposite viewpoint is tested, with the focus being placed on how images entice users to perform specific actions? The description of what happens when the interactor does something—in our unspectacular thesis—is already the result of an engagement between observer and sensory artifact. The image enables or prevents by presenting options, and often in such a refined manner that one is often not explicitly deciding for or against something. It now should be asked how these image worlds condition the player's options. In a system of these types of interactions, how are events organized in concrete interventions? According to the game designer Eku Wand, by means of feedback structures, very subtle mechanisms can be built into "virtual" agents and localities that supposedly play out in the background but in fact influence the interactors, for instance, by shifting their attention. In certain places, for example, one can hear creepy or lulling music, the light can be dimmed or intensified, the tempo of some

peripheral occurrences can change markedly. If a player does not successfully master a level, sometimes more effective measures are also employed: the player might be brought back to repeat the same situation, except that now some informants are suddenly silent or some stores are closed, for example. This can be unsettling to the player at first, but according to Wand, the message is understood.[39]

In what follows, we will show the central role of specifically designed iconicity in connection with similarly formed aspects of interaction. The iconicity of simulations may relate to familiar patterns in many ways, but it has adopted functions that previously remained in the realm of the implicit. At issue are the specific regulation and control mechanisms of the—systemic—image. If the systemic image regulates, then what do the typically iconic types of imperatives and suggestions look like? What relationships can it develop with the observer beyond a dichotomy of allowing and forbidding? Revocation and automatisms, asynchronies and dimensional shifts play an important role.

Before we move to investigating a group of simulation examples along these lines, we address two related concepts that were developed in the milieu of Université VIII in Paris in order to identify how they are different from the approach presented here. With Michel Bret, Hervé Huitric, Monique Nahas, Marie-Hélène Tramus, Christine Buci-Glucksmann, as well as Jean-Louis Boissier, Sophie Lavaud, Edmond Couchot, and Etienne Amato, who are already familiar to us, and others, a closely cooperating group of artists and theorists at Université VIII congregate and have engaged intensively with the possibilities of the iconic, and particularly with the "synthesis image," since the 1960s.[40] The Institut Arts et Technologies de l'Image, founded there in 1984, aims to give students a double skill set, in art as well as (computer programming) technology.

In this stimulating environment, Bret, Couchot, and Tramus together developed a concept that is interesting in our context, that of "second interactivity" (*seconde interactivité*). It alludes to "second cybernetics" and to adaptive systems.[41] Here, "second cybernetics" comes into play in that entities are present that, by means of a perceptual apparatus, can acquire skills related to the system and use these skills to orient their actions and work back on the system in a manner suited to their own interests. Whereas the "first cybernetics" dealt with control, communication, and information in animals and machines, in the "second cybernetics," self-organization, emergence phenomena, networks, adaptation, and evolution are central. The levels of interactivity are constructed analogously: "first interactivity" organizes the relationship of the user to the computer according to the stimulus/response mode, and "second interactivity" is based on action governed by perception, corporeality, sensory-motor processes, and autonomy. In this understanding, the physical models are joined in the second case by those of the cognitive sciences.[42] Here, interactivity is conceived together with a type of modeling of dynamic. Only through the sensorialization of these model data can interactions have a meaningful effect. Therefore, it would only be consistent if the perceivable portrayal of the model results would also somehow reflect whether the latter stand under the influence of the first or the second

cybernetics. If we now continue to direct our view to the iconicity in the frame of which interactivity is formed, the second interactivity would presuppose an iconicity with adaptive features.

It may come as no surprise that this circle of Parisian intellectuals also puts forward another proposition that endeavors to make exactly such a bridge between interactivity and iconicity. Lavaud presents a typological classification of digital images under the aspect of their modes of behavior in order to assign a "type of interactivity" to each one. She first lists the "sign image" (*image-signe*), a compliant graphical element, like an icon, that leads the user further via a simple input, such as a mouse click. The sign image is widely employed and elicits a "press-a-button interactivity," as Lavaud writes. The "object image" (*image-objet*), by contrast, is capable of reactions and holds the interactor's attention longer with what is offered. Nevertheless, from the producer's perspective, this type of iconicity retains a certain integrity or predictability because of its program structure. In this case, Lavaud speaks of a "mirror interactivity" since the image relates to the interactor like a double. Finally, the "system image" (*image-système*) is rebellious. It possesses autonomy and is generally characterized by a phase of adaptation. "The responses of the 'system image' reveal an unpredictability that legitimates its status of 'being' as not 'contemplative' but operant. And operant with a freedom that is surprising and that calls into question and unsettles received ideas. With the techniques of artificial intelligence and connectionist models, the machines that were thought to have been conceived to generate the predictable now engender the unpredictable."[43]

The system image corresponds to a "reflex interactivity" in which the artifact reacts to inputs (that function as its "environment")—in other words, itself puts forward an action. Lavaud connects the term *system image* to learning-capable or adaptive algorithms (neuronal networks or genetic/evolutive programs, respectively). These demands are high and comprise a special case for our study.[44] In order to count as a systemic image in our context, it is sufficient, first, in a focus on the dynamic, to be at work in the frame of simulations (also those of the first cybernetics) and thereby, through the modeling, to play a part among linked influencing entities. Second, in a focus on the iconic, a systemic image in the frame of an interactive application comprises, through its added sensory qualities, an interaction-influencing entity that is additional to the dynamic. The iconic configurations are "that in which the user can intervene" and simultaneously embody "how the user can or will do it" through various subtle steering devices. The image essentially functions as the interface with itself[45] in that through the concrete sensory manifestation, it already modulates and preforms the content of whatever interventions are possible or even suggest themselves to the user.

Consequently, the image has at least two functions: it embodies both a presentational and an operative aspect.[46] In addition, on heuristic grounds, two closely connected operative levels can be held apart: that of the executed dynamic model and that of the perceivable figuration. "Operativity" in this context intends an interaction-related designation. The two

operative levels often, but not always, go hand in hand. When they diverge, this appears as a prominent discrepancy.

6.4.1 Simple Measures with Major Impacts

As an example of a harmonic relationship between the two operative levels, we discuss a work that can be termed classic: the installation *Videoplace* by the computer scientist Myron Krueger from 1973 and following.[47] In order to convey the wealth of manifestations that interactivity makes available, he developed not just one variant of interaction but approximately fifty variants, from which one is selected each time a visitor enters the exhibition space.[48] The interactor connects with the computer world through a video capture (figures 6.5 and 6.6). He or she is positioned between a backlit wall (which produces contrast for the camera) and a partition wall that receives the projection. In several modes of interaction, the recorded and processed silhouette of the visitor is merged with a purely computer-generated two-dimensional world and is projected. In these cases, the contour of the interactor is the operable mode, or "the device through which the 'artificial reality' is explored."[49] As the artist David Rokeby continues, the changes that are enacted on this silhouette offer the

Figure 6.5
Installation plan for Myron W. Krueger's *Videoplace* (1973–1984). At right is a bright wall in front of which the recipient carries out his or her actions. Across from this, a screen is mounted that receives the image from a projector installed on the floor. Below the projection screen, a camera records the visitor. Source: Krueger, "Response Is the Medium," 9.

Figure 6.6
Ground plan of the installation layout for *Videoplace*. Source: Adapted from Krueger, "Response Is the Medium."

key for understanding how this world works. The visitor's own image in silhouette is the sufficiently familiar referent against which the transformation phenomena are contrasted and recognized. In addition, the representation of the visitor's self in its index function is best suited to facilitating the development of the visitor's understanding of what he or she is doing and how he or she comes across in the simulated scenario. Since the interactor's silhouette does not show any internal differentiation, all actions that play out within the silhouette are without effect in the projected scene. Krueger discusses this problematic and publishes a sketch about it (figure 6.7). After a very short period of familiarization, the user understands to keep to this restriction and to express himself or herself in silhouette. In the words of the psychologist and art historian Anne Barclay Morgan, "viewers respond in purely visual terms."[50]

Videoplace is well suited for an introduction into the still rarely considered subject area of movement-based and image-guided interaction design because, in retrospect, Krueger shows almost didactically how astonishing results can be achieved even with minimal means. In his book *Artificial Reality II*, published in 1983, he records several interesting observations that have received little attention in the secondary literature. First, Krueger describes his experiences with the work *Glowflow*, which was exhibited in 1969 at Memorial Union Gallery at the

Pointing to the side

Pointing straight ahead

Figure 6.7
Sketch concerning video tracking and the software programming for *Videoplace*. Source: Krueger, *Artificial Reality II*, 107. Reprinted by permission of Pearson Education, New York, NY.

University of Wisconsin. The conception originated with three people: Daniel Sandin, one of the inventors of CAVE technology; the minimalist sculptor Jerry Erdman; and the computer scientist Richard Venezsky. Krueger was consulted during implementation of the idea. In this work, fifteen to twenty people at a time enter a completely dark, rectangular, hypothetically empty space. Water with phosphorescent particles is pumped through four transparent tubes mounted horizontally on the walls. The tubes, each of which contains a different color pigment, run past six opaque columns standing against the four walls. Four computer-controlled lamps are mounted in each of the columns, one per tube. When a lamp goes on—which visitors cannot see directly—the phosphorescent particles in the corresponding

tube, from that point onward in the direction of flow, begin to light up and successively fade again in their luminescence.

The visitor is not able to reconstruct to what extent the work is responding to his or her own actions: the triggering impulses are sent imperceptibly through the visitor's stepping on flat mats on the floor, and since a lag has been programmed between this action and the corresponding effect, the causal connections are obscured. The developers explicitly avoided immediate responses to particular actions by visitors because they did not want them merely to concentrate on eliciting new responses from the environment. They feared that in this way, the work's intended contemplative character would be lost.[51] In addition, the selected medium requires a certain amount of time to glow and flow, so that certain actions carried out for the purpose of verifying their effects cannot immediately be repeated. The artists, according to Krueger, were well aware of the power of responsivity but decided to subordinate this to a predominantly visual conception.[52] In Krueger's mind, the visual design of *Glowflow* was quite successful, but its interactive potential was far from exhausted because of the conception.

Krueger drew multiple conclusions for himself and his own future work from this experience, including the following:

> [1.] Interactive art is a potentially rich medium in its own right. Since it is new, interactivity should be the focus of the work, rather than a peripheral concern; ... [5.] The choice of sound and visual response systems should be dictated by the system's ability to convey a wide variety of conceptual relationships. The tubes of GLOWFLOW did not have a sufficient variety of responses; they made a single visual statement rather than providing a medium of expression; [6.] The visual responses should not be judged as separate art works; nor should the sounds be judged as music. The only aesthetic concern should be the quality of the interaction, which may be judged by general criteria: the ability to interest, involve, and move people, to alter perception, and to define a new category of beauty.[53]

The work *Videoplace* was created with the ambition to generate situations that the user can engage with intuitively and without technical accouterments on his or her body. It is always important to Krueger that the participants understand why something is happening without assistance in the form of explanations. This does not mean, however, that everything should be anticipated, since in his opinion, unexpected reactions—quite desirably—constitute "a form of visual humor."[54]

Videoplace was developed further over the years, taking into account the intervention attempts of the public. With interactivity as his central concern, Krueger astutely describes design solutions that are impressive in their simplicity and capable of inducing substantial effects. For example, the size of a visually presented entity relative to the projection surface should be taken into consideration. His program allows the silhouette of the interactor, calculated by video tracking, to be offset, scaled, or rotated. If the silhouette fills the projection surface, there are only a limited number of ways that the interactor can relate to the graphical

Figure 6.8
Installation view of *Videoplace* with Myron Krueger interacting with the Critter program mode. Source: Krueger, "VIDEOPLACE: A Report," 145. Reprinted with permission of MIT Press.

objects or creatures. However, when the silhouette is small, the interactor is enabled to move across the entire projection surface. He or she can, for example, crawl underneath graphical objects, float up over them, or play with the character Critter (figures 6.8, 6.9, and 6.10) at the same level.[55]

"Critter" is one mode of play in *Videoplace,* named after the playful creature with "its own personality" who appears in it. We will examine this mode more closely in order to demonstrate what can result for the interactivity when the operative levels of simulations, model and iconicity, act in concert.

To the visitor who enters the environment, Critter first comes across as a shy character. At the beginning of the interaction, it flits across the projection surface and attempts to avoid the visitor's silhouette. Only when the visitor holds still does it come closer. If the visitor continues to be still and reaches out an open hand, Critter will alight there. Then it begins to climb the slope of the silhouette's arm, shoulder, and neck. The way Critter is drawn—essentially a simple oval with two dots for eyes and four lines for limbs—adapts itself to the condition and slope of the contour with which the creature is contending. When it has reached the highest point of the visitor's head, it does a little dance of joy. If the visitor continues to stay still, Critter begins nervously jogging in place; if the visitor raises an arm, Critter does a somersault and lands on the visitor's hand. If the hand is horizontally outstretched, Critter jumps from there to the floor. But if the visitor's arm is directed straight down, then after the character has done its dance, it slides down the arm, grasps a finger at the last minute, and starts swinging back and forth from it. If the visitor now shakes his or her arm, Critter lands

Figure 6.9
Videoplace's Critter: still of the projection and detail. Source: Krueger, *Artificial Reality II*, plate 3. Reprinted by permission of Pearson Education, New York, NY.

on the floor. However, stretching out an arm or spreading the fingers is enough to draw Critter almost magnetically back again.[56]

Every time that Critter dances on the user's head, a new round is initiated with different, playful ways of relating. The tiny creature is capable of approximately 150 articulations. The desire to sample all of them motivates many users to continue interacting for a long time.[57] In order finally to induce them to make room for the next curious visitor, Krueger had a very simple idea: "On what was to be the last time, when CRITTER reached the top of the participant's head, it jumped up and down, causing the participant's image to disappear. CRITTER then floated gently down to the bottom of the screen. You could see people look down to see whether their real bodies were still there."[58]

In this way—purely through the iconic aspect—Kruger succeeds at effectively and permanently stopping interactions. The camera recording the user is still in the space and still functioning. But without the depiction of the interactor on the projection screen, the termination of contact with the calculated world—as it were, by means of an "image act"—has been accomplished de facto for the user.[59]

Figure 6.10
Critter's interaction of with a visitor in *Videoplace*. Series of stills of the projection. Source: Cameron, "Dinner with Myron," 13.

It does not always have to happen in such an inexorable way. Another elegant—because motif-based—solution was realized by the artists Michael Girard and Susan Amkraut together with the media artist Scott Fisher in the CAVE installation *Ménagerie* (1992), which was installed in 1993 at the Centre Pompidou in Paris in the frame of the exhibition *Real-Virtual* (figure 6.11).[60] This stereoscopically presented, monochromatic world (figure 6.12) fascinates visitors since the different animal species that they can encounter never display exactly the same behaviors—as a function of their own interventions. In order to encourage individuals to end the interaction after a while, the developers elected to introduce a motif-based discomfort: "When people stayed for too long, suddenly insects rose up from the ground and began swarming around their heads. The droning sound, which grew steadily more intense, normally made visitors leave quite soon."[61]

But back to Krueger: his understanding of iconic components with respect to interaction design has been received in various ways. Some interpret him to the effect that it is not the

Figure 6.11
"Virtual" creatures appear through the arches in Michael Gerard and Susan Amkraut's *Ménagerie* (1992). Still. Source: Courtesy of Scott S. Fisher.

Figure 6.12
Stereoscopic glasses as interface for *Ménagerie*. Source: Courtesy of Scott S. Fisher.

portrayal in the sense of a visible aesthetic object but rather the user's input that is crucial for the interaction. To take this position is to encounter difficulties—for example, in making Krueger's idea for ending the situation plausible. Even if Krueger writes repeatedly that the beauty of the visual and acoustic reactions is secondary, since "[R]esponse is the medium! ... The beauty of the displays is not as important in this medium as it would be if the form were conceived as solely visual or auditory,"[62] this passage should be construed to the effect that he sees the reaction—in other words, movement as the answer to or consequence of what has preceded it—as the entity of primary artistic concentration, mediation, and experience. Hence, far from a technology-centered approach, he proposes making interactivity into a free-standing (design) medium, with the result that the evaluation of these works can no longer be carried out according to criteria of traditional categories with respect to their visual and acoustic composition. Instead, the reactions, as well as the evocation of reactions, are to be taken into view as the focus of interest. Krueger is interested in an "aesthetic of the responsive," which—itself also controlled by rules—arises from the creation of interreferentialities. But he by no means asserts that the sensory presentation is thereby not essential. On the contrary, it allows and determines the always differently transpiring and differently perceived between-state of the communicative. At issue is merely a shift in accent. Krueger conceives interactivity as a central aesthetic category that is tightly interwoven with the presentation (the output). Meanwhile, the idea of a supposed priority of the input could be inferred from another passage in Krueger's writings: "The perceptual system [sensors of all kinds, for example, a camera] determines what the computer knows and thus to what it can respond. If the computer is aware of only the participant's arms and hands, small movements of the fingers will be invisible and thus will be irrelevant to the interaction."[63]

There is no question that resolution and the manner of data capture (input) determine what one reasonably can do. The same is true, however, for what is shown (output): if no fingers—whether those of the interactor, by means of the silhouette, or those of the "virtual" actor or avatar—are visually presented, then they are not at hand. The user would not even get the idea to want to use them, for inputs only correspondingly follow the ideas that arise as a product of what is offered to the senses. It is just as unlikely that interactors in the two-dimensional version of *Videoplace* will attempt to explore a three-dimensional space.[64] At most, through varying their distance to the camera, they will test effects involving the size of their own shadow projection. Thus, along with interfaces of a technical nature, the image also regulates interactions, for example, through omissions or abstractions.

But the presentation of an excess or a pronounced otherness can become a particular challenge for interactors. This is evident with Human Critter, another of *Videoplace*'s modes of play. Here, the interactor's silhouette is shrunk to one-tenth life size. It no longer follows him or her like a shadow but now is capable of flight. After the model of Superman, the interactor indicates the direction of flight using his or her arm; the program prevents the silhouette from leaving the projection screen (figure 6.13). Having arrived at the edge, it stays there until a change of flight direction is indicated. In this way, orientation is always ensured

Figure 6.13
Interaction with Human Critter program mode in *Videoplace*. The user cannot go outside the edge of the projection. Series of stills of the projection. Source: Author's photographs, Ars Electronica Linz 2004.

and the area of action is clearly bounded.[65] After about a minute of erratic flying, a box—in other words, a rectangle—appears at the lower edge of the projection. The proposition that in an initially homogeneous field, something that previously was not there appears and shifts the balance of the entire constellation and does not fail to achieve the desired effect: "The intent of the box ... is to lure you into landing on it. Although the attraction is not as strong [here I disagree!], participants usually land on the box in a short time."[66] After landing there, the silhouette grows or, more precisely, it doubles, in that it is reflected horizontally underneath itself (figure 6.14). Through the user's continuing to be able to perceive or define the silhouette as a type of creature following this duplication, it is possible to discover that the arms now have acquired new significance and function as legs in the scenario. The user's upward-directed arm movements have a downward effect in the image. Despite this defamiliarization through directional inversion, visitors, after taking a short while to get acclimated, are able to use the mechanism and express themselves in new ways. When they reach out their arms, the figure ascends from the rectangle. If they swing their arms high, the figure is able to push off from the ground, jumping up and then sinking down again under simulated lunar gravitation.[67]

From this observation, it can be seen that it makes quite a difference how behaviors in reality are transferred to the avatar and, above all, how the interactor is presented in the projected image. The reason for this is more clearly elucidated in a first-person account by Manovich: "In short, computer characters can display intelligence and skills only because programs place severe limits on our possible interactions with them. But differently, computers can pretend to be intelligent only by tricking us into using a very small part of who we are when we communicate with them. At the 1997 SIGGRAPH ... [convention] I played against both human and computer-controlled characters in a VR simulation of a nonexistent sports game. All my opponents appeared as simple blobs covering a few pixels of my VR display; at this resolution, it made absolutely no difference who was human and who was not."[68]

We are not concerned here with a type of Turing test; rather, it is of interest that the mode of presentation fundamentally contributes to determining the type of possible articulation. The more differentiated the form, the more specific the communications, acts of showing, and interventions can be. But it always depends on what is to be conveyed. When we observe that two entities come into contact and then either three go on from there or else only one remains, we call on our general body of experience to infer what has happened: procreation or mealtime. As long as only events on this or a similarly general level are to be communicated, the presentation can remain very abstract. But if finer actions are to be distinguished, the designer is presented with a challenge.

At first one might think that if the body is conceived systemically—in other words, in its functional characteristics and its relationality—then its external appearance in "virtual" space can be designed at will. Under the premise that users want to understand what happens, this must be partly contradicted. One example as discussed by the philosopher Boris Groys[69] demonstrates the problematic. In his films *Men in Black* (1997) and *Men in Black*

Figure 6.14
Human Critter's metamorphosis in *Videoplace* after landing on the rectangle. Series of stills of the projection. Source: Author's photographs, Ars Electronica Linz 2004.

II (2002), the director, Barry Sonnenfeld, wanted to create extraterrestrials that would not resemble the human figure at all—they should have a completely different form. However, difficulties gradually arose in the screenplay, which (by necessity) envisioned the extraterrestrials as displaying anthropomorphic characteristics: they would have to be able to see, and it would have to be evident what they were looking at, so they would need the equivalent of eyes. Also, they would have to be able to walk, and if possible in a more complex manner than through levitation or beaming; they would have to be able to grasp something and so would need limbs. If the audience or other characters were to be able to read their emotions or intentions, then familiar facial expressions and gestures would be indispensable. Once the dilemma had been registered, it was embraced and these requirements were surpassed, in that details were added that would have to be considered highly terrestrial—such as smoking, which reveals that the "worm guys" have some kind of lung and, like us, are motivated by addiction or craving.

By analogy, in a simulated world as well, bodies can only be understood in their actions if they are designed in such a way that they are able to communicate in the broadest sense. It must be ascertained what the "virtual" creatures must visibly be capable of in order then to determine how they have to look (how they can possibly look is another question). In comparison to animation, the problem is intensified with simulation because the modeling as the design mode for the formations and the dynamic does not stipulate any exactly determined manifestation, but only specifies the more general level of calculation down to the last detail. As we already noted, it is not the results of calculation but the process of their production that is authorially determined.[70] The innumerable individual states that change across intervals of time depend on the configuration of often highly complex, multiply interdependent parameter settings and variables. Therefore, it is imperative for the developer to think as precisely as possible in those places where he or she can once again make explicit specifications, that is, in the allocation of the particular states and their effects in the presentation. Precisely because simulations are systemically constituted, the presentation of their creatures' bodies has to keep to certain stringencies in order to be understood.

If comprehensibility of the intended sequences of events is an objective for computer agents, for user-guided avatars the question is raised of how a user can express himself or herself in their figure. Here, it very likely matters whether the interactor is portrayed in the simulated situation as his or her own likeness or as an abstract symbol. For example, how does one act in the "virtual" realm by means of a completely other body? Krueger offers the following for consideration in the design process: "No matter how your body is represented, you have the problem of how to make it move. If you are given four or six legs, how do you control them? Do you know how to trot, canter, or gallop?"[71] Even the most willing exhibition visitor will in all likelihood not be practiced in behaving like an ungulate. But he or she will attempt to use comportment to induce effects on the presentation of his or her avatar. Possibly, unfamiliar contortions will be necessary; possibly, multiple people will have to cooperate in order to coordinate six legs. However, it should be noted here that in the

hypothetical example of controlling a six-legged creature, it is assumed that all the legs are individually maneuverable—thus, equipped with functions—and that the creature's presentation is not merely a cursor.

At the beginning of this section, it was stated that in the example of *Videoplace* a harmonic relationship exists between the two operative levels of the calculated dynamic and the image. This means that the functions of the dynamic also reveal themselves in what is presented. If an object vanishes on the visual level, the associated process-based potential for change is also lost. Vice versa, inasmuch as they are shown, objects are also available for interactivity: "In VIDEOPLACE, there is nothing on the screen that you cannot interact with."[72] Anything else would only be a distraction, according to Krueger.

By contrast, the next example contains a prominently positioned element for which the operative levels seemingly are not aligned. This case elicits a particular type of interaction, which could be described as the persistent search for the operative dynamic, of which the user is certain because of the iconic evocation.

6.4.2 Zones Apart: Spatial as Temporal Distancing

The episode described in this section comes from the computer game *fluID—arena of identities*, exhibited in several variants since 2003, by the artists Mathias Fuchs and Sylvia Eckermann.[73] In open countryside bounded by a chain of mountains, the user encounters, centrally and without any chance of missing them, three fetuses floating in a three-chambered bubble (figure 6.15). Through their presence, they invite attempts at "virtual" contact.

One such attempt, in version 29 from 2004, proceeded as follows. Despite their presumed reachability, the babies were lying too high for my avatar to be able to touch them by jumping (figure 6.16). Then I attempted to bring my androgynous avatar into position underneath an entry area where the rotating word fluid is written in two rows, in the hope that he would be drawn up by suction (figure 6.17). These openings suggest only too obviously that it is somehow possible to enter the bubble. When nothing happened, I made other attempts to jump from various distances, but I could never jump high enough. Through the manner of its placement, which makes reaching the goal seem entirely possible, the user is essentially provoked to attempt to achieve it. But the fetuses stubbornly denied my attempts to approach them. Finally I let go of the idea of reaching the desired vantage point. Only one possibility remained: employing a device with remote action, in other words, my weapon (figure 6.18). But the shots did not have any effect. Consequently, the immunity of the embryos could now no longer be explained as merely a separation in space. (The hypotheses remained that the sheath was bulletproof or that my weapon could not harm them because it only functions in the stealing of identities in the form of articles of clothing or hairstyles.)[74]

In all likelihood, it would be equally ineffectual to shoot at the ground. But the baby bubble is more promising for various reasons. First, the fetuses are some of the very few living creatures in the scenario. Through their particularly elevated position, they are the only

Figure 6.15
Screen shot of Sylvia Eckermann and Mathias Fuchs's *fluID—arena of identities,* 2003. Source: Courtesy of Mathias Fuchs. Screen shot © fuchs-eckermann 2003.

(a) (b)

Figure 6.16
An attempt is made in *fluID* to reach the bubble by jumping. This attempt at approach fails. Stills, details. Source: Courtesy of Mathias Fuchs. Screen shot © fuchs-eckermann 2003.

(a) (b)

Figure 6.17
Further attempts at approach in *fluID* follow. Is it possible to get sucked through the tube-shaped openings (left)? The attempt at entry through an opening in the bubble with the word *fluid* written around it also fails. Stills, details. Source: Courtesy of Mathias Fuchs. Screen shot © fuchs-eckermann 2003.

Figure 6.18
Shooting in *fluID*. Still, detail. Source: Courtesy of Mathias Fuchs. Screen shot © fuchs-eckermann 2003.

ones equipped with potential energy. Through the failed attempts at approaching them, the user experiences the limits that the "virtual" gravitation imposes on the avatar's jumping power. Assuming a generally valid law, the user intuits that all other objects and creatures are equally affected by it and the babies would therefore fall to the ground if the strangely buoyant bubble no longer kept them floating. Moreover, the semitransparent bubble signals something fragile, thin, in other words easily pierced, and the user ultimately expects an increase in power, the opening of new possibilities as a reward for the liberating action, or at least a lavish visual effect such as the bursting of the bubble. All of this makes shooting at the ground appear unattractive by contrast. The role of the ground as the supporting lower boundary of the scene seems clear. The function of the inhabited bubble, however, cannot be inferred by means of any comparable everyday intuition.

After multiple failed attempts, a feeling of helplessness is inevitable. One could object that systemically constructed programs generally set boundaries for the player by (almost) arbitrarily fixing the character's radius of action—which in turn is closely connected with the environment. There is nothing special about this. For example, the avatar's not casting a shadow or not leaving footprints does not indicate that he is not walking on the ground (interacting with it computationally); this can also be realized acoustically, and relative to the ground he is in fact moving.[75] But it does show very clearly that it is not included in the avatar's sphere of action to be able to leave or read traces. It is not so remarkable that something is not present that one would expect, since in calculated worlds, one always makes a choice, and not only because the computer capacity requires it, but also to give the game its contours. Nothing would be more boring than allowing as many, or even more, degrees of freedom in a game than are offered in daily life. By the same token, however, in a game it is conspicuous when something perceivable is presented that denies any interaction. If one did not see anything, then in this place one would also not develop any curiosity. But if something is shown with which one cannot enter into contact, this is often not interpreted as "incompleteness" but rather as a deliberately inserted boundary of action. Everything placed overtly before the user's eyes is regarded in a game environment as predestined for interaction. This assumption is so strongly rooted that behind the set boundaries of action, the user senses something he or she has not yet understood.

However, if players recognize that the iconic suggestion of possibilities is in fact only a decoy, this can quickly lead to disappointment, or even to their taking offense, according to Frank Furtwängler.[76] In the game theorist Markku Eskelinen's estimation as well, players regard as intolerable any opportunity for frustration that developers have deliberately built in.[77] Why is this so? Even if this question cannot be pursued here at length, it should at least be noted that the fundamental readiness to act brings with it new expectations for these image worlds that designers can take into account and work with.

The law "no relationship" to a place or object is, according to Niklas Luhmann, inconceivable in a system: "Just as there are no systems without environments or environments without systems, there are no elements without relational connections."[78] Something that cannot

be approached from any angle is equivalent to an exit from the unified space of interaction that systems theory stipulates. A nonunified space of interaction means that the boundaries of systemic perspectivation run right through the image: restrictions of the radius of action that are thus introduced are boundaries of the perspectivation within the image. In a strict sense, only the dynamic operativity is subject to the systemic perspectivation. Such a visually indiscernible rupture is not necessarily given through the mere presence of places that obey "other" laws," since in any case, "in the sphere of play, the laws and customs of ordinary life have no validity."[79]

Now, one could guess that this bubble stands in relationship to other elements in this world and is inaccessible only to the player. But the player will not be willing to accept that the iconic presentation so demonstratively arrayed is not intended for him or her—or that the presentation, from the player's standpoint (that of one who is always ready to act), is meant to function only as eye candy.

Jean-Paul Sartre's approach to action, which for him always follows an intention, is illuminating here: "To act is to modify the shape of the world; it is to arrange means in view of an end; it is to produce an organized instrumental complex such that by a series of concatenations and connections the modification effected on one of the links causes modifications throughout the whole series and finally produces an anticipated result."[80]

This is precisely what an interactor in a computer game also intends. However, according to Sartre, the field of action is also determined by the objects of the environment and their "coefficient of adversity and utility."[81] But, he continues,

In particular the coefficient of adversity in things cannot be an argument against our freedom, for it is *by us*—i.e., by the preliminary positing of an end—that this coefficient of adversity arises. ... Thus although brute things ... can from the start limit our freedom of action, it is our freedom itself which must first constitute the framework, the technique, and the ends in relation to which they will establish themselves as limits. Even if the crag is revealed as "too difficult to climb," and if we must give up the ascent, let us note that the crag is revealed as such only because it was originally grasped as "climbable"; it is therefore our freedom which constitutes the limits which it will subsequently encounter.[82]

We follow Sartre further, who takes up his example of the crag again later in the text:

Here I am at the foot of this crag, which appears to me as "not scalable." This means that the crag appears to me in the light of a projected scaling—a secondary project which finds its meaning in terms of an initial project which is my being-in-the-world. Thus the rock is carved out on the ground of the world by the effect of the initial choice of my freedom. But on the other hand, what my freedom cannot determine is whether the rock "to be scaled" will or will not lend itself to scaling. This is part of the brute being of the rock. Nevertheless the rock can show its resistance to the scaling only if the rock is integrated by freedom in a "situation" of which the general theme is scaling. For the simple traveler who passes over this road and whose free project is a pure aesthetic ordering of the landscape, the crag is not revealed as either scalable or not-scalable; it is manifested only as beautiful or ugly.

Thus it is impossible to determine in each particular case what comes from freedom and what comes from the brute being of the for-itself. The given in-itself as *resistance* or as *aid* is revealed only in the light of the projecting freedom.[83]

Sartre cites this example in order to use it to discuss the possibility of the freedom of an acting human being. However, we are more interested in the attitude to the things in this world as Sartre describes it, as compared with the attitude to the things in the virtual world. For our rhetorical comparison, we substitute the crag in this very apt passage of Sartre's with the bubble in *fluID*. Of course, the bubble appeared to me first in the light of my plan to scale it, then in the light of my plan to destroy it, and so on. But does a player of a computer game have the same assumptions as a traveler in nature, freely making the decision that he or she wants to scale an object (and thus assessing it as scalable)? Very likely not, since here the player is not dealing with a "brute product" of nature, but rather with an artifact, a game, that can be understood as the positing of an action-oriented situation. In the recipient's interpreting the scenario as manufactured, the balance is shifted: the game is precisely not organized like life; it restricts the degree of freedom because the interactive sensory presentation made by the designer as a rule is geared toward action. In *fluID*, the user is also intentionally lured onto this track: in computer games, uniformly animated movements as in a repeating loop draw the user's attention and often indicate that something can be gotten or a solution found here.[84] This is how the user interprets the rising balls of light at the point of intersection of the three lobes of the bubble, as well as the babies' kicking, which thus can be counted as "objects with invitational character."[85] The role of animation as an attracting entity is a familiar topic of discussion and research in interaction design.[86]

One plausible explanation for the bubble emerged in the further course of the game. After a suicide[87] and the subsequent, automatically initiated reincarnation, it became apparent that the desire that I had futilely endeavored to satisfy was the wish to return (as an avatar) to a prenatal state and that the absence of interactivity could be explained through a temporal difference: the embryos represent the user's own past in the womb. If the user starts at the beginning of the game (for a particular avatar), he or she experiences the scene of his or her own entrance into the world (figure 6.19): as soon as the veil has cleared and the view is revealed, the user is looking approximately from the center of the three-chambered bubble at the heads of the recumbent fetuses, of which the user is presumably one.[88] He or she then chooses one of the lobes of the bubble, comes very near to the embryo lying there, is brought past it, just before exiting switches to the third person (that is, the user sees his or her own avatar), and in this tiny—in comparison to the babies—figure, but in the form of an adult, is conveyed through the previously mentioned opening into the world. Immediately after "birth," the avatar still has no personality, is unmarked. This blank to be filled can be recognized in the black-and-white checkerboard pattern, reminiscent of the grid structure of geometric computer models that have not yet been textured.

Because the user cannot return to the bubble, it becomes a past, at least in the view of Luhmann: "He assumes that only when the changes that are triggered by a chain of action are

Figure 6.19
Sequence of entry into the game world in *fluID*. View of the unborn avatar. Series of stills, details. Source: Courtesy of Mathias Fuchs. Screen shot © fuchs-eckermann 2003.

no longer reversible does the past take hold."[89] The presentation of the fetuses in the bubble can be interpreted as a temporal relic of the user's personal past of being born, which remains present throughout the entire game. An allusion is thus made to one possibility of temporal metaphorics that art produced centuries ago: the simultaneous presentation of evidently nonsimultaneous states.[90] In the context of interactive computer applications as they are discussed here, this type of staged temporal remove enters into conflict with the concept of real time, whose temporal mode is simultaneity; this is how the impression of unmediatedness is created.[91] In the case of the bubble, simultaneity is visually given. But functionally, for those avatars with which the user views it from the outside, it has been suspended for the duration of their life and lies in the past. Overall, the bubble does come into play repeatedly, though only at certain moments: specifically, when an avatar dies. Figure 6.20 shows one avatar's view of the not-yet-born avatar of a second player. For one life span, it is the case that this relationship is present only once, as the premise of the game, but then has to be seen as lying in the past. Since the two additional potential avatars originate there, this place is engaged by different players at different times. The three babies signify three potential players who can compete against each other (see figure 6.21).

While in *fluID*, the bubble commands users' attention, there are also applications where the developers attempt to show an area, but in such a way that users will pay it as little notice as possible. At this time, we will refrain from going into detail. With the discussion of all following simulation applications as well, a general or comprehensive analysis of all facets of an

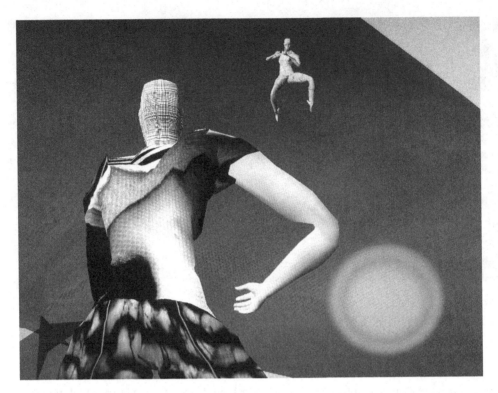

Figure 6.20
View from outside of a player-guided, unborn avatar in the bubble in *fluID*. Still, detail. Source: Courtesy of Mathias Fuchs. Screen shot © fuchs-eckermann 2003.

image's guiding of users' attention would stray too far from the topic at hand. Instead, our concentration will be placed on those aspects that relate to dynamically (re-)acting images and the user's capacity for action.

6.4.3 Partial Granting of Action

When developers envision for the user a particular sequence through a virtual scenario, there are potentially undesirable actions. If these are not to be excluded as a matter of course—for instance, because abruptly introduced boundaries of action are perceived as jarring—there are other options, such as to make certain places appear uninteresting or to comply only partially with users' intentions. Thus design solutions are conceivable in which users are lured with strong signal colors, while "wrong" behaviors are made as unattractive as possible through the deprivation of action combined with an extreme deceleration of movement. For example, the dynamic that is granted to an avatar can force him or her to slow down. Resistance is thus offered, and in the one area over which the interactor has control: his or her

Figure 6.21
Installation architecture in *fluID* for three players at Palais Thienfeld, Graz 2003. Each player has a double projection in front of him or her and interacts through an interface on his or her seat. Source: Courtesy of Mathias Fuchs. Screen shot © fuchs-eckermann 2003.

own movement. This type of feature is not present in the following example. Instead, in this case the avatar moves too quickly in relation to the field that is open to him, and therefore is given optical clues to aid in orientation.

6.4.4 Asynchronies

Stiff Peoples' League, created in the Social Media Group at MIT in 2007, offers two views of and two means of accessing a table-soccer game.[92] The first means of access is enabled with a customary table-soccer table (figure 6.22), upon which an overview of the playing field is projected from above. The table has been prepared by removing the figures from the metal rods. By sliding the handles of the rods on the table as usual, along the axes of the rods (absent in the projected image), the user can change the position of the abstract playing figures, which can be seen only in the projection. Shown from an oblique bird's-eye view, the nameless and distinctly abstract equivalents of the skewered plastic teammates here serve only as blockades. That is, when a user turns a rod's handle in order to pivot the "virtual" figures and thus kick the ball, there is no effect. In order to maneuver the ball, it is necessary to engage the mobile component of the team—dressed either in red or yellow

Figure 6.22
Table-soccer table prepared by the Sociable Media Group at MIT Media Lab shown at Ars Electronica Festival 2007. Players interact with *Stiff People's League* (2007). Source: © Drew Harry/heresiarchic, http://www.flickr.com/photos/drew-harry/1342969523/in/set-72157601753771796.

jerseys—that are simultaneously hustling around on the playing field. A minimum of three of these figures, whose names evoke actual soccer players, make up a team (figure 6.23). They are controlled through the second means of access, using computer terminals in the exhibition space, which are connected with a soccer field in the online world *Second Life*[93] (figure 6.24). A *Second Life* avatar can be controlled at each terminal (figure 6.25), and can be seen on the monitor in either first or third person. Artful ball maneuvers are rarely possible because the steps taken by the advancing figure are too large. The ball ricochets off all objects and players. If it goes into a goal or out of bounds, a new one is automatically thrown into the middle of the field.

The ball's trajectory can be seen in the air for a few seconds as a white strip of condensation (figure 6.26). A process is thus temporarily registered as it occurs, so that the past remains present briefly for the players. Why? This keeps the players in *Second Life,* who have an interior perspective but no overview, from having to concentrate primarily on the ball. There are many possible reasons that an orientation aid is necessary: the field of sight that is granted to each player is restricted, and the many yellow and red obstacles—the players on

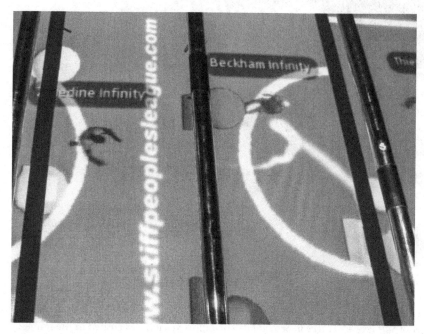

Figure 6.23
Along with the red and yellow spherical players on the rods in *Stiff People's League*, avatars from *Second Life*, identified by name, can also be seen. Source: Author's photographs, Ars Electronica Linz 2007. Courtesy of Dietmar Offenhuber.

the rods—obstruct the view (figure 6.27). In addition, they can cause the more mobile players to be taken off course. When there is a confrontation between the abstract figures that are slid with the real rods on the prepared table and the anthropomorphic players from *Second Life*, the latter have the disadvantage: they can easily be pushed aside by the former. Finally, it should also be noted that a user controls an avatar by keyboard as a whole unit only.[94] This has the result that the direction of view always corresponds to the direction of running and kicking. This rigidity, which is also reflected in the players' very moderate running, can also mean that users easily lose the already oversized virtual ball from view. Thus, what hangs in the air is a successively fading arrow pointing toward the ball, the target object. Because of the movement in the game, the significance of this directional has a short half-life. While the utility of the indicator is posited as crucial, the gradual disappearance of the nebulous trace is also an apt reflection.

6.5 Avatars Astray

The previous examples dealt with strategies of guiding attention that are anchored in the simulated, sensorialized world. The examples in this section involve interaction design

Figure 6.24
View of table soccer of *Stiff People's League* in *Second Life* The online version was created in the frame of the exhibition "Homo ludens ludens: Locating Play in Contemporary Culture and Society," LABoral, Gijón April 18–September 22, 2008. Source: Author's screen shot, *Second Life* 2008. Courtesy of Dietmar Offenhuber.

Figure 6.25
Installation view of *Stiff People's League* at Ars Electronica Festival 2007. At the terminals along the walls, the avatars are guided individually. These actions can also be seen instantaneously on the table-soccer table in the center of the room. Source: © Drew Harry/heresiarchic, http://www.flickr.com/photos/drew-harry/1341069242/sizes/l/in/set-72157601753771796.

(a) (b)

Figure 6.26
Shot as viewed by a player at a terminal for *Stiff People's League* in *Second Life*. The ball leaves a white trail. Stills, details. Source: Author's photographs, Ars Electronica Linz 2007. Courtesy of Dietmar Offenhuber.

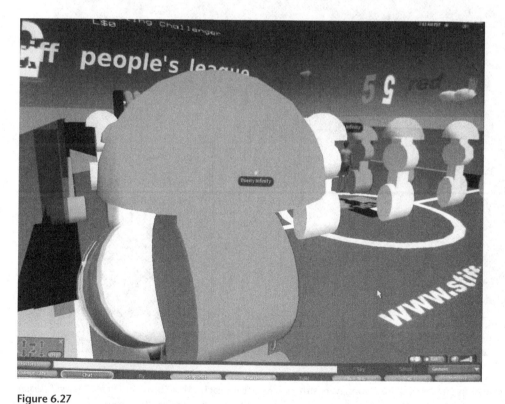

Figure 6.27
The obstacles are the "virtual" soccer players on the rods in the *Second Life*-part of *Stiff People's League*. They often block the view of users guiding the avatars. Still, detail. Source: Author's photograph, Ars Electronica Linz 2007. Courtesy of Dietmar Offenhuber.

measures that solely concern the interactor's point of entry, the avatar. In the disappearance of the silhouette in *Videoplace*, Critter mode, it becomes clear what can happen in a boundary situation when the user is not the complete master of the guided proxy figure. However, this is a transition to a state that does not allow any future interaction. We discuss two examples where the control of the avatar becomes negotiable. It is thus unexpectedly indicated to the user that his or her own role as recipient can be conceived in different ways. In the examples, the cooperative guiding of the avatar is not integrated in a transition phase but rather is the challenge during the entire game.

6.5.1 Divided Actions

The first example displays several points of analogy to *Stiff People's League*, even though the projectile is no longer a soccer ball but live ammunition. The work in question is *Second Person Shooter for 2 Players* (*2ndPS*, 2007), by the artist Julian Oliver (figure 6.28).[95] With *2ndPS* as well, the effects of an exercise of function (here, the use of weapons) can be seen for a certain

Figure 6.28
Installation architecture for two players sitting across from each other in Julian Oliver's *Second Person Shooter for 2 Players,* 2007 at Gameworld, LABoral, Gijón March 30–June 30, 2007. Source: Author's photograph, LABoral Gijón 2007. Courtesy of Julian Oliver.

time in space. The shots emitted by the weapons at the user's disposal have different mani-festations, expressed through sounds, lines, and colors.[96] In contrast to their effects, which happen immediately, the movements of the respective shots dissipate only after a number of seconds. The reasons for this type of asynchrony may again lie in orientation. As with *Stiff Peoples' League,* the avatar's direction of view is simultaneously the direction of his walking or running. In this work too, there are obstacles that obstruct sight, here in the form of inde-structible, massive architectural pillars. But there is a more significant reason that the flight trails of shots that have long since reached or missed their target are made optically visible for a longer span of time. If a player sees shot trails (figure 6.29) that he or she has not caused, this implies—as with *Stiff People's League*—a command to take action. In this case, however, the player will not follow the shot but will avoid it, or another one anticipated as coming in the future (since if the player can see the trail and react to it, this means that his or her avatar has not been struck). Otherwise the player's avatar will be lying as a pile of red boxes and will ultimately sink into the ground (figure 6.30). From the shot's flight trail, an assessment can be made about how to act to avoid being struck in the future.

In any case, in taking action, the player notices very quickly that things transpire quite differently here than in the original game, *Quake III Arena,* that this work builds on. This is indicated in the title. *Second Person Shooter* refers to the modes of presentation that have

Figure 6.29
The rocket launcher's trajectory, depicted with lines, can be seen obliquely from the side and runs from right to left in *Second Person Shooter for 2 Players*. Still. Source: Author's photograph, LABoral Gijón 2007. Courtesy of Julian Oliver.

(a)

(b)

Figure 6.30

(a) A shot from the rocket launcher in *Second Person Shooter for 2 Players* hits its mark and the trajectory gradually fades. (b) The player's own avatar (at least the one indicated as "you" in the radar field), dead, sinks into the ground. The opponent avatar is located at right in the image. Stills, details. Source: Author's photographs, LABoral Gijón 2007. Courtesy of Julian Oliver.

Figure 6.31
Here, the opponent in *Second Person Shooter for 2 Players, depicted on the right side* is colored differently (green)—in contrast to figure 6.36 (where both players are in red). Still. Source: Author's photograph, LABoral Gijón 2007. Courtesy of Julian Oliver.

become standard in computer games: a player either sees the presented scenario in a "first-person view," so that the weapon that he or she is operating can be seen projecting into the pictorial field from the lower right, or in a "third-person view," in which the guided avatar can be seen from behind, at a distance, and always at the center of the picture. In both cases, the player has full control over his or her avatar. But there is no "second-person view." The expression as used in *2ndPS* alludes to the fact that both players simultaneously control both of the two avatars present in the arena. The crux is thus that here, the opponent controls the legs of your own avatar, while you yourself determine only the direction in which your avatar is facing (figures 6.31 and 6.32). The same is true in reverse: with the keyboard and your left hand, you move your opponent forward; with the mouse in your right hand, you pivot your own character. What at first sounds rather organized quickly brings about unfathomable complexities in the game and leads to discrepant and totally unaccustomed situations. Are you the one looking or the one running? In a visual radar field at the upper right, it is often indicated with which avatar you must identify: instead of a locating circle with a point showing the direction of view, sometimes the word *you* appears (figure 6.33 and 6.34). If you interpret this indicator as directed at yourself, then your own avatar is the one that you always see from behind, as usual in the third-person perspective; the one whose field of view you can control by pivoting him on his axis, the one you shoot with and whose weapon you

Figure 6.32
Shot with the plasma gun in *Second Person Shooter for 2 Players*. Source: Author's photograph, LABoral Gijón 2007. Courtesy of Julian Oliver.

Figure 6.33
In the radar field in *Second Person Shooter for 2 Players*, the position indicator is realized by means of circles with beaks. Still, detail. Source: Author's photograph, LABoral Gijón 2007. Courtesy of Julian Oliver.

Figure 6.34
The radar field in *Second Person Shooter for 2 Players* shows what player figure you are supposed to identify with. Still, detail. Source: Author's photograph, LABoral Gijón 2007. Courtesy of Julian Oliver.

Figure 6.35
Preceding variants of *Second Person Shooter for 2 Players* (2005). Still. Source: Author's still, 2008. Courtesy of Julian Oliver.

change.[97] In any case, a person can hardly be induced not to feel connected with the point of view that is offered. One major difference between "virtual" worlds and the situation of cinema, according to Roberto Diodato, is that it is not possible for the recipient to identify with the "subject of his or her vision-action [*visione-azione*],"[98] for example, the other depicted people (apart from the recipient's own avatar). The player cannot locate himself or herself where his or her gaze falls (except in a mirror situation). Therefore, we will continue to call the avatar that is believed to be opposite oneself the "opponent."

If you keep the opponent avatar mobile, you yourself often remain in place (which is advantageous, since you then have time to assess the current constellation and concentrate on shooting), and your opponent has a very agitated demeanor. In this situation, he or she is occupied with trying to get oriented. Keeping the other player at a trot is thus an active self-protective mechanism. With the left and right arrow keys, you turn the opponent avatar in discrete steps around his axis.[99] Here, the turning direction is established with respect to the orientation of his body, not with respect to your view. As long as the opponent avatar is located opposite your own view, the arrow keys function counterintuitively, that is, they are reversed. But as soon as you see the other avatar from behind like your own (figure 6.36), then the left arrow key also means turning him to the left in your view. In order to navigate the opponent figure in a meaningful way, you must always have his momentary orientation present, even when you don't see him for certain periods of time. In these cases the "radar window" is useful—though the artist sees it as a type of compromise in order to assist in orientation.[100] Keeping your bearings is not easy, because if you do not want to get shot, you will paradoxically attempt to keep your own direction of sight turned away from your opponent

Figure 6.36
In the variant where both avatars are seen in red in *Second Person Shooter for 2 Players*, they cannot be distinguished even if the opponent (left) is positioned next to your own avatar. Detail. Source: Author's photograph, LABoral Gijón 2007. Courtesy of Julian Oliver.

and thus give your own movement (which is controlled by your opponent) a (partly) self-determined direction in order to bring yourself out of the opponent's visual field or line of fire. Meanwhile, you navigate your opponent and hope to show him from the side, so that you see him but he does not see your own position from his perspective. Turning your own avatar in order to change your direction of running and sight seems to be a more complex process than navigating in mirror image.

Now and again you get the idea that you now have understood the mechanism and have learned to cope with it. But this is only to realize, in a situation of discrepancy, that you have fallen back into the conventional pattern again and think you are navigating yourself when actually your own avatar is being moved. And, vice versa, you often forget that you are moving the other figure or where you are planning to take him. In some situations, without noticing it, you move the opponent out of the field, up against the arena's impenetrable, horizontally pink-striped exterior wall. Only through an acoustic scuffling is this brought into awareness again; however, the opponent can also "free" himself by turning around.

Above all because of the speed of the game, the rational permeation of circumstances with the urgency to act, which requires dexterity as well as mental presence, is often not given. In truth this is also not necessary. You do not always have to have these intricacies in mind in every detail; it is sufficient to shoot when you see an avatar.[101] Thus, if under normal circumstances, according to a military paradigm, the relationship between the psychophysiological presence of the player and his avatar is set in such a way that it functions to orient control and awareness simultaneously,[102] this is specifically not the case here. But we are also not presented with a simple separation of view and action.[103] Rather, the observer position and the manipulative position overlap in an unusual way. To be precise, in *2ndPS* the player not only has a view of the scene (which has two masters); he or she also occupies two points of action simultaneously. Since each avatar's view is determined by two players, this can lead to a constant tug of war.

Not least because a player does not solely command his or her own view, a nonsimultaneity of events in the detailing of the shots is helpful in the game. In both *Stiff Peoples' League* and *2ndPS,* a function is transported spatially with an object. This function has its effect and determines the course of the game as soon as it meets its target object (the goal, the opponent avatar). For this reason, the transporting object is of greatest interest for all players.[104] Its visibility is enhanced in its past locations being briefly registered, while the players' view is restricted in multiple ways.[105] Temporality can be employed to great effect in real-time applications specifically, because the sense for a deviation from simultaneity is pronounced. It is no coincidence that in his vision for computer game studies as a field, Markku Eskelinen places the examination of temporal structures in the many ways they are treated and the often complex aspects of temporality at the center of the efforts to be undertaken there.[106]

6.5.2 User Interactivity and Simulation: A Conflicting Relationship

The second example makes clear in another way that the player is not identical with the avatar but nevertheless participates in the avatar's perspective. In the installation *The Bush Soul*, which the artist Rebecca Allen developed in three variants from 1997 to 1999 with a team[107] at the University of California, Los Angeles, the player navigates using a joystick with force feedback through a barren, rocky landscape featuring various fantastic sites (figure 6.37). The world is projected on three bent screens. The player can enter into contact with the strange creatures that live there over a microphone; his or her voice is morphed into tones that the artificial life forms are able to perceive (figure 6.38).

In the work's title, Allen makes reference to a belief that was common in parts of West Africa that people possess multiple souls. One of these was called the bush soul because it was borne by a wild animal in the bush: thus, it lay outside the person but was also not the animal itself. This is how the artist wants the user's perspective to be understood in her work: as an itinerant soul in a virtual world, while the bodily person always stands apart from it, working the control panel. The user has not by any means become an avatar through the interaction; rather, his or her "naked bush soul" has merely been sent into the wilds that are to be explored interactively. The bush soul is presented as an elastic, vital knot of white lines (figure 6.39). Thus, in order to demonstrate the role of the interactor, in contrast to other works, there exists a third entity here: the person, "his or her" soul that the person guides, and the animal avatar for this soul. The user must find a body for the soul, or else it will escape.[108] When the soul and animal fuse, this can be seen in the form of disconnected lines swirling around the animal (figure 6.40).

Figure 6.37
Installation view of Rebecca Allen's *The Bush Soul #2* (1998), with three projections. Source: Rebecca Allen, "*The Bush Soul*: Interactive Art Installation, Panoramic Projection: As shown at SIGGRAPH '98," in: http://emergence.design.ucla.edu/images/sigphoto1.jpg. Courtesy of Rebecca Allen.

Figure 6.38
The user in *The Bush Soul #3* (1999), encounters strange creatures whose bodies do not "cohere" but can express emotions effectively. Screen shot. Source: Rebecca Allen, "*The Bush Soul #3*," in http://emergence. design.ucla.edu/images/bsoul3/big/bugeat2.jpg. Courtesy of Rebecca Allen.

Figure 6.39
The soul is searching for an embodiment in *The Bush Soul #3*. Screen shot. Source: Rebecca Allen, "*The Bush Soul #3*," in http://emergence.design.ucla.edu/images/bsoul3/big/Capture_09132000_145128.jpg. Courtesy of Rebecca Allen.

Figure 6.40
In the foreground of *The Bush Soul #3* stands a creature "animated" by a bush soul. Screen shot. Source: Rebecca Allen, "*The Bush Soul #3*," in http://emergence.design.ucla.edu/images/bsoul3/big/Capture_gypcom.jpg. Courtesy of Rebecca Allen.

The interactor is not given a directed goal of play in this unfamiliar world. The artist used her experiences in the field of animation and concentrated on exploring the problematic of communication with simulated creatures. She has succeeded in conveying emotions through simple forms that comprise an ensemble without necessarily having to be connected. The creatures communicate to one another their temperament, their age, and their disposition. This intraworld communication between characters who are kept abstract is accomplished through gestures, sounds, and energy emissions in the form of particles of light or energy fields. The latter can be perceived via an ensouled avatar by means of the joystick's force feedback. The joystick is thus used not only as a navigation instrument but also as a sensorium. Only after a more prolonged engagement with the work do the world's social laws reveal themselves. However, these are not codified once and for all. "As in real life, relationships and behavior patterns can change as the result of particular interactions or time-based events. A script gives life to a virtual object, but complex social environments arise only through the interaction of simple behaviors."[109]

By means of artificial life techniques using parameter settings, every simulated inhabitant is given a unique behavior pattern and a demeanor toward other inhabitants. For animals that receive the user's soul and thus take on the role of avatar, this simulated behavior is combined with the joystick inputs of the user.[110] Thus, unlike in the usual case, the avatar here is not a simple navigational mantle as a figurative representation of the user's own possibilities for action. The creature that the user at first directs without hesitation, because he or she is familiar with this approach from many computer games, turns out to be partially

autonomous. The user learns what this means in the course of interaction, when he or she is suddenly no longer capable of specifying the avatar's direction. If the soul slips into a bush resident, this animal becomes an avatar and can "be controlled by the person; but just like a wild animal it is also marked by its own behavior pattern and at times makes its own decisions. The person has to learn to understand the avatar's behaviors and has to be ready intermittently to give up control through it."[111]

Precisely through the avatar's personality characteristics, the world to be explored presents itself in a specific coloration. Each animal offers another insight (or several possible ones) through its respective embedding in society. For the period of time in which his or her soul is housed in the animal, the interactor can participate in shaping its relationships. All objects in this world are equipped with artificial life of one kind or another.[112] Contact can be made with all of them.

The Bush Soul distinguishes itself in that, on the one hand, the user along with the various bush creatures is more firmly located in this unique world than in most artificial life scenarios. On the other hand, the user is kept at a distance because the character has its own life. This combination of artificial life and interactivity on the part of the user is the ideal constellation to thematize the potential for conflict between human- and algorithm-based control of what is being modeled. In order to foreground this difference, in *The Bush Soul* there is the soul as the link between them. Every bush animal is programmed so that it can act completely independently, while the soul to a large extent follows the interactor's commands. After a soul has gone into an animal, the two governing entities must negotiate compromises among themselves. In the event of a massive difference in the animal's and the interactor's interests, the animal can expel the soul from its body. By the same token, the interactor can also free the soul from the animal at the press of a button.[113] "Possibilities include exchange of souls, transfer of souls between different characters, or banishing from a particular one."[114]

If one intends to get to know the character of a simulated bush creature, one will not be able to force one's will on it too much. In other words, if the results of modeling are to be revealed, which can be assumed for simulations in general, then the user's freedom to act must go into the background, since there is no reason that he or she would keep to the model rules that have been envisioned—inasmuch as the user knows these rules at all. Hence, it is also understandable why, with simulations in the natural sciences, there can be hardly any role for interactors beyond the fine-tuning of parameters.[115] The integration of a user necessarily gives rise to zones of indeterminacy.[116]

Boissier formulates this conflict of dynamic operativity—of being on the one hand autonomously calculated and on the other hand user determined—in yet another way: "The transcription or the figuration of an action by the interactive image in effect consists—paradoxically—in voiding this action of its relational dimension in order to fill it up again with the relation that the recipient's act brings with it."[117] Another way to describe this paradox is that the interactive image, which is embedded in a situation, displays two types of relationing. Boissier discusses at different points the etymological connotations of the word

relation.[118] First, there are connotations of reporting or of referring to something (*relater*); second, there is the sense of connecting (*relier*). These two senses can be associated with two gestures: an attitude of inclusion, which is directed outward, as well as an internal networking. It is through the latter that the former is designed smoothly, since according to Boissier, "playability attests to the figurability of relations."[119]

Through this placement of focus on the forming of interactivity, it becomes apparent that interactive real-time simulations are special cases within simulation production overall and that a place has to be assigned for the user's interventions within model-induced dynamic. While the interactor is compelled by means of restrictions established in the programming to remain within the model's boundaries (e.g., in his or her being conceded only one variable in the model), the extent to which the interactor feels empowered to do something essential differs from case to case.

The user will feel distanced by a situation in which the simulation model generates a sequence independent of him or her, since the user is suspended from involvement here. In computer games, narrative sequences are often embedded through the computer's taking over control at certain points. The transitions are already achieved so fluently in real time that in terms of iconic aesthetics, these passages cannot immediately be distinguished from the interactive parts.[120] With respect to action, however, the difference is massive, since the dynamic is operatively revoked from the user.

To conclude this series of examples, we once again recapitulate the relations between the two only heuristically separated interaction-forming operative aspects that guided the analyses in this chapter. In *Videoplace*, the boundaries of action corresponded with the presented boundaries of the motif. The same can fundamentally be said of *Stiff Peoples' League* and *2ndP2*, except that in the case of the trajectories that are visible for longer periods, the iconic presentation itself cannot be touched, but in its way indicates the site of action and effect. The iconic component thereby takes on two roles: it provides an envelope for the functionality[121] (in the discussed examples, in the projectile) and serves as an indicator of this embodiment. In both cases, a reaction on the part of the user is the objective. With *fluID*, the figuration and the performability of actions relate to each other in such a way that this relationship becomes thematic at the very least. The imagery seems to be more abundant than the potential for action that is granted to the user; hence, there seems to be an imbalance between sensory presentation and dynamic functionality. In *2ndP2* and *The Bush Soul*, the interactor also perceives limitations with respect to the avatars. In one case, it is the opponent player with some sway; in the other case, it is an algorithm. Beyond iconicity, in these examples there is a situation of competition between self-directed movement and movement attributed to another source. Rune Klevjer speaks of the possibility of a "built-in ambiguity in avatar-based play." He continues, "While the relationship between the player and the body of the avatar may be seen as a corporealization of a technologically augmented self, this alternative body-subject does not necessarily facilitate a 'meeting of minds' between the player and the computer."[122] Since these negotiations begin with the avatar, the

player's own perspective is always also affected, which in turn impels the further course of action.

6.6 (Unstable) Image as Variable Interface

The sensory presentation in the field of tension between perceivable, dynamic, and action-promoting components unsettles, emboldens, impairs, seduces the interactor. But by the same token, without interaction, and thus without the user, these image worlds would not achieve their intended purpose. Because the acting recipient is necessary for this aspect of execution, some theorists are in the process of rethinking the nature of the interactive image. Since the appearance of computer-based interactive images, the recipient can no longer be separated from the image, in the opinion of scholars such as Jean-Louis Weissberg. According to him, the body of the interactor (*spectacteur*)[123] is directly mobilized as the condition of the images' manifestation (see figure 3.1d). As an intrinsic (and not external) condition, it opens up the possibility for an aesthetic vocabulary. These new relationships between the body and images are the basis for the concept that Weissberg calls the *image actée*.[124] This is a demanding image that evokes action. According to Weissberg, the term *image actée* can be considered as essentially synonymous with the widely used expression *interactive image*. However, his formulation would emphasize more explicitly the gestural dimension of the concrete act that is precisely the dimension constitutive of this form of image. Although the adjectivally understood, feminine-gendered perfect participle *actée* implies a passivity and the *image actée* is subjected to the user's gestures, it cannot be understood with the opposition active/passive, in Weissberg's analysis.[125] For neither can the traditional image (panel painting) be qualified as exclusively passive, from a reception-aesthetic perspective; nor is it justifiable to stylize the approach to the *image actée* as a purely active engagement, for example, in the sense that the viewer would completely subdue the image—because it very quickly becomes apparent that what the interactor encounters places limits on his or her freedom of action. In fact, says Weissberg, the user must first find his or her place in the offered *dispositif* and bring it into balance, since images can be described as fields of action that do not allow anything whatsoever to occur. Even if the gesture belongs to this image type as its central attribute (which differentiates it from the traditional image), the image is not subjugated to the gesture. The image expects the gesture that it sets in motion; it calls for this gesture. In a technocultural context, the user is always already prepared for the image's potential invitation to act. In the case of computer games, for example, the interactor is called into the image as part of the action, without having to see himself or herself within it. The game cannot advance without his or her actions; rather, it includes the interactor "as the *motor* of events in the image."[126]

Diodato gives even stronger emphasis to the inseparability of the user. He goes so far as to refer to an interactive digital image, in the becoming-perceivable of an algorithm in the interaction with the user, as a "virtual body" (*corpo virtuale*). In his view, precisely in the connection with the recipient, the latter acquires a new ontological status. Following a discussion

of Nelson Goodman's approach[127] with respect to the differentiation of analog (syntactically dense) and digital (disjunct and endlessly differentiated), Diodato concludes for his own concept of the "virtual body" that Goodman's approach is inadequate, since his—Diodato's—perspective brings together the different characteristics that Goodman assigns to different symbol systems. Diodato writes,

> Things become even more complicated if we consider the virtual body as digital image-body, or as hybrid image-body: this is, of course, the self-phenomenalization of an algorithm in binary format, that is, a syntactically differentiated symbolic diagram, and it concerns the scope of exemplicative experience, which involves properties expressed and not simply denoted. But it is not possible in this case to repeat the existing relation between score and performance, in the first place because the virtual body is also image and thus depicts, but also in our case the interaction intervenes, or can intervene, on the score itself. One should notice that the interaction constitutive of the event-being [ente-evento] is an interaction between the discrete and the continuous, between, so to speak, an analog system, a mind-body complex endowed with prostheses, and an algorithm exemplified by these data points that come to saturate perception. It thus seems to me difficult to read the virtual body in terms of Goodman's powerful theory of notation, and this is evidence of the virtual body's peculiar novelty.[128]

Diodato sees in the "virtual body" the interweaving of analog and digital accomplished on two levels: first, the algorithm (disjunct) is also the image (dense); second, the user's interaction (dense) already begins with the program (disjunct). Both become plausible against the background of a close involvement of the recipient.

In chapter 5 we suggested that if the responsibility for completion of interactive works is given to the user, then the last instance of forming is located in execution. The developers configure the mathematical model as a network of relationships. In addition, substantial efforts are exerted in the design of interactivity—which itself is a type of sophisticated transfer of relations—along with the sensory execution. However, for a dynamic sequence of events that includes possibilities of intervention for the user, it is necessary to execute the model together with attendant components of sensorialization: in other words, what is required is the actualization of the virtual. The impression of the ephemeral, of the fleetingness of the images that is thereby created, the sense of underlying connections, and the successive strengthening of the awareness of one's own role as interactor can come into effect only in the act of consumption. Not only must the aspect of the model be integrated into this understanding of the image as what lies "below the surface"; as well, the interactor takes a place in the image. Following Couchot, the observer is no longer positioned facing the image (en face de l'image) but rather interfacing with the image (en interface avec l'image).[129]

The allowing of interactions on the part of the user strengthens the role of the image that comes with computer simulations, since on the one hand the sensory configuration affects the user's interactions in concert with the technical interface, and on the other hand it only shows what is calculated to a certain extent. The sensory configuration is thus a veritable interface. In both instances, what can be perceived is crucial. The user is influenced *directly*

by what is offered to the senses; *indirectly,*[130] so is the data that is interactively sent to the model by the user, inasmuch as the user acts within the frame of what comes to mind as a result of what is presented.

The interface, which Emanuele Quinz aptly terms a "relational vehicle," is on the one hand a "sensory organ of the computer system"[131]; on the other hand, it is generally the only aspect that the user has any contact with. The simulation image as interface forms a hinge between data and recipients, or, as Jacques Lafon expresses it, the digital image travels as an angelic messenger between two worlds: the sensory world and the intelligible world of the model.[132] The relationship between the simulation image as interface and the model level is tangible through the iconization (the graphic elements, the visual effects, the display); the relationship to the audience is expressed in the phrase *systemic image* in its second connotation, that of piloting.

Along with the input and output devices, the sensory presentation should therefore also be seen as "the summit of a double encounter"[133]: in ways that are characteristic of each individual presentation, it mediates between person and program and derives sustenance from both sides for its ceaseless transformation. Not least as a product of their "architecture," these digital image worlds display a mobility or, in the words of the artist and theorist Roy Ascott and many others, an instability. When reference is made to the "instability" of the image, a static understanding of the image serves as the implicit opposing entity with which a contrast is being made.[134] This new type of iconicity articulates itself in time, is in fact dynamic and simultaneously is affine to interactivity. A suitable vocabulary for it for the most part still remains to be created. To conclude that an image termed unstable *in its function as interface* is itself unstable would be a misunderstanding. As an interface, it is variable but not volatile—it does not completely break down; it does not fail to serve its purpose.

What the image-as-interface absorbs and in turn converts into the perceivable has by no means been neutrally transformed. The modalities of presentation must be ascertained in detail. For example, what do the image-specific "filters" look like that establish focal points, specify horizons of interpretation, guide attention, produce the self-evident? If images make something available, then we are particularly interested here in the ways this happens in simulations' sensory presentations. Seeing these as "window-environments," to borrow an expression from Diodato that alludes to Alberti, becomes interesting when they are conceived in a nontrivial sense as free-standing sites at which the relationship of inside and outside changes in each case according to diverse parameters.[135] As the bearers of such parameters, the iconizations play a not insignificant role with respect to the material to be presented.

Conclusion

After the preparatory first chapter on approaches to simulation theory, the following chapters offer different ways of looking at the subject of the image in the frame of computer-based real-time simulations. In reviewing the available interpretive templates once again, we assess the outcome of each approach's analysis and identify where its blind spots make a complementary perspective opportune.

Chapter 2 introduces a process that forms the basis for computer simulations and organizes their dynamic systemically. Since this process as the underlying schema comprises the unifying element, the temporal component moves to the center as the first and the essential aspect. All following considerations begin there. The systemic architecture of simulations is the basis for the mathematical model and, in the examples addressed here, enables well-defined, targeted, and explicit interventions on the part of the user. The seductive and no less crucial incorporation of the audience through the sensory and synesthetic modalities is then also brought in.

How a simulation's sensorially perceptible presentation relates to this primary temporal forming is discussed in chapter 3. In order to avoid misidentifying the sensorialization as a mere addition after the fact that does not contribute anything of its own, we propose the idea of their interweaving as analogous to the combination of different types of models. The sensory components are thereby placed in a context of use, as is only reasonable for interactive works. At the same time, the impression should not wrongly be conveyed that every iconization performs an independent model function just because it occurs in connection with a dynamic model. This would be an overextension of the concept of what models are. But we do intend to emphasize that the perceivable design possesses its own logic.

Nevertheless, the iconization also has jobs it must do with respect to the calculated simulation dynamic; for example, it provides a display. This is addressed in chapter 4. The display is called to "life" under the condition of calculation data that is available to be shown; it is the place where the simulation dynamic makes its appearance. It "frames" the dynamic and, with interactive applications, is generally (in the broadest sense) figurative in nature. Within the overall iconic situation that is offered, there can be multiple displays as iconic

subunits with this special showing function. Through the difference that emerges between the display and its embedding, two things become clear: first, along with the explicit movement effected by the calculation, additional dynamics take place as a result of how the movement is designed, and second, the iconicity expresses much more for the observer than is encoded in the simulation's columns of numbers. Nevertheless, this perspective tends to focus on certain points in particular, specifically, those points where the underlying movement becomes apparent. Within the overall complex of the simulation, or the reception situation more broadly, these elements should be considered only individual particles. By itself, this approach is inadequate in that it cannot take in the characteristic features of spatiotemporal polysensory iconicity altogether.

This deficiency is countered in chapter 5, where the objective is to describe some of the features of the iconicity of simulations. While in the two preceding chapters, the relationship between movement and image was analytically broken down, here a synthetic approach is attempted that comprehends a mobile and reacting structure as an iconic entity. The prominent features of simulations (and their sensory presentations) include showing a "situation" without montage cuts, as well as self-similarity and repetition without exact reproducibility. Even if an attempt is made to formulate some thoughts on this topic, it is nevertheless plainly evident that the elaboration of an aesthetic of the iconicity that occurs in the frame of simulations continues to be a desideratum of research.

Chapter 6 isolates interactivity as an important aspect. There, we discuss different ways the user is taken into account. Interactive applications are designed for audience assistance. Because of this, references to recipients come into play as early as the production stage: for instance, in staging "real time," in gearing hardware components to operationality studies, or in situating data in a presentation's content so as to ensure greater interpretive ease. By means of interactivity, the user is so closely linked to these image worlds that some theorists regard the user as a fundamental component of interactive images that cannot be separated out without losing sight of their essential quality. It was proposed that iconicity in the frame of simulations be thought of as expanding in two directions (toward the model and toward user interactions), because both poles have an equal impact on the content of what occurs. These two expansions belonging to the image are not primarily meant to symbolize all the technologies that are indispensable for the image's purely technical manifestation, but rather, above all, the ingredients that make evident what this unique configuration is about. This specific kind of iconicity receives its full unfolding only through the collaborative performance of computer and recipient.

It can be asserted without reservation that the sensory presentation is crucial for interaction. What else would be? Here, Krueger can be cited again for never having claimed that in his approach the interface would disappear. In his view, this would be a paradox, since "to a significant degree, the reality, and therefore the interface, will be the task. So, rather than disappearing, the interface will be all that remains."[1] The word *interface* concludes the thoughts that have been undertaken here, which should be understood as an

attempt to sketch out the relationships in this complex systemic structure. Simulation iconicity, as a zone of communication, fundamentally designs the user's intervention in the midst of itself and thus, moreover, also what is fed back into the mathematical model. What arrives there is processed again, transformed, and on the surface is provided with a figuration, in other words is staged iconically, in order to strike the recipient's eye (or ear, or fall into the recipient's hand). The iconicity thus has a regulating effect in both directions, without exhausting itself in this mediating role. Simultaneously, however, the iconicity that comes with interactive simulations is always installed in the position of privilege.

Notes

Introduction

1. Wörn and Brinkschulte, *Echtzeitsysteme*, 1. Translated here.

2. The model theorist Herbert Stachowiak classifies simulators "according to the different values of the time scale m_t relating to the simulated and simulating systems. For $m_t = 1$, we speak of 'real-time simulators'; for $m_t \lessgtr 1$, we speak of 'time lapse' or 'slow motion' simulators, respectively." Stachowiak, *Allgemeine Modelltheorie*, 342. Translated here.

3. See von Baer, "Die Abhängigkeit unseres Weltbilds." For a description of various "moments" for different animal species, see Bühler and Rieger, "Schnecke."

4. It is known that for image construction on the monitor, this requires twenty-five refreshes per second; for haptics, approximately one thousand impulses are needed in the same time span.

5. Norberg, "It's Real and It's Alive," 106.

6. See Couchot, "À la recherche du 'temps réel,'" 41.

7. Daniels, "Strategies of Interactivity," 187.

8. Manovich, *The Language of New Media*, 7.

9. The art historian Hans Dieter Huber has been testing this approach for a long time. See his *System und Wirkung*; *Bild Beobachter Milieu* and "Systemische Bildwissenschaft." See also Wyss, *Vom Bild zum Kunstsystem*.

10. See Barbeni, *Webcinema*, 30.

11. Couffignal, "Universalité de la cybernétique," 10. Translated here.

12. See Spencer-Brown, *Laws of Form*.

13. See Luhmann, *Theory of Society*, 29, 113–23; Luhmann, "The Medium of Art"; Luhmann, "Medium and Form."

14. Krämer, "Form als Vollzug," 560–61.

15. This is the purview of software criticism, as, for example, is conducted in the series Software Studies launched by MIT Press in 2009. See also Manovich, *Software Takes Command,* in particular 34, 85–86.

16. Boehm, "Vom Medium zum Bild," 170. Translated here.

17. Wardrip-Fruin, *Expressive Processing,* xi.

18. Under certain circumstances, ray tracing and radiosity procedures in 3D computer graphics could be regarded as simulations of lighting and reflection effects that are oriented toward the image.

19. See Boehm, "Zu einer Hermeneutik"; "Bildsinn und Sinnesorgane"; and "Ikonische Differenz"; see also Müller, *Die ikonische Differenz.*

20. The term *imaging* (*Bildgebung*) is commonly used for various medical diagnostic procedures. This term has already been generalized by numerous authors, including Kittler, "Schrift und Zahl," 192.

21. To give a general sense of what is meant here, biology, medicine, psychology, and sociology typically recognize the following rough gradations of scale: genome, protein, organ, life form, society. However, an infinite number of increments can be inserted between them.

Chapter 1

1. Baudrillard, *The Illusion of the End,* 55.

2. Baudrillard, "The Precession of Simulacra," 6.

3. See Reifenrath, "Geschichte der Simulation," 9.

4. The philosopher Paul Virilio, *A Landscape of Events* (54–56), also speaks of this:

To expose the accident so as no longer to expose oneself to the accident is now, in fact, the principal function of simulators used to drive technological engines. ...

Or perhaps it is like professional simulation processes that accumulate negative situations: not to terrorize the experimenters (drivers, engineers) but to accustom them to the *unusual,* preparing them to react in a predictable and effective way and to avoid the dangers of habit, the professional distortion that comes from taking the reliability of technology for granted.

To expose, to exhibit the accident is thus to expose the unlikely, to expose the unusual and yet inevitable.

5. See Baudrillard, "The Precession of Simulacra," 2.

6. Bredekamp, "Das Bild als Leitbild," 237.

7. Baudrillard, "The Order of Simulacra," 60.

8. See Baudrillard, "The Precession of Simulacra," 12–14, 21.

9. Baudrillard, "Au-delà du vrai et du faux," 139–40. Translated here.

10. For the current state of the discussion on the index in photo theory, see Elkins, *Photography Theory.*

11. See Couchot, *La technologie dans l'art,* 137. By "figuration," Couchot intends remaining with morphology. In media-theoretical and philosophical discourse, *matrix* designates an invisible ordering metaphor. "The conceptual parallel between the aesthetic-technical description and the metatheoretical

contemplation lies in the matrix metaphorically representing a paradoxical visual order: it belongs to an invisible order but can nevertheless take on a shape conditioned by the visible order of a medium." Spielmann, *Video*, 58.

12. *Dargestellt.* While traditionally translated as "to represent," *darstellen* literally means "to place there"; the sense is of making something perceptible, or making a perceptible something. In her summary of the dispute around the representational function of simulations, Hinterwaldner uses *Repräsentation* to refer to the relationship between depiction and depicted and *Darstellung* to refer to the image and how it is composed. In order to preserve this terminological separation, I will use *representation* for the former and *presentation* (or occasionally *picturing*) for the latter. In *The Retreat of Representation*, Martha Helfer discusses an initial semantic overlap between *darstellen* and *vorstellen*, "to present," and defines *darstellen* as "sensible presentation, presencing, or representation" (13–14, 3). Translated here.

13. See Couchot, *Images*, 17, 190. The topos is prevalent that with simulation, a shift has occurred from the perceptual to the conceptual, from visual imitation to functional, from reproduction of the surface to that of laws. But here one could point out that the imitation of nature was always understood in a double sense. "Since antiquity, visual art has attempted to imitate nature, either according to its surface or according to its creative power." Bredekamp, "Mimesis, grundlos," 284. Translated here.

14. Couchot, *Images: De l'optique au numérique*, 222. Translated here.

15. Couchot, "Die Spiele des Realen und des Virtuellen," 348. Translated here.

16. Here Raulet uses the word *Aufnahme*, which can mean a recording in any medium or a photograph in specific. Translated here.

17. Raulet, "Bildsein ohne Ähnlichkeit," 165.

18. Rheinberger, "Objekt und Repräsentation," 55. Translated here. In this text, when science studies scholar Hans-Jörg Rheinberger proposes the term *making visible* to evade the "dilemma of representation," he is not alluding to the possible absence of reference, but rather to the fact that a depiction accessible to the eye displays multiple "layers of representation": these can relate to the object of investigation, but also simultaneously the research strategy, the metaphorics of (popular) scientific mediation, the default settings of the employed graphics program, the guidelines of the organ of publication, and much more.

19. *Repräsentation bzw. Darstellung.*

20. Rötzer, "Von der Darstellung zum Ereignis," 56. Translated here. In order to better understand Rötzer's statement, the reference to real time should not be ignored. In this debate in the field, the view is prevalent that real time is a culmination point, the epitome of the elimination of distance. In this view, the logical paradox of the logic of the image in real time is that this real-time image dominates the object it presents and real time prevails over real space. See Virilio, *The Vision Machine*, 63. To follow Rötzer further: also for computer simulations capable of real time, the precession of the referent or the belatedness of the representation must hold for the entire production of the simulation and not for each individual state of the simulation produced in real time. The latter, in view of the idea of the matrix image, does not make any sense, since it mistakes its own characteristic feature: that when looking at the momentary manifestation, one also has to consider a more comprehensive whole that consti-

tutes the matrix image as such, whereby every individual state that is instantly replaced undergoes the appropriate relativization. For precisely this reason, the publication of stills of simulations, as units that have been torn out of the flow of presentation, is also problematic: they do not reproduce the sequence of action and are unable to adequately demarcate their own status as the fragment of a sequence.

21. Bettetini, *La simulazione visiva*, 6, translated here; see also 4.

22. In her ethnographic study *Simulation and Its Discontents*, Sherry Turkle shows that among natural scientists, much concern is directed at the evaluation of how to conceive of the connection to reality when using simulations. See Turkle, *Simulation and Its Discontents,* especially 25–37.

23. See Rötzer, "Synergie von Mensch und Maschine," 108.

24. Di Paolo, Noble, and Bullock, "Simulation Models as Opaque Thought Experiments," 500.

25. With Baudrillard too, the simulacrum leads to a critical reevaluation. However, then artificial life research has to be seen, like the "excess of media illusion," as that instance of "undeceiv[ing] us about the real." But if, for Baudrillard, the knowledge gained from disillusionment results in apathy and indifference, this is not the case for Emmeche. See Baudrillard, *The Illusion of the End,* 61.

26. Elsewhere, this preconception has been called "prepared description." This is a description that already conceives of the examined phenomenon in the direction of formalization. See Cartwright, *How the Laws of Physics Lie,* 133–34. "System" is such a "prepared description," with which one acts as if it existed as the generator of the dynamics of interest.

27. Emmeche, *The Garden in the Machine,* 163.

28. Ibid.

29. Ibid., 164.

30. Baudrillard, "Simulacra and Science Fiction," 122. The literary scholar Peter Gendolla also proposes a tripartite division. For him, the first two types of simulation are tied to symbol systems (and not, as for Baudrillard, to the real), while the third type also dances to the beat of its own drummer and "unsettles, subverts, reformulates such symbol systems." The pattern of the inversion of cause and effect also remains the same: "That something exists was the indispensable *precondition* of all serious, true communications; the others fell under the headings of semblance, deception, play, theater, lies, betrayal, etc. Of late—and here's the rub, the cause of disturbing fears or futurist exuberance—such becomes the *result* of communication." Gendolla, "Drei Simulationsmodelle," 177–78. Translated here.

31. This paraphrase of a passage has been adapted to simulation; see Baudrillard, *Die Illusion und die Virtualität,* 7–8.

32. Baudrillard, "Simulacra and Science Fiction," 126.

33. Baudrillard, "The Precession of Simulacra," 16–17, see also 2.

34. "Un disque enrayé, immutable." Baudrillard, "L'ordre des simulacres," 90. The existing English translation could not be used here.

35. Actually the philosophical concept of simulation fundamentally dismisses any metaphysics. See Perniola, "Icone, visioni, simulacri," 127.

36. See Baudrillard, "The Order of Simulacra," 56, 78.

37. See De Landa, *Philosophy and Simulation*; Gramelsberger, *Computerexperimente*; and her contributions in Gramelsberger, *From Science to Computational Sciences*.

38. See Snow, *The Two Cultures and a Second Look*.

39. Baudrillard, *Die Agonie des Realen*, 6.

40. "Simulation," ed. Brockhaus and Wahrig, 772. Translated here.

41. Couchot, *La technologie dans l'art*, 146–47.

42. Engell, *Das Gespenst der Simulation*, 6–7. Engell makes reference to Georges, *Ausführliches Lateinisch-Deutsches Handwörterbuch*, among others.

43. Engell, *Das Gespenst der Simulation*, 8.

44. Ibid., 9. According to Engell, fiction never has reality as its object of comparison, just other fictions.

45. For example, the philosopher of science Mario Bunge characterizes both representation and simulation as nonsymmetrical, reflexive, and transitive. In doing so, he presents representation in the natural scientific sphere as a more specific subrelation of simulation. See Bunge, "Analogy, Simulation, Representation," 22.

46. On simulation, Couffignal writes, "One might fear that this approach only leads to ideal constructions too marked by flights of fantasy. And it is possible to cite more than one that wants to sail under the flag of cybernetics. But the firm restriction to efficacy reliably weeds out the useless analogies." Couffignal, "La Cybernétique: Essai méthodologique," 17. Translated here.

47. See Meiffert, "Implantation oder Konvenienz."

48. Mitchell, *Picture Theory*, 16.

49. The German "vor-, ab- oder nachbilden" most literally means to depict a system or process in advance of, concurrently with, or subsequent to its appearance in reality. Trans.

50. Hartmann, "Simulation," 807.

51. See Gordon, *System Simulation*, 1.

52. Händle and Jensen, Einleitung der Herausgeber to *Systemtheorie und Systemtechnik*, 17.

53. Shapiro, "Digitale Simulation," 158–59.

54. The fact that a digital computer is based on Newtonian causal logic does not mean that more complex sequences that no longer involve simple chains of causality cannot be simulated.

55. See Le Meur, "Création artistique en image de synthèse," 211–12.

56. Perrot, Foreword to *Multi-Agent Systems*, xiii.

57. See Lévy, *La machine univers*, 132–33.

58. System changes can be modeled according to the following fundamentally different approaches: deterministically as a differential or difference equation, stochastically, or as a cellular automaton.

59. Rasmussen and Barrett, "Elements of a Theory of Simulation," 515.

60. Dubey, "Simulation and Modeling," 338.

61. See Moles, "La cybernétique," 6. Translated here.

62. See Wiener, Rosenblueth, and Bigelow, "Behavior, Purpose and Teleology."

63. See Lévy, *La machine univers*, 117.

64. Breton, *Une histoire de l'informatique*, 142–43. Translated here.

65. Harbrodt, "Probleme der Computersimulation," 151. Translated here.

66. Hartl, "Die Verkörperung des Unsichtbaren," 69. Translated here.

67. The simulations discussed here allow real-time interaction on the part of the user. Strictly speaking, they would have to be specified as dynamic simulations.

68. von Randow, "Computer-Simulation: Bild statt Welt?" 126. Translated here.

69. See Quéau, *Éloge de la simulation,*161. Translated here.

70. Engell, *Das Gespenst der Simulation*, 7. Translated here.

71. See Warnke, "Computersimulation und Intervention," 192.

Chapter 2

1. Clausberg, "Auf dem Weg zur computergestützten Bilderforschung," 15. The art historian Karl Clausberg rightly implies through his emphasis tat in discussions surrounding recent developments, through their generally very brief references, it is often omitted from mention that there are many approaches to perspective construction in the early modern period.

2. The humanist Leon Battista Alberti describes the impression that can be achieved through a central-perspectively constructed image with the metaphor of a view through a window: "First I trace as large a quadrangle as I wish, with right angles, on the surface to be painted; in this place, it [the rectangular quadrangle] certainly functions for me as an open window through which the *historia* is to be observed ." Alberti, *On Painting*, 39 (book 1).

3. See Morse, "The Body, the Image, and the Space-in-Between," 159–60; Morse, "Virtualities: A Conceptual Framework," 21.

4. Weibel, "Vom Bild zur Konstruktion kontextgesteuerter Ereigniswelten," 39.

5. See Boissier, "La perspective interactive," 263.

6. Couchot and Hillaire, *L'art numérique*, 52.

7. Giesecke, "Der Verlust der zentralen Perspektive," 101. Translated here.

8. Auber's concept of temporal perspective draws from Virilio's identically worded expression and from his "perspective in real time" (*perspective en temps réel*), which Virilio uses to characterize image worlds in which the third spatial dimension, depth of space, is replaced by depth of time. In these cases, telematic information or televisionary instantaneity takes the place of the vanishing point. According to Weissberg, however, this does not apply to interactive simulations, because there, the image can be acted on. This intervention, in its own way, ensures the depth of space. It is uncertain, however, whether Weissberg's charge holds true if, with the concept of depth of time, Virilio is intending the horizon of the imaginary. According to Virilio, in this perspective, the old horizon line retreats to the frame of the screen, so that it is possible to speak of the "quadratic horizon" of the computer screen. Not without humor, Virilio observes, "The *vanishing point* of the original perspective (geometric optics) of real space of the Quattrocento is superseded by the *vanishing of all points* (pixels, data bits) in the second perspective (physical optics) of real time of the Novocento." Virilio, *Open Sky*, 94. See also Virilio, *Polar Inertia*; Virilio, *The Art of the Motor*, 151–52; Weissberg, "Le simulacre interactif," 220–22.

9. See Auber, "Esthétique de la perspective numérique"; Auber, "Esquisse d'une perspective temporelle"; Auber, "Du *Générateur poiétique* à la perspective numérique," 130.

10. See Auber, "Esthétique de la perspective numérique," 27–28.

11. Lavaud, "Les images / systèmes: des *alter ego* autonomes," 247. Translated here.

12. Ibid. Translated here. See also Lavaud, "L'implication du corps dans les scénographies interactives," 144.

13. See Boissier, "L'image n'est pas seule," 233.

14. See Boissier, "*Artifices*," 73.

15. See Boissier, "La Perspective Relationnelle," 197.

16. See Boissier, "Introduction: La relation comme forme," 10.

17. See Boissier, "La perspective interactive," 269. See also Boissier, "Éloge de la planéité," 88.

18. See Boissier, "La Perspective Relationnelle," especially 196–97; Boissier, "L'image n'est pas seule," especially 232.

19. Boissier, "Éloge de la planéité," 87.

20. da Vinci, *A Treatise on Painting*, 132.

21. See Alloway, "Introduction."

22. Panofsky, "Perspective as Symbolic Form," 40–41.

23. See Riegl, *Gesammelte Aufsätze*.

24. See Francastel, *Peinture et Société*, 39.

25. The neo-Kantian Cassirer himself designates the "symbolic forms" as "media":

If we can find a medium through which all the configurations effected in the separate branches of cultural life must pass, but which nevertheless retains its particular nature, its specific character—we shall have found the necessary intermediary link for an inquiry which will accomplish for the *totality* of cultural forms what the transcendental critique has done for pure *cognition*. Our next question must therefore be: do the diverse branches of cultural life actually present such an intermediate field and mediating function, and if so, does this function disclose typical traits, by means of which it can be recognized and described?

Cassirer, *The Philosophy of Symbolic Forms*, 84–85. See also Schmitz, "Bewegung als symbolische Form."

26. See Krämer, "Zentralperspektive, Kalkül, Virtuelle Realität," 27. See also the account presented by Gendolla, "Zur Interaktion von Raum und Zeit."

27. In the chapter "The Subject-Object Problem in the Philosophy of the Renaissance," Cassirer describes the transition from aggregate space to system space [*System-Raum* in Cassirer's rendition], which is characterized in its emancipation, as "space as function," from any type of designation. See Cassirer, *Individual and Cosmos*, especially 180–87. In this book, Cassirer performs a timely reception of Panofsky's lecture, "Perspective as Symbolic Form," which was first printed that same year.

28. See Andrews, *Story and Space in Renaissance Art*, especially chapter 2, "The Viewer and the Vanishing Point," 34–47.

29. See Belting, *Florence and Baghdad*, 16–17. See also the art historian Gottfried Boehm: "Constructing the eye's activity according to the template of optical reflection, depicting its examination of the world with the visual cone, meant both a gain and a loss." Boehm, "Sehen: Hermeneutische Reflexionen," 273–74.

30. Space understood this way, according to Francastel, is not a reality for itself, in view of which the representation changes across the epochs. See Francastel, *Peinture et Société*, 42.

31. Panofsky, *Perspective as Symbolic Form*, 43.

32. See Francastel, *Peinture et Société*, 25.

33. These studies are mainly conducted by the medievalist Graziella Federici Vescovini. Belting also draws from them in devoting himself extensively to Pelacani. See Belting, *Florence and Baghdad*, especially 146–59. See in addition Federici Vescovini, "Le questioni di 'Perspectiva' di Biagio Pelacani da Parma"; Federici Vescovini, "Biagio Pelacani a Firenze, Alhazen e la prospettiva del Brunelleschi."

34. Alberti is considered the one who systematized central perspective, in the tract *On Painting* (1435/36, dedicated to Brunelleschi).

35. Belting, *Florence and Baghdad*, 149.

36. Ibid., 146. Translated here. Our insertions in brackets provide a more literal rendering of Belting's original.

37. Ibid., 148.

38. Ibid., 157.

39. See Wittkower, "Brunelleschi and 'Proportion in Perspective,'" 276.

40. The form of objects moving in a four-dimensional, curved space would change and thus would oppose the concept of central perspective. See Henderson, *The Fourth Dimension,* 6.

41. Ivins, *On the Rationalization of Sight,* 9.

42. See Rapoport, *Allgemeine Systemtheorie,* 9.

43. Prehn, "Der vernetzte Blick," 179.

44. See Boehm, *Studien zur Perspektivität,* 35.

45. Boehm, *Bild und Zeit,* 13; see also 2–3.

46. See von Bertalanffy, "The History and Development of General System Theory," 1974. See also Rapoport, *Allgemeine Systemtheorie,* especially chapter 4, "Organisation," 120–71.

47. With respect to the mathematically formalizable level, "cybernetic" and "systemic" approaches are comparable. Since we are limiting ourselves to computer simulations, we can allow ourselves to use these terms as largely synonymous (while acknowledging each theoretical complex's distinct line of development and placement of focus).

48. Pörksen, "Die Umdeutung von Geschichte in Natur," 16. Translated here.

49. Lévy, *La machine univers,* 119. Translated here.

50. Krämer, "Über die Rationalisierung der Visualität," 57.

51. See Couffignal, *Les Notions de Base,* 28.

52. Büttner, "Rationalisierung der Mimesis," 74.

53. According to Büttner, there is no evidence for the paving tiles that frequently appear in reconstruction drawings. They should therefore be regarded as the suggestive addition of later interpreters.

54. Boehm, "Vom Medium zum Bild," 172. Translated here.

55. See Boehm, *Studien zur Perspektivität,* 33.

56. See Giesecke, "Der Verlust der zentralen Perspektive," 98.

57. The thesis that central perspective also clarifies internal relationships is advanced by the art historian Samuel Edgerton, who, from the standpoint of knowledge dissemination, links central perspective closely to technical drawings. According to him, "[T]he artisan-engineer would learn to explore not just the surface but the covert interior of things, the essential structure that caused nature's exterior appearance in the first place." Edgerton, *The Heritage of Giotto's Geometry,* 111.

58. Couchot, *La technologie dans l'art,* 136. Translated here.

59. Rieder, "Simulation and Modeling," 659.

60. Ibid., 660.

61. This interpretation is suggestive of the simulacrum approach of Nancy Cartwright. As the philosopher of science herself explains it in *How the Laws of Physics Lie*:

I propose instead a "simulacrum" account. That is not a word we use any more, but one of its dictionary definitions captures exactly what I mean. According to the second entry in the *Oxford English Dictionary*, a simulacrum is "something having merely the form or appearance of a certain thing, without possessing its substance or proper qualities." On the simulacrum account, to explain a phenomenon is to construct a model which fits the phenomenon into a theory. The fundamental laws of the theory are true of the objects in the model, and they are used to derive a specific account of how these objects behave. But the objects of the model have only "the form of appearance of things" and, in a very strong sense, not their "substance or proper qualities." The covering-law account supposes that there is, in principle, one "right" explanation for each phenomenon. The simulacrum account denies this. (502)

62. Arnheim, *Art and Visual Perception*, 294.

63. See Alliez, "Für eine Realphänomenologie der virtuellen Bilder," 17.

64. See Alberti, *On Painting*; della Francesca, *De prospectiva pingendi*.

65. Schmeiser, *Die Erfindung der Zentralperspektive*, 27. Translated here.

66. Ibid.

67. Iser, "Mimesis/Emergenz," 683. Translated here. The film and art scholar Mark J. P. Wolf calls computer-supported simulations "subjunctive" because they are concerned with what could be, what might come to be, and what could have been. Since, because of this, constructive steps are taken, the sensory presentations made by simulations under some circumstances require more accurate interpretations. See Wolf, "Subjunctive Documentary," 417.

68. Schmeiser, *Die Erfindung der Zentralperspektive*, 57. Translated here.

69. Panofsky, *Perspective as Symbolic Form*, 65.

70. Ibid., 66.

71. See Huber, *System und Wirkung*, 173.

72. See Janhsen, *Perspektivregeln und Bildgestaltung bei Piero della Francesca*, especially 58 and 98.

73. Boehm, "Vom Medium zum Bild," 173. Translated here.

74. Busch, *Belichtete Welt*, 79, translated here; see also 76.

75. Francastel, *Peinture et Société*, 59. Translated here.

76. See ibid., 61–62.

77. See Vasari, *Lives of the Most Eminent Painters, Sculptors and Architects*, 131.

78. Hertlein, *Masaccios Trinität*, 48. Translated here.

79. Fiala, "Symbolische Welten und Abstraktionen," 148. Translated here.

80. See Bredekamp, "die endlosen anfänge des museums," 43.

81. Lafon, *Esthétique de l'image de synthèse*, 72. Translated here.

82. Alberti, *On Painting*, 28 (book 1).

83. Belting, *Florence and Baghdad*, 172.

84. See Zimmer, *Abstraction for Programmers*, 7.

85. Couchot, "Zwischen Reellem und Virtuellem," 346. Translated here.

86. See Couchot, *Images: De l'optique au numérique*, 215.

87. Alberti, *On Painting*, 34 (book 1).

88. See Giannetti, *Ästhetik des Digitalen*.

89. Rotman, *Signifying Nothing*, 17.

90. See Moles, "La cybernétique," 6.

91. The expression *reverse engineering*, which is common in engineering science, denotes a reconstructive process in which, through the examination of structures, states, and modes of behavior, the construction elements are extracted from a preexisting system. Thus, a plan is made from the finished object. See "Reverse Engineering."

92. So that one can experience this dynamic, a compromise between the static and the dynamic is often made: as many results from the history are retained as are necessary to make the movement perceivable as a structure (trajectory).

93. On the distinction in image theory between the terms *figurative* and *figural*, Antonia Pocock states, "The adjectives 'figurative' and 'figural' derive from the above noun ['figure'], though the former often expresses the more tangible connotations of the word while the latter expresses the symbolic ones." See Pocock, "Figurative/Figural." Translated here. We are using *figurative* to indicate images of bodies.

94. Grodsky, "Man-Machine Simulation," 83.

95. Baudrillard, "Videowelt und fraktales Subjekt," 114.

96. Hagner, "Bilder der Kybernetik," 385. Translated here.

97. Ibid., 389.

98. Gramelsberger, "Das epistemische Gewebe simulierter Welten," 84.

99. See Thieme, "Leonardo da Vinci," 532–33.

100. Flusser, *Medienkultur*, 212.

101. Baudrillard, "Holograms," 107–8.

102. Those sections of reality for which this compositional principle cannot be applied (i.e., for which sequentialization even in an approximation is not permissible) consequently cannot be simulated at this time. Thus, for example, quantum mechanics requires an intrinsically parallel treatment of events, which cannot be represented serially. This requires (quantum) computers that can cope with the Heisenberg uncertainty principle.

103. Stoop, "Der zeitliche Ablauf der Simulation," 72–73.

104. See Rasmussen and Barrett, "Elements of a Theory of Simulation," 517–18.

105. Bergson had no way of knowing about computer-based simulations when he published his book *Creative Evolution* (1907). Without having to insist on a connection with the human intellect, Bergson's description of the latter can be transferred to event-based computer simulation. At least his characterization of the "tailoring" of processes that takes place in the intellect is fitting. However, his description is a far worse match for the operations of the cinematograph, which he uses as a metaphor for the description of the staccato-esque concentration economy of the intellect. In his conceit, the stringing together of still shots is the "mechanism" of the intellect: "the mechanism of our ordinary knowledge is of a cinematographical kind." Bergson, *Creative Evolution*, 195. But since the points of rest on which the intellect sets its sights are the intermediate ends of an undertaken action, they are not uniformly segmented, as is the showing of single film positives by the projection equipment of the cinematograph. Rather, these "stopping points" or "still states" determined by the mind are defined *in terms of content*. Thus, with his description, Bergson approximates the mechanism of event-based simulation more closely than that of the film projector.

Bergson is not the first or the only one to discuss the "theoretical cinematograph" in the sense of a relationship of transition from beginning- to end-states necessary for thought. Cassirer and Heinrich Hertz do so implicitly; Otto Wiener and Norbert Wiener do so explicitly. See Rieger, *Kybernetische Anthropologie*, 137–39.

106. Bergson, *Creative Evolution*, 191.

107. Ibid., 191–92.

108. For the iconic aspect, one could also think of key frame-based animation techniques, for example. Here, in accordance with changes in what is shown, one deliberately establishes "changeless views" at selected intervals as orienting markers. Between these iconic markers, morphing technologies, for example, can be used to create automated intermediate images.

109. The founder of cybernetics, Norbert Wiener, contradicts him when he asserts that the consecutive time of statistical dynamics is proper to automata; but they exist in Bergsonian duration just as living organisms do. See Wiener, *Cybernetics: or Control and Communication in the Animal and the Machine*, 43–44.

110. Baudrillard, "The Order of Simulacra," 70.

111. Ibid., 62.

112. Ibid., 64.

113. See Riegas and Vetter, "Gespräch mit Humberto R. Maturana," 16.

114. See von Bertalanffy, "Vorläufer und Begründer der Systemtheorie," 26.

115. Weber, *Umkämpfte Bedeutungen*, 238. Translated here.

116. Langton, "Artificial Life" (1993), 27.

117. Langton, "Artificial Life" (1996), 53.

118. Weber, *Umkämpfte Bedeutungen,* 138. Translated here.

119. Bec, "Vorläufiger Versuch über die Upokrinomenologie," 402–3.

120. Rodler, "Eyn schön nützlich büchlin," AII v. Translated here.

121. Boehm, "Vom Medium zum Bild," 171.

122. Boehm, "Ikonisches Wissen: Das Bild als Modell," 124–25. Translated here.

123. Plessner, "Zur Hermeneutik nichtsprachlichen Ausdrucks," 476.

124. Heidegger, *Kant und das Problem der Metaphysik,* 96. Translated here. See the translation by Richard Taft, *Kant and the Problem of Metaphysics,* 68. I am grateful to Richard Taft for the first half of the sentence, while the second half could not be used for our purposes.

125. Kant, *Critique of Pure Reason,* 274 (A 143 / B 182).

126. Bellour, "The Double Helix," 185.

127. Lafon, *Esthétique de l'image de synthèse,* 12–13. Translated here.

128. See Gere, "Jack Burnham and the Work of Art in the Age of Real Time Systems," 149; Burnham, "Real Time Systems."

129. Burnham's systems aesthetics is conceived as an alternative to the art historian Michael Fried's concept of theatricality. See Fried, *Art and Objecthood.*

130. See Hartl, "Die Verkörperung des Unsichtbaren," 74.

131. See Burnham, *Beyond Modern Sculpture,* 316.

132. Rather than closed works, interactive artists create networks of relationships, according to the artist David Rokeby. "The ability to represent relationships in a functional way adds significantly to the expressive palette available to artists." Rokeby, "Transforming Mirrors," 152–53.

133. See Gow, "Invisible Environment."

134. See Burnham, "The Aesthetics of Intelligent Systems," 100.

135. See Burnham, "Systems Esthetics," 32.

136. See Quéau, *Éloge de la simulation,* 238.

137. Breidbach, "Einleitung: Neuronale Ästhetik," 11.

Chapter 3

1. Wenzel, "Initialen," 639. Translated here.

2. See Grube, "Computerbilder," 47. Consequently, Grube speaks not of a "not perceivable" code but rather of an "unseen" code.

3. Nake and Grabowski, "Zwei Weisen, das Computerbild zu betrachten," 143. Translated here. However, when the art historian Victor Stoichita speaks of the "doubled image" (*das verdoppelte Bild*), he means the picture-in-a-picture with metapictorial reflection on the problem of representation as such. See Stoichita, *Das Selbstbewußte Bild*, especially chapter 1, section 1.1, "Das verdoppelte Bild: Text und Textzugabe" (available in English as *The Self-Aware Image*, chapter 1.1, "The Split Painting: Text and Outside-the-Text").

4. Nake, "The Display as a Looking-Glass," 346–47. Translated here. See also Nake, "Algorithmus, Bild und Pixel," 114.

5. Nake, "Das doppelte Bild," 45. Translated here. While most positions see the code as the descriptive entity, for Krämer, the executing instruments that can "interpret" the (image) files perform this function: the programs are "operative descriptions through which that which is described is simultaneously generated." Krämer, "Philosophie und Neue Medien," 189. Translated here.

6. Nake and Grabowski, "Zwei Weisen, das Computerbild zu betrachten," 137. Translated here.

7. Grube, "Digitale Abbildungen—ihr prekärer Zeichenstatus," 186–87. Translated here.

8. Frieder Nake contrasts the "*Oberfläche*" (which in German has the sense of "surface" as well as "user interface") with the "*Unterfläche*" (a rarely used German term for "underside," which Nake thinks of in English as the "subface").

9. Grube, "Digitale Abbildungen—ihr prekärer Zeichenstatus," 186.

10. See Nake and Grabowski, "Zwei Weisen, das Computerbild zu betrachten," 133.

11. Stefan Heidenreich laments the loss of means of access to what lies "below the surface" via the graphical user interface. See Heidenreich, "Icons."

12. A similar classification is made by Anne-Sarah Le Meur. The artist characterizes the approaches as ascribable to a visual, numerical, and evolutive regime. See Le Meur, "Création artistique en image de synthèse," 13–16.

13. Nake, "The Display as a Looking-Glass," 349. Translated here.

14. The philosopher Umberto Eco explicates what is intended here using an analogous example: "Now, a dictionary clearly presents us with thousands upon thousands of words which we could freely use to compose poetry, essays on physics, anonymous letters, or grocery lists. In this sense the dictionary is clearly open to the reconstitution of its raw material in any way that the manipulator wishes." Eco, *The Open Work*, 20.

15. See Sierra, Bajka, and Székely, "Evaluation of Different Pathology Generation Strategies."

16. See Sierra, Bajka, and Székely, "Pathology Design for Surgical Training Simulators."

17. See Sierra, Székely, and Bajka, "Generation of Pathologies for Surgical Training Simulators."

18. See Sierra, Bajka, and Székely, "Pathology Growth Model Based on Particles."

19. See Bailer-Jones, "Tracing the Development of Models."

20. See Morrison, "Models as Autonomous Agents," 43.

21. See Suárez, "Theories, Models, and Representations," 75.

22. See Morrison and Morgan, "Introduction," 3.

23. Cartwright, Shomar, and Suárez in "The Tool Box of Science" discuss "phenomenological models" as a paradigm. The philosopher of science Margaret Morrison is in principle sympathetic to the idea that some form of model building can be motivated by phenomena; however, she finds that Cartwright and colleagues' argument encounters difficulty in spelling out what exactly constitutes these models' independence from theory. In her view, neither are all so-called theoretical models models of theory in the sense that they can be derived from theory, nor is every phenomenological model free from theoretical postulates. See Morrison, "Models as Autonomous Agents," 44. Philosophers of science Steven French and James Ladyman cast their vote in a similar direction. They see a clear separability of models and theory as implausible and criticize Cartwright's approach as too dichotomy oriented. See French and Ladyman, "Superconductivity and Structures."

24. See Frigg and Hartmann, "Models in Science."

25. See Cartwright, *The Dappled World,* 36–37.

26. Cartwright, "Models and the Limits of Theory," 243.

27. Lessing, as cited in Cartwright, *The Dappled World,* 37.

28. Cartwright brings up the metaphor of the vending machine. See Cartwright, *The Dappled World,* 179–83.

29. For a heuristics of models, see Hesse, *Models and Analogies in Science*; Lakatos, *Science and Epistemology.*

30. See Black, *Models and Metaphors*; Apostel, "Towards the Formal Study of Models."

31. Suárez, "Theories, Models, and Representations," 79.

32. See ibid., 82.

33. Giere, "How Models Are Used to Represent Reality," 747. See also Suárez, "Scientific Representation"; Suárez, "The Role of Models in the Application of Scientific Theories."

34. See Morrison, "Modelling Nature," 70. See also Morrison, "Models as Autonomous Agents," 43.

35. See Morgan and Morrison, "Models as Mediating Instruments," 10. Recently, the mediating role of models between different planes, disciplines, discourses, and so forth has also become the subject of discussion; see the articles in Knuuttila, Merz, and Mattila (eds), *Computer Models and Simulations in Scientific Practice.*

36. See Morrison, "Modelling Nature," 83.

37. See Morrison and Morgan, "Models as Mediating Instruments," 32.

38. See Winsberg, "Simulated Experiments," 106.

39. See Cartwright, *The Dappled World*, 179–80.

40. See Winsberg, "Simulation and the Philosophy of Science," 47.

41. "Simulation," in *Brockhaus: Computer und Informationstechnologie*, 811. It is necessary to differentiate between model and simulation, as also occurs in this definition. For the observation of a new tendency to equate the two terms, see Keller, "Models, Simulation, and 'Computer Experiments,'" 199.

42. Küppers and Lenhard, "Computersimulationen: Modellierungen 2. Ordnung," 323. Translated here.

43. Winsberg, "Simulated Experiments," 108. See Winsberg, "The Hierarchy of Models in Simulation," 255. Winsberg locates model building where the philosopher of science Ian Hacking speaks of calculation (as an activity that accompanies speculation in the development of theory). In order to understand this, two short passages from Hacking's likely best-known book, *Representing and Intervening* (1983), are reproduced here, in which he presents his idea of speculating and calculating. First, "By speculation I shall mean the intellectual representation of something of interest, a playing with and restructuring of ideas to give at least a qualitative understanding of some general feature of the world." Hacking, *Representing and Intervening*, 212–13. Then he writes, "Thus Kuhn's articulation must denote two kinds of thing, the articulation of theory and the articulation of experiment. I shall arbitrarily call the more theoretical of these two activities 'calculation.' I do not mean mere computation, but the mathematical alteration of a given speculation, so that one brings it into closer resonance with the world." Ibid., 214. Winsberg selects other terminology, possibly because an abbreviating conception—such as is revealed in the reference to "alteration"—does not appeal to him. A critical examination of the word *alteration* is important here. Later we will encounter this term, as well as related conceptions, in reference to "visualization," and will subject it to a critique because too much is elided in its use. Winsberg also deliberately renames the activity of calculation in order to place a particular accent. With the expression "model building," he intends to emphasize that the model should be seen as fabricated; viewed correctly, it is not a component of theory itself. In this respect, from his point of view, Hacking's pair of terms *speculation* and *calculation* is likely to be misleading because in this pairing, it is suggested that under the direction of theory, there is nothing speculative in the process of model building, while in fact nothing is further from the truth. See Winsberg, "Simulated Experiments," 118. Granted, Winsberg does not acknowledge that Hacking himself speaks of model building in connection with calculation (in Thomas Kuhn's expression, as an "articulation of theory"): "Thus far I have written as if getting theory to mesh with possible determinations of nature is just a matter of articulation and calculation. We begin with speculations that we gradually cast into a form from whence experimental tests may be deduced. Not so. There is an enormously wide ranging intermediary activity best called model-building." Hacking, *Representing and Intervening*, 216.

44. The concept of a hierarchy of models is introduced by the philosopher of science Patrick Suppes. See Suppes, "Models of Data." For a general discussion of model hierarchies, see Harris, "A Hierarchy of Models and Electron Microscopy."

45. Winsberg, "The Hierarchy of Models in Simulation," 259; see Winsberg, *Science in the Age of Computer Simulation*, 17.

46. Other passages of text demonstrate better that not only at the end, but rather at every stage of modeling, all available sources are tapped into in order to make the model: "If we were to review each of the different mediating transformations in … [a] simulation, and ask about what sources of knowledge were required in order to justify them rationally, we would inevitably find that most of these sources lie outside of any of our general theories." And further, "The models that we need to construct in order to do our science need to be constructed delicately and from as many sources as are available." Winsberg, "Simulation and the Philosophy of Science," 50, 61.

47. See Boumans, "Built-In-Justification," 91–93.

48. See Winsberg, "Simulation and the Philosophy of Science," 58–61.

49. Kaufmann and Smarr, *Supercomputing and the Transformation of Science*, 2–3.

50. Küppers and Lenhard, "Computersimulationen: Modellierungen 2. Ordnung," 308. Translated here.

51. See Hartmann, "The World as a Process," 84.

52. Winsberg, "The Hierarchy of Models in Simulation," 264.

53. Humphreys, *Extending Ourselves*, 112–13.

54. For the insight that even the output of numbers should be treated as a specific presentation, see Pias, "Das digitale Bild gibt es nicht," sec. 50: "One should also not be deceived by the presentation of data sets as columns of numbers: alphanumeric signs are not one iota closer to a supposed 'truth' of data than are brightly-colored pixels." Translated here.

55. See Winsberg, "Sanctioning Models," 83–85.

56. See Winsberg, "Simulation and the Philosophy of Science," 70.

57. See Kaufmann and Smarr, *Supercomputing and the Transformation of Science*, 1–3.

58. *Verwandlung*. See Neunzert, "Mathematik und Computersimulation," 53.

59. *Rückübersetzung*. See ibid., 44–45.

60. See Humphreys, *Extending Ourselves*, 5.

61. See Wolf, "Subjunctive Documentary," 431.

62. See De Landa, *Philosophy and Simulation*, 15, 19.

63. Gramelsberger, "Theorie–Simulation–Experiment," 124. Translated here.

64. A tendency is this direction can already be felt in the critique of the syntactic approach. According to the philosopher of science Daniela Bailer-Jones, if one takes the position that images are not propositional, it can be deduced that models are very heavily based on images and image apparatuses and therefore only to an extent can they be analyzed in line with propositions. This in turn makes it impossible to concede to models a truth content. See Bailer-Jones, "When Scientific Models Represent," 73, note 3.

65. Gramelsberger, "Semiotik und Simulation," 93.

66. Rohrlich, "Computer Simulation in the Physical Sciences," 515. To an inquiry as to the term *picture-ableness*, Rohrlich amiably replied, "'Pictur[e]ableness' is a word that I made up: it does not exist in the English dictionary. I mean of course: expressible by pictures which can also be graphics, i.e. diagrams. 'Anschaulich' is more general; it can mean 'intuitively clear.' I did not mean to provide a philosophically clean distinction." Rohrlich, personal email correspondence, March 17, 2007.

67. "Simulation," in *Brockhaus: Naturwissenschaft und Technik*, 1799. Hartmann is also convinced that simulation is very closely connected with dynamics: "As far as I see, scientists reserve the term 'simulation' exclusively for the exploration of dynamic models." Hartmann, "The World as a Process," 84. On the other hand, the philosopher Richard I. G. Hughes is to be endorsed in his statement that the epistemic dynamic of the simulation model does not necessarily have to correspond to a temporal dynamic (in the sense of the prospective). See Hughes, "The Ising Model," 130.

68. Gramelsberger, "Semiotik und Simulation," 96, translated here; see also 87–88.

69. Goodman states pointedly, "Denotation is the core of representation and is independent of resemblance." Goodman, *Languages of Art*, 5.

70. Hughes, "The Ising Model," 125–26. See also Hughes, "Models and Representation."

71. Strothotte and Strothotte, *Seeing between the Pixels*, 128.

72. Ibid., 128–29.

73. It may also be symptomatic here that through their choice of focus, the authors explicitly exclude sensory applications, such as so-called "virtual realities," from their observations.

74. On this point, the computer scientist Michael Syrjakow writes:

Prerequisite for comfortable experimentation with an AL simulation is a suitable graphical interface that allows the user a clear, comprehensive observation of dynamic processes in the artificial world. Beyond this, there must be many different possibilities for interactive intervention in the simulated course of events. In order to meet these requirements, the Java Media Tool (JMT) developed at the Institute for Computer Design and Error Tolerance was used for the realization of the graphical user interface. The JMT provides a flexible operating environment for shared multimedia applications in Java and enables a nearly complete decoupling of the simulation from the model used to represent the simulated processes.

Syrjakow, "Web- und Komponenten-Technologien in der Modellierung und Simulation," 136. Translated here.

75. See Syrjakow et al., "Simulation and Visualization of Distributed Artificial Life Scenarios."

76. See Püttmann, "Künstliches Leben."

77. Couchot, *Images*, 145.

78. At the top of figure 3.14, to the right, the user can choose from different menu selections: "world" gives the intervention possibilities that were just described; "groups" lists the current average number of group members, the yield and the configuration of the most successful group, and the performance of the average; "internal" allows the user to vary the characteristics of the agents; "population" shows all

the agents' attributes and differentiates between the currently existing maximum and the mean; finally, "detailed" shows the statistics for the particular individual that the user has selected in the field.

79. The Knowledge Query and Manipulation Language (KQML) was developed for conveying information between agents.

80. Therefore, one rightly inquires as to the utility of the hills that are present in the world (also called "mountains" or simply "obstacles"), which on the one hand appear modest in size with respect to the population but on the other hand suggest enormity through their snowy peaks. Precisely because they serve the function of barriers that the agents have to go around, they cannot be crossed at will. The creatures cannot go over these hills centrally, but it is indeed quite possible for them to walk across the green lower slopes. Here, too, the "physical" boundary does not correspond to the optical boundary. The hills, along with the portals, are the only static objects. Through them, it is easy to recognize that at each new start of the simulation, a random generator varies the living conditions by distributing the hills arbitrarily across the surface of the field.

81. See Syrjakow, "Web- und Komponenten-Technologien in der Modellierung und Simulation," 138–39.

82. Of course, to the developers, this feature is associated with the investigation of to what extent enlargement of the terrain—while no world has information about the others—can yield a more stable population dynamic.

83. Sismondo, "Models, Simulations, and Their Objects," 250.

84. Humphreys, *Extending Ourselves*, 113.

85. "The image makes visible, perceptible, and hence to a certain extent comprehensible, that which is to be understood in the model. For the image is not a simple *mass* of forms or attributes. The image, by the simple act of gathering forms in one place, creates a (visible) tie between them. This connection is already a *com*-prehension. Every connection is a relation, and every relation is a placing in common. The intellect makes relationships in order to 'comprehend' [from Latin *com*-, 'together,' and *prehendere*, 'grasp']. The image, site of gathering and placing in relation, is an 'image' of the model, object of intellection." Quéau, *Le virtuel*, 170. Translated here.

86. Gramelsberger, "Semiotik und Simulation," 95.

87. See Suchman, *Plans and Situated Actions*, 16.

88. See Dowling, "Experimenting on Theories," especially 267.

89. See Turkle, "A Tale of Two Aesthetics."

90. Dowling, "Experimenting on Theories," 268–69. In order to avoid misunderstanding, it should be noted that Dowling's use of "theory" (at the beginning of the quotation) should be treated as an abbreviation. What is intended is the executable mathematical model.

91. See Lawo et al., "Über ein neuartiges System zur Veröffentlichung von Operationsverfahren."

92. Flusser, "Curies' Children," 15.

93. Ibid.

94. For further thoughts on this topic, see Hinterwaldner, "Zur Fabrikation operativer Bilder in der Chirurgie."

95. Matthias Harders and Markus Gross (ETH Zurich, Zentrum campus), Michael Bajka (University Hospital Zurich), Hannes Bleuler (École Polytechnique Fédérale de Lausanne), Walter Gantert (ETH Luzern, Zentrum campus), and Markus Thaler (Zurich University of Applied Sciences, Winterthur) led the research project supported by the Swiss National Science Foundation.

96. See Paget, Harders, and Székely, "A Framework for Coherent Texturing in Surgical Simulators," 112.

97. See Harders et al., "Highly-Realistic, Immersive Training Environment for Hysteroscopy."

98. *Segmentation* refers to the process in which a digital image is subdivided into multiple regions. Typically it is used in an attempt to isolate depicted objects, in other words, to determine objects' boundaries. In medical diagnostics, much activity is devoted to the development of segmentation algorithms for data from MRIs and CT scans.

99. See Zsemlye and Székely, "Model Building for Interactive Segmentation of the Femoral Head"; Sierra, et al., "Generation of Variable Anatomical Models."

100. In Michael Hampe's terms, it could be said that "metric images" are created. The philosopher defines a "metric image" as an entity that refers to numerical relationships and can be used as a *"manipulable model* of the measured object" (here, the "statistically average" organ) "by varying its metrical basis, in other words, the measurements that it refers to." Hampe, "Sichtbare Wesen, deutbare Zeichen," 1047.

101. See Müller and Teschner, "Volumetric Meshes for Real-Time Medical Simulations."

102. See Kauer et al., "Inverse Finite Element Characterization of Soft Tissues."

103. See, for two-dimensional nets, Bianchi, Harders, and Székely, "Mesh Topology Identification for Mass-Spring Models"; for three-dimensional nets, Bianchi et al., "Simultaneous Topology and Stiffness Identification."

104. See Harders et al., "Comparing a Simplified FEM Approach."

105. See Teschner, Heidelberger, Müller et al., "Optimized Spatial Hashing for Collision Detection."

106. See Heidelberger et al., "Collision Handling of Deformable Anatomical Models."

107. See Bielser et al., "A State Machine for Real-Time Cutting"; Bielser, Maiwald, and Gross, "Interactive Cuts through 3-Dimensional Soft Tissue"; Bielser, *A Framework for Open Surgery Simulation.*

108. See Szczerba and Székely, "Macroscopic Modeling of Vascular Systems."

109. See Szczerba and Székely, "Computational Model of Flow-Tissue Interactions."

110. See Müller, Schirm, and Teschner, "Interactive Blood Simulation for Virtual Surgery"; Müller et al., "Interaction of Fluids with Deformable Solids."

111. See Paget, "An Automatic 3D Texturing Framework."

112. See Bachofen et al., "Enhancing the Visual Realism of Hysteroscopy Simulation."

113. See Zátonyi et al., "Real-Time Synthesis of Bleeding for Virtual Hysteroscopy."

114. This irrigation, which can be regulated by the doctor, causes the hollow organ to stretch and induces a flow inside it. The distention of the organ is calculated in advance, taking into account the fluid pressure applied, for one hundred different values. These prepared deformation states are then imported into the simulator, and the individual states are interpolated linearly in real time according to the currently prevailing pressure. The movement of fluid is calculated with a nonlinear partial differential equation (simplified Navier-Stokes equation). Velocity, pressure, fluid density, and the type of inflow and outflow are accounted for. The temperature is assumed to be constant. The uterine mucosa, the pathologies, and the inserted instrument itself comprise the geometric boundary conditions for the circulation of fluid.

115. This is a simulator for training in endoscopic cystoscopy in the bladder.

116. The fact that in Storz's application, the tags attached to the dynamic obey another logic than the organ does can be seen when the bladder is not illuminated with the light source on the inserted endoscope, so that it appears very dark. Only the blood particles are not "in darkness," seeming to glow as bright red spots.

117. See Matthes et al., "Efficacy and Costs."

118. Hochberger, Maiß, and Hahn, "Aus- und Weiterbildung in der gastrointestinalen Endoskopie," 18.

119. The pump is model SP 04 GBR16 manufactured by Otto Huber GmbH, Böttingen. The artificial blood is made from one liter of water mixed with two packets of Cherry Red food coloring by Brauns-Heitmann GmbH & Co. KG, Warburg. See Maiß et al., "Hemodynamic Efficacy," 576.

120. First, several researchers' attempts at definition and differentiation are presented here in order to bring a couple of these models' characteristic properties into discussion. According to the computational biologist Andreas Wagner, so-called iconographic models, as opposed to mathematical models, are characterized through their advantage of particularly accentuating spatial relationships. See Wagner, "Models in the Biological Sciences," 47. The philosophers Steven French and James Ladyman do not use the term *iconographic models*, but they do refer to "iconic models" in the context of ascertaining a commonality with another type of model, "material models." As an example of the latter, the authors cite the billiard ball model for gas. The two model types correspond in that they represent structure. French and Ladyman then write, "The difference between iconic and material models, however, is that whereas the former are typically given a linguistic formulation, the latter are presented visually, and have all the advantages of the image over the written word (or formula). Even more so than two-dimensional images they allow for the immediate appreciation of the spatial relationships between the elements concerned (hence the interest in 'virtual' modelling on computers) and together with the former, are central to what Nersessian calls 'imagistic' reasoning." French and Ladyman, "Reinflating the Semantic Approach," 109. This distinction surely leaves questions open; it is not possible to pursue them further here. However, it becomes clear that computer-based, programmed "iconic" models share certain capacities with material models, but not all.

121. Hacking, *Representing and Intervening,* 216.

122. In this context, Peter Asaro and Roberto Cordeschi's concept of the "working model" is also of interest. See Asaro, "Working Models and the Synthetic Method"; Cordeschi, *The Discovery of the Artificial.*

123. de Chadarevian and Hopwood, "Dimensions of Modelling," 8.

124. See Pickering, *The Mangle of Practice.*

125. See Blightman, "Where Now with Simulation?" 769. For the medical field, the engineer Robert Mann was the pioneer who promoted the transference of computer-aided design (CAD) to the simulation of surgical procedures (called computer-aided surgery, short: CAS). See Mann, "Computer Aided Surgery."

126. Morgan, "Experiments without Material Intervention," 223.

127. Griesemer, "Three-Dimensional Models in Philosophical Perspective," 438–39.

128. On the aspect of materiality, the philosopher of science Peter Asaro writes, for example, "But the nature of computational simulations, which are really an outgrowth of pencil-and-paper mathematical models, is to realize a mathematical formalism as precisely as possible. ... As such, the materiality of these computational simulations is usually disparaged as the cause of errors, rather than as a source of any insights to the theory. Working models, by contrast, are more likely to embrace their materiality, rather than hide it. While they often start by realizing a mathematical theory, they further aim to demonstrate phenomena that may not be easily expressed by mathematical formalism." Asaro, "Working Models and the Synthetic Method," 16.

129. Griesemer, "Three-Dimensional Models in Philosophical Perspective," 439.

Chapter 4

1. Mayröcker, "30.9. ('über die Sturzengel')", 39. Translated here.

2. In the iconic presentation of simulation results, "mental functions" can be endowed with a corporeality. Processes expressed in functions are then designated as "external," for instance, when they involve the skeleton and thus are related to space. Or else they are understood as "internal," if that which is intended with them is not perceivable in the everyday world (such as cognitive performance). However, the boundary is given only through interpretation, and not through a formally different treatment. But then what does it mean when one differentiates between "internal" and "external" functions? Does this distinction lead to a categorical difference, or is it simply motivated by the experiential world?

While fewer iconic points of reference are available for internal functions, external functions lend themselves to a spatial presentation in the sensorialization. But nothing prevents parameters of any function from being presented visually. The iconization of real-time simulations entails a giving of form. The question of interest is to what extent this can be conceived as an attempt to link functional and morphological aspects.

3. See Komosiński and Kubiak, "Taxonomy in Alife."

4. For some examples of his approach, see Sims, "Evolving 3D Morphology and Behavior by Competition"; Sims, "Evolving Virtual Creatures."

5. See Komosiński, "The *Framsticks* System," 156.

6. Komosiński, "The World of *Framsticks*," 220–21.

7. See ibid., 215.

8. The works can thereby be classed with a strategy that boasts a long tradition in European art: one infers an internal situation from that which is shown externally on the body. "Expression" can be seen as the going-outside or externalization of an inner, otherwise invisible reality. See Boehm, "Ausdruck und Dekoration," 190.

9. Figure 4.6 shows at the top left an "average" body part without any special aptitudes. The stick to the right of it is specialized for adaptation, the one next to that is particularly good at taking in food. This is shown through tinyballs at the joints that mirror in miniature the spherical food sources. When there is a fight, a robust stick is of use. Stability is depicted through the size of the flanking rails. The surface texture of the round tip influences locomotion: a rough surface means a lot of friction and is useful for pushing off, while a smooth surface enables gliding. A particularly strong example can be seen in the bottom row, second from the left. Speed of movement depends on the musculature. A type of gyroscope ensures the sense of orientation and balance. This capacity is presented by a white band around the stick that is so equipped (in the middle of the bottom row). Feeler-like instruments can register touch. In order to locate sources of food and energy, smell is perceived through nondirectionally oriented sensors, which are presented as perforated bands.

10. "Anzeige (Technik)." Translated here.

11. See "Display"; Marshall, *Bower-Birds*.

12. See "Copy-Plattform," 555.

13. See Nake, "Künstliche Kunst," 86.

14. Jonas, "Die Freiheit des Bildens," 31. Translated here.

15. Ibid., 37. Translated here.

16. See Stansfield et al., "Design and Implementation of a Virtual Reality System," 527.

17. The project was led by the psychologists Dietrich Dörner and Jürgen Gerdes, as well as Viola Hämmer and Frank Detje.

18. "Nucleotides" have the appearance of lumps of gold; the only difference is in their having been renamed. The whole game is modeled after a treasure hunt. The coinage alludes to nuclear energy production. Hence, it does not refer to the term from biochemistry; rather, it is meant to designate an environmentally friendly energy source.

19. See Gerdes, "Face–Das Gesicht von Psi."

20. See Dörner, Hamm, and Hille, "EmoRegul."

21. These multiplications (or also divisions) with certain factors cause a redistribution of weighting, which in this model complex is necessary for a calibration to human experience: "we 'jiggled' these factors until the facial expression seemed reasonable to us and adequate to the particular situation." Gerdes and Dshemuchadse, "Gefühlsausdruck," 230. Translated here.

22. Ibid., 222.

23. For instance, the following can be read: "Dörner's agents indicate their reactions also by a number of graphical displays, including a face that is animated in accordance to the respective theory of emotion." Elkady, "The Simulation of Action Strategies of Different Personalities," 128.

24. Schaub, "Künstliche Seelen," 57. Translated here. By "computer model," Schaub means the simulation model.

25. See Schindler, *UNIQUE*. The application is programmed in C++ and Direct X.

26. We are borrowing the concept of trans-appearance from Virilio. "The passages and their 'trans-appearance' signal the innermost constituents of the form-image: *shape of that which has no shape, form of that which has no form*." By "trans-appearance," Virilio does not mean a simple transparency, but rather the mixing of different images: "the virtual images of consciousness, the ocular and optical image of the look, and the electro-optical or radio-electrical image of video computing." Virilio, *Polar Inertia*, 10, 58. See also Virilio, *Open Sky*, 28–36.

27. See Couchot and Hillaire, *L'art numerique*, 33.

28. Metzger, *Grundbegriffe der Gestaltpsychologie*, 130. Translated here.

29. See Diodato, *Aesthetics of the Virtual*, 11. Diodato approaches the concept of the display with his idea of the "virtual body" (*corpo virtuale*). Since he relates the "virtual body" very closely to interactivity (which is not necessarily the case for the display), we will address him in the last chapter.

30. See Virilio, *Polar Inertia*, 18–19.

31. The computer scientist Stewart Wilson introduced the term *animat* (for "artificial animal" or "animal automat") in 1985, in order to designate organisms that show characteristics of aliveness. They have manipulable genetic, behavioral, and robotic capacities and are "lifelike." Since 1990, the International Conference on the Simulation of Adaptive Behavior has been taking place every two years under the heading "From Animals to Animats." Also in circulation are *progranimal* (for "program animal") and *zooid*. See Wilson, "Knowledge Growth in an Artificial Animal"; Meyer and Wilson, *From Animals to Animats*; Ascott, "The Ars Electronica Center Datapool," 291; Quéau, *Metaxu*, 247–48.

32. The classical cellular automata, which were developed beginning in the 1940s by researchers such as John von Neumann, Stanislaw Ulam, and John Conway, are based on the premise that the individual cells have a fixed location and—often in discrete time steps—can change their status according to state transition rules that are valid for all. Complex patterns or structures can thereby be examined through the self-organization of small, subordinate component systems. The example considered here, however, interprets cells as locomoting entities. Therefore it counts as a so-called migration model and could be described as "based on cellular automata." This difference is not consequential in our context. See Hegselmann, "Cellular Automata in the Social Sciences," especially 213–14.

33. See Dewdney, "Computer Recreations."

34. In technical parlance, the term *cell space* may also be used.

35. This second published illustration of *Party Planner* should be understood metaphorically. Evidence for this includes, for example, that Wally here would like to have Penelope at a distance of zero steps, while three are given in the table. Therefore, there would actually have to be a hollow right in front of Penelope, or she would have to be surrounded by a circular ditch. However, there's no doubt that this type of illustration functions in a descriptive sense.

36. Goldstein, "The Plenitude," 94.

37. Since every cell is given a value, without smoothing functions there would be tiered gradations. The curvings through always differentiable transitions afford a sleeker impression, since smooth surfaces in this case facilitate rough orientation more directly than more precise but jagged, stepwise divisions would do. This type of approach is widely employed.

38. Dewdney, "Computer Recreations," 107.

39. The idea of analyzing the evolution of complex systems by depicting the distribution of fitness values as a kind of landscape goes back to the biologist Sewall Wright. His fitness or potential landscapes looked like a diagrammatic assemblage of contour lines similar to the ones in geographic maps. See Wright, "The Roles of Mutation." Hermann Haken, the father of synergetics, also used the depiction of hills (repulsors) and valleys (attractors) for mapping the stability of a system behavior. See, for instance, Haken, *Erfolgsgeheimnisse der Natur*.

40. Goldstein, "The Plenitude," 91.

41. See chapter 3, note 67.

42. As is the case for the development of most simulations, multiple people were also involved in *double helix swing:* Damm (conception); Christian Kessler (programming); Yunchul Kim (sound); Alexander Holtkamp, Gwendolin Taube, and Lars Vaupel (camera construction and programming); and Claus Orendt (scientific consulting). See Ars Electronica Online Archive, *double helix swing*. For further technical details, see Damm, *double helix swing*, 122–23.

43. See Quéau, *Metaxu*.

44. Damm, "*double helix swing*: Eine Installation für Mückenschwärme," n.p. Translated here.

45. Ibid.

46. Strictly speaking, to speak of "different species" is misleading. All entities that appear in the simulation have the same basic disposition. This means that the differences are only gradual. In the course of time, however, some genetic constellations have prevailed in the struggle for survival. These are named (Xaver, Centi, Per, Enzo, Wonder), entered in a "hit list" (see figure 4.21), and referred to as "species." Individuals from this evolutionary branch can be implanted in the current situation by the user. They then appear in the wall projection at the place where they were located when they were first entered into the list.

47. The "virtual" colony lives in a nonoriented topology, while the video recordings clearly have to be understood as spatiotemporal fragments of a larger continuum.

48. See Quinz, "Scènes virtuelles du corps," 188.

49. In order to complete the breadth of transformabilities that obviously comprise a central aspect of the work, we will briefly list all other movements that occur in addition to the movements of the calculated population sketched above. The structure of the projection image can be described in layers. The bottommost level is a recorded or live transmitted video. It shows an image of a landscape, ideally with swarms of insects. The space they fly through is converted to two dimensions through the recording. The second layer builds on the statics of the landscape, which thereby serves as a stabilizing backdrop against which changes can be emphasized. Since the objective if possible is to extract only the movement of insects, all other movements are to be inhibited. Thus, lines of sight are sought across which no great frequency of passersby is expected, for example, toward the sky or directly on the shore toward the water. For this reason, too, the pan and zoom functions are disabled as soon as the camera begins recording.

For the second layer, the recorded flight paths are used in two dimensions, in that the changes that transpire from video image to video image are registered and the remaining "landscape" is subtracted. The isolated traces of past frames are colored in and remain in place for a while. Thus put before the eyes, interesting patterns are formed, often with curved or looping, intricate convolutions. (Incidentally, one connotation of the work's title is revealed in the observation that the swarms of insects seem to fly in spirals around an axis, thus approximating the form of a double helix.) Sometimes the insects do not leave a continuous line, as would a bumblebee flying at a leisurely pace, but rather, individual spots (figure 4.22). Here, the recording frequency of the video technology reveals itself in the case of insects flying past the camera close up, and therefore relatively quickly. The ephemeral is thus extracted from the static and added temporally so that streaks are formed, which in turn gradually change color from dark green to white. They fade when they are not found and eaten quickly enough. The second level thus provides the food source, in the form of the traces, for the "virtual" microbes of the third level, and makes the incidence of food and its unforeseeable distribution plausible. From the manner of its creation it also results that the food, with its sharp horizontal lines, comes from another world than does the fine, thin-skinned "virtual" creatures that make use of these traces. The energy invested in flying seems to benefit them. A hinge of the entire constellation can be located between the extracted past flight paths and the artificial creatures. In this interface (in addition to the one that interacting person uses) completely different dynamics come into contact and effect a quantitative swelling and shrinking. According to laws that are unique and independent from each other, an accumulation is made through the recording and a reduction through the simulation calculations: that which the artificial creatures cause to decrease, increases through the processed video. The demarcation of a creature is shown in the form of a black outline around all its cells and is located at the same level as it. Because, in the case of many multilimbed creatures occurring simultaneously, the video background is no longer visible (figure 4.24), in a fourth layer, trimmed flight trails are again laid over this "virtual" colony. This is a swarming bundle of field lines that does not stay still as a trace, but rather only indicates the position of the insects currently being recorded (figure 4.25). This "truncated" flight trail serves to clarify where the insect is located that, concealed behind the "virtual" organisms, is tracing its circle and producing food with its "presence." Finally, in the topmost layer, the mouse pointer can be seen that registers the action of the interacting party.

50. With a population that in general moves less and hence stays closer together, there at first develops a rounded, lichenous formation with fringed edges formed by rays of vision. Where a view is enabled, there are many such rays; however, when cells are in the middle of a group, they are so small that the viewer hardly notices them. Those cells that keep watch on the edges are oriented outward. Their attention is drawn far away. Consequently, they move apart from the dense crowd of cells, making spaces appear between them.

51. Eco, untitled, in *Arte programmata*, n.p.

52. Damm, "*double helix swing:* Eine Installation für Mückenschwärme," n.p. Translated here.

53. Koebner, "Rhythmus," 599. Translated here.

54. Metzger, *Grundbegriffe der Gestaltpsychologie*, 130. Translated here.

55. See Bryden and Noble, "Computational Modelling," 520.

56. Nance and Sargent, "Perspectives on the Evolution of Simulation," 164.

57. This passage is remarkable because it grants motion a more autonomous status instead of simply identifying it with the essence of numerical simulation.

58. A statement with the expression "fidelity to data" should always be understood under the auspices of the conclusions explicated in chapter 3, according to which the iconization contributes its own qualities.

59. The simulation's graphical presentation is programmed in Open GL.

60. Since at this point, a detailed technical and conceptual description must be omitted, the following primary sources are cited: Sommerer and Mignonneau, "Interacting with Artificial Life"; Sommerer and Mignonneau, "A-Volve: A Real-Time Interactive Environment"; Sommerer and Mignonneau, "A-Volve: Designing Complex Systems for Interactive Art"; Mignonneau and Sommerer, "Designing Emotional, Metaphoric, Natural and Intuitive Interfaces"; Sommerer and Mignonneau, *Interactive Art Research*, 72–87. Among the secondary literature, the following detailed discussions are recommended: Felstau, "Christa Sommerer & Laurent Mignonneau"; Grau, *Virtual Art: From Illusion to Immersion*, 300–20; Witzgall, *Kunst nach der Wissenschaft*, 125–28; Reichle, *Kunst aus dem Labor*, 150–54; Whitelaw, *Metacreation*, 66–68.

61. The console and the water tank are turned away from each other and installed at such a distance that it is not possible to switch between the two stations before the creature one has just created is already swimming in the dark, gray-blue aquarium. The creature appears instantaneously at middle depth by one of the walls leading to the bottom. Since one just misses its birth, one often cannot determine for sure in a densely populated tank which one the newly created creature is. Over the course of time, this identification problem has worsened, in that with increasing computer performance, more and more creatures can be calculated simultaneously. At the beginning, it was only a few, which also were presented at a larger scale. Thus Sommerer recalls that the creatures were once so big that one could only capture them with two hands; today, one hand is sufficient.

So that one can recognize one's own creature at all and feel connected to it, one will design it to appear unusual and will test conspicuous forms or sizes or else call on the help of a second observer. The

ends of the creature's digestive tract can be seen, and thus its orientation is evident. In retrospect, one realizes that the creature's front side—at least, the side at which eating happens—is located to the left in the left-hand window of the drawing console (figure 4.35). Contrary to some statements in the literature, it is possible for a tiny animal to suck in a gigantic one with as little difficulty and at the same speed as the reverse. Eating can happen while swimming, while creatures are passing each other at high speed. All additional characteristics besides bodily form are acquired by the creatures from a gene pool, which, for example, assigns movement capacities in accordance with form. Every creature can turn in space, curve around, pause briefly, swim in a straight line, speed up, take a longer rest in one location, and so on. Synesthetic effects are also produced in that the organisms make a sound. The sound corresponds with their movement and is hence generally rhythmic. When standing on the two-level platform of the installation (figure 4.36), one experiences the tonal vibrations with one's whole body—all the more strongly when the tank is fuller. The panel on which the projection falls trembles with the collective gurgling, bubbling, and deep droning.

62. See Sommerer and Mignonneau, "*A-Volve:* An Evolutionary Artificial Life Environment," 168.

63. According to Michael Klein, director of the Institute for New Media in Frankfurt, where the installation was also developed, it was the first time reflection was possible with a standard solution: the 3D texture mapping function of the silicon graphics machine.

64. The term *interference phenomenon* refers to the complex warpings that become visible on the boundary to nonaffine distortions of the reflected image: it appears as if the reflected image were broken down into partial entities and thus there were no longer a continuous surface.

65. *LifeSigns* was also produced as a team project. Innocent came up with the concept. The following people also participated: Nicholas Sandow, Shee Zon Chen, and Leng Hou Tan (software development); Jeremy Yuille (interactive sound design); Steve Law (sound design); and Steve Taylor and Harry Lee (database design and database programming).

66. See Morse, "The Poetics of Interactivity," 21.

67. Innocent, "*lifeSigns:* Description," n.p.

68. The selected spatial configuration has many consequences. With respect to the simulation results, it is by no means neutral; rather, different configurations suggest different interpretations. Thus, from an intrinsic standpoint, one believes one is in an explorative situation; from the external view of the constellation, the sense of control and oversight predominates. One sees oneself in a different role depending on whether one believes oneself to be traveling in infinite, cosmic space or whether one is viewing events as if they were contained in a petri dish.

69. According to the communication theorist Lucia Santaella-Braga, it is specifically a dialogical structure that promotes the impression that one is acting with a living entity. See Santaella-Braga, "Penser l'interactivité à la lumière du dialogisme," 158.

70. This is also the terminology that Innocent uses: "Each living sign, or 'lifeSign,' may be played like an 'instrument,' enacting its internal process through synaesthetic performance of image and sound." Innocent, "*lifeSigns* 2003," 25.

71. See Weissberg, "Corps à corps à propos de *La Morsure*," 66.

72. See Leonard, *Bots*, 21. See Jones, "Sensing, Communication and Intentionality in Artificial Life."

73. The hyphen is favored among artificial life researchers because "logical" indicates the mathematical basis: "Von Neumann's equivocation leads Emmeche to reassert the interdependence of form and matter or the dual 'bio-logical' depiction of life processes." Kember, *Cyberfeminism and Artificial Life*, 71.

74. See Bec, "Life Art," 83.

75. See Sano and Sayama, "*Wriggraph*."

76. Boissier, "Die Präsenz, Paradoxon des Virtuellen?" 379. Translated here.

77. See Innocent, "*lifeSigns*: Eco-System of Signs and Symbols," n.p.

78. Engelbach, "Zwischen Body Art und Videokunst," 8. Translated here.

79. Weber, *Umkämpfte Bedeutungen*, 176, translated here. See also 173.

80. See Innocent, "*lifeSigns*: Statement," n.p.

81. See Innocent, "*lifeSigns* 2003," 24.

82. For every lifeSign, a set of geometric base forms is selected. This selection in turn defines a number of building blocks that can be used for its construction. The possible forms of the underlying database include spheres, ellipsoids, rectangles, cones, cubes, cylinders, elbows and corners, wedges, rings, four-sided forms, and several curving forms. These are classified as either "soft" or "hard." Different combinations of structural conditions allow either only one class or both within a sign. For Innocent, it is important to restrict the combinations to such that produce meaning within the work's intended aesthetic and statement. Therefore, the database of forms includes those that are "natural" to electronic space. They are typically used in 3D-modeling programs, specifically for the construction of computer icons. See Innocent, "*lifeSigns*: Eco-System of Signs and Symbols," n.p.

83. This has the effect that the selected term is arbitrarily set to the highest value. According to the compatibility of the attribute meanings of two different lifeSigns, a cooperative, neutral, or hostile approach is selected. Which one is the case is shown by a round symbol above the lifeSigns: red with an "×" means hostile, gray with a dot means neutral, and green with a "+" means friendly. If one gives credence to the biologist Donna Haraway, these two realms—meaning and material—are not so strictly separated: "The worlds that people fight over are formed from meanings. Meanings are extremely powerful material forces—much like food and sexuality." Haraway, "Primatologie ist Politik," 140. Translated here (the published English version of this essay does not contain the section from which this quote is taken).

84. See Funes and Pollack, "Evolutionary Body Building."

85. For example, these include *Iconworld* (1991), *Idea-ON>!* (1994), *Memetic Mutation* (1997), and *Iconica* (1998).

86. Schwarz, *Medien—Kunst—Geschichte*, 46. Translated here (the existing English translation could not be used for our purposes).

87. See Hoppe-Sailer, "Die neuen Medien–die letzten Biotope." A lifelike impression is purposely employed in certain simulations, for example, those that are used for phobia therapy. Here, a requirement for successful therapy is patients' acceptance of the computer-generated scenario as a relevant challenge such that they engage with it seriously. The dynamic is intended to make the so-called suspension of disbelief easier for patients. See Hinterwaldner, "Verortungen der Benutzer in medizinischen virtuellen Welten"; Hinterwaldner, "Präsenzproduktion." But the topos of aliveness can already be found in the visionary writings of computer pioneers such as J. C. R. Licklider: "And we believe that we are entering a technological age in which we will be able to interact with the richness of living information—not merely in the passive way that we have become accustomed to using books and libraries, but as active participants in an ongoing process, bringing something to it through our interaction with it, and not simply receiving something from it by our connection to it." Licklider and Taylor, "The Computer," 21.

88. Schwarz, *Medien—Kunst—Geschichte*, 45–46. Translated here (see n. 86).

89. In his now well-known article "Defining Virtual Reality," the media theorist Jonathan Steuer organizes media according to the criteria of interactivity and vividness. He thereby distances himself from hardware or technology-centered approaches and focuses more strongly on the user's experiences. However, Steuer's approach differs from that pursued here in that he sees the components interactivity and vividness, which for him are central with respect to virtual reality, as related to stimulus but solely dependent on a medium's technical characteristics. By contrast, we are not beginning on the level of a comparison of media but, rather, distinguish different modes of aliveness within the medium of computer simulation through the manner of design of an iconized simulation complex. See Steuer, "Defining Virtual Reality."

90. Davis, "Interacting with Pictures," 72.

91. Bec, "Monographie," 138–39.

92. Ibid., 143.

93. Ibid., 147.

94. Bec, "Über das Wiederflottgemachte," 359. Translated here. Bec defines *zoosystemics* as the development, modeling, and study of zoological systems, which obey entirely different parameters from those that condition the nature that is viewed as given. Drawing on the semiotician Thomas Albert Sebeok's concept of zoosemiotics (1963), Bec has used the term *technozoosemiotics* since 1975 to designate the study of the production of signs (colors, forms, sounds) by artificial organisms that are generated through a technological procedure. By "the living" (*vivant*) Bec means the real human beings, the recipients and producers. See Bec, "Les réseaux technozoosémiotiques."

95. See Bec, "Artificial Life under Tension," 93.

96. Bec, "Über das Wiederflottgemachte," 358. Translated here.

97. Bec, "Prolegomena," 178.

98. See Le Meur, "Création artistique en image de synthèse," 322.

99. Laurel, *Computers as Theater*, 145–46.

100. Krueger, "Response Is the Medium," 11.

101. Lasko-Harvill, "Identität und Maske," 311. Translated here.

102. See Burnham, *Beyond Modern Sculpture*, 334; Quéau, *Le virtuel*, 50.

103. See Boissier, "L'image-potentiel," 168.

104. See Morse, "Cyberscapes, Control, and Transcendence," 184.

105. See Boehm, "Ikonisches Wissen: Das Bild als Modell," especially 125–26.

106. "The term 'valence' (Lat. for *value*), following Norbert Elias, refers in sociology to the interwoven relationships of interdependent people who are oriented toward and reliant upon each other (also called 'figuration).' Therefore, 'valence' in sociology can only be conceived in the plural, as valences. A valence refers to affective connections of people to people, other living creatures, or symbols." "Valenz (Soziologie)," translated here.

107. The programming did not set a boundary for the depth of space, but the four walls of the aquarium do present insurmountable obstacles for the creatures.

108. See Keller, "Die Zeit des Bewusstseins," 64–65; Pochat, "Erlebniszeit und bildende Kunst."

109. This comparison assumes that the struggling creatures are located at approximately the same height as the dead creature when they begin their movement toward the bottom. A reference here is provided by the always identical birth location of man-made individuals. Even with a slightly different starting position, the difference in time it takes to cross the distance, in comparing the two types of movement, is considerable.

110. The following designers were involved in the project: Joachim Sauter, Dennis Paul, Patrick Kochlik, and Jussi Ängeslevä. The simulation is based on preliminary studies initiated by the television company Blue Wave Productions and conducted by a team of scientists commissioned by National Geographic. With their studies, they aimed to imagine the evolution of extraterrestrial life by combining approaches of accretion theory, climatology, and xenobiology. The resulting TV program, *Alien Worlds*, was aired by Channel 4 in the UK in 2005.

111. Two plantlike forms and four zoomorphic species are introduced: Along with the skywhale and the stalker, there is the helibug—another insect-like creature that moves like a helicopter using its three wings. It dives for food in the water-filled catch-basins of the high trees. The hovering kites with their spiral tentacles also fish here. The plants include, first, the pagoda tree, a gigantic tree that can grow over 1 kilometer tall, whose leaves collect water and channel it inside the trunk. At the same time, this species of tree, which forms extensive forests, serves as a habitat for many creatures. Second, there are balloon plants, plants with a bulbous, floating body that—anchored in the ground by means of vinelike ropes—is filled with hydrogen and rises as it gets warmer. Through the heat of the regularly occurring forest fires, these balloons, which are filled with fire-resistant seeds, explode and thus make use of the clearings that the fire makes in the pagoda forest. In the research that forms the basis for this simulation

scenario, a ghost trap is also introduced, which attempts to catch everything that flies past with its transparent, sticky tentacles. See *Alien Worlds* (DVD); Challoner, "Alien Imagination."

112. The phenomenon of figure/ground alternation was first described in gestalt psychology and later adopted in art theory. Static objects form the basis of these examinations. With *Blue Moon*, however, there is a transient figure/ground alternation in the sense that a manifest sequence comes into play. The artist and theorist Stephen Jones discusses a figure/ground relationship not on an optical level, interestingly, but in relation to the behavior of artificial organisms toward the environment: "The organism and its environment bear a relation of figure (the organism) to ground (the environment) in which it is the very behaviour and autonomy of the organism which serves to distinguish them." Jones, "Intelligent Environments: Organisms or Objects?" 29.

113. On account of the whale's large size—in comparison to the section of the world that is shown—the designers have elected to integrate the whale into the ground in order to be able to avoid the very high-contrast change that would be the result of an abrupt elimination.

114. In the context of simulations and central-perspectivally constructed images, Erwin Fiala speaks of the possibility of a rationalization of iconic representation as abstraction. See Fiala, "Symbolische Welten und Abstraktionen," 147.

115. Spies, *Die Trägheit des Bildes,* 23. Translated here.

Chapter 5

1. See Deleuze, *Cinema 1: The Movement-Image*; Deleuze, *Cinema 2: The Time-Image.*

2. See Boissier, "L'image-relation," 274.

3. Boissier, "L'image-potentiel," 153. Translated here.

4. Schmitt, "Manifesto of the Artwork on Computer," 212. (This passage has been slightly edited for comprehensibility.)

5. Quéau, *Le virtuel,* 198. Translated here.

6. As an objection to "uniformity" understood in this manner, one could point out that there are self-modifying (e. g., evolutive) models for which it cannot be asserted that the prescriptions remain the same. The discussion of to what extent these algorithms' capacity for modification is not itself already framed by a metamodel or to what extent anything really new can develop on a computer without human input very likely remains open. Also worthy of mention is the incipient practice of a fusion of composition and realization, called "live coding" (also "interactive programming," "on-the-fly programming," "just-in-time programming"), which like a DJ or VJ act integrates a presentation of programming as part of a performance. Programs are rewritten while they run. See "Live Coding"; de Campo and Rohrhuber, "Else If–Live Coding."

7. See Laurel, *Computers as Theater,* 144.

8. For example, in strategy games there are often simulated clandestine goings-on that are not always immediately revealed or made transparent to the recipient. But when he or she discovers the place where enemy machinations are calculated to be in progress, this is not withheld.

9. Laurel, *Computers as Theater*, 45.

10. See ibid., 68, 78, 95, 134.

11. See Massumi, *The Thinking-Feeling of What Happens*, 78–79.

12. See Diodato, *Aesthetics of the Virtual*, 5.

13. Laurel, *Computers as Theater*, 79.

14. Neunzert, "Mathematik und Computersimulation," 45.

15. See Quéau, *Metaxu*, 112.

16. See Eco, untitled, in *Arte programmata*, n.p. Translated here (the existing translation could not be used for our purposes).

17. Eco, *Das offene Kunstwerk*, 42. Translated here (the existing translation could not be used for our purposes).

18. Eco, untitled, in *Arte programmata*, n.p. Translated here (see note 16).

19. Moles, *Kunst und Computer*, 152. Translated here. See also 136.

20. Janecke, "Performance *und* Bild / Performance *als* Bild," 90. Translated here.

21. Without simplification there is also no explanation, in the summation of computer scientist Prze-myslaw Prusinkiewicz: "The moral is that simplifications, or abstractions, are a necessary part of the modeling of nature. Without them, the models would mimic reality instead of explaining it." Prusinkie-wicz, "In Search of the Right Abstraction," 62.

22. See Morrison, "Modelling Nature," 82.

23. Wiesing, "Widerstreit und Virtualität," 234.

24. See Le Meur, "Création artistique en image de synthèse," 390.

25. "The images have to shake hands with the model," writes Quéau. The ideal of as close as possible a linkage of iconic elements to the simulation dynamic nevertheless implies a difference that is produc-tive: "This plasticity is the cause and effect of the development of the modern simulation, whose possi-bility and efficacy are specifically connected to the accentuated decoupling between the simulated object and the figurative support of the simulation. Herein lies the power of the tool of informatics. ... The decoupling is the coding chain (binarity/calculation/analog recomposition). This chain is the basic structure that guarantees the plasticity, the formability of the essential support of the simulation's pre-sentation, which is the image." Weissberg, "Le simulacre interactif," 57–58. Translated here. See Quéau, *Le virtuel*, 183.

26. Gadamer, *Truth and Method*, 108.

27. Ibid., 122.

28. Gendolla, "Gefälschte Welt," 184.Translated here.

29. Stanislaw Lem, as quoted in Gendolla, "Gefälschte Welt," 184. Translated here.

30. Gendolla, "Gefälschte Welt," 180. Translated here.

31. Hasselblatt, "Die Wahrheit des Unmöglichen," 192. Translated here.

32. Thomsen, "Psivilisation und Chemokratie," 359. Translated here. See Hasselblatt, "Die Wahrheit des Unmöglichen," 196.

33. Satava, "Disruptive Visions" (2002), 1406. For a critique of this position, see Reiche, "'Dual Use'?"

34. Satava, "Disruptive Visions" (2004), 1298.

35. See Oppenheimer, "The Irony of Virtual Flesh," 49. The phenomenologist Maurice Merleau-Ponty could also be interpreted along these lines when he writes, "I guessed the possible fissures in the solid block of the thing given a simple fantasy of closing an eye or of thinking of perspective." Merleau-Ponty, *Phenomenology of Perception*, 340.

36. See the classic short film *Powers of 10* by the designers Charles and Ray Eames from 1977.

37. Dörner, *Die Logik des Mißlingens*, 116. Translated here.

38. Dörner, et al., "Die Mechanik des Seelenwagens," 14. Translated here.

39. Marshall McLuhan, as quoted in Youngblood, *Expanded Cinema*, 139.

40. Winsberg, *Science in the Age of Computer Simulation*, 27; see also ibid., chap. 5.

41. See Rheinberger, *Experimentalsysteme und epistemische Dinge*, 116.

42. See Hughes, "Models and Representation," especially S335.

43. "Third generation" simulators, which enact physiological functions, would operate in this way. At this time, most applications remain in the second generation, the content of which (e.g., in the case of the trainee's cauterization of tissue) is less appealing for scholarly examination.

44. Rilke, *The Notebooks of Malte Laurids Brigge*, 117.

45. See Nake, "Algorithmus, Bild und Pixel," 109.

46. Diefenbach, "Practical Considerations of VR," 87. For us, "interaction" includes pure navigation (change of angle from which the presented scene is viewed), whereas "intervention" always (also) means a change in the presented scene. On the idea that interactivity is often confused with navigability, see Sundar, "Theorizing Interactivity's Effects," 389.

47. See Delp et al., "Surgical Simulation: An Emerging Technology for Training in Emergency Medicine," 153.

48. Heidenreich, "Icons," 84.

49. See Delp et al., "Surgical Simulation: An Emerging Technology for Military Medical Training," 32.

50. Guala, "Models, Simulations, and Experiments," 67.

51. Johannes Lenhard also takes this position for simulations in general, in diagnosing a shift from artificiality-for-essence to artificiality-for-performance. See Lenhard, "Artificial, False, and Performing Well."

52. See Boissier, "L'image-relation," 279.

53. See Delp et al., "Surgical Simulation: An Emerging Technology for Training in Emergency Medicine," 152.

54. At least, interactivity on the whole will not be oriented to the subject matter of the simulation (e.g., physiological processes), but will be primarily menu based. For a discussion of additional approaches to solving the problem of the regulation of action in medical simulators, see Hinterwaldner, "Arbeit am Eindruck."

55. There are examples in which a main justification for the "switching" of models and scenarios is that within a single simulation application, the trainee is required to perform both large-scale/strategic as well as minute/fine motor actions. See Hinterwaldner, "Vom Sprung ins Detail."

56. Another interface device is also being tested with the sinus simulator, as described in Pößneck et al., "A Virtual Training System in Endoscopic Sinus Surgery."

57. Balázs, "Zur Kunstphilosophie des Films," 215. Translated here.

58. A similar experience with a "virtual" environment, in which the necessity for a symbiosis of movement and direction of sight becomes evident because different people are controlling each, can be found in Bricken, "Virtual Worlds: No Interface to Design," especially I-55–I-56.

59. Arnheim, *Film als Kunst*, 187–88. Translated here (the existing translation could not be used for our purposes).

60. Ibid., 200. Translated here (see note 59). It should be noted that a "virtual" camera should also not be equated with a real one. See Fisher, "Virtuelle Realität," 196.

61. Pößneck, personal e-mail correspondence, August 10, 2006. When the user is located outside the cylinder, a message communicates this, and the switch is not made to full-screen mode as planned. In this case, following the failed attempt, the button on the input device must be held down so that a navigation image remains visible. Conversely, the user must release the button upon having achieved what he or she believes to be an optimal position in order to switch from the navigation to the intervention mode.

62. But in this nose surgery, the quite effective force feedback and the manner in which the instrument comes back "into appearance" (that is, through the stretching of the resistant "virtual" tissue) indicates that the instrument produces effects even when outside the visible area.

63. In addition to the complete change of view such as occurs in *VR-FESS*, fractures within a view are also common. These boundaries are set with respect not only to locality but also to the action being

performed. Concretely, this is experienced as the user's not having the same intervention repertoire at his or her disposal at all times and locations within a single section of the screen. For a discussion of different "actions of interest" within a simulation scenario, see Hinterwaldner, "'Actions of Interest' in Surgical Simulators."

64. Amato uses the phrase *image interagie* to refer to the possibility of composing the field of view, which is produced through the movement of a "virtual" camera. See Amato, "Interactivité d'accomplissement."

65. Massumi, "The Thinking-Feeling of What Happens," S. 73.

66. See Bourriaud, *Relational Aesthetics*, 19–21.

67. See Lunenfeld, "Digital Photography," 65.

68. See Brown, "Virtual Unreality and Dynamic Form."

69. See Quinz, *Dell'invisibile*, 22, 26. In 1966, the artist and theorist Roy Ascott coined the term *behaviorist art*. See Ascott, *Telematic Embrace*. For a shift of attention from object to experience, see also Murray, *Hamlet on the Holodeck*; Murray, *Inventing the Medium*.

70. See De Barros, "Membranes et Tunnels," 127; Burnham, *Beyond Modern Sculpture*, 343.

71. See Quéau, *Le virtuel*, 190.

72. See Quéau, *Metaxu*, 298.

73. Eco, *Das Offene Kunstwerk*, 182. Translated here (see note 17).

74. Ibid., 55.

75. See Peacock, "Towards an Aesthetic of 'the Interactive,'" 238.

76. See Moles, *Kunst und Computer*, 129.

77. A divine perspective is suggested in a "landscape of events" in that here, there is no sequence in the sense of a course of events (history) because everything is present simultaneously. See Virilio, *A Landscape of Events*, x.

78. Sartre, *Being and Nothingness*, 484.

79. Quéau, *Le virtuel*, 150. Translated here. See also Quéau, *Metaxu*, 59–60.

80. Merleau-Ponty, *Phenomenology of Perception*, 347.

81. Deleuze, *Difference and Repetition*, 212.

82. Merleau-Ponty, *Phenomenology of Perception*, 344.

83. Deleuze, *Difference and Repetition*, 212.

Chapter 6

1. Quéau, *Éloge de la simulation*, 190.

2. See Buxton, "There's More to Interaction Than Meets the Eye."

3. "The Interaction of Man and Images," II-3.

4. The art theorist Söke Dinkla already recognized this and pointed it out. See Dinkla, "Das flottierende Werk," 68.

5. For example, the computer scientists Steven Feiner and Clifford Beshers argue that a graphical hand is not always the best solution for all applications; they advocate a "metamorphotic" employment of the user indicator. See Feiner and Beshers, "World within Worlds."

6. See Popper, "Les images artistiques de la technoscience," especially 148.

7. Hemken, "Die kategoriale Interaktion," 73. Translated here.

8. Heibach, *Literatur im elektronischen Raum*, 69. Translated here. The dispute between a recipient-centered and a media-bound understanding of interactivity is also being carried out in communication studies. As an example of the idea that interactivity should be seen as an attribute of technology, see Sundar, "Theorizing Interactivity's Effects." According to this perspective, evaluating interactivity through the user runs the risk of only reflecting the media savvy of the latter. For the idea that human perception is indispensable in evaluating interactivity, see Sohn and Lee, "Dimensions of Interactivity."

9. Heibach, *Literatur im elektronischen Raum*, 74. Translated here.

10. See Huber, "Internet," especially 187–188; Huber, "Digging the Net."

11. See Laurel, "Interface as Mimesis," 78.

12. See Laurel, *Computers as Theater*, 20–21.

13. See "Interaction," 162.

14. Huhtamo, "Seven Ways of Misunderstanding Interactive Art," section 5.

15. Jensen, "Interactivity: Tracking a New," 171; see also 169.

16. See also the position of Sénécal, "Interactivité et interaction," 145.

17. See Popper, *Art of the Electronic Age*, 21.

18. Manovich, *The Language of New Media*, 67.

19. Dinkla, *Pioniere interaktiver Kunst von 1970 bis heute*, 12. Translated here.

20. It could be supposed that with her consistent capitalization ("*Interaktive Kunst*"), Dinkla is demarcating a distinct type and defining it in such a way that the objection raised here does not hold. But this suspicion is weakened after reading her definition: "In 1990, when the competition for the *Ars Electronica* festival in Linz introduced the category 'Interactive Art,' this designation gained currency for inter-

active installations and environments, telematics works, robots, as well as works that develop an internal interactivity between effects such as sound and image. In contrast to this very broad term, I use 'Interactive Art' exclusively for works that use the computer to involve the recipient in a dialogic situation. Interaction in this context is the interplay between a person and a digital computer system in real time." Dinkla, "Vom Zuschauer zum Spieler," 10. Translated here.

21. See Youngblood, *Expanded Cinema*; Huhtamo, "Anything Interactive—But Not Just Any Thing!"

22. *Lorna* was produced in an edition of twenty at the University of Texas, Lubbock, by Carl Loeffler and Kim Smith. The production team included Ann Marie Garti (programming), Terry Allen (music), Joanna Mross (actress), and Starr Sutherland (production management). See Hershman, *Private I*, 77–79.

23. In this respect, Hershman explicitly confirms not having built any hierarchies into the work *Lorna*. See Hershman, "Touch-Sensitivity," 434.

24. See Couchot, "Des images en quête d'auteur," 184. In the context of hypermedia computer games, Rune Klevjer distinguishes modes of presentation that entail different agency on the part of players depending on whether they function as "(interactive) images" or "depictive models." See Klevjer, "Model and Image."

25. Polaine, "The Playfulness of Interactivity," quoted in Willis, "User Authorship and Creativity within Interactivity," 733.

26. Haraway, "A Manifesto for Cyborgs," 22. See Beaudouin-Lafon, "Designing Interaction, Not Interfaces."

27. For emphasis on the dimension of the player's experience, see Furtwängler, "Computerspiele am Rande des metakommunikativen Zusammenbruchs"; Furtwängler, "Menschliche Praxis," n.p.

28. Spies, *Die Trägheit des Bildes*, 156. Translated here.

29. Couchot, "L'image numérique au-delà des Paradoxes," 113.

30. Weibel, "Vom Bild zur Konstruktion kontextgesteuerter Ereigniswelten," 39. Translated here. See also Weibel, "Die Welt der virtuellen Bilder," especially 39–40.

31. For a differentiation between "movement as medium" and "movement as iconic form," see Paech, "Der Bewegung einer Linie folgen," 38.

32. The characterization of projects structured around databases is certainly too crude and generalizing here, in a deliberate exaggeration. For a long time now, not all transitions have been designed as "hard cuts." However, a marked distinction from simulations remains in these works' placing at the user's disposal prefabricated, unalterable segments that are perceived as units.

33. Here, it is worthwhile to emphasize once again what was addressed at the beginning of chapter 3: for a discussion of design, the level of the content-oriented model is far more interesting than the essentially more general basis of mathematical calculation that provides the foundation of the computer. However, it is important to consider the complex cascade of formations in light of the fact that models for their own part are created in software environments that in turn run on a particular operating system, among other considerations.

34. See Frasca, "Simulation versus Narrative," 232. Inspired by the pictorial or iconic turn, recently and above all in German-speaking countries, many researchers are engaging with the topic of iconicity in computer games from an art-historical or phenomenological perspective. See Schwingeler, *Die Raummaschine*; Hensel, *Nature Morte im Fadenkreuz*; Hensel, *Das Spielen des Bildes*; Günzel, "Simulation und Perspektive"; Günzel, "Die Geste des Manipulierens"; Günzel, *Egoshooter*; Beil, *Avatarbilder*.

35. Polaine, "The Flow Principle in Interactivity," 153.

36. See Aarseth, *Cybertext*, 94–95. For Aarseth, a "cybertextual process" is "ergodic" if, in a given situation, a chain of events comes to pass through nontrivial efforts on the part of mechanisms or individuals (through selection while reading). The particular chain can vary in each case. Aarseth rightly stresses that games, which are actualized in a sequence of events in reception, should not be treated like a sequence of events in film. If the production conditions under which these image worlds are generated are not taken into account, there is the risk of omitting an essential characteristic: that the game could also have played out differently. However, the term *ergodicity* is possibly an unfortunate word choice for this concept that would characterize a potentially always differently elapsing reading or playing experience. In the context of its origin, physics, what it designates is totally incompatible with a reception-aesthetic approach. For an extensive critique of Aarseth's use of this term, see Furtwängler, "Menschliche Praxis," n.p.

37. Aarseth, "Aporia and Epiphany in *Doom* and *The Speaking Clock*," 35.

38. Pias, "Bilder der Steuerung," 60. Translated here. On "teleactions" by means of "image-instruments," see also Manovich, *The Language of New Media*, 167–70.

39. See Wand, "Interactive Storytelling," 176.

40. In order to be able to attempt more refined definitions within the "digital image" (*image numérique*), terms are introduced such as the "digitalized image" (*image numérisée*) and the "computer-generated synthesis image" (*image de synthèse* or *image synthésique*—and not *synthétique*). See Le Meur, "De l'expérimentation en image de synthèse."

41. See Demiaux, "Digital Art—Paris Berkeley 2002–2004"; Couchot, Tramus, and Bret, "A Segunda interatividade"; Bret, Tramus, and Berthoz, "Interacting with an Intelligent Dancing Figure," especially 48.

42. See Couchot and Hillaire, *L'art numerique*, 99–100. The concept of "second cybernetics" alludes to cybernetics of the second order. According to Heinz von Foerster, in order to comply with the conception of second-order cybernetics, it is necessary to integrate a recursive principle of observation-of-observation.

43. Lavaud, "Les images/systèmes: des *alter ego* autonomes," 240. Translated here. See also Ghattas, "L'action sur l'image," 654.

44. The performance artist Stelarc places similarly high demands on the interactive image in the context of his posthuman vision of the future: "The nature of both bodies and images has been significantly altered. IMAGES ARE NO LONGER ILLUSORY WHEN THEY BECOME INTERACTIVE. In fact, interactive images become operational and effective agents sustained in software and transmission systems. The

body's representation becomes capable of response as images become imbued with intelligence." Stelarc, "From Psycho-Body to Cyber-Systems," 122.

45. See Nake, "Das doppelte Bild," 49.

46. This twofold attribution of the function of interactive images finds its counterpart in game studies in relation to the user. Thus, the computer game specialist Markku Eskelinen differentiates between interpretive and manipulative user function. Britta Neitzel writes of the two perspectives of the recipient: an internal action perspective and an external observer perspective. See Eskelinen, "The Gaming Situation"; Neitzel, "Videospiele—zwischen Fernsehen und Holodeck."

47. For additional descriptions, see Krueger, "Videoplace: Eine Künstliche Realität"; Krueger, Gionfriddo, and Hinrichsen, "Videoplace: An Artificial Reality"; (Krueger, "Artificial Reality") in Mountford et al., "Drama and Personality in User Interface Design," 106.

48. See Krueger, *Artificial Reality II*, 45.

49. Rokeby, "Transforming Mirrors," 146.

50. Morgan, "Interactivity: From Sound to Motion to Narrative," 9.

51. See Krueger, "In Richtung einer interaktiven Ästhetik," 361.

52. See Krueger, *Artificial Reality II*, 16.

53. Ibid., 17.

54. Krueger, "*Videoplace*: A Report from the Artificial Reality Laboratory," 149.

55. See Krueger, *Artificial Reality II*, 53–54. John Rinaldi, Bruce Shay, Thomas Gionfriddo, and Karin Hinrichsen devote their master's theses to an elaboration of Critter's behavior. Thanks to intricate software by Roger Schank from Yale University, Critter can also understand English.

56. For this description, see Dinkla, *Pioniere interaktiver Kunst von 1970 bis heute*, 85; Krueger, Gionfriddo, and Hinrichsen, "Videoplace: An Artificial Reality."

57. See (Krueger) Garvey, et al., "Interactive Art and Artificial Reality (Panel Session)," 7, 16.

58. Krueger, *Artificial Reality II*, 96.

59. Conversely, interactors prove to be less hesitant about killing Critter by capturing him and depriving him of his living space (the pictorial ground—see figure 6.10, bottom row). In these cases, Critter explodes and then is resurrected. Krueger can rely on the user's testing of this boundary situation so that he or she uses it in a next step: if the interactor makes Critter explode a second time, this initiates a round with new interaction patterns. Visitors are not put off by this, according to Krueger, because they accept this change as a consequence of the dramatic turn of events. Krueger rightly sees one of the greatest future challenges in these types of solutions: "The artful composition of such transitions will be an important aspect of the medium in the future." Krueger, *Artificial Reality II*, 95; see also 46.

60. This is another pioneering work in the view of its developers. As they explain it, it is one of the first attempts to create a "totally immersive virtual environment" that is inhabited by "virtual" characters

who in turn are specially designed to react to the visitor. *Ménagerie* was produced by Fisher (Telepresence Research) in collaboration with Magic Box Productions. The simulation software and the world design originated with Girard and Amkraut; the sound artist, Mark Trayle, was responsible for sound design and software development. Technical support was provided by Fakespace and Crystal River Engineering. For a more detailed description of *Ménagerie*, see Girard and Amkraut, "Menagerie"; "Menagerie (1993)," n. p.; Fisher, "Virtuelle Realität"; Fisher et al., "'MENAGERIE': Designing a Virtual Experience"; Boissier, *La relation comme forme*, 141, 166–67, 221–22.

61. Fisher, "Die Animation des Cyberspace," 64.

62. Krueger, *Artificial Reality II*, 86.

63. Ibid., 102.

64. As a result of further developments in computer technology, in the mid-1980s, Krueger considered adding a third spatial dimension in *Videoplace*.

65. This solution is in opposition to that in which the interactor is dismissed through the Critter character's making his or her silhouette disappear. In the latter case, there is precisely no more orientation.

66. Krueger, *Artificial Reality II*, 54.

67. See ibid., 54–55.

68. Manovich, *The Language of New Media*, 34.

69. Groys, discussion presented in the seminar "Genealogie des Begriffs Medium" at Karlsruhe University of Arts and Design, May 10, 2000.

70. The terms *proceduralism* and *procedural art* were introduced as early as the second half of the 1980s in an attempt to comprehend this shift in which creation happens indirectly. The image comes into being through the formulation of commands and procedures that describe the behavior of the model. See Bret, "Procedural Art with Computer Graphics Technology"; Rosebush, "The Proceduralist Manifesto"; Kerlow and Rosebush, *Computer Graphics for Designers and Artists*, 217.

71. Krueger, *Artificial Reality II*, 128.

72. Krueger, "Response Is the Medium," 11.

73. The following people were involved in this game modification using the Unreal Engine: Eckermann and Fuchs (concept, 3D modeling, animation, textures, sound, gameplay); Christopher Beckford, Mark Walsh (Unreal scripting); Matt Bell, Todd Gantzler, Matt Vitalone (additional modeling); Massimo Buffalardi (additional settings). The game's title is subsequently abbreviated as *fluID*. Also see Farshi, "Klangspiele"; Esmailzadeh, "Mathias Fuchs/Sylvia Eckermann"; Mundt, "Fuchs-Eckermann"; "fuchs/ eckermann electronic arts," 105.

74. In this work, whose title alludes to "fluent identity," the objective is to acquire as many identities as possible (in succession, though they cannot be accumulated) by visiting specific places, such as the river of constant change, which meanders through the valley basin and is studded with eyes, or the pupil as

the hoard of brand names. As another option, one can steal the identity of "virtual" players by shooting at them with the "fluID SkinGun."

75. Walking in this case is also distinctly emphasized through the striped ground: the stripes enable a good assessment of the distance traveled.

76. See Furtwängler, "Mensch-Maschine Computerspiel."

77. See Eskelinen, "The Gaming Situation," n.p.

78. Luhmann, *Social Systems*, 41.

79. Huizinga, *Homo Ludens*, 21.

80. Sartre, *Being and Nothingness*, 409.

81. See ibid., 480.

82. Ibid., 458.

83. Ibid., 464.

84. This convention is employed at one point in *fluID* itself: specifically, in the place where the weapon can be acquired by running over a constantly twisting snake.

85. Bopp, "Immersive Didaktik und Framingprozesse in Computerspielen," 184. Translated here. The phrase "invitational character" (*Aufforderungscharakter*) refers to the psychologist Kurt Lewin. See Lewin, "Psychologie der Entwicklung und Erziehung."

86. See Sundar, "Theorizing Interactivity's Effects," 389.

87. In this game, players can drown in the river or initiate a new life cycle by pressing a button on the mouse.

88. The fact that in some circumstances players do not start the game from the beginning can be attributed to the unique way the installation is constructed. Three semitransparent partition walls positioned at 120 degree angles receive three projections (figure 6.21). Each projection shows the world from the perspective of a player. Each player sits between two of the partition walls and thus has two views of the same world simultaneously but controls only one of them. When a player leaves the installation, his or her avatar remains in the world and can still be navigated. Only when an avatar dies (e.g., by suicide through clicking the mouse button) does a player then experience the birth scenario.

89. Neitzel, "Videospiele—zwischen Fernsehen und Holodeck," 109–10, translated here. See Luhmann, "Temporalstrukturen des Handlungssystems," 133.

90. See Holländer, "Augenblicksbilder," 178. Translated here.

91. See Wiemer, "Körpergrenzen," 251.

92. The following members of the Sociable Media Group at MIT Media Lab were involved in the creation of *Stiff People's League*: Drew Harry, Dietmar Offenhuber, Orkan Telhan, and Judith Donath.

93. The three-dimensionally presented computer-based world *Second Life*, developed by Linden Lab, has been online since 2003.

94. This control involves few degrees of freedom, not least as determined by the home of the Linden Dollar. Avatars are guided with the four arrow keys, with the up and down arrows effecting a movement forward or backward. The right and left arrows indicate direction of rotation (and not movement to the side!).

95. This is a game modification of the released *Quake III Arena*, in which two players play against each other. Traces of the original include rudiments of the menu presentation on the right side of the screen, which here have been divested of their functionality. The architecture, which overall is kept an austere, unadorned gray-green with the inscription "Second Person Arena: Looklab 2," was redesigned by the artist. The dodecagonal space has, on every fourth outer wall, an inward-facing trapezoidal enclosure that is reflected. While apart from the shadows, clouds, and lamps, there are no curves and everything is strictly rectilinear—as in a construction drawing—and clearly outlined, the appearance of the two avatars deviates from this substantially. In contrast to all other elements in the space, they have no solidly delineated form. One could concede that their form is anthropomorphic; however, in contrast to the clearly contoured architecture, with its strict perspectival alignment and readily perceivable dimensions, they do not consist of a compact mass but rather are composed from many different-sized semi-transparent red areas whose black framings stand apart from the areas of color and thus cannot be clearly matched with them. The volume of the avatar is broken apart—a structure of areas and lines. To be seen are only individual parts that are constantly parallel to viewpoint, which shift slightly with respect to each other during movements and vaguely resemble something anthropomorphic because of their angular overlappings.

96. Thus, the plasma gun's shot, a yellow, slightly bent quadratic frame, causes a green, shock-wave-esque dent in the target object and is accompanied by a bright, metallic sound. What remains is something rounded with many edges and a light green/yellow/white circle, which gradually fades again. With the rocket launcher, it seems as if a vortex of nested squares with black outlines is emitted. Within the shaft of lines, two yellow rectangles appear whose orientation recalls an exclamation point. As the result, a black spot remains at the place that has been struck. Finally, the rail gun sends out a red beam that makes what it hits and the surrounding area briefly appear more detailed and pink in color.

97. Paradoxically, the game's announcement reads, "Two Player Second Person Arena [–] Objective establish the second person format as the dominant shooter paradigm [–] You are looking through the eyes of your opponent [–] Use the radar and cursor keys to locate and fight your opponent." But if the "you" in the radar field is addressed to the player, this description is incorrect in that you are *not* looking through your opponent's eyes. In fact, you identify at once with the figure that is always in front of you from the third-person perspective, the figure with which you control the view and shoot. It does not cross your mind that "you" might be the avatar that you yourself are eliminating. But this is possibly what the artist in fact intends, and it is suggested in the precursor variant (2005) of *2ndPS*. Here, in accordance with the first-person perspective, you see a weapon at the lower left protruding into the scene toward the right. This implies a left-hander. Normally the weapon can be seen reflected on the right side of the image. It is not you, but rather the program, operating the weapon. The view is also not controlled by you, even if the word *you* is inscribed above the weapon. Are you meant to identify with

this weapon, which protrudes into the visual field but over which you have not the slightest influence? Probably not, since there is another inscription that addresses the user even more strongly. The avatar that you can see in this geometric, minimally structured arena has a head formed from the word *ME* (figure 6.35). And in fact, you can turn this figure with the mouse and move him with the keyboard. The space bar is used to shoot. Thus, here, you have to identify with the figure that you can control completely, except that you do not share his view. In this precursor variant, the idea that you are looking through your opponent's eyes succeeds because none of your own possibilities for control are associated with this viewpoint. Since there is no other target, you shoot with "me" in the direction of this opponent viewpoint, which is your own.

With *2ndPS*, however, the situation is fundamentally different because the control functions are more distributed. But it would be possible that by "you" in the radar field Oliver does not mean the player, but rather the opponent (figure 6.30b). However, in this case, on successful liquidation of the avatar whose view the player shares, the "you" in the announcement "you fragged player" that then fades in would also be ambiguous (see figure 6.30a). In the original game *Quake III Arena*, as the player, you felt that "you" was addressing you.

98. Diodato, *Aesthetics of the Virtual*, 106.

99. The up arrow means go forward, and the down arrow means go backward. The space bar makes the avatar jump; *c* puts him into a crouch.

100. Oliver, "Ideas," n.p.

101. The avatar's diffuse form causes further confusion. When you hit your opponent, you then immediately see many red pieces on the screen—not because the slain avatar is in front of you but because the view instantly changes to your own red avatar. In being seen from a worm's-eye view, his triumph is further emphasized. (For the version that was presented in the exhibition *Gameworld,* your own avatar was always red, while the opponent's was red on one screen and light green on the other.) For a moment you are drawn to the wrong interpretation: you associate being dead because the avatar's body in any case appears essentially "disintegrated." The avatar is given this figuration so that players will not identify with him through his form, but rather only through his constantly central position in their own field of view. Through the placement of a cut at the moment of death, the confusion of the two avatars is deliberately intended. In some hectic fighting scenes, this causes a moment of uncertainty as to whether you have been successful or are now dead.

102. See Eskelinen, "The Gaming Situation."

103. See, for example, Neitzel's study on the relationship between the game protagonist James Sunderland in *Silent Hill 2* and the player: Neitzel, "Wer bin ich?" especially 206. For analyses of interactivity, Neitzel proposes differentiating the manipulative position ("point of action") and the observing position ("point of view") as two fundamentally influential functions or aspects of player involvement. See Neitzel, "Point of View und Point of Action."

104. One could also say with Massumi—who invokes a long chain of discussion with respect to ball games (Michel Serres, Bruno Latour, Pierre Lévy)—that the (presented) ball as thing is an "object marker" of the actual "subject" of play, which consists in moving the ball forward. See Massumi, "The Political Economy of Belonging and the Logic of Relation," 73.

105. Phenomena such as trajectories that remain for a brief time can also be analyzed under temporal aspects, as well as with respect to the concept of "enhancement," which implies the orientation to the world-as-lived.

106. See Eskelinen, "Towards Computer Game Studies."

107. At that time, in the absence of a game engine, a software (*Emergence*) was specifically developed in advance that allowed individual creatures to be equipped with an artificial intelligence. The labor-intensive installation is the product of a whole team: Loren McQuade, Eitan Mendelowitz, John Ying (programming); Daniel Shiplacoff, Jino Ok, Peter Conolly, Damon Seeley, Karen Yoo, Vanessa Zuloaga, Josh Nimoy (design of the "virtual" world); Mark Mothersbaugh-Devo / Mutato Muzika (sound design); Franz Keller, Jay Flood (additional sound); Maroun Harb (technical support).

108. See Allen, "The Bush Soul" [*LifeScience*], 357.

109. Ibid. Translated here.

110. See Allen, "The Bush Soul," *Emergence* website, n.p.

111. Allen, "The Bush Soul," in *Media Time*, 48. Translated here.

112. See (Allen, "Emergence and The Bush Soul") Fraser and Fisher, "Real-Time Interactive Graphics," 18.

113. See Huhtamo, "The Art of Rebecca Allen."

114. Allen, "The Bush Soul," in *LifeScience*, 357. Translated here.

115. Early attempts do already exist that involve the interactor as a component of research. See Diebner, *Performative Science and Beyond*.

116. See Weissberg, "Introduction générale," 18.

117. Boissier, "La Perspective Relationnelle," 197.

118. See, for example, Jean-Louis Boissier, in Bour, "Towards an Interactive Cinema," 236.

119. Boissier, "La Perspective Relationnelle," 196.

120. See Furtwängler, "A Crossword at War with a Narrative," 393–94.

121. Here, a discussion about the topological "catchment area" of functionality could certainly be appended. Often it is simply a case of an approximation between iconic presentation and action-based functionality. Apart from the developers' conscious decisions, the reasons for this are not infrequently technical complications of different modeling techniques.

122. Klevjer, "What Is the Avatar?" 208.

123. *Spectacteur* is a neologism composited from observer (*spectateur*) and actor (*acteur*). According to Weissberg, who used the term in his dissertation (1985), not all forms of interaction are to be subsumed in it. See Amato and Weissberg, "Body Meets Interactivity." Other theoreticians besides Weissberg also fuse the two terms, such as Quéau with *spectateuracteur*, as well as both François Soulages and Laurence

Allard-Chanial with *spect-acteur*. See Allard-Chanial, "Le spectateur de la fiction interactive"; Soulages, "Le travail de l'inconscient & l'art de l'ordinateur," 234; Quéau, *Le virtuel*, 16.

124. See Weissberg, "Corps à corps à propos de *La Morsure*," 52, 66–67; Weissberg, *Présences à distance*, 65.

125. A clearer indication of the "image's attitude of expectation" is given in the expression *image act-able*. Amato differentiates this from the *image actée* in that it does not already encompass the consequences of the intervention after it has been performed but rather exhibits its "readiness to be deployed" or its potentiality. The terms are not by any means mutually exclusive; rather, they illuminate two facets of the same phenomenon: while *image actée* foregrounds the temporal component that accompanies interaction, *image actable* emphasizes a structural aspect of the work. See Amato, "Interactivité d'accomplissement," 139–40.

126. Wiemer, "Horror, Ekel und Affekt," 179. Translated here.

127. See Goodman, *Languages of Art*.

128. Diodato, *Aesthetics of the Virtual*, 45. By "prostheses" Diodato means the interactor together with hardware components.

129. See Couchot, *Images: De l'optique au numérique*, 201.

130. Indirectly, because the model itself as a rule does need sensoriality, except in the case of approaches in digital image recognition.

131. Quinz, "Dell'invisibile," 27; see also 20.

132. See Lafon, *Esthétique de l'image de synthèse*, 15–16.

133. See Diodato, *Aesthetics of the Virtual*, 58.

134. This aligns with the assessment made by the art historian Annette Hünnekens: "It is striking that the artists mentioned—Ascott, Boissier, Couchot, Forest, Krueger, Shaw, and Weibel—indeed use the methods of computer science, but frequently continue to understand the 'image' in terms of the idea of the work according to traditional aesthetics, while it is these artists' different conceptions of an 'interaction with the synthesis image' that constitute the diverse nuances of the term 'interactive art.' ... In fact, only from this standpoint is it possible for them to gain ... better insight into the different nature of an interaction with the new media and the processes that are possible through them." Hünnekens, *Der bewegte Betrachter*, 17. Translated here.

135. See Diodato, *Aesthetics of the Virtual*, 9.

Conclusion

1. Krueger, "Foreword: The Interface Will Not Disappear," 3.

Interviews

Allen, Rebecca: Linz, September 4, 2004.

Damm, Ursula: Düsseldorf, March 1, 2007.

Dörner, Dietrich: January 12, 2007 (telephone).

Fuchs, Mathias: Manchester, June 20, 2007.

Gerdes, Jürgen: Bamberg, June 19, 2006.

Groys, Boris: Karlsruhe, May 10, 2000 (contribution in the seminar *Genealogie des Begriffs Medium*, University of Art and Design).

Hampe, Michael: Zurich, October 17, 2006.

Harders, Matthias: Zurich, March 28, 2006, and June 13, 2008.

Hartmann, Stephan: April 12, 2007 (e-mail).

Kühnapfel, Uwe / Heiko Maaß / Hüseyin Çakmak: Karlsruhe, September 21, 2004.

Lehmann, Kai: Berlin, June 25, 2006.

Paul, Dennis / Patrick Kochlik / Jussi Ängeslevä: Berlin, June 26, 2006.

Pößneck, Antje: Leipzig, June 23, 2006, and August 10, 2006 (e-mail).

Rohrlich, Fritz: March 17, 2007 (e-mail).

Schindler, Irene: Ottobrunn, February 21, 2008.

Sommerer, Christa: Linz, September 2, 2004.

Sommerer, Christa / Laurent Mignonneau: Linz, August 10, 2006.

Syrjakow, Michael: Karlsruhe, May 17, 2004.

Bibliography

Aarseth, Espen. "Aporia and Epiphany in *Doom* and *The Speaking Clock*: The Temporality of Ergodic Art." In *Cyberspace Textuality*, edited by Marie-Laure Ryan, 3–41. Bloomington: University of Indiana Press, 1998.

Aarseth, Espen. *Cybertext: Perspectives on Ergodic Literature*. London: Johns Hopkins University Press, 1997.

Alberti, Leon Battista. *On Painting: A New Translation and Critical Edition*. Edited and translated by R. Sinisgalli. Cambridge: Cambridge University Press, 2011.

Alien Worlds: A Spectacular CGI Documentary. Big Wave Productions MMV for Channel 4, 2005, DVD.

Allard-Chanial, Laurence. "Le spectateur de la fiction interactive. Vers un modèle culturel solipsiste?" In *Cinéma et dernières technologies*, edited by Frank Beau, Gérard Leblanc, and Philippe Dubois, 251–62. Brussels: De Boeck et Larcier and INA, 1998.

Allen, Rebecca. "Emergence and the Bush Soul (in Real-Time Interactive Graphics: Intelligent Virtual Worlds Continue to Develop, edited by Glen Fraser and Scott S. Fisher)." *ACM SIGGRAPH Computer Graphics Newsletter* 32, no. 3 (1998): 15–19.

Allen, Rebecca. "The Bush Soul." In *LifeScience: Ars Electronica 1999*, edited by Gerfried Stocker and Christine Schöpf, 356. Vienna: Springer, 1999.

Allen, Rebecca. "The Bush Soul." In *Media Time: Wood and Byte. Festival der neuen multimedialen Technologien*, 48–51. Exhibition catalog. Centro Trevi Bozen September 1–30, 1999. Bolzano: Autonome Provinz Bozen-Südtirol, 1999.

Allen, Rebecca. *The Bush Soul*. Accessed April 10, 2008, http://emergence.design.ucla.edu/papers/bushabstract.htm.

Alliez, Éric. "Für eine Realphänomenologie der virtuellen Bilder." In *Telenoia: Kritik der virtuellen Bilder*, edited by Elisabeth von Samsonow and Éric Alliez, 13–27. Vienna: Turia + Kant, 1999. First published in 1996.

Alloway, Lawrence. "Introduction." In *Systemic Painting*, 11–21. Exhibition catalogue, Solomon R. Guggenheim Foundation September 21–November 21, 1966. New York: Solomon R. Guggenheim Foundation, 1966.

Amato, Etienne Armand. "Interactivité d'accomplissement et de réception dans un jeu tridimensionnel: de l'image actée à l'image interagie." In *L'image actée: Scénarisations numériques, parcours du séminaire L'action sur l'image*, edited by Pierre Barboza and Jean-Louis Weissberg, 123–60. Paris: Editions L'Harmattan, 2006.

Amato, Etienne Armand, and Jean-Louis Weissberg. "Body Meets Interactivity: Interface, Narrativity, Gesture." In *Anomalie digital_arts 3: Interfaces*, edited by Madeleine Aktypi, Susanna Lotz, and Emanuele Quinz, 240–45. N.p., 2003.

Andrews, Lew. *Story and Space in Renaissance Art: The Rebirth of Continuous Narrative*. Cambridge: Cambridge University Press, 1995.

Anzeige (Technik)." In *Wikipedia. Die freie Enzyklopädie*. Accessed March 19, 2007. http://de.wikipedia.org/wiki/Anzeige_%28Technik%29.

Apostel, Leo. "Towards the Formal Study of Models in the Non-Formal Sciences." *Synthese* 12, nos. 2–3 (1960): 125–61.

Arnheim, Rudolf. *Art and Visual Perception: A Psychology of the Creative Eye*. Berkeley: University of California Press, 1974. First published in 1954.

Arnheim, Rudolf. "Film als Kunst." In *Texte zur Theorie des Films*, edited by Franz-Josef Albersmeier, 179–203. Stuttgart: Philipp Reclam, 1979. First published in 1932.

Ars Electronica Online Archive. "Double Helix Swing, Ursula Damm." Accessed March 2, 2007, http://www.aec.at/de/archives/prix_archive/prix_projekt.asp?iProjectID=13759.

Asaro, Peter. "Working Models and the Synthetic Method: Electronic Brains as Mediators between Neurons and Behavior." *Science Studies* 19, no. 1 (2006): 12–34.

Ascott, Roy. "The Ars Electronica Center Datapool." In *Telematic Embrace: Visionary Theories of Art, Technology, and Consciousness*, 284–309. Berkeley: University of California Press, 2003. First published in 1993.

Ascott, Roy. "No Simple Matter: Artist as Media Producer in a Universe of Complex Systems." *AND. Journal of Art (London)* 28 (1993): 3.

Ascott, Roy. *Telematic Embrace: Visionary Theories of Art, Technology, and Consciousness*. Berkeley: University of California Press, 2003.

Auber, Olivier. "Esquisse d'une perspective temporelle." *Recherches Poïétiques. Revue de la Société Internationale de Poïétique* 7 (Spring 1998): 160–65.

Auber, Olivier. "Esthétique de la perspective numérique." In *Ligeia. Dossiers sur l'Art 45–48: Art et multimédia, Actes du Colloque Artmedia VIII, July–December 2003*, edited by Raymond Hains and Richard Long, 25–29. Paris: CNRS Éditions, 2003.

Auber, Olivier. "Du *Générateur poiétique* à la perspective numérique." *Revue de l'Est* 43 (2003): 127–36.

Bachofen, Daniel, János Zátonyi, Matthias Harders, Gábo Székely, Peter Frueh, and Markus Thaler. "Enhancing the Visual Realism of Hysteroscopy Simulation." *Studies in Health Technology and Informatics* 119 (2006): 31–36.

Bailer-Jones, Daniela M. "Tracing the Development of Models in the Philosophy of Science." In *Model-Based Reasoning in Scientific Discovevy*, edited by Lorenzo Magnani, Nancy Nersessian, and Paul Thagard, 23–40. New York: Plenum, 1999.

Bailer-Jones, Daniela M. "When Scientific Models Represent." *International Studies in the Philosophy of Science* 17, no. 1 (2003): 59–74.

Balázs, Béla. "Zur Kunstphilosophie des Films." In *Texte zur Theorie des Films*, edited by Franz-Josef Albersmeier, 204–26. Stuttgart: Philipp Reclam, 1979. First published in 1938.

Barbeni, Luca. *Webcinema. L'immagine cibernetica*. Milan: Costa & Nolan, 2006.

Baudrillard, Jean. *Die Agonie des Realen*. Translated by L. Kurzawa and V. Schaefer. Berlin: Merve, 1978.

Baudrillard, Jean. "Au-delà du vrai et du faux, ou le malin génie de l'image." *Cahiers Internationaux de Sociologie* 82 (1987): 139–45.

Baudrillard, Jean. "Holograms." In *Simulacra and Simulation*,105–9. Translated by S. F. Glaser. Ann Arbor: University of Michigan Press, 2000.

Baudrillard, Jean. *The Illusion of the End*. Translated by C. Turner. Stanford: Stanford University Press, 1994. First published in 1992.

Baudrillard, Jean. *Die Illusion und die Virtualität*. Translated by H. P. Einfalt. Berne: Benteli, 1994.

Baudrillard, Jean. "Die Illusion und die Virtualität." In *Die Illusion und die Virtualität*, 7–22. Translated by H. P. Einfalt. Berne: Benteli, 1994.

Baudrillard, Jean. "L'ordre des simulacres." In *L'échange symbolique et la mort*, 75–128. Paris: Éditions Gallimard, 1976.

Baudrillard, Jean. "The Order of Simulacra." In *Symbolic Exchange and Death*, 50–86. Translated by I. H. Grant. Thousand Oaks, CA: Sage, 2005.

Baudrillard, Jean. "The Precession of Simulacra." In *Simulacra and Simulation*, 1–42. Translated by S. F. Glaser. Ann Arbor: University of Michigan Press, 2000. First published in 1978.

Baudrillard, Jean. "Simulacra and Science Fiction." In *Simulacra and Simulation*, 121–27. Translated by S. F. Glaser. Ann Arbor: University of Michigan Press, 2000.

Baudrillard, Jean. *Simulacra and Simulation*. Translated by S. F. Glaser. Ann Arbor: University of Michigan Press, 2000.

Baudrillard, Jean. "Simulacra Videowelt und fraktales Subjekt." In *Philosophien der neuen Technologie*, edited by Ars Electronica, 113–31. Berlin: Merve, 1989.

Beaudouin-Lafon, Michel. "Designing Interaction, Not Interfaces." In *Proceedings of the Working Conference on Advanced Visual Interfaces*, 15–22. New York: ACM Press, 2004.

Bec, Louis. "Artificial Life under Tension: A Lesson in Epistemological Fabulation." In *Art @ Science*, edited by Christa Sommerer and Laurent Mignonneau, 92–98. New York: Springer, 1998.

Bec, Louis. "Life Art." In *Signs of Life: Bio Art and Beyond*, edited by Eduardo Kac, 83–92. Cambridge, MA: MIT Press, 2007.

Bec, Louis. "Monographie. Die Upokrinomene." *Kunstforum International* 97 (November–December 1988): 138–49.

Bec, Louis. "Prolegomena. Ästhetik und fabulöse Erkenntnistheorie des künstlichen Lebens." In *Genetische Kunst—Künstliches Leben, Ars Electronica 1993*, edited by Karl Gerbel and Peter Weibel, 172–80. Vienna: PVS Verleger, 1993.

Bec, Louis. "Les réseaux technozoosémiotiques." In *Communautés virtuelles: penser et agir en réseau*, edited by Serge Proulx, Louise Poissant, and Michel Sénécal, 203–12. Sainte-Foy: Presses de l'Université Laval, 2006.

Bec, Louis. "Über das Wiederflottgemachte." In *Cyberspace: Zum medialen Gesamtkunstwerk*, edited by Florian Rötzer and Peter Weibel, 357–65. Munich: Klaus Boer, 1993.

Bec, Louis. "Vorläufiger Versuch über die Upokrinomenologie, oder: Eine verheerende zoosystemische Expedition durch ein Glossar." In *Digitaler Schein*, edited by Florian Rötzer, 397–416. Frankfurt am Main: Suhrkamp, 1991.

Beil, Benjamin. *Avatarbilder. Zur Bildlichkeit des zeitgenössischen Computerspiels*. Bielefeld: transcript, 2012.

Bellour, Raymond. "The Double Helix." In *Electronic Culture: Technology and Visual Representation*, edited by Timothy Druckrey, 173–99. New York: Aperture Foundation, 1997. First published in 1990.

Belting, Hans. *Florence and Baghdad: Renaissance Art and Arab Science*. Translated by D. L. Schneider. Cambridge, MA: Harvard University Press, 2011. First published in 2008.

Bergson, Henri. *Creative Evolution*. Translated by A. Mitchell. New York: Palgrave MacMillan, 2007. First published 1907.

Bettetini, Gianfranco. *La simulazione visiva: Inganno, finzione, poesia, Computer Graphics*. Milan: Bompiani, 1991.

Bianchi, Gérald, Matthias Harders, and Gábor Székely. "Mesh Topology Identification for Mass-Spring Models." In *Medical Image Computing and Computer-Assisted Intervention*, edited by Randy E. Ellis and Terry M. Peters, 50–58. New York: Springer, 2003.

Bianchi, Gérald, Barbara Solenthaler, Gábor Székely, and Matthias Harders. "Simultaneous Topology and Stiffness Identification for Mass-Spring Models Based on FEM Reference Deformations." In *Medical Image Computing and Computer-Assisted Intervention*, edited by Christian Barillot, David R. Haynor, and Pierre Hellier, 293–301. New York: Springer, 2004.

Bielser, Daniel. *A Framework for Open Surgery Simulation.* Konstanz: Hartung-Gorre Verlag, 2003.

Bielser, Daniel, Pascal Glardon, Matthias Teschner, and Markus H. Gross. "A State Machine for Real-Time Cutting of Tetrahedral Meshes." *Journal of Graphical Models and Image Processing* 66, no. 6 (2004): 398–417.

Bielser, Daniel, Volker A. Maiwald, and Markus H. Gross. "Interactive Cuts through Three-Dimensional Soft Tissue." *Computer Graphics Forum* 18, no. 3 (1999): C31–C38.

Black, Max. *Models and Metaphors: Studies in Language and Philosophy.* Ithaca, NY: Cornell University Press, 1962.

Blightman, Bob. "Where Now with Simulation?" *Journal of the Operational Research Society* 38, no. 8 (1987): 769–70.

Boehm, Gottfried. "Ausdruck und Dekoration: Die Verwandlung des Bildes durch Henri Matisse." In *Wie Bilder Sinn erzeugen: Die Macht des Zeigens*, 180–98. Berlin: Berlin University Press, 2007.

Boehm, Gottfried. "Bild und Zeit." In *Das Phänomen Zeit in Kunst und Wissenschaft*, edited by Hannelore Paflik, 1–23. Weinheim: VCH, 1987.

Boehm, Gottfried. "Bildsinn und Sinnesorgane." *Neue Hefte für Philosophie* 18/19 (1980): 118–32.

Boehm, Gottfried. "Ikonische Differenz." *Rheinsprung 11* 1, no. 1 (March 2011). Accessed August 6, 2013, http://rheinsprung11.unibas.ch/archiv/ausgabe-01/glossar/ikonische-differenz.html.

Boehm, Gottfried. "Ikonisches Wissen: Das Bild als Modell." In *Wie Bilder Sinn erzeugen: Die Macht des Zeigens*, 114–40. Berlin: Berlin University Press, 2007.

Boehm, Gottfried. "Sehen: Hermeneutische Reflexionen." In *Kritik des Sehens*, edited by Ralf Konersmann, 272–98. Leipzig: Reclam, 1999. First published in 1992.

Boehm, Gottfried. *Studien zur Perspektivität: Philosophie und Kunst in der Frühen Neuzeit.* Heidelberg: Carl Winter Universitätsverlag, 1969.

Boehm, Gottfried. "Vom Medium zum Bild." In *Bild—Medium—Kunst*, edited by Yvonne Spielmann and Gundolf Winter, 165–78. Munich: Fink, 1999.

Boehm, Gottfried. "Die Wiederkehr der Bilder." In *Was ist ein Bild?* 11–38. Munich: Fink, 1994.

Boehm, Gottfried. "Zu einer Hermeneutik des Bildes." In *Die Hermeneutik und die Wissenschaften*, edited by Hans-Georg Gadamer and Gottfried Boehm, 444–71. Frankfurt am Main: Suhrkamp, 1978.

Boissier, Jean-Louis. "*Artifices.*" In *La relation comme forme: L'interactivité en art*, 55–77. Geneva: Mamco, 2004.

Boissier, Jean-Louis. "Éloge de la planéité." *Revue de l'Esthetique* 39 (July 2001): 86–93.

Boissier, Jean-Louis. "L'image-potentiel: Hypothèse du tableau chinois." In *Faire Image, Les Cahiers de Paris VIII*, 152–70. Saint-Denis: Presses Universitaires de Vincennes, 1989.

Boissier, Jean-Louis. "L'image n'est pas seule." In *La relation comme forme: L'interactivité en art*, 231–37. Geneva: Mamco, 2004.

Boissier, Jean-Louis. "L'image-relation: L'ouvrage inclut le CD-ROM *Essais interactifs*." In *La relation comme forme: L'interactivité en art*, 273–306. Geneva: Mamco, 2004.

Boissier, Jean-Louis. "Introduction: La relation comme forme." In *La relation comme forme: L'interactivité en art*, 9–13. Geneva: Mamco, 2004.

Boissier, Jean-Louis. "Le logiciel comme rêverie." In *La relation comme forme: L'interactivité en art*, 47–53. Geneva: Mamco, 2004.

Boissier, Jean-Louis. "La perspective interactive." In *La relation comme forme: L'interactivité en art*, 263–71. Geneva: Mamco, 2004.

Boissier, Jean-Louis. "La perspective relationnelle." In *Invisibile*, edited by Christine Buci-Glucksmann, Luca Marchetti, Marco Pierini, and Emanuele Quinz, 195–203. Exhibition catalogue, Palazzo delle Papesse. Centro d'Arte Contemporanea Siena, October 9, 2004–January 9, 2005. Siena: Gli Ori, 2004.

Boissier, Jean-Louis. "Die Präsenz, Paradoxon des Virtuellen." Translated by K. Meßmer. In *Weltbilder. Bildwelten. Computergestützte Visionen. Interface 2*, edited by Klaus Peter Dencker, 370–79. Hamburg: Verlag Hans-Bredow-Institut für Rundfunk und Fernsehen, 1995.

Boissier, Jean-Louis. *La relation comme forme: L'interactivité en art*. Geneva: Mamco, 2004.

Boissier, Jean-Louis. "The Relation-Image." In *Future Cinema: The Cinematic Imaginary after Film*, edited by Jeffrey Shaw and Peter Weibel, 398–407. Cambridge, MA: MIT Press, 2003.

Bopp, Matthias. "Immersive Didaktik und Framingprozesse in Computerspielen: Ein handlungstheoretischer Ansatz." In *Das Spiel mit dem Medium: Partizipation—Immersion—Interaktion. Zur Teilhabe an den Medien von Kunst bis Computerspiel*, edited by Britta Neitzel and Rolf F. Nohr, 170–86. Marburg: Schriftenreihe der Gesellschaft für Medienwissenschaft, 2006.

Boumans, Marcel. "Built-In-Justification." In *Models as Mediators: Perspectives on Natural and Social Sciences*, edited by Mary S. Morgan and Margaret Morrison, 66–96. Cambridge: Cambridge University Press, 1999.

Bour, Martine. "Towards an Interactive Cinema: Interview with Jean-Louis Boissier." *Anomalie. Digital_Arts* 3 (2003): 21–33.

Bourriaud, Nicolas. *Relational Aesthetics*. Dijon: Les presses du réel, 2002. First published in 1998.

Bredekamp, Horst. "Mimesis, grundlos." *Kunstforum International* 114 (July–August 1991): 278–88.

Bredekamp, Horst. "Das Bild als Leitbild: Gedanken zur Überwindung des Anikonismus." In *LogIcons: Bilder zwischen Theorie und Anschauung*, edited by Ute Hoffmann, Bernward Joerges, and Ingrid Severin, 225–45. Berlin: Edition Sigma, 1997.

Bredekamp, Horst. "die endlosen anfänge des museums." In *7 Hügel: Bilder und Zeichen des 21. Jahrhunderts*, vol. 6: *Wissen*, edited by Gereon Sievernich and Hendrik Budde, 41–46. Berlin: Henschel, 2000.

Bredekamp, Horst. "Kulturtechnik zwischen Mutter und Stiefmutter Natur." In *Bild—Schrift—Zahl*, edited by Sybille Krämer and Horst Bredekamp, 117–41. Munich: Fink, 2003.

Bredekamp, Horst, Matthias Bruhn, and Gabriele Werner, eds. *Bildwelten des Wissens. Kunsthistorisches Jahrbuch für Bildkritik* 5, no. 1 (2007).

Breidbach, Olaf. "Einleitung: Neuronale Ästhetik—Skizze eines Programms." In *Natur der Ästhetik— Ästhetik der Natur*, edited by Olaf Breidbach, 1–18. Vienna: Springer, 1997.

Bret, Michel. "Procedural Art with Computer Graphics Technology." *Leonardo* 21, no. 1 (1988): 3–9.

Bret, Michel, Marie-Hélène Tramus, and Alain Berthoz. "Interacting with an Intelligent Dancing Figure: Artistic Experiments at the Crossroads between Art and Cognitive Science." *Leonardo* 38, no. 1 (2005): 46–53.

Breton, Philippe. *Une histoire de l'informatique.* Paris: Éditions La Découverte, 1990. First published in 1987.

Bricken, Meredith. "Virtual Worlds: No Interface to Design." In *Imagina 92: Images Beyond Imagination ...* , *Proceedings of the Eleventh Monte-Carlo International Forum on New Images* (I-43–I-57). Bry-sur-Marne: Centre National de la Cinematographie, 1992.

Brown, Richard D. "Virtual Unreality and Dynamic Form: An Exploration of Space, Time and Energy." *Leonardo* 33, no. 1 (2000): 21–25.

Bryden, John, and Jason Noble. "Computational Modelling, Explicit Mathematical Treatments, and Scientific Explanation." In *Artificial Life X: Proceedings of the Tenth International Conference on the Simulation and Synthesis of Living Systems*, edited by Luis Mateus Rocha, Larry S. Yaeger, Mark A. Bedau, Dario Floreano, Robert L. Goldstone, and Alessandro Vespignani, 520–26. Cambridge, MA: MIT Press, 2006.

Bühler, Benjamin, and Stefan Rieger. "Schnecke." In *Vom Übertier: Ein Bestiarium des Wissens*, 221–29. Frankfurt am Main: Suhrkamp, 2006.

Büttner, Frank. "Rationalisierung der Mimesis: Anfänge der konstruierten Perspektive bei Brunelleschi und Alberti." In *Mimesis und Simulation*, edited by Andreas Kablitz and Gerhard Neumann, 55–87. Freiburg im Breisgau: Rombach, 1998.

Bunge, Mario. "Analogy, Simulation, Representation." *Revue Internationale de Philosophie* 23, no. 87 (1969): 16–33.

Burnham, Jack. "The Aesthetics of Intelligent Systems." In *On the Future of Art*, edited by Edward F. Fry, 95–122. New York: Viking Press, 1970.

Burnham, Jack. *Beyond Modern Sculpture: The Effects of Science and Technology on the Sculpture of This Century.* New York: George Braziller, 1968.

Burnham, Jack. "Real Time Systems." *Artforum* 8, no. 1 (September 1969): 49–55.

Burnham, Jack. "Systems Esthetics." *Artforum* 7, no. 1 (September 1968): 30–35.

Busch, Bernd. *Belichtete Welt: Eine Wahrnehmungsgeschichte der Fotografie*. Munich: Carl Hanser, 1989.

Buxton, William A. S. "There's More to Interaction Than Meets the Eye: Some Issues in Manual Input." In *User Centered System Design: New Perspectives on Human-Computer Interaction*, edited by Donald A. Norman and Stephen W. Draper, 319–37. Hillsdale, NJ: Erlbaum, 1986.

Cameron, Andy. "Dinner with Myron Or: Rereading Artificial Reality 2: Reflections on Interface and Art." In *ARt&D: Research and Development in Art*, edited by Joke Brouwer, Sandra Fauconnier, Arjen Mulder, and Anne Nigten, 10–26. Rotterdam: V2_NAi Publishers, 2005.

Cartwright, Nancy. *The Dappled World: A Study of Boundaries of Science*. Cambridge: Cambridge University Press, 1999.

Cartwright, Nancy. *How the Laws of Physics Lie*. Oxford: Clarendon Press, 1983.

Cartwright, Nancy. "Models and the Limits of Theory: Quantum Hamiltonians and the BCS Model of Superconductivity." In *Models as Mediators: Perspectives on Natural and Social Sciences*, edited by Mary S. Morgan and Margaret Morrison, 241–81. Cambridge: Cambridge University Press, 1999.

Cartwright, Nancy, Towfic Shomar, and Mauricio Suárez. "The Tool Box of Science: Tools for the Building of Models with a Superconductivity Example." In *Poznan Studies in the Philosophy of the Sciences and the Humanities 44: Theories and Models in Scientific Processes*, edited by William E. Herfel, Wladyslaw Krajewski, Ilkka Niiniluoto, and Ryszard Wójcicki, 137–49. Amsterdam: Rodopi, 1995.

Cassirer, Ernst. *The Individual and the Cosmos in Renaissance Philosophy*. Translated by M. Domandi. New York: Dover, 2000. First published in 1927.

Cassirer, Ernst. *The Philosophy of Symbolic Forms*, vol. 1: *Language*. Translated by R. Manheim and J. M. Krois. New Haven, CT: Yale University Press, 1955. First published in 1923.

Challoner, Jack. "Alien Imagination." In *The Science of Aliens*, 74–109. Exhibition catalogue, Science Museum, London, October 14, 2005–February 26, 2006. Munich: Prestel, 2005.

Clausberg, Karl. "Auf dem Weg zur computergestützten Bilderforschung: Perspektivität als Interface-Problem." In *Weltbilder. Bildwelten. Computergestützte Visionen. Interface 2*, edited by Klaus Peter Dencker, 10–31. Hamburg: Verlag Hans-Bredow-Institut für Rundfunk und Fernsehen, 1995.

"Copy-Plattform." In *FOCUS-Lexikon Werbeplanung—Mediaplanung Marktforschung—Kommunikationsforschung—Mediaforschung*, edited by Wolfgang J. Koschnick, 554–56. Munich: Focus Magazin Verlag, 2003.

Cordeschi, Roberto. *The Discovery of the Artificial: Behavior, Mind and Machines before and beyond Cybernetics*. Dordrecht: Kluwer Academic, 2002.

Couchot, Edmond. Images: *De l'optique au numérique*. Paris: Hermès, 1988.

Couchot, Edmond. "L'image numérique au-delà des Paradoxes." *Les Dossiers de l'ingénierie éducative: Les images numériques* 47–48 (2004): 112–15.

Couchot, Edmond. "Des images en quête d'auteur." In *Faire Image, Les Cahiers de Paris VIII*, 172–86. Saint-Denis: Presses Universitaires de Vincennes, 1989.

Couchot, Edmond. "À la recherche du 'temps réel.'" *Traverses. Revue trimestrielle du Centre de Création Industrielle du Musée d'Art Moderne* 35 (September 1985): 41–45.

Couchot, Edmond. "Die Spiele des Realen und des Virtuellen." In *Digitaler Schein: Ästhetik der elektronischen Medien*, edited by Florian Rötzer, 346–55. Frankfurt am Main: Suhrkamp, 1991.

Couchot, Edmond. *La technologie dans l'art: De la photographie à la réalité virtuelle*. Nîmes: Éditions Jacqueline Chambon, 1998.

Couchot, Edmond. "Zwischen Reellem und Virtuellem: die Kunst der Hybridation." In *Cyberspace: Zum medialen Gesamtkunstwerk*, edited by Florian Rötzer and Peter Weibel, 340–49. Munich: Klaus Boer, 1993.

Couchot, Edmond, Marie-Hélène Tramus, and Michel Bret. "A Segunda interatividade: Em direção a novas práticas artísticas." In *Arte e vida no século XXI*, edited by Diana Domingues, 27–38. Brazil: Edition UNESP, 2003.

Couchot, Edmond, and Norbert Hillaire. *L'art numérique*. Paris: Flammarion, 2003.

Couffignal, Louis P. "La Cybernétique: Essai méthodologique." *Structure et évolution des techniques* 8, nos. 51–52 (February–April 1957): 1–17.

Couffignal, Louis P. "Universalité de la cybernétique." In *Cybernétique—Electronique—Automation*, vol. 8 of *L'Ere Atomique—Encyclopédie des Sciences Modernes*, 10–16. Geneva: Éditions René Kister, 1960.

Couffignal, Louis P. *Les notions de base*. Paris: Gauthier-Villars, 1958.

Damm, Ursula. "Double Helix Swing." In *CyberArts 2006. International Compendium—Prix Ars Electronica 2006*, edited by Hannes Leopoldseder, Christine Schöpf, and Gerfried Stocker, 122–23. Ostfildern-Ruit: Hatje Cantz, 2006.

Damm, Ursula. "Double Helix Swing: Eine Installation für Mückenschwärme an Flussufern und seichten Gewässern." Accessed March 2, 2007, http://www.khm.de/~ursula/double_helix_de.pdf.

Daniels, Dieter. "Strategies of Interactivity." In *Art Media Interaction: The 1980s and 1990s in Germany*, edited by Dieter Daniels and Rudolf Frieling, 170–97. Vienna: Springer, 1999.

da Vinci, Leonardo. *A Treatise on Painting*. Translated by J. F. Rigaud. New York: Prometheus Books, 2002. Originally published ca. 1480–1516.

Davis, Stephen Boyd. "Interacting with Pictures: Film, Narrative and Interaction." *Digital Creativity* 13, no. 2 (2002): 71–84.

de Barros, Manuela. "Membranes et Tunnels: Entretien avec Maurice Benayoun." In *L'art à l'époque du virtuel*, edited by Christine Buci-Glucksmann, 127–31. Paris: Editions L'Harmattan, 2003.

de Campo, Alberto, and Julian Rohrhuber. "Else If—Live Coding: Strategien später Entscheidung." In *Digitale Transformationen: Medienkunst als Schnittstelle von Kunst, Wissenschaft, Wirtschaft und*

Gesellschaft, edited by Monika Fleischmann and Ulrike Reinhard, 155–57. Heidelberg: whois Verlags- und Vertriebsgesellschaft, 2004.

de Chadarevian, Soraya, and Nick Hopwood. "Dimensions of Modelling." In *Models: The Third Dimension of Science*, edited by Soraya de Chadarevian and Nick Hopwood, 1–15. Stanford: Stanford University Press, 2004.

De Landa, Manuel. *Philosophy and Simulation: The Emergence of Synthetic Reason*. New York: Continuum Press, 2011.

Deleuze, Gilles. *Cinema 1: The Movement-Image*. Translated by H. Tomlinson and B. Habberjam. Minneapolis: University of Minnesota Press, 1986. First published in 1983.

Deleuze, Gilles. *Cinema 2: The Time-Image*. Translated by H. Tomlinson and R. Galeta. Minneapolis: University of Minnesota Press, 1989. Fist published in 1985.

Deleuze, Gilles. *Difference and Repetition*. Translated by P. Patton. New York: Columbia University Press, 1994. First published in 1968.

della Francesca, Piero. *De prospectiva pingendi*. Edited by G. Nicco Fasola. Florence: C. C. Sansoni Editore, 1974. Written in 1474–1482 and first published in 1899.

Delp, Scott L. J., Peter Loan, Gagatay Basdogan, Thomas S. Buchanan, and Joseph M. Rosen. "Surgical Simulation: An Emerging Technology for Military Medical Training." In *Proceedings of National Forum '95, Military Telemedicine On-Line Today: Research, Practices and Opportunities*, edited by Russ Zajtchuk, Fred Goeringer, and Seong K. Mun, 29–34. Washington, DC: IEEE Computer Society Press, 1996.

Delp, Scott L., Peter Loan, Cagatay Basdogan, and Joseph M. Rosen. "Surgical Simulation: An Emerging Technology for Training in Emergency Medicine." *Presence* 6, no. 2 (1997): 147–59.

Demiaux, Bernard. *Digital Art—Paris Berkeley 2002–2004, Michel Bret*. Accessed December 14, 2006, http://www.demiaux.com/a&t/bret.htm.

Dewdney, Alexander K. "Computer Recreations: Diverse Personalities Search for Social Equilibrium at a Computer Party." *Scientific American* 257, no. 3 (September 1987): 104–7.

Diebner, Hans H. *Performative Science and Beyond: Involving the Process in Research*. New York: Springer, 2006.

Diefenbach, Paul J. "Practical Considerations of VR." In *Wescon/94: Idea/Microelectronics: Proceedings of Western Electronics Show and Convention*, edited by Yoke Tanaka, 87–90. New York: IEEE Press, 1994.

Dinkla, Söke. "Das flottierende Werk: Zum Entstehen einer neuen künstlerischen Organisationsform." In *Formen interaktiver Medienkunst*, edited by Peter Gendolla, Norbert M. Schmitz, Irmela Schneider, and Peter M. Spangenberg, 64–91. Frankfurt am Main: Suhrkamp, 2001.

Dinkla, Söke. *Pioniere interaktiver Kunst von 1970 bis heute: Myron Krueger, Jeffrey Shaw, David Rokeby, Lynn Hershman, Grahame Weinbren, Ken Feingold*. Ostfildern-Ruit: Hatje Cantz and ZKM Edition, 1997.

Dinkla, Söke. "Vom Zuschauer zum Spieler." In *InterAct! Schlüsselwerke Interaktiver Kunst*. Edited by Söke Dinkla, 8–21. Exhibition catalogue, Wilhelm Lehmbruck Museum, Duisburg, April 27–June 15, 1997. Ostfildern-Ruit: Hatje Cantz, 1997.

Diodato, Roberto. *Aesthetics of the Virtual*. Translated by J. L. Harmon, revised and edited by Silvia Benso. Albany: State University Press of New York, 2012.

Di Paolo, Ezequiel A., Jason Noble, and Seth Bullock. "Simulation Models as Opaque Thought Experiments." In *Proceedings of the Seventh International Conference on Artificial Life*, edited by Mark A. Bedau, John S. McCaskill, Norman H. Packard, and Steen Rasmussen, 497–506. Cambridge, MA: MIT Press, 2000.

"Display." In *TheFreeDictionary*. Accessed March 19, 2007, http://www.thefreedictionary.com/display.

Dörner, Dietrich. *Die Logik des Mißlingens: Strategisches Denken in komplexen Situationen*. Reinbek bei Hamburg: Rowohlt, 1992.

Dörner, Dietrich, Christina Bartl, Frank Detje, Jürgen Gerdes, Dorothée Halcour, Harald Schaub, and Ulrike Starker. *Die Mechanik des Seelenwagens: Eine neuronale Theorie der Handlungsregulation*. Berne: Verlag Hans Huber, 2002.

Dörner, Dietrich, Angela Hamm, and Katrin Hille. *EmoRegul: Beschreibung eines Programms zur Simulation der Interaktion von Motivation, Emotion und Kognition bei der Handlungsregulation (Memorandum No. 2)*. Lehrstuhl Psychologie II, University of Bamberg, 1996.

Dowling, Deborah. "Experimenting on Theories." *Science in Context* 12, no. 2 (1999): 261–73.

Dubey, Yogendra, P. "Simulation and Modeling." In *Encyclopedia of Microcomputers*, edited by Allen Kent and James G. Williams, vol. 15, 337–56. New York: Marcel Dekker, 1993.

Eckermann, Sylvia, and Mathias Fuchs. "Dead or Alive." *A Minima: Contemporary Visual and Conceptual Proposals* 7 (2004): 80–95.

Eco, Umberto. [Untitled.] In *Arte Programmata, Arte cinetica, opere moltiplicate, opera aperta*. Edited by Bruno Munari and Giorgio Soavi. Exhibition catalogue, Milan: Olivetti, 1962.

Eco, Umberto. *Das offene Kunstwerk*. Frankfurt am Main: Suhrkamp, 1973. First published in 1963.

Eco, Umberto. *The Open Work*. Translated by A: Cancogni. U.K.: Hutchinson Radius, 1989. First published in 1963.

Edgerton, Samuel Y., Jr. *The Heritage of Giotto's Geometry*. Ithaca, NY: Cornell University Press, 1991.

Elkady, Ayman. "The Simulation of Action Strategies of Different Personalities in Perspective of the Interaction between Emotions, Motivations and Cognition (An Experimental Study in the Field of Cognitive Psychology and Artificial Intelligence)." PhD diss., University of Bamberg, 2006.

Elkins, James, ed. *Photography Theory*. New York: Routledge, 2007.

Elkins, James. *The Poetics of Perspective*. Ithaca, NY: Cornell University Press, 1994.

Emmeche, Claus. *The Garden in the Machine: The Emerging Science of Artificial Life*. Translated by S. Sampson. Princeton, NJ: Princeton University Press, 1994. First published in 1991.

Engelbach, Barbara. *Zwischen Body Art und Videokunst: Körper und Video in der Aktionskunst um 1970*. Munich: Verlag Silke Schreiber, 2001.

Engell, Lorenz. *Das Gespenst der Simulation: Ein Beitrag zur Überwindung der ›Medientheorie‹ durch Analyse ihrer Logik und Ästhetik*. Weimar: Verlag und Datenbank für Geisteswissenschaften, 1994.

Eskelinen, Markku. "The Gaming Situation." *Game Studies* 1, no. 1 (July 2001). Accessed February 22, 2007, http://www.gamestudies.org/0101/eskelinen/.

Eskelinen, Markku. "Towards Computer Game Studies." *Digital Creativity* 12, no. 3 (2001): 175–83.

Eskelinen, Markku. "Towards Computer Game Studies." *Electronic Book Review* (2004). Accessed April 1, 2008, http://www.electronicbookreview.com/thread/firstperson/anticolonial.

Esmailzadeh, Karina. "Mathias Fuchs / Sylvia Eckermann: fluID—arena of identities, 2004." In *Artgames: Analogien zwischen Kunst und Spiel*. Edited by Ludwig Forum für Internationale Kunst, 70–71. Exhibition catalogue, Ludwig Forum für Internationale, Kunst, December 16, 2005–March 6, 2006. Aachen: Ludwig Forum, 2005.

Farshi, Olly. "Klangspiele." *Kunstforum International* 178 (November 2005–January 2006): 70–75.

Feiner, Steven K., and Clifford M. Beshers. "World within Worlds: A Metaphor for Exploring n-Dimensional Virtual Worlds." In *User Interface Software and Technology: Proceedings of the Third ACM SIGGRAPH Symposium*, edited by Scott E. Hudson, 76–83. New York: ACM Press, 1990.

Felstau, Michael, "Christa Sommerer & Laurent Mignonneau: A-Volve." In *Der elektronische Raum: 15 Positionen zur Medienkunst*. Edited by Kunst- und Ausstellungshalle BRD, 160–61. Exhibition catalogue, Kunst- und Ausstellungshalle der Bundesrepublik Deutschland in Bonn. Ostfildern-Ruit: Hatje Cantz 1998.

Fiala, Erwin. "Symbolische Welten und Abstraktionen." In *Leib. Maschine. Bild. Körperdiskurse der Postmoderne*, edited by Elisabeth List and Erwin Fiala, 139–55. Vienna: Passagen, 1997.

Fisher, Scott S. "Die Animation des Cyberspace." In *Schöne neue Welten? Auf dem Weg zu einer neuen Spielkultur*, edited by Florian Rötzer, 57–68. Munich: Klaus Boer, 1995.

Fisher, Scott S. "Virtuelle Realität: Ein Gespräch mit Florian Rötzer." In *Künstliche Spiele*, edited by Georg Hartwagner, Stefan Iglhaut, and Florian Rötzer, 195–201. Munich: Klaus Boer, 1993.

Fisher, Scott S., Susan Amkraut, Michael Girard, and Mark Trayle. "'MENAGERIE': Designing a Virtual Experience." In *SPIE 2177: Stereoscopic Displays and Virtual Reality Systems: Proceedings of the International Society for Optics and Photonics*. Bellingham, WA: International Society for Optical Engineering, 1994.

Flusser, Vilém. "Curies' Children." *Artforum* 26 (April 1988): 14–15.

Flusser, Vilém. *Medienkultur*. Frankfurt am Main: Fischer, 1997.

Francastel, Pierre. *Peinture et Société: Naissance et Destruction d'un Espace Plastique de la Renaissance au Cubisme*. Lyon: Audin Editeur, 1951.

Frasca, Gonzalo. "Simulation versus Narrative: Introduction to Ludology." In *The Video Game Theory Reader*, edited by Mark J. P. Wolf and Bernard Perron, 221–34. New York: Routledge, 2003.

French, Steven, and James Ladyman. "Reinflating the Semantic Approach." *International Studies in the Philosophy of Science* 13, no. 2 (1999): 103–21.

French, Steven, and James Ladyman. "Superconductivity and Structures: Revisiting the London Approach." *Studies in History and Philosophy of Modern Physics* 28, no. 3 (1997): 363–93.

Fried, Michael. *Art and Objecthood: Essays and Reviews*. Chicago: University of Chicago Press, 1998.

Frigg, Roman, and Stephan Hartmann. "Models in Science." In *Stanford Encyclopedia of Philosophy*. Accessed December 12, 2006, http://plato.stanford.edu/entries/models-science/.

"Fuchs/Eckermann Electronic Arts." In *SELFWARE File.02: Politics of Identity*, edited by Reinhard Braun and Michael Rieper, 98–105. Graz: MVD AUSTRIA, 2003.

Funes, Pablo, and Jordan Pollack. "Evolutionary Body Building: Adaptive Physical Designs for Robots." *Artificial Life* 4, no. 4 (Fall 1998): 337–57.

Furtwängler, Frank. "Computerspiele am Rande des metakommunikativen Zusammenbruchs." In *Das Spiel mit dem Medium: Partizipation—Immersion—Interaktion. Zur Teilhabe an den Medien von Kunst bis Computerspiel*, edited by Britta Neitzel and Rolf F. Nohr, 154–69. Marburg: Schüren, 2006.

Furtwängler, Frank. "'A Crossword at War with a Narrative': Narrativität versus Interaktivität in Computerspielen." In *Formen interaktiver Medienkunst: Geschichte, Tendenzen, Utopien*, edited by Peter Gendolla, Norbert M. Schmitz, Irmela Schneider, and Peter M. Spangenberg, 369–400. Frankfurt am Main: Suhrkamp, 2001.

Furtwängler, Frank. "Menschliche Praxis: Wie das Ergodenproblem eine Re-Animation anthropologischer Perspektiven in den game studies herausfordert." *Dichtung-Digital. Journal für Digitale Ästhetik* 7, no. 34 (2005). Accessed April 3, 2008, http://www.brown.edu/Research/dichtung-digital/2005/1/Furtwaengler/index.htm.

Furtwängler, Frank. "Mensch-Maschine Computerspiel: Über eine notwendige Paartherapie in der Medienrealität." In *Jahrbuch für Computerphilologie 7*, edited by Georg Braungart, Peter Gendolla, and Fotis Jannidis, 111–30. Paderborn: Mentis, 2006.

Gadamer, Hans-Georg. *Truth and Method*, 2nd rev. ed. Translation revised by J. Weinsheimer and D. G. Marshall. London: Bloomsbury, 2004. First published in 1960.

Gendolla, Peter. "Drei Simulationsmodelle." In *Qualitative Perspektiven des Medienwandels*, edited by Helmut Schanze and Peter Ludes, 172–82. Opladen: Westdeutscher Verlag, 1997.

Gendolla, Peter. "Gefälschte Welt: Möglichkeiten der Simulation." In *Verleugnen, Vertuschen, Verdrehen: Leben in der Lügengesellschaft*, edited by Robert Hettlage, 173–97. Konstanz: Universitätsverlag Konstanz, 2003.

Gendolla, Peter. "Zur Interaktion von Raum und Zeit." In *Formen interaktiver Medienkunst*, edited by Peter Gendolla, Norbert M. Schmitz, Irmela Schneider, and Peter M. Spangenberg, 19–38. Frankfurt am Main: Suhrkamp, 2001.

Georges, Karl Ernst. *Ausführliches Lateinisch-Deutsches Handwörterbuch*. Basel: Benno Schwabe & Co, 1962.

Gerdes, Jürgen. "Face—Das Gesicht von Psi." Accessed June 13, 2006, http://giftp.ppp.uni-bamberg.de/projekte/psi/face.

Gerdes, Jürgen, and Maja Dshemuchadse. "Gefühlsausdruck." In *Die Mechanik des Seelenwagens: Eine neuronale Theorie der Handlungsregulation*, edited by Dietrich Dörner, Christina Bartl, Frank Detje, Jürgen Gerdes, Dorothée Halcour, Harald Schaub, and Ulrike Starker, 221–30. Berne: Verlag Hans Huber, 2002.

Gere, Charlie. "Jack Burnham and the Work of Art in the Age of Real Time Systems." In *Get Real: Real Time + Art*, edited by Morten Søndergaard, Perttu Rastas, and Björn Norberg, 149–63. New York: Braziller, 2005.

Getsy, D. J., ed. *From Diversion to Subversion: Games, Play, and Twentieth Century Art*. University Park: Pennsylvania State University Press, 2011.

Ghattas, Nadia. "L'action sur l'image: Narration, geste et parcours (Bilder unter Einfluß: Narration, Gebärde und ([Ver-]Lauf) (Tagung v. 7.6.– 8.6.2002 in Paris), Konferenzbericht." *Zeitschrift für Germanistik*, n.s. 3 (2003): 653–55.

Giannetti, Claudia. *Ästhetik des Digitalen: Ein intermediärer Beitrag zu Wissenschaft, Medien- und Kunstsystemen*. Vienna: Springer, 2004.

Giere, Ronald N. "How Models Are Used to Represent Reality." *Philosophy of Science* 71 (Suppl. 2004): 742–52.

Giesecke, Michael. "Der Verlust der zentralen Perspektive und die Renaissance der Multimedialität." In *Vorträge aus dem Warburg-Haus*, edited by Wolfgang Kemp, Gert Mattenklott, Monika Wagner, and Martin Warnke, vol. 2, 85–116. Berlin: Akademie, 1998.

Girard, Michael, and Susan Amkraut. "Menagerie." In *Prix Ars Electronica 1994: Internationales Kompendium der Computerkünste*, edited by Hannes Leopoldseder, 118–19. Linz: VERITAS, 1993.

Goldstein, Richard. "The Plenitude: Design and Engineering in the Era of Ubiquitous Computing, draft version 0.9, 2002." Accessed March 11, 2007, http://www.o-art.org/Plenitude/ThePlenitude.pdf.

Goodman, Nelson. *Languages of Art: An Approach to a Theory of Symbols*. Indianapolis: Bobbs-Merrill, 1986.

Gordon, Geoffrey. *System Simulation*. Englewood Cliffs, NJ: Prentice Hall, 1978.

Gow, Marcelyn Grace. "Invisible Environment—Art, Architecture and a Systems Aesthetic, 1960–1971." PhD diss., ETH Zurich, 2007.

Gramelsberger, Gabriele. *Computerexperimente: Zum Wandel der Wissenschaft im Zeitalter des Computers*. Bielefeld: transcript, 2010.

Gramelsberger, Gabriele. "Das epistemische Gewebe simulierter Welten." In *Simulation: Unfold Architecture—Grundbegriffe zwischen Kunst, Wissenschaft und Technologie*, edited by Andrea Gleininger and Georg Vrachliotis, 83–91. Basel: Birkhäuser, 2008.

Gramelsberger, Gabriele, ed. *From Science to Computational Sciences: Studies in the History of Computing and its Influence on Today's Sciences*. Zurich: Diaphanes, 2011.

Gramelsberger, Gabriele. "Semiotik und Simulation: Fortführung der Schrift ins Dynamische. Entwurf einer Symboltheorie der numerischen Simulation und ihrer Visualisierung." PhD diss., Freie Universität Berlin, 2001.

Gramelsberger, Gabriele. "Theorie—Simulation—Experiment: Computergestützte Simulation als erkenntnistheoretische Erweiterung der Erklärungs- und Prognosemöglichkeiten in den Naturwissenschaften." Master's thesis, University of Augsburg, 1996. Accessed June 21, 2004, http://www.philart.de/magisterarbeit/.

Grau, Oliver. *Virtual Art: From Illusion to Immersion*. Cambridge, MA: MIT Press, 2004.

Griesemer, James. "Three-Dimensional Models in Philosophical Perspective." In *Models: The Third Dimension of Science*, edited by Soraya de Chadarevian and Nick Hopwood, 433–42. Stanford: Stanford University Press, 2004.

Grodsky, Milton A. "Man-Machine Simulation." In *Prospects for Simulation and Simulators of Dynamic Systems*, edited by George Shapiro and Milton Rogers, 83–103. New York: Spartan Books / Macmillan, 1967.

Großklaus, Götz. "Das technische Bild der Wirklichkeit: Von der Mimesis zur Simulation." In *Medien-Zeit Medien-Raum: Zum Wandel der raumzeitlichen Wahrnehmung in der Moderne*, 113–42. Frankfurt am Main: Suhrkamp, 1997.

Grube, Gernot. "Computerbilder: Bildschirmaufführungen einer Schriftmaschine." In *Grenzfälle: Transformationen von Bild, Schrift und Zahl*, edited by Pablo Schneider and Moritz Wedell, 41–64. Weimar: Verlag und Datenbank für Geisteswissenschaften, 2004.

Grube, Gernot. "Digitale Abbildungen—ihr prekärer Zeichenstatus." In *Konstruierte Sichtbarkeiten: Wissenschafts- und Technikbilder seit der Frühen Neuzeit*, edited by Martina Heßler, 179–96. Munich: Fink, 2005.

Guala, Francesco. "Models, Simulations, and Experiments." In *Model-Based Reasoning: Science, Technology, Values*, edited by Lorenzo Magnani and Nancy J. Nersessian, 59–74. New York: Kluwer Academic and Plenum, 2002.

Günzel, Stephan. "Die Geste des Manipulierens: Zum Gebrauch statischer und beweglicher Digitalbilder." In *Freeze Frames: Zum Verhältnis von Fotografie und Film*, edited by Stefanie Diekmann and Winfried Gerling, 115–29. Bielefeld: transcript, 2010.

Günzel, Stephan. *Egoshooter: Das Raumbild des Computerspiels*. Frankfurt am Main: Campus, 2012.

Günzel, Stephan. "Simulation und Perspektive: Der bildtheoretische Ansatz in der Computerspielforsc-hung." In *Shooter: Eine multidisziplinäre Einführung*, edited by Matthias Bopp, Rolf F. Nohr, and Serjoscha Wiemer, 331–52. Münster: Lit, 2009.

Hacking, Ian. *Representing and Intervening: Introductory Topics in the Philosophy of Natural Science*. Cambridge: Cambridge University Press, 2005. First published in 1983.

Hampe, Michael. "Sichtbare Wesen, deutbare Zeichen, Mittel der Konstruktion: zur Relevanz der Bilder in der Wissenschaft." *Angewandte Chemie* 118, no. 7 (2006): 1044–48.

Händle, Frank, and Stefan Jensen. "Einleitung der Herausgeber." In *Systemtheorie und Systemtechnik*, edited by Frank Händle and Stefan Jensen, 7–61. Munich: Nymphenburger, 1974.

Hagner, Michael. "Bilder der Kybernetik: Diagramm und Anthropologie, Schaltung und Nervensystem." In *Konstruierte Sichtbarkeiten: Wissenschafts- und Technikbilder seit der Frühen Neuzeit*, edited by Martina Heßler, 383–404. Munich: Fink, 2005.

Haken, Hermann. *Erfolgsgeheimnisse der Natur: Synergetik: Die Lehre vom Zusammenwirken*. Reinbek bei Hamburg: Rowohlt, 1995.

Haraway, Donna. "A Manifesto for Cyborgs: Science, Technology and Socialist Feminism in the 1980s." In *The Haraway Reader*, 7–45. New York: Routledge, 2004. First published in 1990.

Haraway, Donna. "Primatology Is Politics by Other Means." In *PSA: Proceedings of the Biennial Meeting of the Philosophy of Science Association 1984*, vol. 2, edited by Peter D. Asquith and Philip Kitcher, 489–524. East Lansing, MI: Philosophy of Science Association, 1985.

Haraway, Donna. "Primatologie ist Politik mit anderen Mitteln." In *Das Geschlecht der Natur. Feministische Beiträge zur Geschichte und Theorie der Naturwissenschaften*, edited by Barbara Orland and Elvira Scheich, 136–98. Frankfurt am Main: Suhrkamp, 1995. First published in 1985.

Harbrodt, Steffen. "Probleme der Computersimulation." In *Systemtheorie als Wissenschaftsprogramm*, edited by Hans Lenk and Günter Ropohl, 151–65. Königstein: Athenäum, 1978.

Harders, Matthias. *Surgical Scene Generation for Virtual Reality–Based Training in Medicine*. London: Springer, 2008.

Harders, Matthias, Daniel Bachofen, Michael Bajka, Markus Grassi, Bruno Heidelberger, Raimundo Sierra, Ulrich Spaelter, et al. "Virtual Reality Based Simulation of Hysteroscopic Interventions." *Presence* 17, no. 5 (2008): 441–62.

Harders, Matthias, Michael Bajka, Ulrich Spaelter, Stefan Tuchschmid, Hannes Bleuler, and Gábor Székely. "Highly-Realistic, Immersive Training Environment for Hysteroscopy." In *Medicine Meets Virtual Reality 14: Accelerating Change in Healthcare, Next Medical Toolkit*, edited by James D. Westwood, Randy S. Haluck, and Helene M. Hoffman, 176–81. Amsterdam: IOS Press, 2006.

Harders, Matthias, Roland Hutter, Andrea Rutz, Peter Niederer, and Gábor Székely. "Comparing a Simplified FEM Approach with the Mass-Spring Model for Surgery Simulation." In *Medicine Meets Virtual Reality 11: NextMed—Health Horizon*, edited by James D. Westwood, Helene M. Hoffman, Greg T. Mogel, Roger Philips, Richard A. Robb, and Don Stredney, 103–9. Amsterdam: IOS Press, 2003.

Harris, Todd. "A Hierarchy of Models and Electron Microscopy." In *Model-Based Reasoning in Scientific Discovery*, edited by Lorenzo Magnani, Nancy Nersessian, and Paul Thagard, 139–48. New York: Plenum, 1999.

Hart Nibbrig, Christiaan L. "Zum Drum und Dran einer Fragestellung: Ein Vorgeschmack." In *Was heißt 'Darstellen'?"* edited by Christiaan L. Hart Nibbrig, 7–14. Frankfurt am Main: Suhrkamp, 1994.

Hartl, Lydia Andrea."Die Verkörperung des Unsichtbaren: Vom Analphabetismus beim Bilderlesen." In *Vom Tafelbild zum globalen Datenraum: Neue Möglichkeiten der Bildproduktion und bildgebender Verfahren*, edited by Peter Weibel, 51–75. Ostfildern-Ruit: Hatje Cantz and ZKM edition, 2001.

Hartmann, Stephan. "Simulation." In *Enzyklopädie Philosophie und Wissenschaftstheorie*, vol. 3, edited by Jürgen Mittelstraß, 807–9. Stuttgart: J. B. Metzler, 1995.

Hartmann, Stephan. "The World as a Process: Simulations in the Natural and Social Sciences." In *Modelling and Simulation in the Social Sciences from the Philosophy of Science Point of View*, edited by Rainer Hegselmann, Ulrich Müller, and Klaus Troitzsch, 77–100. Dordrecht: Kluwer Academic, 1996.

Hasselblatt, Dieter. "Die Wahrheit des Unmöglichen." In *Stanislaw Lem: Der didaktische Weise aus Kraków, Insel Almanach auf das Jahr 1976*, edited by Werner Berthel. 192–96. Frankfurt am Main: Insel, 1976.

Hegselmann, Rainer. "Cellular Automata in the Social Sciences." In *Modelling and Simulation in the Social Sciences from the Philosophy of Science Point of View*, edited by Rainer Hegselmann, Ulrich Müller, and Klaus Troitzsch, 209–33. Dordrecht: Kluwer Academic, 1996.

Heibach, Christiane. *Literatur im elektronischen Raum*. Frankfurt am Main: Suhrkamp, 2003.

Heidegger, Martin. *Kant und das Problem der Metaphysik*. Frankfurt am Main: Vittorio Klostermann, 1991. First published in 1929.

Heidegger, Martin. *Kant and the Problem of Metaphysics*, 5th ed., enl. Translated by R. Taft. Bloomington: Indiana University Press, 1997. First published 1929.

Heidelberger, Bruno, Matthias Teschner, Thomas Frauenfelder, and Markus Gross. "Collision Handling of Deformable Anatomical Models for Real-Time Surgery Simulation." *Journal of Technology and Health Care* 12, no. 3 (2004): 235–43.

Heidenreich, Stefan. "Icons: Bilder für User und Idioten." In *Icons: Localizer 1.3*, edited by Birgit Richard, Robert Klanten, and Stefan Heidenreich, 82–86. Berlin: Die Gestalten Verlag, 1998.

Helfer, Martha. *The Retreat of Representation: The Concept of Darstellung in German Critical Discourse*. Albany: State University of New York Press, 1996.

Hemken, Kai-Uwe. "Die kategoriale Interaktion: Von Sehnsüchten der Teilhabe und Mythen der Interesselosigkeit." In *Bilder in Bewegung: Traditionen digitaler Ästhetik*, edited by Kai-Uwe Hemken, 53–76. Cologne: DuMont, 1996.

Henderson, Linda Dalrymple. *The Fourth Dimension and Non-Euclidean Geometry in Modern Art*. Princeton, NJ: Princeton University Press, 1983.

Hensel, Thomas. *Nature Morte im Fadenkreuz: Bilderspiele mit dem Computerspiel*. Trier: Intermedia Design Books, 2011.

Hensel, Thomas. "Das Spielen des Bildes: Ikonizität." Habilitation thesis, University of Siegen, 2014.

Hershman, Lynn. "The Fantasy beyond Control." In *Illuminating Video: An Essential Guide to Video Art*, edited by Doug Hall and Sally Jo Fifer, 267–73. New York: Aperture in Association with the Bay Area Video Coalition, 1990.

Hershman, Lynn. "Private I: An Investigator's Timeline." In *The Art and Films of Lynn Hershman Leeson: Secret Agents, Private I*, edited by Meredith Tromble, 12–103. Berkeley: University of California Press, 2005.

Hershman, Lynn. "Touch-Sensitivity and Other Forms of Subversion: Interactive Artwork." *Leonardo* 26, no. 5 (1993): 431–36.

Hertlein, Edgar. *Masaccios Trinität: Kunst, Geschichte und Politik der Frührenaissance in Florenz*. Florence: Leo S. Olschki, 1979.

Hesse, Mary B. *Models and Analogies in Science*. Notre Dame: University of Notre Dame Press, 1966.

Hinterwaldner, Inge. "'Actions of Interest' in Surgical Simulators." In *Making Things Public: Atmospheres of Democracy*, edited by Bruno Latour and Peter Weibel, 338–41. Cambridge, MA: MIT Press, 2005.

Hinterwaldner, Inge. "Arbeit am Eindruck: Zur Konstruktion von Sichtbarkeiten und Taktilitäten im virtuellen Körper." In *TechnoNaturen: Design&Styles*, edited by Elke Gaugele and Petra Eisele, 63–73. Vienna: Schlebrügge, 2008.

Hinterwaldner, Inge. "Präsenzproduktion in immersiven und symbolischen Computerbildszenarien zur Phobientherapie." In *Bildtheorie und Bildpraxis in der Kunsttherapie*, edited by Peter Sinapius, Marion Wendlandt-Baumeister, Annika Niemann, and Ralf Bolle, 181–94. Frankfurt am Main: Peter Lang, 2010.

Hinterwaldner, Inge. "Programmierte Operativität und operative Bildlichkeit." In *Die Kunst der Systemik*, edited by Roman Mikuláš, Sibylle Moser, and Karin S. Wozonig, 77–108. Berlin: Lit, 2013.

Hinterwaldner, Inge. "Simulationsmodelle: Zur Verhältnisbestimmung von Modellierung und Bildgebung in interaktiven Echtzeitsimulationen." In *Visuelle Modelle*, edited by Ingeborg Reichle, Steffen Siegel, and Achim Spelten, 301–14. Munich: Fink, 2008.

Hinterwaldner, Inge. "Verortungen der Benutzer in medizinischen virtuellen Welten." In *Topologien der Bilder*, edited by Inge Hinterwaldner, Carsten Juwig, Tanja Klemm, and Roland Meyer, 307–22. Munich: Fink, 2008.

Hinterwaldner, Inge. "Vom Sprung ins Detail und zurück: Zur Rolle der Montage im generativen Medium der Computersimulation." In *Prekäre Bilder*, edited by Robert Suter and Thorsten Bothe, 277–95. Munich: Fink, 2010.

Hinterwaldner, Inge. "Zur Fabrikation operativer Bilder in der Chirurgie." In *The Picture's Image: Wissenschaftliche Visualisierung als Komposit*, edited by Inge Hinterwaldner and Markus Buschhaus, 206–21. Munich: Fink, 2006.

Hinterwaldner, Silke. "Außerirdische und der unwirkliche Urwald." *Südtiroler Tageszeitung*, September 4–5, 1999, 14.

Hochberger, Jürgen, Jürgen Maiß, and Eckhart Gustav Hahn. "Aus- und Weiterbildung in der gastrointestinalen Endoskopie: Was muss gefordert werden, was sind die Voraussetzungen?" *Chirurgische Gastroenterologie Interdisziplinär* 19, Suppl. 1 (2003): 14–20.

Hörl, Erich, and Michael Hagner. "Überlegungen zur kybernetischen Transformation des Humanen." In *Die Transformation des Humanen: Beiträge zur Kulturgeschichte der Kybernetik*, edited by Erich Hörl and Michael Hagner, 7–37. Frankfurt am Main: Suhrkamp, 2008.

Holländer, Hans. "Augenblicksbilder: Zur Zeit-Perspektive in der Malerei." In *Augenblick und Zeitpunkt: Studien zur Zeitstruktur und Zeitmetaphorik in Kunst und Wissenschaften*, edited by Christian W. Thomsen and Hans Holländer, 175–97. Darmstadt: Wissenschaftliche Buchgesellschaft, 1984.

Hoppe-Sailer, Richard. "Die neuen Medien—die letzten Biotope: Notizen zur Geschichte der Naturmetaphorik in der Medienkunst." In *Bilder in Bewegung: Traditionen digitaler Ästhetik*, edited by Kai-Uwe Hemken, 147–57. Cologne: DuMont, 2000.

Huber, Hans Dieter. Bild Beobachter Milieu: Entwurf einer allgemeinen Bildwissenschaft. Ostfildern-Ruit: Hatje Cantz, 2004.

Huber, Hans Dieter. "Digging the Net—Materialien zu einer Geschichte der Kunst im Netz." In *Bilder in Bewegung: Traditionen digitaler Ästhetik*, edited by Kai-Uwe Hemken, 158–74. Cologne: DuMont, 2000.

Huber, Hans Dieter. "Internet." In *Vom Holzschnitt zum Internet: Die Kunst und die Geschichte der Bildmedien von 1450 bis heute*, edited by René Hirner, 186–90. Ostfildern-Ruit: Hatje Cantz, 1997.

Huber, Hans Dieter. "Systemische Bildwissenschaft." In *Bildwissenschaft zwischen Reflexion und Anwendung*, edited by Klaus Sachs-Hombach, 155–62. Cologne: Herbert von Halem Verlag, 2005.

Huber, Hans Dieter. System und Wirkung: Rauschenberg—Twombly—Baruchello. Fragen der Interpretation und Bedeutung zeitgenössischer Kunst. Ein systemtheoretischer Ansatz. Munich: Fink, 1989.

Hünnekens, Annette. Der bewegte Betrachter: Theorien der interaktiven Medienkunst. Cologne: Wienand, 1997.

Hughes, Richard I. G. "The Ising Model, Computer Simulation, and Universal Physics." In *Models as Mediators: Perspectives on Natural and Social Sciences*, edited by Mary S. Morgan and Margaret Morrison, 97–145. Cambridge: Cambridge University Press, 1999.

Hughes, Richard I. G. "Models and Representation." In *Papers, Philosophy of Science: Proceedings of the 1996 Biennial Meetings of the Philosophy of Science Association*. Supplemental Issue PSA 1996, edited by Lindley Darden, S325–36. East Lansing, MI: Philosophy of Science Association, 1997.

Huhtamo, Erkki. "Anything Interactive—But Not Just Any Thing!" In *Interactive Media Festival*, edited by Timothy Druckrey and Lisa Goldman, 36–37. Exhibition catalogue, Variety Arts Center, June 4–7, 1995. Los Angeles: IMF, 1995.

Huhtamo, Erkki. "The Art of Rebecca Allen: Inserting Human Presence into the Machine." Accessed April 10, 2008, http://rebeccaallen.com/v2/bio/the.art.of.ra.long.php.

Huhtamo, Erkki. "Seven Ways of Misunderstanding Interactive Art." In *Digital Mediations*. Pasadena, CA: Williamson Gallery of the Art Center College of Design. Accessed August 30, 2013, http://sophia.smith.edu/course/csc106/readings/interaction.pdf. First published in 1995.

Huizinga, Johan. *Homo Ludens: Vom Ursprung der Kultur im Spiel*. Reinbek bei Hamburg: Rowohlt, 1994.

Humphreys, Paul. *Extending Ourselves: Computational Science, Empiricism, and Scientific Method*. Oxford: Oxford University Press, 2004.

Innocent, Troy. "lifeSigns 2003." In *Unnatural Selection*, edited by Antoanetta Ivanova and Alessio Cavallaro, 22–25. Melbourne: Novamedia, 2004.

Innocent, Troy. "lifeSigns: Eco-System of Signs & Symbols." In *Proceedings of the Fourth International Conference on Computational Semiotics for Games and New Media*, edited by Andy Clarke. Accessed December 25, 2007, http://www.cosignconference.org/downloads/papers/innocent_cosign_2004.pdf.

Innocent, Troy. *lifeSigns. Description*. Accessed September 9, 2004, http://www.iconica.org/lifesigns/description.htm.

Innocent, Troy. *lifeSigns: Statement*. Accessed December 18, 2007, http://www.iconica.org/lifesigns/statement.htm.

"Interaction." In *Dictionnaire de l'informatique*, edited by Pierre Morvan, 162. Paris: Larousse, 1981.

The Interaction of Man and Images. In *Imagina 92: Des Images qui dépassent l'imagination … / Images beyond Imagination. … Proceedings of the Eleventh Monte-Carlo International Forum on New Images, Edited with the collaboration of the Centre National de la Cinematographie*, II-3. Bry-sur-Marne: n.p., 1992.

Iser, Wolfgang. "Mimesis/Emergenz." In *Mimesis und Simulation*, edited by Andreas Kablitz and Gerhard Neumann. 669–84. Freiburg im Breisgau: Rombach, 1998.

Ivins, William Mills Jr. *On the Rationalization of Sight*. New York: Da Capo Press, 1975. First published in 1939.

Janecke, Christian. "Performance *und* Bild/Performance *als* Bild." In *Performance und Bild: Performance als Bild*, edited by Christian Janecke, 11–113. Dresden: Philo Fine Arts, 2004.

Janhsen, Angeli. *Perspektivregeln und Bildgestaltung bei Piero della Francesca*. Munich: Fink, 1990.

Janitschek, Hubert, ed. *Leone Battista Alberti's Kleinere Kunsttheoretische Schriften*. Vienna: Wilhelm Braumüller, 1877.

Jantzen, Hans. *Über den kunstgeschichtlichen Raumbegriff*. Darmstadt: Wissenschaftliche Buchgesellschaft, 1962. First published in 1938.

Jensen, Jens F. "Interactivity: Tracking a New Concept in Media and Communication Studies." In *Computer Media and Communication*, edited by Paul Mayer, 160–87. Oxford: Oxford University Press, 1999.

Jonas, Hans. "Die Freiheit des Bildens: Homo pictor und die differentia des Menschen." In *Zwischen Nichts und Ewigkeit: Drei Aufsätze zur Lehre vom Menschen*, 26–43. Göttingen: Vandenhoeck und Ruprecht, 1963.

Jones, Stephen. "Sensing, Communication and Intentionality in Artificial Life." In *Proceedings of the Fifth International Symposium on Artificial Life and Robotics*, edited by Masanori Sugisaka and Hiroshi Tanaka, 26–29. Tokyo: Springer, 2000.

Jones, Stephen. "Intelligent Environments: Organisms or Objects?" *Convergence (London)* 7 (2) (2001): 25–33.

Jordan, Ken, and Carl Goodman eds. *Gameworld: Videogames on the Edge of Art, Technology and Culture*. Exhibition catalogue, LABoral, Centro de Arte Y Creación Industrial, Gijón. LABoral: Gijón, 2007.

Kacunko, Slavko. *Closed Circuit Videoinstallationen: Ein Leitfaden zur Geschichte und Theorie der Medienkunst mit Bausteinen eines Künstlerlexikons*. Berlin: Logos, 2004.

Kant, Immanuel. *Critique of Pure Reason*. Edited and translated by P. Guyer and A. W. Wood. Cambridge: Cambridge University Press, 1998. First published 1871.

Kauer, Martin, Vladimir Vuskovic, Jürg Dual, Gábor Székely, and Michael Bajka. "Inverse Finite Element Characterization of Soft Tissues." In *Proceedings of the Fourth International Conference on Medical Image Computing and Computer-Assisted Intervention*, edited by Wiro J. Niessen and Max A. Viergever, 128–36. Berlin: Springer, 2001.

Kaufmann, William J., and Larry L. Smarr. *Supercomputing and the Transformation of Science*. New York: Scientific American Library, 1993.

Keller, Evelyn Fox. "Models, Simulation, and 'Computer Experiments.'" In *The Philosophy of Scientific Experimentation*, edited by Hans Radder, 198–215. Pittsburgh: University of Pittsburgh Press, 2003.

Keller, Wilhelm. "Die Zeit des Bewusstseins." In *Das Zeitproblem im 20. Jahrhundert*, edited by Rudolf Walter Meyer, 44–69. Berne: Verlag der Francke-Buchhandlung, 1964.

Kember, Sarah. *Cyberfeminism and Artificial Life*. London: Routledge, 2003.

Kerlow, Isaac Victor, and Judson Rosebush. *Computer Graphics for Designers and Artists*. New York: Van Nostrand, 1986.

Kittler, Friedrich. "Fiktion und Simulation." In *Philosophien der neuen Technologie*, edited by Ars Electronica. 57–80. Berlin: Merve, 1989.

Kittler, Friedrich. "Schrift und Zahl: Die Geschichte des errechneten Bildes." In *Iconic Turn: Die neue Macht der Bilder*, edited by Christa Maar and Hubert Burda, 186–203. Cologne: DuMont, 2004.

Kittler, Friedrich, and Sara Ogger. "Computer Graphics: A Semi-Technical Introduction." *Grey Room* 2 (Winter 2001): 30–45.

Klevjer, Rune. "Model and Image: Towards a Theory of Computer Game Pepiction." Paper presented at the Annual Conference, The Philosophy of Computer Games, Oslo, 2009. Accessed September 19, 2013, http://www.hf.uio.no/ifikk/english/research/projects/thirdplace/Conferences/proceeding.

Klevjer, Rune. "What Is the Avatar? Fiction and Embodiment in Avatar-Based Singleplayer Computer Games." PhD diss., University of Bergen, 2006. Accessed September 19, 2013, http://folk.uib.no/smkrk/docs/RuneKlevjer_What%20is%20the%20Avatar_finalprint.pdf.

Knuuttila, Tarja, Martina Merz, and Erika Mattila, eds. *Computer Models and Simulations in Scientific Practice.* Special issue of *Science Studies* 19, no. 1 (2006).

Koebner, Thomas. "Rhythmus." In *Reclams Sachlexikon des Films*, edited by Thomas Koebner, 599–601. Stuttgart: Philipp Reclam, 2007.

Komosiński, Maciej. "The Framsticks System: Versatile Simulator of 3D Agents and Their Evolution." *Kybernetes: The International Journal of Systems and Cybernetics* 32, nos. 1–2 (2003): 156–73.

Komosiński, Maciej. "Framsticks: A Platform for Modeling, Simulating, and Evolving 3D Creatures." In *Artificial Life Models in Software*, edited by Andrew Adamatzky and Maciej Komosiński, 39–66. Berlin: Springer, 2005.

Komosiński, Maciej. "The World of Framsticks: Simulation, Evolution, Interaction." In *Virtual Worlds, Second International Conference*, edited by Jean-Claude Heudin, 214–24. Berlin: Springer, 2000.

Komosiński, Maciej, Grzegorz Koczyk, and Marek Kubiak. "On Estimating Similarity of Artificial and Real Organisms." *Theory in Biosciences* 120, nos. 3–4 (2001): 271–86.

Komosiński, Maciej, and Marek Kubiak. "Taxonomy in Alife: Measures of Similarity for Complex Artificial Organisms." In *Proceedings of the Sixth European Conference on Artificial Life*, edited by Josef Kelemen and Petr Sošík, 685–94. Berlin: Springer, 2001.

Komosiński, Maciej, and Ádám Rotaru-Varga. "Comparison of Different Genotype Encodings for Simulated 3D Agents." *Artificial Life Journal* 7, no. 4 (2001): 395–418.

Komosiński, Maciej, and Szymon Ulatowski. *Framsticks: Artificial Life for Real People.* Accessed August 7, 2009, http://www.framsticks.com.

Krämer, Sybille. "Form als Vollzug oder: Was gewinnen wir mit Niklas Luhmanns Unterscheidung von Medium und Form?" *Rechtshistorisches Journal* 17 (1998): 558–73.

Krämer, Sybille. "Philosophie und Neue Medien." In *Neue Realitäten: Herausforderungen der Philosophie (16. Deutscher Kongreß der Philosophie, Berlin 20.–24.9.1993)*, edited by Hans Lenk and Hans Poser. 185–89. Berlin: Akademie, 1995.

Krämer, Sybille. "Über die Rationalisierung der Visualität und die Visualisierung der Ratio. Zentralperspektive und Kalkül als Kulturtechniken des geistigen Auges." In *Bühnen des Wissens: Interferenzen von Kunst und Wissenschaft*, edited by Helmar Schramm, Hans-Christian von Herrmann, Florian Nelle, Wolfgang Schäffner, Henning Schmidgen, and Bernhard Siegert, 50–67, Berlin: Dahlem University Press, 2003.

Krämer, Sybille. "Zentralperspektive, Kalkül, Virtuelle Realität." In *Medien—Welten—Wirklichkeiten*, edited by Gianni Vattimo and Wolfgang Welsch, 27–37. Munich: Fink, 1997.

Krueger, Myron W. *Artificial Reality II*. Reading, MA: Addison-Wesley, 1991.

Krueger, Myron W. "Foreword: The Interface Will Not Disappear." *International Journal of Human-Computer Interaction* 8, no. 1 (1996): 1–3.

Krueger, Myron W. "Response Is the Medium." In *Cultural Diversity in the Global Village: The Third International Symposium on Electronic Art*, edited by Alessio Cavallaro, Ross Harley, Linda Wallace, and McKenzie Wark, 8–11. Sydney: n.p., 1992.

Krueger, Myron W. "In Richtung einer interaktiven Ästhetik." In *Timeshift: Die Welt in 25 Jahren, Ars Electronica 2004*, edited by Gerfried Stocker and Christine Schöpf, 361–63. Ostfildern-Ruit: Hatje Cantz, 2004.

Krueger, Myron W. "*Videoplace*: A Report from the Artificial Reality Laboratory." *Leonardo* 18, no. 3 (1985): 145–51.

Krueger, Myron W. "Videoplace: Eine Künstliche Realität." *Kunstforum International* 103 (September–October 1989): 210–15.

Krueger, Myron W. "Artificial Reality." In S. Joy Mountford, William A. S. Buxton, Myron W. Krueger, Brenda K. Laurel, and Laurie Vertelney. "Drama and Personality in User Interface Design." In *Proceedings of the CHI '89 Conference, Human Factors in Computing Systems, Special Issue of the Special Interest Group on Computer Human Interaction*, edited by Ken Bice and Clayton H. Lewis, 105–8. New York: ACM Press, 1989.

Krueger, Myron. [Untitled.] In Gregory P. Garvey, Myron W. Krueger, Ed Tannenbaum, and Don Ritter. Interactive Art and Artificial Reality (panel session). In *Proceedings of the ACM SIGGRAPH '90 Panel Proceedings*, edited by James T. Thomas, Judith R. Brown, and Alyce Kaprow, 7/1–7/18. New York: ACM Press, 1990.

Krueger, Myron W., Thomas Gionfriddo, and Katrin Hinrichsen. "Videoplace: An Artificial Reality." In *Human Factors in Computing Systems II: Proceedings of Computer-Human Interaction '85 Conference*, edited by Lorraine Borman and Bill Curtis, 35–40. New York: ACM Press, 1985.

Küppers, Günter, and Johannes Lenhard. "Computersimulationen: Modellierungen 2. Ordnung." *Journal for General Philosophy of Science* 36, no. 2 (September 2005): 305–29.

Kusahara, Machiko, Christa Sommerer, and Laurent Mignonneau. "Art as Living System." *Artificial Life* 40, no. 8 (1996): 16–23.

Lafon, Jacques. *Esthétique de l'image de synthèse: La trace de l'ange*. Paris and Montreal: Editions L'Harmattan, 1999.

Lakatos, Imré. *Science and Epistemology: Philosophical Papers*, vol. 2. Cambridge: Cambridge University Press, 1987.

Langton, Christopher G. "Artificial Life." In *Genetische Kunst—künstliches Leben (Ars Electronica 1993)*, edited by Karl Gerbel and Peter Weibel. 25–78. Vienna: PVS Verleger, 1993.

Langton, Christopher G. "Artificial Life." In *The Philosophy of Artificial Life*, edited by Margaret A. Boden, 39–94. Oxford: Oxford University Press, 1996.

Lasko-Harvill, Ann. "Identität und Maske in der Virtuellen Realität." In *Cyberspace: Zum medialen Gesamtkunstwerk*, edited by Florian Rötzer and Peter Weibel. 305–16. Munich: Klaus Boer, 1993.

László, Ervin. *Introduction to Systems Philosophy: Toward a New Paradigm of Contemporary Thought.* New York: Gordon and Breach, Science Publishers, 1972.

Latour, Bruno. "Visualization and Cognition: Thinking with Eyes and Hands." In *Sociology of Knowledge Studies in the Sociology of Culture Past and Present*, vol. 6. Edited by Henrika Kuklick and Elizabeth Long, 1–40. London: JAI Press, 1986.

Laurel, Brenda. *Computers as Theatre.* Boston: Addison-Wesley, 2007. First published in 1991.

Laurel, Brenda. "Interface as Mimesis." In *User Centered System Design: New Perspectives on Human-Computer Interaction*, edited by Donald A. Norman and Stephen W. Draper, 67–85. Hillsdale, NJ: Erlbaum, 1968.

Lavaud, Sophie. "Les images/systèmes: des *alter ego* autonomes." In *L'image actée: Scénarisations numériques, Parcours du séminaire L'action sur l'image*, edited by Pierre Barboza and Jean-Louis Weissberg, 237–49. Paris: Editions L'Harmattan, 2006.

Lavaud, Sophie. "L'implication du corps dans les scénographies interactives." In *Ligeia: Dossiers sur l'Art 45–48: Art et multimédia, Actes du Colloque Artmedia VIII*, edited by Raymond Hains and Richard Long, 140–45. Paris: CNRS Éditions, 2003.

Lawo, Michael, Volker Cleeves, Uwe Kühnapfel, Hüseyin K. Çakmak, Heiko Maaß, Georg Bretthauer, K. Lehmann, and Heinz J. Buhr. "Über ein neuartiges System zur Veröffentlichung von Operationsverfahren für die chirurgische Simulation unter Verwendung der virtuellen Realität." In *Computer- und Roboterassistierte Radiologie und Chirurgie: Proceedings of the First Annual Conference* (Leipzig, October 4–5, 2002). in: CURAC.science_Journal, 2002. Accessed August 2, 2004, http://www.curac.org/curac02/download/abstracts_fulllength/03_03lawo.pdf.

Le Meur, Anne-Sarah. "Création artistique en image de synthèse: expression de la corporéité." PhD diss., Université Paris VIII, 1999.

Le Meur, Anne-Sarah. "De l'expérimentation en image de synthèse." *Les Cahiers du Numérique* 1, no. 4 (2000): 145–65.

Lenhard, Johannes. "Artificial, False, and Performing Well." In *From Science to Computational Sciences: Studies in the History of Computing and Its Influence on Today's Sciences*, edited by Gabriele Gramelsberger, 165–76. Zurich: diaphanes, 2011.

Leonard, Andrew. *Bots: The Origin of New Species.* San Francisco: HardWired, 1997.

Lessing, Gotthold Ephraim. "Von dem Wesen der Fabel." In *Gotthold Ephraim Lessing. Werke 1758–1759, (= Lessing Werke und Briefe*, vol. 4). Edited by Gunter E. Grimm, 345–411. Frankfurt am Main: Deutscher Klassiker Verlag, 1997.

Lévy, Pierre. *La machine univers: Création, cognition et culture informatique.* Paris: Éditions La Découverte, 1987.

Lewin, Kurt. *Psychologie der Entwicklung und Erziehung (= Kurt-Lewin-Werkausgabe*, vol. 6). Edited by Carl-Friedrich Graumann. Berne: Verlag Hans Huber and Stuttgart: Klett-Cotta 1982.

Licklider, J. C. R., and W. Robert Taylor. "The Computer as a Communication Device." *Science and Technology* 76 (April 1968): 21–31.

Lindberg, David C. *Theories of Vision from al-Kindi to Kepler.* Chicago: University of Chicago Press, 1976.

"Live Coding." In *Wikipedia. The Free Encyclopedia.* Accessed September 20, 2008, http://en.wikipedia.org/wiki/Live_coding.

Luhmann, Niklas. "The Medium of Art." In *Essays on Self-Reference*, 215–26. New York: Columbia University Press, 1990. First published in 1986.

Luhmann, Niklas. "Medium and Form." In *Art as a Social System*, 102–32. Translated by E. M. Knodt Stanford: Stanford University Press, 2000.

Luhmann, Niklas. *Social Systems.* Translated by J. Bednarz Jr. with D. Baecker. Stanford: Stanford University Press, 1995. First published in 1984.

Luhmann, Niklas. "Temporalstrukturen des Handlungssystems: Zum Zusammenhang von Handlungs- und Systemtheorie." In *Soziologische Aufklärung*, vol. 3, 126–50. Opladen: Westdeutscher Verlag, 1993.

Luhmann, Niklas. *Theory of Society.* 2 Vols. Translated by R. Barrett. Stanford: Stanford University Press, 2012 and 2013. First published in 1997.

Lunenfeld, Peter. "Digital Photography: The Dubitative Image." In *Snap to Grid: A User's Guide to Digital Arts, Media, and Cultures*, 55–69. Cambridge, MA: MIT Press, 2000.

Maiß, Jürgen, C. Dumser, Yurdagül Zopf, Andreas Naegel, Norbert Krauss, Jürgen Hochberger, Kai Matthes, et al. "Hemodynamic Efficacy of Two Endoscopic Clip Devices Used in the Treatment of Bleeding Vessels, Tested in an Experimental Setting Using the Compact Erlangen Active Simulator for Interventional Endoscopy (compactEASIE) Training Model." *Endoscopy* 38, no. 6 (2006): 575–80.

Maiß, Jürgen, Johannes Wiesnet, Andreas Proeschel, Kai Matthes, Frederic Prat, Jonathan Cohen, Stanislas Chaussade, et al. "Objective Benefit of a 1-Day Training Course in Endoscopic Hemostasis Using the ›compactEASIE‹ Endoscopy Simulator." *Endoscopy* 37, no. 6 (2005): 552–58.

Mann, Robert W. "Computer Aided Surgery." In *Technology—a Bridge to Independence: Proceedings of the Eighth Annual Conference on Rehabilitation Technology*, edited by Cliff Brubaker, 160–62. Memphis: Rehabilitation Engineering and Assistive Technology Society of North America, 1985.

Manovich, Lev. *The Language of New Media.* Cambridge, MA: MIT Press, 2001.

Manovich, Lev. *Software Takes Command*. New York: Bloomsbury, 2013.

Marshall, Alan John. *Bower-Birds: Their Displays and Breeding Cycles*. Oxford: Claredon Press, 1954.

Massumi, Brian. "The Political Economy of Belonging and the Logic of Relation." In *Parables for the Virtual: Movement, Affect, Sensation*, 68–88. Durham, NC: Duke University Press, 2002.

Massumi, Brian. "The Thinking-Feeling of What Happens." In *Interact or Die!* edited by Joke Brouwer and Arjen Mulder, 70–91. Exhibition catalogue, Dutch Electronic Art Festival 2007, Rotterdam, April 10–29, 2007. Rotterdam: V2_Publishing and Nai Publishers, 2007.

Matthes, Kai, Jonathan Cohen, Michael L. Kochman, Maurice A. Cerulli, Kinjal C. Vora, and Jürgen Hochberger. "Efficacy and Costs of a One-Day Hands-On EASIE Endoscopy Simulator Train-the-Trainer Workshop." *Gastrointestinal Endoscopy* 62, no. 6 (2005): 921–27.

Mayröcker, Friederike. "30.9. ('über die Sturzengel')." In *brüll oder Die seufzenden Gärten*, 39–44. Frankfurt am Main: Suhrkamp, 1998.

Meiffert, Torsten. "Implantation oder Konvenienz: Zum Charakter der Informationstechnologien." In *Bildmaschinen und Erfahrung*, edited by BILDO_Akademie, 29–37. Berlin: Edition Hentrich, 1990.

"Menagerie (1993): An Immersive Virtual World." In *Tumbling Sparks*. Accessed December 15, 2006, http://www.tumblingsparks.com/projects_past_menagerie.php.

Merleau-Ponty, Maurice. *Phenomenology of Perception*. Translated by C. Smith. London: Routledge, 1962. First published in 1945.

Metzger, Wolfgang. "Grundbegriffe der Gestaltpsychologie." In *Gestalt-Psychologie: ausgewählte Werke aus den Jahren 1950–1982*, edited by Michael Stadler and Heinrich Crabus, 124–33. Frankfurt am Main: Verlag Dr. Waldemar Kramer, 1986. First published in 1954.

Meyer, Jean-Arcady, and Stewart W. Wilson eds. *From Animals to Animats: Proceedings of the First International Conference on Simulation of Adaptive Behavior*. Cambridge, MA: MIT Press, 1990.

Mignonneau, Laurent, and Christa Sommerer. "Designing Emotional, Metaphoric, Natural and Intuitive Interfaces for Interactive Art, Edutainment and Mobile Communications." *Computers and Graphics* 29 (2005): 840–42.

Mitchell, W. J. Thomas. "Addressing Media." In *What Do Pictures Want? The Lives and Loves of Images*, 201–21. Chicago: University of Chicago Press, 2005.

Mitchell, W. J. Thomas. *Picture Theory: Essays on Verbal and Visual Representation*. Chicago: University of Chicago Press, 1994.

Moles, Abraham A. *Art et ordinateur*. Paris: Casterman, 1971.

Moles, Abraham A. *Kunst und Computer*. Cologne: M. DuMont Schauberg, 1973.

Moles, Abraham A. "La cybernétique est une révolution secrète." In *Cybernétique—Electronique—Automation*, vol. 8 of *L'Ere Atomique—Encyclopédie des Sciences Modernes*, 5–9. Geneva: Éditions René Kister 1960.

Morgan, Anne Barclay. "Interactivity in the Electronic Age." *Sculpture* 10, no. 3 (May–June 1991): 36–43.

Morgan, Anne Barclay. "Interactivity: From Sound to Motion to Narrative." *Art Papers* 15 (1991): 7–11.

Morgan, Mary S. "Experiments without Material Intervention: Model Experiments, Virtual Experiments, and Virtually Experiments." In *The Philosophy of Scientific Experimentation*, edited by Hans Radder, 216–35. Pittsburgh: University of Pittsburgh Press, 2003.

Morgan, Mary S., and Margaret Morrison, eds. *Models as Mediators: Perspectives on Natural and Social Sciences*. Cambridge: Cambridge University Press, 1999.

Morrison, Margaret. "Modelling Nature: Between Physics and the Physical World." *Philosophia Naturalis* 35, no. 1 (1998): 65–85.

Morrison, Margaret. "Models as Autonomous Agents." In *Models as Mediators: Perspectives on Natural and Social Sciences*, edited by Mary Morgan and Margaret Morrison, 38–65. Cambridge: Cambridge University Press, 1999.

Morrison, Margaret, and Mary S. Morgan. "Introduction." In *Models as Mediators: Perspectives on Natural and Social Sciences*, edited by Mary Morgan and Margaret Morrison, 1–9. Cambridge: Cambridge University Press, 1999.

Morrison, Margaret, and Mary S. Morgan. "Models as Mediating Instruments." In *Models as Mediators: Perspectives on Natural and Social Sciences*, edited by Mary Morgan and Margaret Morrison, 10–37. Cambridge: Cambridge University Press, 1999.

Morse, Margaret. "The Body, the Image, and the Space-in-Between: Video Installation Art." In *Virtualities: Television, Media Art and Cyberculture*, 155–77. Bloomington: Indiana University Press, 1998.

Morse, Margaret. "Cyberscapes, Control, and Transcendence: The Aesthetics of the Virtual." In *Virtualities: Television, Media Art and Cyberculture*, 178–211. Bloomington: Indiana University Press, 1998.

Morse, Margaret. "The Poetics of Interactivity." In *Women, Art, and Technology*, edited by Judy Malloy, 16–33. Cambridge, MA: MIT Press, 2003.

Morse, Margaret. "Virtualities: A Conceptual Framework." In *Virtualities: Television, Media Art and Cyberculture*, 3–35. Bloomington: Indiana University Press, 1998.

Müller, Axel. *Die ikonische Differenz: Das Kunstwerk als Augenblick*. Munich: Fink, 1997.

Müller, Matthias, Simon Schirm, and Matthias Teschner. "Interactive Blood Simulation for Virtual Surgery Based on Smoothed Particle Hydrodynamics." *Journal of Technology and Health Care* 12, no. 1 (2004): 25–32.

Müller, Matthias, Simon Schirm, Matthias Teschner, Bruno Heidelberger, and Markus H. Gross. "Interaction of Fluids with Deformable Solids." *Journal of Computer Animation and Virtual Worlds* 15, nos. 3–4 (2004): 159–71.

Müller, Matthias, and Matthias Teschner. "Volumetric Meshes for Real-Time Medical Simulations." In *Bildverarbeitung für die Medizin: Algorithmen—Systeme—Anwendungen (CEUR Workshop Proceedings, Erlangen March 9 –11, 2003)*, edited by Thomas Wittenberg, Peter Hastreiter, Ulrich Hoppe, Heinz Handels, Alexander Horsch, and Hans-Peter Meinzer, 279–83. Berlin: Springer, 2003.

Mundt, Katrin. "Fuchs-Eckermann." In *Games: computerspiele von künstlerInnen*. Edited by Hartware Medien Kunst Verein and Tilman Baumgärtel, 60–61. Exhibition catalogue, Hartware MedienKunstVerein, PHOENIX Halle Dortmund-Hörde, October 11–November 30, 2003. Frankfurt am Main: Revolver Publishing, 2003.

Murray, Janet. *Hamlet on the Holodeck: The Future of Narrative in Cyberspace*. Cambridge, MA: MIT Press, 1997.

Murray, Janet. *Inventing the Medium: A Principled Approach to Interactive Design*. Cambridge, MA: MIT Press, 2002.

Nake, Frieder. "Algorithmus, Bild und Pixel: Das Bild im Blickfeld der Informatik." In *Bildwissenschaft zwischen Reflexion und Anwendung*, edited by Klaus Sachs-Hombach. 101–21. Cologne: Herbert von Halem Verlag, 2005.

Nake, Frieder. "Das doppelte Bild." *Bildwelten des Wissens. Kunsthistorisches Jahrbuch für Bildkritik* 3, no. 2 (2005): 40–50.

Nake, Frieder. "The Display as a Looking-Glass: Zu Ivan E. Sutherlands früher Vision der grafischen Datenverarbeitung." In *Geschichten der Informatik: Visionen, Paradigmen, Leitmotive*, edited by Hans Dieter Hellige, 339–65. Berlin: Springer, 2004.

Nake, Frieder. "Künstliche Kunst: In der Welt der Berechenbarkeit." *Kunstforum International* 98 (January–February 1989): 85–94.

Nake, Frieder, and Susanne Grabowski. "Zwei Weisen, das Computerbild zu betrachten." In *HyperKult II: Zur Ortsbestimmung analoger und digitaler Medien*, edited by Martin Warnke, Wolfgang Coy, and Georg Christoph Tholen, 123–49. Bielefeld: transcript, 2005.

Nance, Richard E., and Robert G. Sargent. "Perspectives on the Evolution of Simulation." *Operations Research* 50, no. 1 (January–February 2002): 161–72.

Neitzel, Britta. "Point of View und Point of Action—eine Perspektive auf die Perspektive in Computerspielen." *Hamburger Hefte zur Medienkultur* 5 (2007): 8–28.

Neitzel, Britta. "Videospiele—zwischen Fernsehen und Holodeck." In *TV-Trash: The TV-Show I Love to Hate*, edited by Ulrike Bergermann and Hartmut Winkler, 107–22. Marburg: Schüren, 2000.

Neitzel, Britta. "Wer bin ich? Zur Avatar-Spieler Bindung." In *'See? I'm real ...': Multidisziplinäre Zugänge zum Computerspiel am Beispiel von 'Silent Hill,'* edited by Matthias Bopp, Britta Neitzel and Rolf F. Nohr, 193–209. Münster: Lit, 2004.

Neunzert, Helmut. "Mathematik und Computersimulation: Modelle, Algorithmen, Bilder." In *Simulation: Computer zwischen Experiment und Theorie*, edited by Valentino Braitenberg and Inga Hosp, 44–55. Reinbek bei Hamburg: Rowohlt, 1995.

Norberg, Björn. "It's Real and It's Alive." In *Get Real: Real Time + Art*, edited by Morten Søndergaard, Perttu Rastas, and Björn Norberg, 99–106. New York: George Braziller, Inc, 2005.

Oliver, Julian. "Ideas." May 5, 2007, Blog. Accessed November 28, 2007, http://selectparks.net/~julian.

Oppenheimer, Peter. "The Irony of Virtual Flesh." In *Semiotic Flesh: Information and the Human Body*, edited by Phillip Thurtle and Robert Mitchell, 48–51. Seattle: University of Washington Press, 2002.

Paech, Joachim. "Der Bewegung einer Linie folgen" In *Bild—Medium—Kunst*, edited by Yvonne Spielmann and Gundolf Winter, 35–44. Munich: Fink, 1999.

Paget, Rupert. "An Automatic 3D Texturing Framework." In *Proceedings of the Fourth International Workshop on Texture Analysis and Synthesis*, edited by Mike Chantler and Ondrej Drbohlav, 1–6. Edinburgh: Heriot-Watt University, 2005.

Paget, Rupert, Matthias Harders, and Gábor Székely. "A Framework for Coherent Texturing in Surgical Simulators." In *Proceedings of the Thirteenth Pacific Conference on Computer Graphics and Applications*, 112–14. Macao: n.p., 2005.

Panofsky, Erwin. *Perspective as Symbolic Form*. Translated by C. S. Wood. New York: Zone Books, 1991. First published in 1927.

Peacock, Alan. "Towards an Aesthetic of 'the Interactive.'" *Digital Creativity* 12, no. 4 (2001): 237–46.

Perniola, Mario. "Icone, visioni, simulacri." In *La società dei simulacri*, 115–29. Bologna: Cappelli Editore, 1983.

Perniola, Mario. *La società dei simulacri*. Bologna: Cappelli Editore, 1983.

Perrot, Jean-François. Foreword to *Multi-Agent Systems: An Introduction to Distributed Artificial Intelligence*, by Jacques Ferber xiii—xix. Reading, MA: Addison-Wesley, 1999. First published in 1995.

Phillips Mahoney, Diana: "Simulating Medical Emergencies." *Computer Graphics World* 20, no. 8 (August 1997): 95–96.

Pias, Claus. "Bilder der Steuerung." In *Bild Medien Wissen: Visuelle Kompetenz im Medienzeitalter*, edited by Hans Dieter Huber, Bettina Lockemann, and Michael Scheibel, 47–67. Munich: kopaed VerlagsGmbH, 2002.

Pias, Claus. "Das digitale Bild gibt es nicht: Über das (Nicht-)Wissen der Bilder und die informatische Illusion." *Seitenblicke* 2, no. 1 (2003). Accessed June 1, 2013, http://www.zeitenblicke.historicum .net/2003/01/pias/index.html.

Pickering, Andrew. *The Mangle of Practice: Time, Agency, and Science*. Chicago: University of Chicago Press, 1995.

Plessner, Helmuth. "Zur Hermeneutik nichtsprachlichen Ausdrucks." In *Ausdruck und menschliche Natur*. vol. 7 of *Gesammelte Schriften*, 459–77. Frankfurt am Main: Suhrkamp, 1982. First published in 1967.

Pochat, Götz. "Erlebniszeit und bildende Kunst." In *Augenblick und Zeitpunkt: Studien zur Zeitstruktur und Zeitmetaphorik in Kunst und Wissenschaften*, edited by Christian W. Thomsen and Hans Holländer, 22–46. Darmstadt: Wissenschaftliche Buchgesellschaft, 1984.

Pocock, Antonia. "Figurative/Figural." Accessed May 29, 2014, http://lucian.uchicago.edu/blogs/ mediatheory/keywords/figurativefigural/

Pörksen, Uwe. "Die Umdeutung von Geschichte in Natur: Das metaphorische Kunststück der Übertragung und Rückübertragung." *Gegenworte. Zeitschrift für den Disput über Wissen* 9 (Spring 2002): 12–17.

Pößneck, Antje, Edgar Nowatius, Christos Trantakis, Hüseyin Çakmak, Heiko Maaß, Uwe Kühnapfel, Andreas Dietz, and Gero Strauß. "A Virtual Training System in Endoscopic Sinus Surgery." In *Proceedings of the Fourth International Workshop on Texture Analysis and Synthesis,* edited by Heinz U. Lemke, Kiyonari Inamura, Kunio Doi, Michael W. Vannier, and Allan G. Farman, 527–30. Amsterdam: Elsevier, 2005.

Polaine, Andrew. "The Flow Principle in Interactivity." In *Proceedings of the Second Australasian Conference on Interactive Entertainment,* edited by Yusuf Pisan, 151–58. Sydney: Creativity & Cognition Studios Press, 2005.

Polaine, Andrew. "The Playfulness of Interactivity." In *Proceedings of the Fourth International Conference on Design and Emotion 2004,* edited by Aren Kurtgözü. [CD-ROM]. Ankara: Middle East Technical University and Design and Innovation Society Ankara, 2004.

Popper, Frank. *Art of the Electronic Age.* London: Thames & Hudson, 1993.

Popper, Frank. *From Technological to Virtual Art.* Cambridge, MA: MIT Press, 2007.

Popper, Frank. "Les images artistiques de la technoscience." In *Faire Image, Les Cahiers de Paris VIII,* 135–53. Saint-Denis: Presses Universitaires de Vincennes, 1989.

Prehn, Horst. "Der vernetzte Blick." In *COMTEC art '99,* edited by Klaus Nicolai and Dresden Kulturamt, 179–81. Exhibition catalogue, III. Festival für computergestützte Kunst und interdisziplinäre Medienprojekte, Dresden, November 11–25, 1999. Dresden: Kulturamt der Landeshauptstadt Dresden, 1999.

Prusinkiewicz, Przemyslaw. "In Search of the Right Abstraction: The Synergy between Art, Science and Information Technology in the Modeling of Natural Phenomena." In *Art@Science,* edited by Christa Sommerer and Laurent Mignonneau, 60–68. Vienna: Springer, 1998.

Püttmann, Dietmar. "Künstliches Leben: Simulation und Visualisierung durch ein verteiltes Multiagenten-System." Master's thesis, University of Karlsruhe, 2000.

Quéau, Philippe. *Éloge de la simulation: De la vie des langages à la synthèse des images.* Seyssel: Champ-Vallon and Institut national de la communication audiovisuelle, 1986.

Quéau, Philippe. *Metaxu: Théorie de l'art intermédiaire.* Paris: Champ-Vallon-INA, 1989.

Quéau, Philippe: *Le virtuel: Vertus et vertiges.* Seyssel: Champ Vallon and Institut national de la communication audiovisuelle, 1993.

Quinz, Emanuele. "Dell'invisibile: Note sull'esperienza interattiva." In *Invisibile,* edited by Christine Buci-Glucksmann, Luca Marchetti, Marco Pierini, and Emanuele Quinz, 19–37. Exhibition catalogure, Palazzo delle Papesse, Centro d'Arte Contemporanea, Siena October 9, 2004–January 9, 2005. Siena: Gli Ori, 2004.

Quinz, Emanuele. "Scènes virtuelles du corps." In *L'art à l'époque du virtuel,* edited by Christine Buci-Glucksmann, 187–96. Paris: Editions L'Harmattan, 2003.

Rampley, Matthew. "Systems Aesthetics: Burnham and Others." *vector [e-zine]* 12 (January 2005). Accessed July 24, 2008, http://virose.pt/vector/b_12/rampley.html.

Rapoport, Anatol. *Allgemeine Systemtheorie: Wesentliche Begriffe und Anwendungen.* Darmstadt: Verlag Darmstädter Blätter, 1988.

Rasmussen, Steen, and Christopher L. Barrett. "Elements of a Theory of Simulation." In *Advances in Artificial Life: Proceedings of the Third European Conference on Artificial Life*, edited by Federico Morán, Alvaro Moreno, Juan Julián Merelo, and Pablo Chacón, 515–29. Berlin: Springer, 1995.

Raulet, Gérard. "Bildsein ohne Ähnlichkeit." In *Wahrnehmung und Geschichte: Markierungen zur Aisthesis materialis*, edited by Bernhard J. Dotzler and Ernst Müller, 165–77. Berlin: Akademie, 1995.

Reiche, Claudia. "'Dual Use'? High Tech für militärische und zivile Nutzungen in Medizin und Kunst." In *Industrialisierung: Technologisierung von Kunst und Wissenschaft*, edited by Elke Bippus and Andrea Sick, 42–61. Bielefeld: transcript, 2006.

Reichle, Ingeborg. *Kunst aus dem Labor: Zum Verhältnis von Kunst und Wissenschaft im Zeitalter der Technoscience.* Vienna: Springer, 2004.

Reifenrath, André. "Geschichte der Simulation." PhD diss., Humboldt Universität Berlin, 2000. Accessed March 4, 2007, http://www.zacklos.de.

Repenning, Alex. "Programming Substrates to Create Interactive Learning Environments." *Interactive Learning Environments* 4, no. 1 (1994): 45–75.

"Reverse Engineering." In *Wikipedia. Die freie Enzyklopädie.* Accessed September 13, 2008. http://de.wikipedia.org/wiki/Reverse_Engineering.

Rheinberger, Hans-Jörg. *Experimentalsysteme und epistemische Dinge: Eine Geschichte der Proteinsynthese im Reagenzglas.* Göttingen: Wallstein, 2001.

Rheinberger, Hans-Jörg. "Objekt und Repräsentation." In *Mit dem Auge denken: Strategien der Sichtbarmachung in wissenschaftlichen und virtuellen Welten*, edited by Jörg Huber and Bettina Heintz. 55–61. Vienna: Springer, 2001.

Rieder, William G. "Simulation and Modeling." In *Encyclopedia of Physical Science and Technology*, edited by Robert A. Meyers, vol. 12, 659–79. New York: Academic Press, 1987.

Riegas, Volker, and Christian Vetter. "Gespräch mit Humberto R. Maturana." In *Zur Biologie der Kognition: Ein Gespräch mit Humberto R. Maturana und Beiträge zur Diskussion seines Werkes*, edited by Volker Riegas and Christian Vetter, 11–90. Frankfurt am Main: Suhrkamp, 1990.

Rieger, Stefan. *Kybernetische Anthropologie: Eine Geschichte der Virtualität.* Frankfurt am Main: Suhrkamp, 2003.

Riegl, Alois. *Gesammelte Aufsätze.* Augsburg: Dr. Benno Filser, 1929.

Rilke, Rainer Maria. *The Notebooks of Malte Laurids Brigge.* Translated by B. Pike. Champaign: Dalkey Archive Press, 2008. First published in 1910.

Rodler, Hieronymus. *Eyn schön nützlich büchlin und underweisung der kunst des Messens*. Simmern, 1531.

Rötzer, Florian. "Synergie von Mensch und Maschine. Friedrich Kittler im Gespräch mit Florian Rötzer." *Kunstforum International* 98 (January–February 1989): 108–17.

Rötzer, Florian. "Virtual Worlds: Fascinations and Reactions." In *Critical Issues in Electronic Media*, edited by Simon Penny, 119–31. New York: SUNY Press, 1995.

Rötzer, Florian. "Von der Darstellung zum Ereignis: Spekulative Bemerkungen." In *Was heißt 'Darstellen'?*, edited by Christiaan L. Hart Nibbrig, 49–79. Frankfurt am Main: Suhrkamp, 1994.

Rohrlich, Fritz. "Computer Simulation in the Physical Sciences." In *PSA 1990: Proceedings of the Biennial Meeting of the Philosophy of Science Association*, vol. 2: *Symposia and Invited Papers*, edited by Arthur Fine, Micky Forbes, and Linda Wessels, 507–18. East Lansing: Philosophy of Science Association, 1990.

Rokeby, David. "Transforming Mirrors: Subjectivity and Control in Interactive Media." In *Critical Issues in Electronic Media*, edited by Simon Penny, 133–58. New York: SUNY Press, 1995.

Rosebush, Judson. "The Proceduralist Manifesto." *Leonardo*, Supplemental Issue: Computer Art in Context. SIGGRAPH '89 Art Show Catalog, (1989): 55–56.

Rotman, Brian. *Signifying Nothing: The Semiotics of Zero*. New York: St. Martin's Press, 1987.

Sano, Koji, and Hiroki Sayama. "Wriggraph: A Kinetic Graph Model that Uniformly Describes Ontogeny and Motility of Artificial Creatures." In *Artificial Life X: Proceedings of the Tenth International Conference on the Simulation and Synthesis of Living Systems*, edited by Luis Mateus Rocha, Larry S. Yaeger, Mark A. Bedau, Dario Floreano, Robert L. Goldstone, and Alessandro Vespignani, 77–83. Cambridge, MA: MIT Press, 2006.

Santaella-Braga, Lucia. "Penser l'interactivité à la lumière du dialogisme." In *Communautés virtuelles: penser et agir en réseau*, edited by Serge Proulx, Louise Poissant, and Michel Sénécal, 147–64. Sainte-Foy: Presses de l'Université Laval, 2006.

Sartre, Jean-Paul. *Being and Nothingness: An Essay on Phenomenological Ontology*. Translated by H. E. Barnes. New York: Philosophical Library, 1956. First published in 1943.

Satava, Richard M. "Accomplishments and Challenges of Surgical Simulation." *Surgical Endoscopy* 15, no. 3 (2001): 232–41.

Satava, Richard M. "Disruptive Visions." *Surgical Endoscopy* 16, no. 10 (2002): 1403–8.

Satava, Richard M. "Disruptive Visions." *Surgical Endoscopy* 18, no. 9 (2004): 1297–98.

Schaub, Harald. "Künstliche Seelen—Die Modellierung psychischer Prozesse." *Widerspruch. Münchner Zeitschrift für Philosophie* 29 (1996): 56–82.

Schindler, Irene. *UNIQUE. Dastellung und Animation computergenerierter Gesichtsmodelle in 3D zur Simulation von Mimik und Emotionen mit Anbindung an ein psychologisches Modell*. Saarbrücken: VDM, 2008.

Schmeiser, Leonhard. *Die Erfindung der Zentralperspektive und die Entstehung der neuzeitlichen Wissenschaft.* Munich: Fink, 2002.

Schmitt, Antoine. "Manifesto of the Artwork on Computer." In *Invisibile,* edited by Christine Buci-Glucksmann, Luca Marchetti, Marco Pierini, and Emanuele Quinz, 209–212. Exhibition catalogue, Palazzo delle Papesse, Centro d'Arte Contemporanea, Siena, October 9, 2004–January 9, 2005. Siena: Gli Ori, 2004.

Schmitz, Norbert M. "Bewegung als symbolische Form." In *Über Bilder sprechen: Positionen und Perspektiven der Medienwissenschaft,* edited by Heinz-B. Heller, Matthias Kraus, Thomas Meder, Karl Prümm and Hartmut Winkler, 79–95. Marburg: Schüren, 2000.

Schwarz, Hans-Peter. *Medien—Kunst—Geschichte: Medienmuseum ZKM.* Munich: Prestel, 1997.

Schwingeler, Stephan. *Die Raummaschine: Raum und Perspektive im Computerspiel.* Boizenburg: vwh, 2008.

Sénécal, Michel. "Interactivité et interaction: sens, usages et pratiques." In *Communautés virtuelles: penser et agir en réseau,* edited by Serge Proulx, Louise Poissant, and Michel Sénécal, 133–46. Sainte-Foy: Presses de l'Université Laval, 2006.

Shapiro, Jeremy J. "Digitale Simulation: Theoretische und geschichtliche Grundlagen." In *bildklangwort. Grundlagenwissen Gestaltung 1,* edited by Thomas Friedrich and Ruth Dommaschk, 158–76. Münster: Lit, 2005.

Shin, Seung-Chol. *Vom Simulakrum zum Bildwesen: Ikonoklasmus der virtuellen Kunst.* Vienna: Springer, 2012.

Sierra, Raimundo, Michael Bajka, and Gábor Székely. "Evaluation of Different Pathology Generation Strategies for Surgical Training Simulators." In *Proceedings of the Seventeenth International Congress and Exhibition on Computer Assisted Radiology and Surgery,* edited by Heinz U. Lemke, Kiyonari Inamura, Michael W. Vannier, Allan G. Farman, Kunio Doi, and Johan H. C. Reiber, 376–81. Amsterdam: Elsevier, 2003.

Sierra, Raimundo, Michael Bajka, and Gábor Székely. "Pathology Design for Surgical Training Simulators." In *Proceedings of the International Symposium on Surgery Simulation and Soft Tissue Modeling,* edited by Nicholas Ayache and Herve Delingette, 375–84. Berlin: Springer, 2003.

Sierra, Raimundo, Michael Bajka, and Gábor Székely. "Pathology Growth Model Based on Particles." In *Proceedings of the Sixth International Conference on Medical Image Computing and Computer-Assisted Intervention,* edited by Randy E. Ellis and Terry M. Peters, 25–32. Berlin: Springer, 2003.

Sierra, Raimundo, Gábor Székely, and Michael Bajka. "Generation of Pathologies for Surgical Training Simulators." In *Proceedings of the Fifth International Conference on Medical Image Computing and Computer-Assisted Intervention,* part II, edited by Takeyoshi Dohi and Ron Kikinis, 202–10. Berlin: Springer, 2002.

Sierra, Raimundo, János Zátonyi, Michael Bajka, Gábor Székely, and Matthias Harders. "Hydrometra Simulation for VR-Based Hysteroscopy Training." In *Proceedings of the Eighth International Conference on*

Medical Image Computing and Computer-Assisted Intervention, edited by James S. Duncan and Guido Gerig, 575–82. Berlin and Heidelberg: Springer, 2005.

Sierra, Raimundo, Gabriel Zsemlye, Gábor Székely, and Michael Bajka. "Generation of Variable Anatomical Models for Surgical Training Simulators." *Medical Image Analysis* 10, no. 2 (2006): 275–85.

Sims, Karl. "Evolving 3D Morphology and Behavior by Competition." *Artificial Life* 1 (1994): 353–72.

Sims, Karl. "Evolving Virtual Creatures." In *Proceedings of the Twentyfirst International ACM Conference on Computer Graphics and Interactive Techniques*, edited by Andrew Glassner, 15–22. New York: ACM SIGGRAPH, 1994

"Simulacrum." In *The Oxford English Dictionary*, vol. 15, edited by E. S. C. Weiner, 502. Oxford: Clarendon Press, 1989.

"Simulation." In *Deutsches Wörterbuch*, vol. 5, edited by Brockhaus and Gerhard Wahrig, 772. Wiesbaden: F. A. Brockhaus and Deutsche Verlags-Anstalt, 1983.

"Simulation." In *Der Brockhaus: Computer und Informationstechnologie. Hardware, Software, Multimedia, Internet, Telekommunikation*, edited by Walter Greulich, 811. Mannheim: F. A. Brockhaus, 2003.

"Simulation." In *Der Brockhaus: Naturwissenschaft und Technik*, vol. 3, edited by Ulrich Kilian, 1799–1800. Mannheim: F. A. Brockhaus and Spektrum Adademischer Verlag, 2003.

Sismondo, Sergio. "Models, Simulations, and Their Objects." *Science in Context* 12 (1999): 247–60.

Snow, Charles Percy. *The Two Cultures and a Second Look: An Expanded Version of the Two Cultures and the Scientific Revolution*. Cambridge: Cambridge University Press, 1965.

Sohn, Dongyoung, and Byung-Kwan Lee. "Dimensions of Interactivity: Differential Effects of Social and Psychological Factors." *Journal of Computer-Mediated Communication* 10, no. 3 (2005). Accessed November 1, 2007, http://jcmc.indiana.edu/vol10/issue3/sohn.html.

Sommerer, Christa, and Laurent Mignonneau. "The Application of Artificial Life to Interactive Computer Installations." *Artificial Life and Robotics* 2, no. 4 (1998): 151–56.

Sommerer, Christa, and Laurent Mignonneau. "'A-Volve': An Evolutionary Artificial Life Environment. In *Artificial Life V: Proceedings of the Fifth International Workshop on the Synthesis and Simulation of Living Systems*, edited by Christopher G. Langton and Katsunori Shimohara, 167–75. Cambridge, MA: MIT Press, 1997.

Sommerer, Christa, and Laurent Mignonneau. "A-Volve: Designing Complex Systems for Interactive Art." In *ARt&D: Research and Development in Art*, edited by Joke Brouwer, Arjen Mulder, Anne Nigten, and Laura Martz, 208–23. Rotterdam: V2_Nai Publishers, 2005.

Sommerer, Christa, and Laurent Mignonneau. "A-Volve: A real-time interactive environment." In *Interactive Art Works 1992–2006*. Accessed December 11, 2007. http://www.interface.ufg.ac.at/christa-laurent/WORKS/CONCEPTS/A-VolveConcept.html.

Sommerer, Christa, and Laurent Mignonneau. *Interactive Art Research*. Vienna: Springer, 2009.

Sommerer, Christa, and Laurent Mignonneau. "Interacting with Artificial Life: A-Volve." *Complexity* 2, no. 6 (1997): 13–21.

Soulages, François. "Le travail de l'inconscient et l'art de l'ordinateur." In *Ligeia. Dossiers sur l'Art 45–48: Art et multimédia, Actes du Colloque Artmedia VIII, July—December 2003*, edited by Raymond Hains and Richard Long, 233–37. Paris: CNRS Éditions, 2003.

Spencer-Brown, George. *Laws of Form*. London: Allen & Unwin, 1969.

Spielmann, Yvonne. *Video: The Reflexive Medium*. Cambridge, MA: MIT Press, 2010. First published in 2005.

Spies, Christian. *Die Trägheit des Bildes: Bildlichkeit und Zeit zwischen Malerei und Video*. Munich: Fink, 2007.

Stachowiak, Herbert. *Allgemeine Modelltheorie*. Vienna: Springer, 1973.

Stansfield, Sharon, Daniel Shawver, Annette Sobel, Monica Prasad, and Lydia Tapia. "Design and Implementation of a Virtual Reality System and Its Application to Training Medical First Responders." *Presence* 9, no. 6 (December 2000): 524–56.

Steinbuch, Karl. "Kybernetik: Weg zu einer neuen Einheit der Wissenschaften." *VDI-Zeitschrift* 104, no. 25 (September 11, 1962): 1307–14.

Stelarc. "From Psycho-Body to Cyber-Systems: Images as Post-human Entities." In *Virtual Futures: Cyberotics, Technology and Post-Human Pragmatism*, edited by Joan Broadhurst Dixon and Eric J. Cassidy, 116–23. London: Routledge, 1998.

Steuer, Jonathan S. "Defining Virtual Reality: Dimensions Determining Telepresence." *Journal of Communication* 42, no. 4 (1992): 73–93.

Stoichita, Victor I. *Das Selbstbewußte Bild: Vom Ursprung der Metamalerei*. Munich: Fink, 1998. First published in 1989.

Stoichita, Victor I. *The Self-Aware Image: An Insight into Early Modern Meta-Painting*. Cambridge: Cambridge University Press, 1996. First published in 1989.

Stoop, Karl. "Der zeitliche Ablauf der Simulation." In *Digitale Simulation*, edited by Kurt Bauknecht and Walter Nef, 72–85. Berlin: Springer, 1971.

Strothotte, Christine, and Thomas Strothotte. *Seeing between the Pixels: Pictures in Interactive Systems*. Berlin: Springer, 1997.

Suárez, Mauricio. "The Role of Models in the Application of Scientific Theories: Epistemological Implications." In *Models as Mediators: Perspectives on Natural and Social Sciences*, edited by Mary S. Morgan and Margaret Morrison. 168–96. Cambridge: Cambridge University Press, 1999.

Suárez, Mauricio. "Theories, Models, and Representations." In *Model-Based Reasoning in Scientific Discovevy*, edited by Lorenzo Magnani, Nancy Nersessian and Paul Thagard, 75–83. New York: Plenum, 1999.

Suárez, Mauricio. "Scientific Representation: Against Similarity and Isomorphism." *International Studies in the Philosophy of Science* 17, no. 3 (2003): 225–44.

Suchman, Lucy A. *Plans and Situated Actions: The Problem of Human-Machine Communication.* Cambridge: Cambridge University Press, 1987.

Sundar, S. Shyam. "Theorizing Interactivity's Effects." *Information Society* 20, no. 5 (November–December 2004): 387–91.

Suppes, Patrick. "Models of Data." In *Logic, Methodology and Philosophy of Science,* edited by Ernest Nagel, Patrick Suppes and Alfred Tarski, 252–61. Stanford: Stanford University Press, 1962.

Syrjakow, Michael. "Web- und Komponenten-Technologien in der Modellierung und Simulation: Neue Möglichkeiten der Modellerstellung, -ausführung und -optimierung." Habilitation thesis, University of Karlsruhe, 2003. Accessed May 24, 2007, http://ces.univ-karlsruhe.de/goethe/syrjakow/publications/habilitation/habilitation.pdf.

Syrjakow, Michael, Jörg Berdux, and Helena Szczerbicka. "Interactive Webbased Animations for Teaching and Learning." In *Proceedings of the Winter Simulation Conference , Orlando December 10–13, 2000,* edited by Jeffrey A. Joines, Russell R. Barton, Keebom Kang, and Paul A. Fishwick, 1651–59. Piscataway, NJ: Institute of Electrical and Electronics Engineers, 2000.

Syrjakow, Michael, Jörg Berdux, Dietmar Püttmann, and Helena Szczerbicka. "Simulation and Visualization of Distributed Artificial Life Scenarios." In *Intelligence in a Materials World: Selected Papers from the Third International Conference on Intelligent Processing and Manufacturing of Materials,* edited by John A. Meech, Marcello M. Veiga, Yoshiyuki Kawazoe, and Steven R. LeClair, 261–70. Boca Raton, FL: CRC Press, 2003.

Szczerba, Dominik, and Gábor Székely. "Macroscopic Modeling of Vascular Systems." In *Proceedings of the Fifth International Conference on Medical Image Computing and Computer-Assisted Intervention,* part II, edited by Takeyoshi Dohi and Ron Kikinis, 284–92. Berlin: Springer, 2002.

Szczerba, Dominik, and Gábor Székely. "Computational Model of Flow-Tissue Interactions in Intussusceptive Angiogenesis." *Journal of Theoretical Biology* 234, no. 1 (2005): 87–97.

Teschner, Matthias, Bruno Heidelberger, Matthias Müller, Danat Pomeranets, and Markus Gross. "Optimized Spatial Hashing for Collision Detection of Deformable Objects." In *Proceedings of Vision, Modeling, and Visualization 2003,* edited by Thomas Ertl, Bernd Girod, Günther Greiner, Heinrich Niemann, Hans-Peter Seidel, Eckehard Steinbach, and Rüdiger Westermann, 47–54. Berlin: Akademische Verlagsgesellschaft Aka, 2003.

Thieme, Klaus. "Leonardo da Vinci: Die Grenzen der Quantifizierung." *Zeitschrift für Germanistik,* n.s. 3 (2003): 520–38.

Thomsen, Christian W. "Psivilisation und Chemokratie: Stanislav Lems Phantastik-Konzeption erläutert an theoretischen Schriften und an seinem Roman Der futurologische Kongress." In *Phantastik in Literatur und Kunst,* edited by Jens M. Fischer and Christian W. Thomsen, 353–68. Darmstadt: Wissenschaftliche Buchgesellschaft, 1980.

Tramus, Marie-Hélène. "Dispositifs interactifs d'images de synthèse." PhD diss., University of Paris VIII, 1990.

Turkle, Sherry. *Simulation and Its Discontents*. Cambridge, MA: MIT Press, 2009.

Turkle, Sherry. "A Tale of Two Aesthetics." In *Life on the Screen: Identity in the Age of the Internet*, 29–49. New York: Simon & Schuster, 1995.

"Valenz (Soziologie)." In *Wikipedia. Die freie Enzyklopädie*. Accessed October 3, 2008, http://de.wikipedia.org/wiki/Valenz_(Soziologie).

Vasari, Giorgio. "Life of Paolo Uccello: Painter of Florence." In *Lives of the Most Eminent Painters, Sculptors and Architects*, translated by G. du C. De Vere, vol. 2, 131–40. London: Macmillan, 1912. First published in 1550.

Vasari, Giorgio. *Lives of the Most Eminent Painters, Sculptors and Architects*, translated by G. du C. De Vere, London: Macmillan, 1912. First published in 1550.

Vescovini, Graziella Federici. "Biagio Pelacani a Firenze, Alhazen e la prospettiva del Brunelleschi." In *Filippo Brunelleschi: La sua opera e il suo tempo. Relazioni presentate al convegno internazionale di studi tenutosi a Firenze nel 1977*, vol. 1, 333–48. Florence: Centro Di, 1980.

Vescovini, Graziella Federici, ed. "Le questioni di 'Perspectiva' di Biagio Pelacani da Parma." *Rinascimento* 12 (1961): 163–206 (commentary) and 207–43 (transcription of the original text).

Virilio, Paul. *The Art of the Motor*. Minneapolis: University of Minnesota Press, 1995. First published in 1993.

Virilio, Paul. *A Landscape of Events*. Cambridge, MA: MIT Press, 2000. First published in 1997.

Virilio, Paul. *Open Sky*. London: Verso, 1997. First published in 1995.

Virilio, Paul. "The Perspective of Real Time." In *Open Sky*. Translated by J. Rose, 22–34. London: Verso, 1997. First published in 1995.

Virilio, Paul. *Polar Inertia*. London: Sage, 1999. First published in 1990.

Virilio, Paul. *The Vision Machine*. Bloomington: Indiana University Press, 1994. First published in 1988.

von Baer, Karl Ernst. "Die Abhängigkeit unseres Weltbilds von der Länge des Moments." *Grundlagenstudien aus Kybernetik und Geisteswissenschaft* 3 (Supplement) (1962): 251–75. First published in 1864.

von Bertalanffy, Ludwig. *General System Theory: Foundations Development Applications*. London: Allen Lane, Penguin Press, 1971. First published in 1968.

von Bertalanffy, Ludwig. "The History and Development of General System Theory." In *Perspectives on General System Theory*, 149–69. New York: Braziller, 1968.

von Bertalanffy, Ludwig. "Vorläufer und Begründer der Systemtheorie." *Forschung und Information* 12 (1972): 17–27.

von Randow, Gero. "Computer-Simulation: Bild statt Welt?" In *Das kritische Computerbuch*, edited Gero von Randow, 121–29. Dortmund: Grafit Verlag, 1990.

von Samsonow, Elisabeth. "(Präliminarien zu einer) Phänomenologie des halluzinierenden Geistes." In *Telenoia. Kritik der virtuellen Bilder*, edited by Elisabeth von Samsonow and Éric Alliez, 28–46. Vienna: Turia + Kant, 1999.

Wagner, Andreas. "Models in the Biological Sciences." *Dialektik. Enzyklopädische Zeitschrift für Philosophie und Wissenschaften* 1 (1997): 43–57.

Wand, Eku. "Interactive Storytelling: The Renaissance of Narration." In *New Media Screen Cinema/Art/Narrative*, edited by Martin Rieser and Andrea Zapp, 163–78. London: British Film Institute, 2002.

Wardrip-Fruin, Noah. *Expressive Processing: Digital Fictions, Computer Games, and Software Studies*. Cambridge, MA: MIT Press, 2009.

Warnke, Philine. "Computersimulation und Intervention." PhD diss., TU Darmstadt, 2002. Accessed October 27, 2005, http://elib.tu-darmstadt.de/diss/000277/DissWarnke_LHB.pdf.

Weber, Jutta. *Umkämpfte Bedeutungen: Naturkonzepte im Zeitalter der Technoscience*. Frankfurt am Main: Campus, 2003.

Weibel, Peter. "Vom Bild zur Konstruktion kontextgesteuerter Ereigniswelten." *Camera Austria International* 49 (1994): 33–44.

Weibel, Peter. "Die Welt der virtuellen Bilder: Zur Konstruktion kontextgesteuerter Ereigniswelten." In *Weltbilder—Bildwelten—Computergestützte Visionen (Interface 2)*, edited by Klaus Peter Dencker, 34–47. Hamburg: Verlag Hans-Bredow-Institut für Rundfunk und Fernsehen, 1995.

Weissberg, Jean-Louis. "Corps à corps à propos de *La Morsure*, CD-Rom d'Andréa Davidson." In *L'image actée: Scénarisations numériques, parcours du séminaire* L'action sur l'image, edited by Pierre Barboza and Jean-Louis Weissberg, 51–71. Paris: Editions L'Harmattan, 2006.

Weissberg, Jean-Louis. "Espaces virtuels." *Imaginaire numérique. Revue internationale et interdisciplinaire* 1, no. 1 (1987): 67–71.

Weissberg, Jean-Louis. "Introduction générale." In *L'image actée: Scénarisations numériques, parcours du séminaire* L'action sur l'image, edited by Pierre Barboza and Jean-Louis Weissberg, 9–20. Paris: Editions L'Harmattan, 2006.

Weissberg, Jean-Louis. *Présences à distance. Déplacement virtuel et réseaux numériques: Pourquoi nous ne croyons plus la télévision*. Paris: Editions L'Harmattan, 1999.

Weissberg, Jean-Louis. "Le simulacre interactif." PhD diss., University of Paris VIII, 1985.

Wenzel, Horst. "Initialen: Vom Pergament zum Bildschirm." *Zeitschrift für Germanistik*, n.s., 3, (2003): 629–41.

Whitelaw, Mitchell. *Metacreation: Art and Artificial Life*. Cambridge, MA: MIT Press, 2004.

Wiemer, Serjoscha. "Horror, Ekel und Affekt: Silent Hill 2 als somatisches Erlebnisangebot." In *'See? I'm real …': Multidisziplinäre Zugänge zum Computerspiel am Beispiel von 'Silent Hill'*, edited by Matthias Bopp, Britta Neitzel, and Rolf F. Nohr, 177–92. Münster: Lit, 2004.

Wiemer, Serjoscha. "Körpergrenzen: Zum Verhältnis von Spieler und Bild in Videospielen." In *Das Spiel mit dem Medium: Partizipation—Immersion—Interaktion. Zur Teilhabe an den Medien von Kunst bis Computerspiel*, edited by Britta Neitzel and Rolf F. Nohr, 244–60. Marburg: Schüren, 2006.

Wiener, Norbert. *Cybernetics: or Control and Communication in the Animal and the Machine*. Cambridge, MA: MIT Press, 2000. First published in 1968.

Wiener, Norbert, Arturo Rosenblueth, and Julian Bigelow. "Behavior, Purpose and Teleology." *Philosophy of Science* 10 (1943): 18–24.

Wiesing, Lambert. "Widerstreit und Virtualität." In *Störzeichen: Das Bild angesichts des Realen*, edited by Oliver Fahle, 223–35. Weimar: Verlag und Datenbank für Geisteswissenschaften, 2003.

Willis, Karl D. D. "User Authorship and Creativity within Interactivity." In *Proceedings of the Fourteenth Annual ACM International Conference on Multimedia, POSTER SESSION: Arts short poster session 2*, edited by Klara Nahrstedt, Matthew Turk, Yong Rui, Wolfgang Klas, and Ketan Mayer-Patel, 731–35. New York: ACM Press, 2006.

Wilson, Stephen. *Information Arts: Intersections of Art, Science and Technology*. Cambridge, MA: MIT Press, 2002.

Wilson, Stewart W. "Knowledge Growth in an Artificial Animal." In *Proceedings of the First International Conference on Genetic Algorithms)*, edited by John J. Grefenstette, 16–23. Hillsdale, NJ: Erlbaum, 1985.

Winsberg, Eric. "The Hierarchy of Models in Simulation." In *Model-Based Reasoning in Scientific Discovery*, edited by Lorenzo Magnani, Nancy Nersessian, and Paul Thagard, 255–69. New York: Plenum, 1999.

Winsberg, Eric. "Sanctioning Models: The Epistemology of Simulation." *Science in Context* 12 (1999): 275–92.

Winsberg, Eric. *Science in the Age of Computer Simulation*. Chicago: University of Chicago Press, 2010.

Winsberg, Eric. "Simulated Experiments: Methodology for a Virtual World." *Philosophy of Science* 70 (January 2003): 105–25.

Winsberg, Eric. "Simulation and the Philosophy of Science: Computationally Intensive Studies of Complex Physical Systems." PhD diss., Indiana University, 1999.

Wittkower, Rudolf. "Brunelleschi and 'Proportion in Perspective.'" *Journal of the Warburg and Courtauld Institutes* 16, nos. 3–4 (1953): 275–91.

Witzgall, Susanne. *Kunst nach der Wissenschaft: Zeitgenössische Kunst im Diskurs mit den Naturwissenschaften*. Nürnberg: Verlag der modernen Kunst Nürnberg, 2003.

Wörn, Heinz, and Uwe Brinkschulte. *Echtzeitsysteme: Grundlagen, Funktionsweisen, Anwendungen*. Berlin: Springer, 2004.

Wolf, Mark J. P. "Subjunctive Documentary: Computer Imaging and Simulation." In *Visual Rhetoric in a Digital World*, edited by Carolyn Handa, 417–33. Boston: Bedford Presss, 2004.

Wright, Sewall. "The Roles of Mutation, Inbreeding, Crossbreeding, and Selection in Evolution." In *Proceedings of the Sixth International Congress on Genetics*, edited by D. F. Jones, vol. 1, 355–66. Brooklyn: Brooklyn Botanic Garden, 1932.

Wyss, Beat. *Vom Bild zum Kunstsystem*. Cologne: Verlag der Buchhandlung Walter König, 2006.

Youngblood, Gene. *Expanded Cinema*. New York: Dutton, 1970.

Zátonyi, János, Rupert Paget, Gábor Székely, and Michael Bajka. "Real-time Synthesis of Bleeding for Virtual Hysteroscopy." In *Proceedings of the Sixth International Conference on Medical Image Computing and Computer-Assisted Intervention, Part I*, edited by Randy E. Ellis and Terry M. Peters, 67–74. Berlin: Springer, 2003.

Zimmer, J. Adrian. *Abstraction for Programmers*. New York: McGraw-Hill, 1985.

Zsemlye, Gabriel, and Gábor Székely. "Model Building for Interactive Segmentation of the Femoral Head." In *Proceedings of the Third Annual Meeting of Computer Assisted Orthopaedic Surgery*, edited by Frank Langlotz, Brian L. Davies, and Andre Bauer, 420–21. Heidelberg: Verlag Steinkopff Dietrich, 2004.

Index

Printed in the United States
by Baker & Taylor Publisher Services